In memory of my mother and my grandparents
Oktyabrina, Maria, and Ivan Astaf'ev.

Infinite Instances: Studies and Images of Time
© Olga Ast

All art and text © its respective artists and authors.
Curation and Design: Olga Ast
Cover image: Jesse Stewart, *Untitled*
Typefaces used: ITC Avant Garde Gothic Book
Condensed, Rotis Semi Sans

Editors: Buzz Poole, Eli Stockwell
Printed and bound in China through Asia Pacific Offset

Every effort has been made to trace accurate
ownership of copyrighted text and visual
materials used in this book. Errors or omissions
will be corrected in subsequent editions, provided
notification is sent to the publisher.

Library of Congress Control Number: 2010940182

10 9 8 7 6 5 4 3 2 1 First edition

This edition © 2011
Mark Batty Publisher
68 Jay Street, Suite 410
Brooklyn, NY 11201
www.markbattypublisher.com

ISBN: 978-1-9356132-1-3

Distributed outside North America by:
Thames & Hudson Ltd
181A High Holborn
London WC1V 7QX
United Kingdom
Tel: 00 44 20 7845 5000
Fax: 00 44 20 7845 5055
www.thameshudson.co.uk

INFINITE INSTANCES

Studies and Images of Time

With thanks to all the contributors without whom this book would not be possible.

David Z. Albert
Vladimir Aristov
Olga Ast
Chris Basmajian
Ilya Bernstein
Sarah Bliss
John Boone
David Bowen
Costica Bradatan
Keith Brown
Patrick Calinescu
Sean Carroll
Stephanie Clare
Hallie Cohen
Irina Danilova
Robert David
Katherine Davis
Luba Drozd
Julia Druk
Ula Einstein
Dan Falk
Nathan Felde
Michael Filimowicz
Christian Friedrich
Matthew Fritze
Evgeeny Golovakha
Elizabeth Grachev
Christian Hawkey
Kai-Min Hsiung
Duoling Huang
Ken Jacobs
Edward Johnston
Katya Kronick
Aleksandr Kronik
Elliott Kaufman
Eliza Lamb
Hélène Lanois
MaryAnne Laurico
Jeremy Levine
Richard Leslie
Andrea Liu
Craig Morehead
Julia Morgan-Leamon
Paul Doru Mugur
George Musser
Michaela Nettell
Brandon Neubauer
Gary Nickard

Mark Norell
Satomi Orita
Evgeny Ostashevsky
Emanuel Pimenta
Vanessa Place
Buzz Poole
Melissa Potter
Don Relyea
Glen River
Kara Rooney
Anje Roosjen
Catherine Rutgers
Daniel Rosenberg
Michael Shara
Alexei Sharov
Michael Shulman
Jesse Stewart
Linda Stillman
Debra Swack
Lisa Tannenbaum
Catinca Tilea
Camilla Torna
Vladimir Tuchkov
Peter Whiteley
Ellen Wiener
Steve Witham
Sean Wrenn
Matvei Yankelevich
Jayoung Yoon
Norman Zabusky

Through time this world comes into existence. Time makes possible our life here, our journey through this space. Without time we would not be able to write or read sentences. We would not be able develop anything, including our thoughts. Many words in our everyday language are connected to time: fast, quick, slow, immediate, tomorrow, yesterday, today, moment, permanent, after, before, now ... and yet we still grapple with defining "time."

Time creates astonishing complexity through an endless series of replications—leaves, planets, stones, clouds, animals. These constructs are remarkably similar yet simultaneously individual, with innumerable subtle or significant variations. From a distance, the crown of a tree is a volume of identical leaves, but from close up we can see the uniqueness of each leaf. In examining deeper, we again find a mass of similar-seeming cells.

Evolution has created the complexity of our environment through an endless process of reproduction, with miniscule changes from instance to instance of the same object. Development— evolution—is possible only in time through creation and destruction, which are two sides of the same coin. Each moment in time is in turn a slightly altered configuration of the instance that preceded it. Time can be seen as the arena or medium in which change occurs, through layers of infinite instances.

Once upon a time...

... I was a little girl, growing up in my grandparents' house, listening to their myths and stories. I thought that my grandfather had a "Key to Time," which he used to wind the stately old clock that hung in the dining room. This was my introduction to the concept of time—perhaps the first abstract concept I came to know.

Filled with the effusive curiosity of childhood, I asked: Where does time go? Why doesn't it stop? Why doesn't it wait around for anyone? Where is the future hidden? Where is the past? My grandfather laughed as he answered, "You'll find out when you grow up. You'll go to school, and they'll explain everything there."

But of course, these questions have been the subject of constant human fascination for untold thousands of years. Our lives are ruled and delineated by time—from life-death cycles, to quotidian rhythms of going to school and work. Time preoccupies our day-to-day worries and our flights of imagination. Recently, "time management" has become a hot topic on self-help shelves; meanwhile blockbuster films like *2012* dramatize the end-of-days supposedly predicted by the Mayan's Long Count calendar, drawing in millions of moviegoers worldwide.

Infinite Instances is a book about time. It came to life out of a personal search for meaning among the multitude of theories and viewpoints on the subject. Having finished my education without—as my grandfather had hoped—satisfactory answers to most of my questions, I began to reach out to experts and thinkers from different disciplines, all of whom see time through a unique lens.

In 2009, I had the opportunity to bring together a group of scientists, artists, philosophers, writers, and filmmakers from around the world to participate in ArcheTime, a conference dedicated to sharing and debating their views on time and creating lines of dialogue and collaboration between the disciplines. Presentations, lectures, film screenings, and panel discussions were held over two days in New York City, and a two-week-long art exhibition coincided with the event.

Infinite Instances is a result of the ArcheTime discussions—as much an attempt to freeze time and record what happened as a challenge to provoke further examination and discourse. It is a multitude of ideas, theories, and diverse approaches to the problem of time. There is no domineering voice, or consensus—no precise answers or neat conclusions. This collection is meant to be seen as almost accidental, which is, after all, the condition that leaves room for serendipity.

Olga Ast

THE MATTER
OF TIME

George Musser

If any subject deserves an interdisciplinary treatment, it is time. Our experience of time is so fundamental and so mysterious that it takes all areas of human endeavor to come to grips with it. Historically, scientific and artistic ideas of time have played off one another, and that remains true today.

The major questions of modern physics boil down to an inability to understand time and its conjoined twin, space. Conundrums arise from the particular way of conceptualizing time that physicists have adopted, so let me begin with it. This conception of time has been extremely useful in making physics the most precise of all sciences. Yet it has its limits and those limits have become increasingly pressing.

Physicists conceptually divide nature into two elements: the state of the world and the laws of physics. The state of the world is defined in space. In classical mechanics, such as the rules that govern a pool table, the state consists of the positions and velocities of objects. The laws of physics operate in time. They take one state to the next. These laws work both ways: we can run the laws in reverse to reconstruct what the world used to be like.

This division of labor leads us to a picture known as the spacetime diagram (see Figure 1). For these purposes, we're not worried about all the spatial relationships that objects can have, so we can represent all the spatial dimensions with a single dimension, the horizontal axis of this diagram. The state of the world is defined along this direction. By applying the laws of physics, you can take the state and predict the state at any time in the future. Over time, objects trace out an entire line. A car moving at a steady speed, for example, corresponds to a straight, tilted line. So you can lay out time like a spatial dimension.

This geometric idea of time as a gridline underpins everything I have to say about time. Spatializing time seems so commonsensical that even many non-physicists forget how remarkable it is. We do not perceive time as anything remotely resembling a spatial dimension. We routinely draw the path of a baseball thrown into the air as an arc, but we do not directly see it that way. Rather, we see the world unfold from one moment to the next.

What gives this spatialized view of time more than metaphorical significance is that how you divvy up

Catherine Rutgers: Origins (making time — view one): 12.94" x 10": 2010

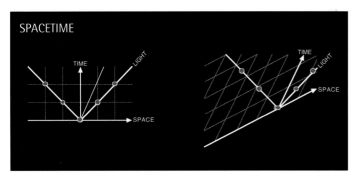

SPACETIME

Figure 1. A spacetime diagram represents time spatially. A tilted line represents the path of a moving object. A 45-degree line represents the path of a light beam. People moving at different speeds slice spacetime into space and time differently.

space and time can change. Spacetime gets sliced into space and time differently, depending on your velocity. To the driver of the car, it looks like he's stationary and the rest of the world shoots by. The speed of a car looks like zero if you're driving, 55 mph if you're on the ground, or 110 mph in a head-on collision. The moving car becomes, to the driver, a fixed reference point, and he divides up space differently than the observer on the ground. This is the principle of relativity first articulated by Galileo.

Einstein showed that even time looks different depending on your velocity. The reason is that the speed of light, unlike the speed of a car, looks the *same* to every observer. For the speed of light to remain the same, you can't simply determine relative speed by adding or subtracting, because then you could exceed the speed of light; instead you need a more complicated relative-velocity formula that mixes space and time. Loosely speaking, for the speed of light to remain the same as you speed up, the passage of time

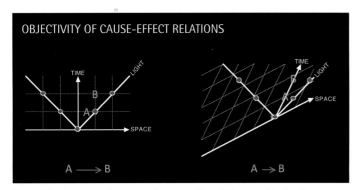

OBJECTIVITY OF CAUSE-EFFECT RELATIONS

Figure 2. Time is structured to ensure that cause-effect relations are objective. If one person sees an event A cause, or help to cause, an event B, so will other people, even when they're moving at different speeds. The time interval between A and B might differ, but one will always precede the other.

must slow down for you. On a spacetime diagram, the faster you go, the more the line representing your velocity gets tilted, approaching the diagonal line that represents the speed of light. Each of us moves into the future at his or her own pace.

You have to take care with spatializing time. People often talk of time as the fourth dimension, but that doesn't mean space and time are the same; the two may be related, but they're still distinct. Time plays a special role in nature. This distinctiveness is the heart of many of the deep problems in modern physics.

Maybe the most important is what physicists refer to as causality: the principle that there is an objective distinction between cause and effect. More precisely, if we have two events A and B, event A can help cause event B if it (a) precedes it in time, and (b) is close enough to exert an influence on B. If these two conditions are true for one observer, they're true for all observers, no matter how fast those observers are moving (see Figure 2). For example, in pool, if the cue ball hits the 4-ball and the 4-ball knocks the 8-ball into a pocket, this sequence will be the same for everyone watching the game. Nobody will see the reverse sequence in which the 8-ball jumps out of the pocket and hits the 4-ball.

The reason causality holds is that there's a limit to how much space and time mix. The space axis always remains below the line representing the speed of light, and the time axis always remains above it. Otherwise, you might get a case where space and time switch places, such that events that occur sequentially to a slow observer occur simultaneously to a faster one and in reverse order to an even faster one. If such reversals happened, you could set up time loops in which cause and effect wouldn't be clear. And that might allow for paradoxes—the same kinds of paradoxes that can arise in time travel, such as events that cause themselves or, conversely, prevent themselves from happening. It would give a whole new twist to the chicken-and-egg problem if a chicken could lay the egg that she hatched from.

So time looks almost but not quite like a spatial dimension. In space, you have freedom to move around and you can see a whole landscape spread out before you. That's obviously not true in time. Our experience of time is different from that of space in several ways.

First, we experience that time is unidirectional—the so-called arrow of time. The past is different from the future, even though the laws of physics are bidirectional. The classic example is an egg breaking. We see eggs crack and then break open, but never the opposite, an egg spontaneously healing its cracks. How do you reconcile the unidirectionality we see with the bidirectionality of the laws of physics?

The thinking, going back to the nineteenth century, is that time itself has no directionality and that the arrow is an emergent property of nature: something that's not present at the foundations, but arises in the aggregate. The arrow characterizes the motion not of individual molecules, but of a mass of molecules. After all, there's no such thing as an egg, broken or otherwise, in the basic laws. The difference between eggs in various states of repair, and therefore the directionality of the process, has to do with how the molecules are organized. The fresh egg is the most highly organized, the broken egg slightly less so, the shattered egg even less.

What I mean by the word "organized" is that there are more ways for the egg to be a little broken than pristine, and even more ways to be completely broken. So just by the laws of probability, the egg is more likely to be broken than not, and if you start with a pristine egg, practically anything the molecules do is likely to lead to breakage. The real question, then, is why you ever had a pristine egg to begin with. The probabilistic progression implies that whatever came before was even less probable, and before that, even less probable, all the way to the origin of the universe. The universe was originally in a very particular state.

Over time, the universe approaches the most probable, most generic state possible, a condition of complete dissipation known as "heat death." Living things resist this overall trend toward degeneration; we carve out little pockets of order in an increasingly disorderly world. But in bucking the trend, we actually contribute to the overall degeneration. The act of living literally kills the universe.

And you know what makes it even more tragic? It's *forgetting* that causes the most damage. Because the laws of physics are reversible, whenever we forget, the world must take on the burden of remembering for us. Forgetting—erasing—is essential to the process

of creation. Art is tragic in many ways, but surely this is the worst.

The second way that time differs from space is that not only do we perceive a directionality to time, we perceive a "flow" to time: the sense that only the present moment is real. Yet physics and philosophical logic hold that time is laid out in its entirety—that the past and future exist equally. Otherwise, how could different observers slice up time differently? Whose flow would be right? Most scientists would argue that past, present, and future all exist, and we move among them like a car driving down the road. Some, to be sure, think it's the physicists' notion of time that should give.

The flow of time raises two questions. Why do we perceive it? That is, why don't we see time as spatialized? Presumably that, too, has something to do with what it means to be alive. An even deeper question is: If the world is laid out and everything is preordained, does time matter at all? The state of the world at one time determines it at all times. The past and future exist in the present, as T.S. Eliot wrote:

Time present and time past
Are both perhaps present in time future,
And time future contained in time past.
If all time is eternally present
All time is unredeemable.

Third, and finally, there's a specific technical sense in which time doesn't seem to matter at all. This is something that comes out of Einstein's general theory of relativity. In this theory, not only do space and time unite, but they can distort (see Figure 3). They're malleable. We become aware of this as the force of gravity. The problem comes when you try to describe the distortion of space as a process occurring in time. You find that the shapes space takes are mathematically different, but physically equivalent. So nothing truly changes. The world according to physics is frozen in place, incapable of true change, which flies in the face of what we see. This is one of the biggest reasons why it has been hard to unite general relativity with other theories of physics.

Lecturers on physics often mention the malleability of space without explaining what it means, so let me digress for just a moment to flesh it out a little bit. The idea is that Earth, for example, bends both

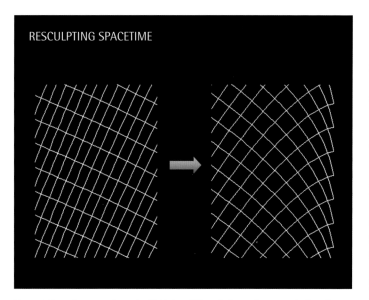

RESCULPTING SPACETIME

Figure 3. Spacetime not only can be divided up differently, it can distort, producing what we perceive as the force of gravity. The fact that time can distort is one of the reasons physicists suspect that it is not truly fundamental to nature.

In relativity theory, that's why things accelerate toward the center of the Earth. If you throw a baseball, the curved arc is typically about a quadrillionth of a second longer than sitting on the ground. The baseball doesn't want to go too crazy and fly off into deep space, though, or otherwise spatial distance *would* become a factor and the increases in duration would be offset by spatial distance. This balance is what determines the precise shape of the arc it follows.

I'm glossing over the details here, and I want to get back from this digression to my regularly scheduled program, but I just wanted to connect this concept of spacetime distortion that you may have heard about to something you can actually see and think about the next time you throw a ball up into the air.

In short, physicists face the problem that their concept of time doesn't match our everyday experience of time. Ironically, their reaction is to go even *further* away from everyday notions of time. The leading idea is that time is not fundamental. How could it be if it can bend? Just as substances emerge from atoms, and we emerge from substances, time might emerge, too. The seemingly contradictory properties of time might emerge with it. So we can treat time (and space) much as we treat matter.

Just as you see structure, such as atoms, as you zoom in on matter, if you zoom in on the spacetime continuum, you may seem some kind of filigree structure. There might be the smallest meaningful time duration—an "atom" of time. These atoms of time would be governed by quantum theory, with its own rules. For instance, there would be no single unique arrangement of atoms. The spacetime we see would be a composite of all possible arrangements.

Even these atoms may not be truly fundamental. Space and time might emerge from still more fundamental ingredients. This is hard to get your head around. How do you describe emergence if it is something that occurs within time? Here's one way that some physicists try. Earlier, I mentioned the role that time plays in ordering the world. You can flip this role on its head and say that the world has an order and time describes it. We usually assume time precedes and defines processes, but you could relate processes to one another without introducing time. Time provides a convenient but unnecessary medium of exchange, like money.

space and time. At the surface of our planet, the fractional distortion is about one part in a billion. The temporal distortion is a distortion to how fast clocks tick. The closer you are to the center of the Earth, the slower a clock will tick; clocks on the ground tick more slowly than they do in orbit. Space also gets distorted, altering the distance between objects, but most of the things we deal with, like baseballs, move so slowly that they don't probe much of space. Their path through spacetime is mostly a path through time.

What physicists do is define a notion of spacetime distance that includes both spatial distance and time duration. The baseball naturally follows a path that *maximizes* its spacetime distance; this is the spacetime counterpart to a straight line in space. Now, because the spacetime distance for a baseball is mostly just the time distance, this means that the baseball wants to *maximize* the duration of its flight, as measured by its own internal clock. And that means it wants to spend as much time far from the Earth's center as it can. When it's far out, its internal clock ticks faster, so the baseball maximizes its flight time out there. The ball wants to move slowly at the top of its arc and faster at the bottom, so it can linger as long as possible at the top. Thus it decelerates as it moves up, or conversely accelerates as it moves down.

In that case, time is meaningful because processes in nature have a particular structure to their relationships. You can imagine a set of relationships that is too complicated to describe by a time parameter. So, the world, at root, may have no concept of duration. That concept, and the rest of time's structure, may have developed in the aggregate as the relationships organized themselves. Time does not impose order on the world, but rather the opposite.

As you can see, physicists have conflicted attitudes toward time. Let me close by noting this is also true of our culture. On the one hand, we're hyperscheduled and obsessed with punctuality. We have come to regard aging as something to be resisted. On the other hand, we tell ourselves we need to relax about time, to spend quality time with people, to goof off online.

Our attitudes toward space are conflicted, too. Airline travel and telecommunications have made distance matter a lot less to us than it did to our grandparents. The modern world is defined by mobility, both geographical and social. At the same time, there's a countervailing attitude that our individuality and independence are important to us—that we want to keep our distance from other people. And we obsess about the trade-offs this involves. We bemoan that we feel disconnected from one another.

This conflict defines modern society, and physicists are discovering that it defines the physical universe as well. On the one hand, time may not matter at a fundamental level. It emerges. On the other hand, it *has* to emerge if we are to exist. Life is meaningless without time. We fight the ravages of time, but time gives us dynamism and purpose. On the one hand, distance, too, may be a construct. When two people are far apart, they might actually be right next to one another, considered in some broader sense. On the other hand, our existence requires the emergence of a concept of distance. The very concept of a "thing" requires it. If space and time had never emerged, the world would have remained a structureless mush.

Art thrives on tension, so this should give artists some rich ideas to explore, and physicists, for their part, can learn from artists that tension is not something to be explained away, but to be embraced.

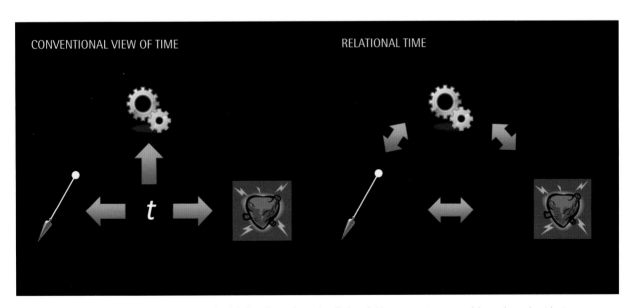

Figure 4. In the conventional view, time is fundamental and defines the motion and oscillation of objects: a gear turns, a pendulum swings, a heart beats once per second. In the relational view, time is derivative. Objects bear certain relationships to one another—a gear turns once per swing of a pendulum or beat of a heart—and we introduce the abstraction of time to make it easier to describe this web of relationships, much as we introduce money to simplify economic transactions.

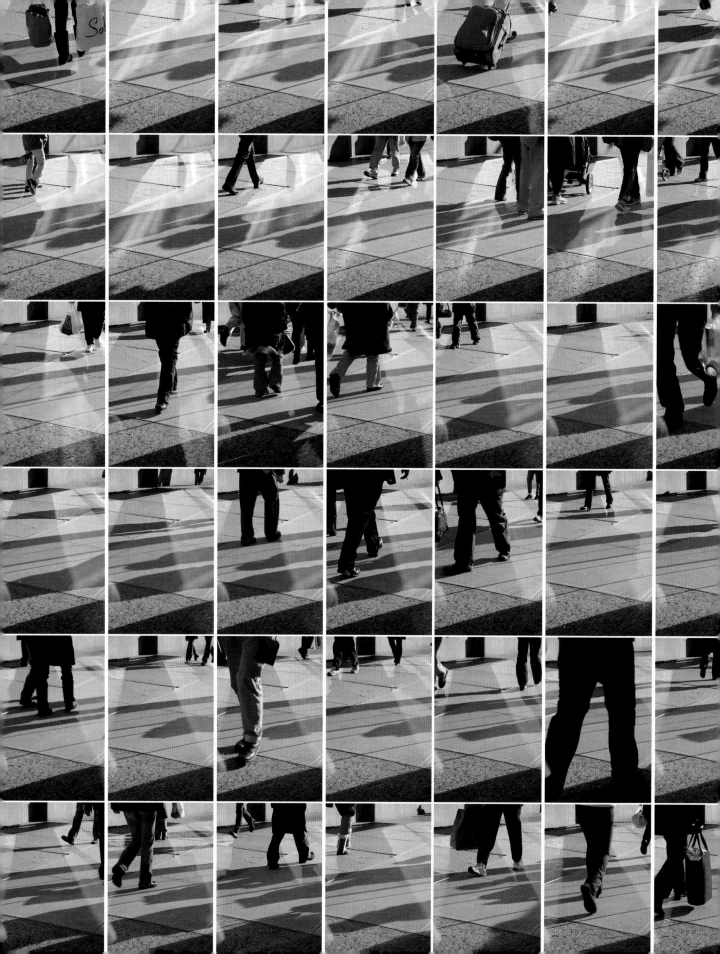

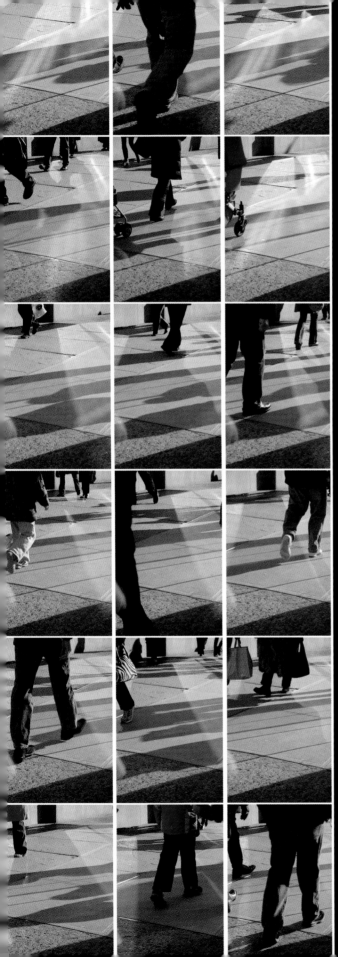

Elliott Kaufman

My architectural photography results from the observation of light and how the movement of the sun alters the environment, either built or natural. As I shot a building and the frame remained locked, the drama of how different it would be as the sun moved has always been of great interest to me. This series, "Time Transformations," has given me the opportunity to work with these concepts in the abstract of time.

The original source is just what it seems. I set up a static camera shot sometimes for twenty-four hours or just a few minutes at intervals from every second to every hour, depending on the view and dynamic movement of the scene. I am totally dependent on cooperative weather and people patterns. The surprises are remarkable.

Streetdance x 60; 30" x 40"; 2009.

TIME IN LIVING SYSTEMS

Alexei Sharov

TIME AND CHANGE

Most physicists view time and space as fundamental properties of the world, where change is described as a trajectory in space and time. They optimistically assume that all changes can be explained in terms of effective cause. However, Aristotle pointed out that effective cause is only one of four possible kinds of causation, and not every change can be explained fully by following trajectories in time and space. According to Aristotle, change is a more fundamental category than time; in fact, time is made of changes. Also time is not universal, it can be specific for some systems. This view of time is assumed by several biologists who think that living systems have their own time scales and time sequences. For example, organisms develop and age at different rates.

In order to study time we first need to learn how to study change. This issue was investigated in detail by a Russian paleobotanist Sergei Meyen. His main ideas can be summarized as follows:

1. Change is first qualitative and only then quantitative; time represents quality (archetype). Thus, Meyen called his conception of time "typological time."

2. To detect change we need a model of a system (i.e., a list of parts and relations between parts).

3. Change follows certain rules (logic) and we need to reconstruct these rules.

4. Change leaves footprints that can be used for temporal reconstructions.

Let us first address the problem of modeling. A living organism can be modeled as a system of interconnected parts. For example, a fish has a head, eyes, fins, and tail. More parts can be found inside the body: liver, guts, gills, heart, other organs. Meyen suggested the term "meronomy" for a science about parts of systems and principles of partitioning. Paleontologists often find isolated parts of organisms (e.g., leaves or fruits of plants), which are difficult to classify unless somebody finds an attachment of a part to the whole organism. Each part can be further partitioned into smaller parts down to the cellular or even molecular level, and each level of organization

brings additional details about the structure and function of the organism.

Change of organisms in the individual life or in evolution can be described in terms of alteration of the composition of parts or relations between parts. For example, a tadpole has a tail, but the frog that develops from it has no tail. The evolution of fish can be described by the change of part size (e.g., paddlefish has a long nose), or by the loss of parts (e.g., eels lost most of the fins that other fish have).

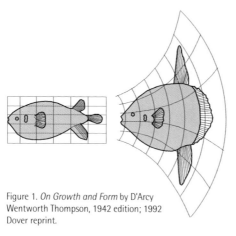

Figure 1. *On Growth and Form* by D'Arcy Wentworth Thompson, 1942 edition; 1992 Dover reprint.

Using a model of an animal we can start understanding the rules (i.e., logic) of animal evolution. In particular, it is possible to identify parts and relations that emerge or get modified. Above is an example from the book by D'Arcy Thompson *On Growth and Form*. The picture shows that the change of metrics (i.e., distances between parts) can transform one kind of fish into another, or transform the skull of a monkey into the human skull. These transformations occur in time, so we can measure evolutionary time by the degree of geometric change.

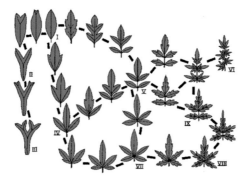

Figure 2. Meyen's evolution of leaves.

Meyen was specifically interested in following the logic of leaf evolution. It appears that the evolution of leaves follows its own internal logic. A leaf can be modified in three basic ways: (a) splitting the end into two branches, (b) producing feather-like nodes, (c) palm-like nodes. Also, there may be combinations of different patterns, as shown in the picture that is taken from Meyen's book *Fundamentals of Paleontology* (see Figure 2).

LIFE CYCLE, INDIVIDUAL TIME

Now let us switch from evolutionary time to a shorter time scale, which is individual time or a life cycle. Change becomes time only when it is *reproducible*. The main reproducible element of any living organism is its life cycle. The butterfly lays the eggs, small caterpillars emerge from eggs, they start feeding and growing, and then a caterpillar becomes a motionless pupae, attached to a branch. Finally, a new butterfly emerges from the pupae.

Platonic philosophers view change as a destruction of form, which may be true in the case of death. However, the change can also make a new level of form as in the life cycle. We tend to consider an organism in its current form, which is an incorrect approach because the organism is a circular process of its life cycle. Some parts of the organism may not be functional currently, but they are needed for the next phase of the cycle. You cannot understand a caterpillar unless you know that it will eventually become a butterfly.

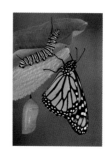

Figure 3. Butterfly life cycle.

Humans also have a reproducible life cycle, which is a form of our existence. We can understand our life at a new level if we think that any stage of our physical and psychological development is transient and a part of the life cycle. Several organs change their function as a human ages. Many philosophers and artists interpret human life from the perspective of the life cycle.

Aging should be viewed as a part of our nature, as our biological time scale. Also, aging is not just fate,

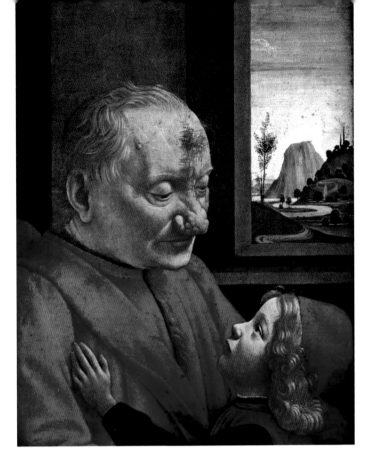

Figure 4. Domenico Ghirlandaio; *An Old Man and His Grandson*; tempera on wood; 24.4" x 18.1"; c. 1490. Distributed by DIRECTMEDIA Publishing GmbH. Wikimedia Commons.

it can be modified if we learn its logic. Eventually we may learn how to throw an extra handful of sand into our sand clock.

The life cycle has internal logic, which is extremely complex and we understand only a small fraction of it. For example, the early development of a Drosophila embryo is controlled by the interplay of two major genes, which together guide the formation of the anterior-posterior polarity of the embryo. The "*hunchback*" gene is transcribed uniformly within the egg, whereas "*nanos*" is transcribed only in the posterior pole. Nanos protein binds to hunchback mRNA and blocks its translation. Thus, at the protein level, the embryo has mirror gradients of proteins: nanos at the posterior pole and hunchback at the anterior pole. These proteins regulate the transcription of other genes that control the formation of body parts along the anterior-posterior axis. This regulation is mediated by several homeobox genes that are activated at regions of the embryo with a certain ratio of nanos and hunchback.

TEMPOFIXATION

Past changes leave their footprints, which allow us to reconstruct historical events. Meyen was a paleontologist; thus, he had a professional interest in making historical reconstructions based on such footprints of time, which he called "tempofixators." The most well-known tempofixators are tree rings, which indicate the rate of tree growth, climate changes, insect outbreaks, and forest fires. Similarly, chambers of the shell of the Nautilus mollusk represent the earlier stages of its development. Tempofixation is not designed for scientists who do historical reconstructions; instead it may be useful for the organisms themselves. For example, tree rings have important structural and water-conducting functions. Neurons layers in the cortex of the brain represent multiple waves of neuron migration in early embryonic development, and this layered structure is very important for the functionality of the adult brain.

Paleontologists use fossilized organisms for reconstructing the evolutionary process. Individual fossils may represent ancestors of currently living organisms. For example, the Archaeopteryx is viewed as an ancestor of birds. Other fossils represent evolutionary branches that left no surviving species. Extinct Paleodictyoptera resembles a giant dragonfly but it has nothing in common with contemporary dragonflies.

Paleontologists are interested not just in individual organisms but also at reconstruction of ecosystems of the past. It is important to know which organisms lived together at a specific time and place. Fossils can be dated by evolutionary periods. For example, the

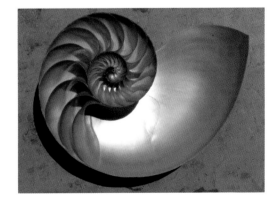

Figure 5. Nautilus shell. Wikimedia Commons.

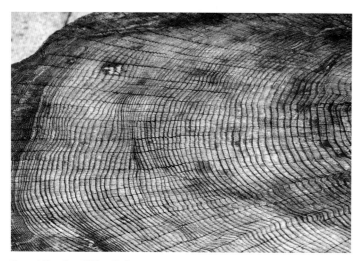

Figure 6. Tree rings. Wikimedia Commons.

Ordovician period was the era of gigantic cephalopods and trilobites, and the Jurassic period was the era of dinosaurs.

Evolutionary periods are a perfect example of a qualitative time scale. Each period has its own key features, and the absolute time scale is not that important.

LIVING SYSTEMS MAKE THEIR OWN TIME

So far we have used Aristotle's conception of time as change in living systems. But what is the source of change? Here I would like to focus on the idea that change is controlled/encoded by living systems themselves, in other words, living systems make their own time. Because living organisms are self-referential systems, they don't need an external observer to detect or make changes. Biologist Jacob von Uexkull developed a theory of meaning (Bedeutungslehre, 1940), which assumed that all organisms develop a model of their environment (Umwelt). Organisms make meanings of objects by interpreting them as food, shelters, or enemies. Only living systems can create new meanings, and this can be viewed as a fundamental property of life. Organisms perceive the world through their functions and their tools. According to the law of instrument (attributed to Mark Twain): "To a man with a hammer, everything looks like a nail." By making a new tool or organ, organisms can modify their perception of the world. This concept has developed into a novel area

of science called biosemiotics. The main thesis of biosemiotics is that life and meaning are co-extensive. Every living organism makes and communicates a model of its environment, and all meanings are produced in this way. This idea is opposite to the Platonic philosophy, which considers all forms and meanings as given a priori.

Time can be viewed as a part of the Umwelt of an organism, which is designed to organize individual processes into functional behavior. Some processes need to be synchronized, whereas others are invoked sequentially in a specific order. Even single-cell organisms make their Umwelt and their time; thus, the brain is not necessary for making models. Nucleus is the brain of eukaryotic cell that includes both long-term genetic memory represented by DNA sequence, and short-term memory represented by epigenetic marks, i.e., various modifications of DNA-binding proteins called histones. Histones can be methylated, acetylated, phosphorylated, or ubiquetinated, and these modifications control the activity (transcription) of genes in the genome. There is a hypothesis that our brain memory is based on the epigenetic memory of individual neurons.

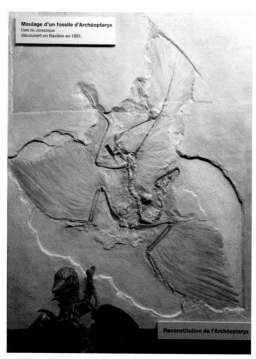

Figure 7. Model of an Archaeopteryx on display at Geneva natural history museum. Wikimedia Commons.

Let us consider the most fundamental temporal phenomenon in biology, self-reproduction. Because the majority of living organisms are represented by cells, the basic self-reproduction is implemented as a cell cycle. For example, bacterial cells grow and then divide to produce offspring cells. The division of a bacterial cell starts with the duplication of its circular DNA. DNA rings move to the opposite sides of the cell, and a new cell wall is assembled in the middle to separate two daughter cells. This process is repeated indefinitely until resources are available in the environment.

Most organisms have much bigger cells than bacteria. They are called eukaryotic because each cell has a nucleus that encloses most of the DNA. Division of eukaryotic cells is much more complex than in bacteria. The DNA is organized into multiple chromosomes, which are duplicated and then distributed between daughter cells. The whole process can be viewed as a dance of chromosomes with macromolecular partners that include microtubules, nuclear membrane, and centrosomes. After duplication all chromosome pairs become aligned in the center of the cell. Then pairs separate and chromosomes are pulled to the poles. How is this dance of chromosomes designed and orchestrated?

Cell division is a living clock with periodic divisions. A mechanical clock has a barrel with a spring, and various wheels, but there are no wheels in the cell. Nevertheless, the cell cycle is controlled by a perfectly tuned wet mechanism. Each chromosome in a cell is a huge DNA molecule, which is a chain of linked nucleotides. All chromosomes in a human genome carry about three billion nucleotides, which we read as A, T, G, and C characters. Genes represent the portions of this sequence used to encode proteins. Genes are first transcribed, which means making an RNA copy of the gene. Then the protein is manufactured using RNA sequence as a template. Some proteins can regulate the activity of other genes; they are called transcription factors. Transcription factors can bind to a specific short sequence of nucleotides near the beginning of the gene, and then they can either activate or suppress the transcription of the gene.

Regulation of gene activity is a very complex process that involves hundreds of regulatory proteins with sophisticated rules of assembly and disassembly. They make logical switches resembling human logic. Some regulators can start working only in the presence of specific partners, and they may be inactivated by specific repressors. Biologists understand only a small portion of these interactions. An additional layer of complexity is represented by so called "histone code," which is the basis for epigenetic short-term memory in the nucleus. It is also controlled by hundreds of proteins with logical switches.

Mechanisms of the cell cycle were studied in the details of yeast. There is a technology called "microarray" that makes it possible to measure the activity of all individual genes in the genome at each time point. Gene expression measurements done in a time course covering the entire cell cycle show clear oscillations in the activity of many genes. Each step in the cell cycle is characterized by a specific set of active genes that produce regulatory proteins. Cyclins and cyclin-dependent protein kinases are two major classes of proteins that control the progression of the cell cycle. When they bind together, they are able to activate certain transcription factors, which in turn regulate the activity of numerous target genes. The target genes, in turn, produce proteins that are necessary for the processes involved in cell division, including replication of DNA, condensation of chromosomes, assembly of microtubules connecting chromosomes to centrosomes, separation of chromosomes, and assembly of a cell membrane between daughter cells.

The circadian clock is another cyclic process in organisms. In contrast to the cell cycle, this clock is adjustable by external light periodicity. As a result, the organism can anticipate environmental changes during the day by addressing its circadian clock. Molecular mechanisms of this clock include several key proteins like transcription factors Per2, Cry1, and others. The circadian clock includes cell cycle-related genes and it is often synchronized with cell division.

Photoperiodism adds more complexity on the top of the circadian clock. Organisms can detect changes in the length of light and dark periods of the day and adjust their activity to the seasonal changes. For example, the well-known Christmas plant poinsettia produces only green leaves and no flowers if grown in the long day conditions. However, after transition to a short day and long night condition, it produces red leaves and small hardly visible flowers.

Plants and animals developed their own calendar based on photoperiodism. Trees "know" when to start growing leaves and when it is time to turn them red in the fall. Insects synchronize their life cycle with the season so that larvae appear exactly at the time when food (e.g., foliage) becomes available, and dormant stages (e.g., eggs or pupae) are used to survive the winter.

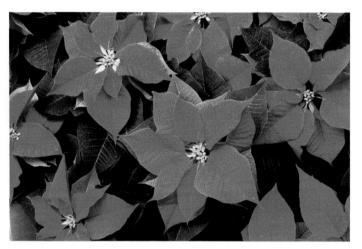

Figure 8. Poinsettia. Photo by Scott Bauer.

Molecular functions of organisms are often described as "mechanisms." Unfortunately, the word "mechanism" has unjustified connotation of something foreign to life, something that destroys life. However, human-made mechanisms and tools represent the functional envelope of the human society.

All life processes are based on developing functional envelopes. The cell is a functional envelope of DNA, and somatic cells represent the functional envelope of potentially immortal germ cells that can be transferred from parents to the offspring. Mechanisms are essential for life because they support living functions. The difference between human clocks and cellular clocks is mostly in the scale and materials, but the principles of their function are similar.

In conclusion, I would like to point out the unity of time and life. This unity was foreseen by Heidegger who called his famous book *Being and Time*. Life cannot exist without making clocks because: (1) life is based on self-reproduction, (2) self-reproduction is a periodic clock-like process. Does time exist without life? We can reconstruct past events, including the origin of life; but we (who do the reconstruction) are alive. Time structure is needed for storage and communication of useful functions (e.g., well-tuned sequence of processes in cell division); and useful functions and communication exist only in living organisms. Thus, time is a product of life. However, we can extrapolate processes beyond human life and biological evolution. But we should not forget that time without life is an abstraction.

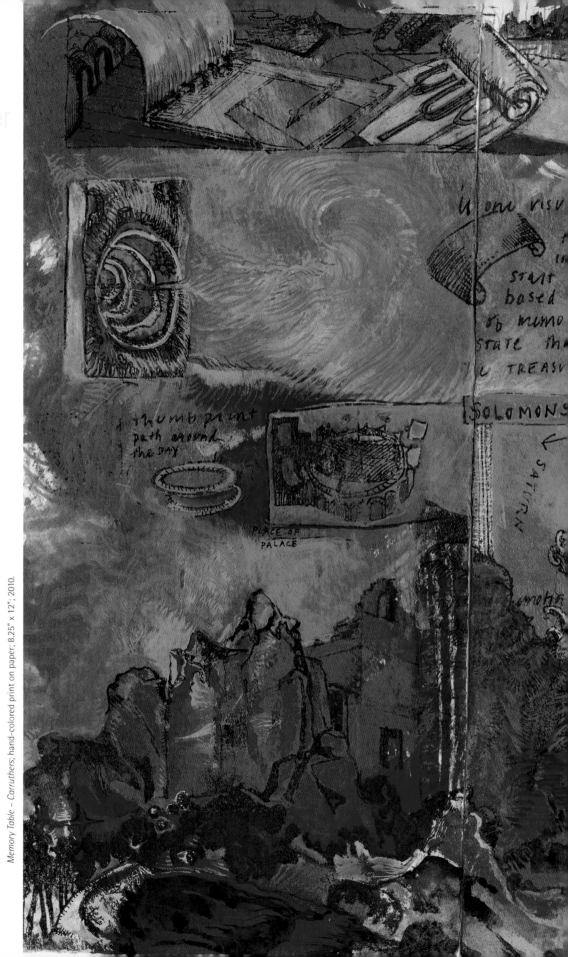

Ellen
Wiener

Memory Table – Carruthers; hand-colored print on paper; 8.25" x 12"; 2010.

MEMORY TABLE

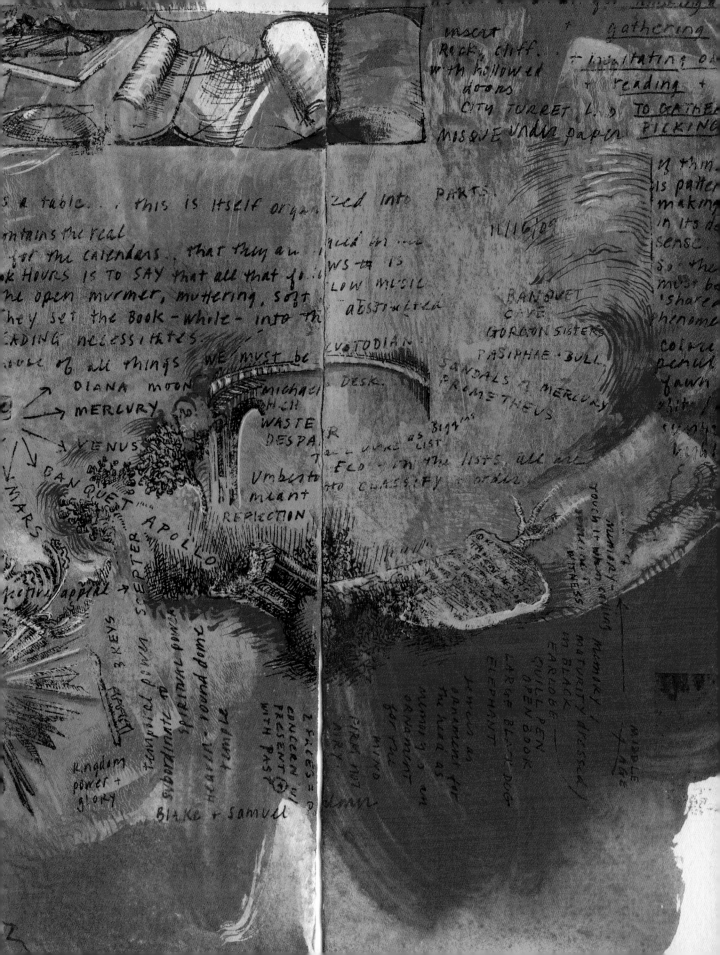

Daniel Rosenberg

ONE: ART AND HISTORY

This paper is not about art; it is about a category of non-art that has a formal and historical relationship to art that produces some interesting critical friction. It is about chronographics. Most objects that belong to this category—historical charts, chronological tables, timelines, and related visual devices—are the creations of scholars not artists, and typically these objects have been created with functional rather than aesthetic goals in mind. In other words, whether or not we choose to think of them as art, that is not how they have usually been intended or viewed.[1]

Historically, there have been some exceptions, especially in the twentieth century, including time charts by artists such as Ad Reinhardt, John Cage, and Hans Haacke, and more recently, Christoph Fink, Huang Yong Ping, and Paul Chan. This is in part a reflection of a general effort to infiltrate the realm of art with non-art. But the time charts that have made it into the sphere that is typically referred to as art also raise significant questions about the role of history in art and about the relationship between history and the definition of art itself.

Among the many intriguing examples of artist chronologies are the several celebrated time charts of the Fluxus artist George Maciunas from the 1960s and 70s—works that are at once an extension of the analytic chronology charts that Maciunas learned to make in college history classes and a self-conscious challenge to the historicisms of the critical and curatorial establishment represented by institutions such as the Museum of Modern Art in New York.

But are Maciunas's charts works of art or works about art? And in what ways can the history of art itself be the subject of art? If the Fluxcharts are art, what about the intricate folding time chart of Russian history that Maciunas made as a study aid for a college history class less than a decade earlier? For that matter, what of the many chronological charts that appear in art history textbooks and exhibition catalogs such as the famous genealogical flow chart published on the cover of the exhibition catalog *Cubism and Abstract Art* published by MoMA in 1936? What of torpedo-diagrams that MoMA director Alfred H. Barr, Jr. circulated internally at the museum to depict its possible collecting strategies? Or the vast body of little-noticed graphic time charts

FLUXUS (ITS HISTORICAL DEVELOPMENT AND RELATIONSHIP TO AVANT-GARDE MOVEMENTS)

Today it is fashionable among the avant-garde and the pretending avant-garde to broaden and obscure the definition of fine arts to some ambiguous realm that includes practically everything. Such broad-mindedness although very convenient in shortcutting all analytical thought, has nevertheless the disadvantage of also shortcutting the semantics and thus communication through words. Elimination of borders makes art nonexistent as an entity, since it is an opposite or the existence of a non-art that defines art as an entity.

Since fluxus activities occur at the border or even beyond the border of art, it is of utmost importance to the comprehension of fluxus and its development, that this borderline be rationally defined.

Diagram no.1 attempts at such a definition by the process of eliminating categories not believed to be within the realm of fine arts by people active in these categories.

DEFINITION OF ART DERIVED FROM SEMANTICS AND APPLICABLE TO ALL PAST AND PRESENT EXAMPLES.

(definition follows the process of elimination, from broad categories to narrow category)

	INCLUDE	ELIMINATE
1. ARTIFICIAL:	all human creation	natural events, objects, sub or un-conscious human acts, (dreams, sleep, death)
2. NONFUNCTIONAL: LEISURE	non essential to survival	production of food, housing, utilities, transportation, maintenance of health, security.
	non essential to material progress	science and technology, crafts.
	games, jokes, sports, fine arts.*	education, documentation, communication (language)
3. CULTURAL	all with pretence to significance, profundity, seriousness, greatness, inspiration, elevation of mind, institutional value, exclusiveness. FINE ARTS** only. literary, plastic, musical, kinetic.	games, jokes, gags, sports.

* Past history shows that the less people have leisure, the less their concern for all these leisure activities. Note the activities in games, sports and fine arts among aristocrats versus coal miners.

** Dictionary definition of fine arts: "art which is concerned with the creation of objects of imagination and taste for their own sake and without relation to the utility of the object produced."

Since the historical development of fluxus and related movements are not linear as a chronological commentary would be, but rather planometrical, a diagram would describe the development and relationships more efficiently.

Diagram no.2 (relationships of various post-1959 avant-garde movements)
Influences upon various movements is indicated by the source of influence and the strength of influence (varying thickness of connecting links).
Within fluxus group there are 4 categories indicated:
1) individuals active in similar activities prior to formation of fluxus collective, then becoming active within fluxus and still active up to the present day, (only George Brecht and Ben Vautier fill this category);
2) individuals active since the formation of fluxus and still active within fluxus;
3) individuals active independently of fluxus since the formation of fluxus, but presently within fluxus;
4) individuals active within fluxus since the formation of fluxus but having since then detached themselves on following motivations:
 a) anticollective attitude, excessive individualism, desire for personal glory, prima dona complex (Mac Low, Schmit, Williams, Nam June Paik, Dick Higgins, Kosugi),
 b) opportunism, joining rival groups offering greater publicity (Paik, Kosugi,
 c) competitive attitude, forming rival operations (Higgins, Knowles, Paik).
These categories are indicated by lines leading in or out of each name. Lines leading away from the fluxus column indicate the approximate date such individuals detached themselves from fluxus.

George Maciunas, Fluxus (Its Historical Development and Relationship to Avante Garde Movements), ca. 1966. Courtesy of the Gilbert and Lila Silverman Fluxus Collection. Photograph Heman Seidl/Salzburg in association with Astrit Schmidt-Burkhardt.

in history books and quarterly reports that have nothing explicitly to do with art at all? [2]

All of these questions may, of course, be approached from a theoretical perspective, and there are a number of good answers to be given to each. But my interest here—an interest shared with the chart makers themselves—is more historical than theoretical, based on observations about historical time charts, not as art objects, but as something like the opposite of art objects, as graphic objects designed precisely *not* to be noticed as such.

TWO: A TIMELINE OF TIMELINES

Several years ago, I was asked to give a talk at a conference on "objects of study." The notion was to put scholars from different fields together on panels and to have them talk about the paradigmatic objects of their discipline. At that conference, a literary scholar was talking about novels, an art historian was talking about paintings, and so forth. As a historian, I found it difficult to decide what object I should present. What, after all, is the object of history? The novels and paintings discussed by scholars of art and literature are equally fodder for the historian, as indeed are the bones of the archeologist, the tree rings of the dendrochronologist, the ice cores of the climatologist, and virtually every other kind of object, depending on the historian's subject of inquiry.

Finding myself without something to show and tell, I decided to take a half step back, and rather than pick a *typical* object of history, I chose to present a timeline, a visual device that in a certain sense makes historical time itself an object. For my example, I chose a simple timeline from a history textbook that I was using in one of my introductory college history classes, the sort of timeline that any contemporary reader would immediately recognize.

This was not the first time that I had thought about chronography. Since a few years earlier, I had been casually collecting timelines, mostly in connection with my work on concepts of futurity.[3] And I had assembled a number of timelines that treated the chronological future—a timeline from the Department of Energy indicating the half-life of radioactive waste, a timeline of aliens from science fiction stories, a timeline of the coming apocalypse of 1843 published in 1842 by the soon-to-be-disappointed followers of the New England preacher William Miller, and so forth. Of course, for the conference in question, I was interpreting my mandate very broadly: historians *use* timelines all the time, but very few of us actually *study* timelines. Yet, for this same reason, it seemed worthwhile to investigate the subject in more depth.

So why *this* timeline? I picked it not because it seemed remarkable, but because to all appearances, there was really nothing to it. It seemed designed to disappear into the background, to give prominence to events that might be inscribed upon it, to organize them while allowing them their own meaning.

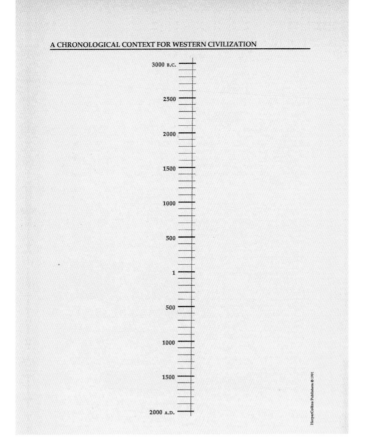

Gerald A. Danzer, "A Chronological Context for Western Civilization," from *Mapping Western Civilization (A Guide for Beginning Students)*. New York: HarperCollins, 1991. Courtesy of the author.

Graphics of this sort are familiar to all of us. The fact that we encounter them every day in textbooks, newspapers, advertisements, and websites without ever thinking too hard about them suggests that they are to a great extent successful in what they do. But this does not mean that they are simple.

Consider the timeline from my history textbook in more detail. Though it appears empty, it has a good deal of content already. First, there is periodization. This particular timeline runs from 3000 BC to 2000 AD. From this, we can surmise that it comes from a world history textbook, that the textbook equates history with what is usually called civilization, and links the birth of civilization with that of writing. And because there is only one line here, we can also guess (correctly) that the textbook strives in some way to weave the many histories of the world into something like a single story. We can also note that the internal periodization is decimal; that history, for this writer, does not move principally in thematic periods, but plays itself out inexorably though the space of what Walter Benjamin called "homogeneous empty time." [4]

What is more, however uneventful this history appears, it is a history that, at least in the background coding, BC/AD, revolves around a specific religious chronology. This chronology, of course, has its own contested history, emerging surprisingly late—more than half a millennium after the foundation of the Christian church—and catching on only slowly after that. It is a history that itself brings into view many of the formal and cultural complexities of chronological representation. The more recent practice of using BCE/CE to mark the same chronology only highlights how deeply embedded this reference point remains for secular cultures in the West and elsewhere. Throughout its history, the BC/AD convention has produced a variety of strange effects as, for example, in the seventeenth-century bibles that placed chronological markers in the margins next to the events recounted in the text of scripture itself. Rigorously following the state-of-the-art scholarship of the period, these bibles place the birth of Jesus in the year 4 BC.

Additionally, there is the way in which this timeline terminates at the top and bottom. In contrast to its incorporation of a central point of orientation drawn from Christian historiography, here the chart brackets an important theological question, the problem of millennial time. Not all timelines do this. To the contrary, as the explosion of timelines from the "Great Disappointment" of 1843 demonstrates clearly, such charts may be used equally well to indicate end times. In contrast, the structure of this chart suggests that, for the purposes of historical study, time is to be considered as neither beginning nor ending, but rather as a continuum moving outward into the obscure regions of prehistory and the unknowns of the future, flowing uniformly, giving a stable background for

The Holy Bible. London: Charles Bill, 1701. Courtesy of the William Andrews Clark Memorial Library, University of California, Los Angeles.

human events and achievements. This is implied by the continuation of the vertical line past the final horizontal hashes, using a graphic convention that is almost certainly second nature to all of us.

THREE: CARTOGRAPHIES OF TIME

At all events, this was something like the talk that I gave at that conference several years ago, and with that, I thought that my work on timelines was done. Back then, my curiosity about timelines was mostly formal. I thought that it would be valuable to look at a number of timelines together in the kind of optic that I have just suggested, and because of the *Histories of the Future* project, I was especially interested in those timelines that tried to indicate future events or trends (whether projecting from historical evidence or religious revelation) and continued past the present day.

It is easy to imagine that the province of future timelines would be the exclusive territory of visionaries, but, in fact, this turns out not to be the case. Projections of future time are common features of the most ordinary timelines, even if, as in the case we have been examining so far, this future is shown without events. Take the example of the Scottish historian Adam Ferguson's handsome chart of history published in the second edition of the *Encyclopaedia Britannica* (1778-83). Ferguson's chart resembles the modern one that we have been looking at but also differs in notable ways. Along the top of this chart is a series of geographic divisions of the world. The chart attempts to synchronize world history without precisely unifying it. Along the vertical path of historical time, political powers wax and wane, nations swallow empires, empires dissolve into nations, and so forth. At the top of the chart, Ferguson makes a single nod to biblical history in his inscription on the years of the Flood.

What intrigues me here is what Ferguson did when he came to the end. There were a number of choices available to him. He might have stopped at precisely the moment when his research ended, or at the year of publication. He might also have ended the chart at the year 1800, which would have been a close and numerically neat place to cut things off. For reasons that I have not yet settled, Ferguson chose the somewhat distant date of 1900 to end the chart. Of course, at the time of publication there were no events or rulers to fill in for those future years. This

does not, however, mean that they had no content in the terms of the chart. Ferguson continued the chart itself (hand-painted columns descending into the nineteenth century) as if natural time, rather than, say, a narrative of supernatural beginnings and endings, were its principal structuring framework. Ferguson's choices here reflect a transition to a familiar way of thinking, to a way of thinking about time characteristic of our contemporary world.

It occurred to me, as I approached having a critical mass of these artifacts, that there was more to be done with them than just typology. There was also a very interesting history to be investigated. Coming to these artifacts, I had expected to find a long history with little change. What, after all, could be new in a straight, measured line? What I found was quite the opposite: the timeline in this now-common form turned out to be a recent contrivance, not much older than the *Britannica* chart itself. What is more, the story of historical graphics in general—including lines, grids, circles, waves, trees, and a variety of other forms—was full of twists and turns, heterogeneity, and change.

Of course, claiming that timelines are modern must sound very strange. In the broadest sense, visual representations of time—certainly of events—are as old as visual representation itself. We have striking archeological evidence of lunar notations, for example, that date back 35,000 years. Yet, the timeline in the sense that we normally think of it—unilinear, regular, measured, scaleable—is modern. Moreover, it is a signal artifact of modernity.

This is not to suggest that in modernity we are stuck with linear time, or that the importance of the measured, linear representation of time has chased all other kinds of temporal representation from the field. To the contrary, the style of historical representation exemplified by the historical timeline is only one of many possible projections of time—to borrow a figure from cartography, a field that much influenced the chronographers of the seventeenth and eighteenth centuries—and part of what is valuable about doing the history of the timeline is learning how historians engaged these questions of temporal mapping when the timeline was first proposed.

The 1765 *Chart of Biography* by the English scientist and theologian Joseph Priestley—the discoverer of

oxygen—was one of the most influential timelines of the eighteenth century. The aim of *Chart* is simple: it is a reference tool for seeing when different famous people lived. The structure is intuitive: it is a kind of bar chart. But Priestley's *Chart* was one of the first of its kind. Like Ferguson's chart in the *Britannica* (which was directly influenced by Priestley) Priestley's includes a little bit of extra time at the end. Along the top and the bottom of Priestley's chart are dates for every century beginning in 1200 BC and continuing to 1800 AD. Centuries are marked by vertical lines; horizontal lines define areas of biographical achievement: in the top row, we find the historians, antiquaries, and lawyers; below them, orators and critics; then artists and poets; mathematicians and physicians; divines and metaphysicians; and statesmen and warriors. Solid horizontal lines inscribed on the grid show the dates for each life; ellipses indicate approximations.

Priestley's *Chart of Biography* performs an impressive feat of data compression, but it is also evocative as a visual form. Priestley thought of the biographical lines as "so many small straws swimming on the surface of [an] immense river."[5] Notice that the lines are densest at the farthest right margin. This is no accident. According to Priestley, the accumulating lines show an actual historical phenomenon, what he called the "acceleration" of science and technology in his own time: the closer you get to the present, the denser the crowd of scientists.

This, of course, only becomes visible because of choices made by Priestley: treating individual lives as subjects (rather than highlighting the history of institutions, for example), categorizing by career (rather than quality of achievement, say), putting various groups together (why are the historians with the lawyers, the mathematicians with the physicians?), choosing which figures to represent (where are the women?), identifying historical figures with single categories (where would Priestley—scientist, theologian, historian—himself have figured?), and so on. Priestley made it clear that, just as in geographical mapping, in chronological mapping myriad choices govern both content and form.

This is in no way to suggest that Priestley believed his charts to be mere fictions: he understood them to be factual, and what was demonstrated on them to be genuine. For him, they nonetheless repre-

sented perspectives on historical data, ways of sorting that necessarily and productively highlighted specific things. In his prefatory pamphlet, the *Description of a Chart of Biography*, Priestley guides his reader's attention to the bottom of his chart in order to show what kinds of insights such projections made possible.

Note the contrast between the scientists and the politicians on the chart, he says. In the first group, a distinct development takes place over the course of modern history: science leads to more science, and then to still more, through a multiplier effect. In the second, much happens but nothing changes: every period produces and equivalent number of statesmen and warriors. "The world," Priestley writes, "has never wanted competitors for empire and power, and least of all in those periods in which the sciences and the arts have been the most neglected."[6]

Priestley understood the power of his chart to lie in its representation of aggregates. Thus, while he gives us very valuable information about the individuals—

Isaac Newton and René Descartes, for example—the innovative is his presentation of both as participants in and representatives of a historical process much larger than either. I want to emphasize, too, the extent to which Priestley understood these visual techniques to be experimental. It is not that he viewed them as in any way false. Rather, he viewed them as exercises in heuristics, techniques for testing ideas.

Priestley did not see himself as the "inventor" of the timeline, and neither do I. In our book *Cartographies of Time*, Anthony Grafton and I tell the story of the modern timeline beginning with precedents from all the way back in the fourth century when the Roman Christian scholar, Eusebius, represented the history of the world in the form of a matrix with columns representing empires and rows for years. And over the course of the millennium that separates Eusebius and Priestley, countless scholars, illustrators, and printers tried their hand at perfecting Eusebius's matrix form or creating their own graphic rubrics for history. Indeed, right up to Priestley's time, it was the

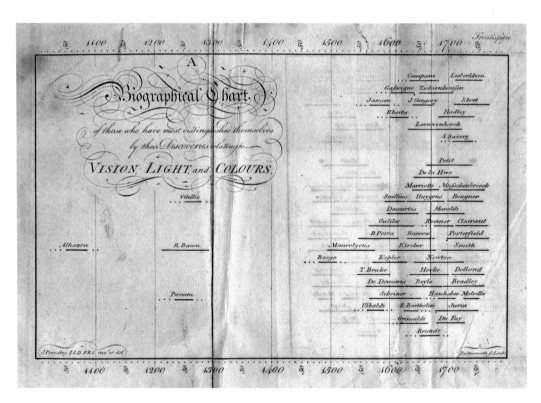

Joseph Priestley, "A Biographical Chart," from *The History and Present State of Discoveries Relating to Vision, Light, and Colours*. London: J. Johnson, 1772. Courtesy of the Department of Rare Books and Special Collections, Princeton University Library.

typographic grid, rather than the measured line that most Western scholars thought of as the paradigmatic visual form of history.

Priestley's innovation was not to improve upon the chronological table but to offer an alternative visual form that emphasized the importance of historical scales, measures, and aggregates, and that foregrounded the representation of flows and processes. Of course, none of this meant that the older table form would disappear. It would persist and flourish, as would tree forms such as in the genealogies of influence in Alfred Barr's *Cubism and Abstract Art* or and circular forms such as those in the recent spate of publications on the 2012 prophecies. All of these forms continue to flourish alongside the timeline, and none makes historical sense without the others. Still, it would be highly misleading not to acknowledge that within the discipline of history, since the eighteenth century, representing history by means of the timeline has become second nature.

The challenge, then, and it is one with which I think the early chronographers may assist us, is not to free ourselves from the timeline—the utility of which Priestley demonstrates brilliantly and economically— it is rather to see the timeline as Priestley and his contemporaries saw it, as a refraction rather than a reflection of historical fact.

During the past half century, this project has been engaged by many artists who have created alternative timelines and put timelines in surprising new contexts. Such works show how powerful and how contingent our traditions of historical representation are. What I hope to have suggested here is that the artists are not alone in this work and that they have never been—that within the domain of historiographical practice (note the "graphic" in historiography) many important experiments and debates have taken place, even if they have not received the attention that they deserve. In doing so, I hope also to have suggested some ways in which the critical projects of history and art may be of mutual help.

NOTES:

1 See Daniel Rosenberg and Anthony Grafton, *Cartographies of Time* (New York: Princeton Architectural Press, 2010).

2 Astrit Schmidt-Burkhardt, *Maciunas' Learning Machines: From Art History to a Chronology of Fluxus* (Detroit: Gilbert and Lila Silverman Fluxus Collection and Vice Versa, 2003).

3 Daniel Rosenberg and Susan Harding, *Histories of the Future* (Durham, NC: Duke University Press, 2005); *Cabinet: A Quarterly of Art and Culture* 13 (2004).

4 Walter Benjamin, "Theses on the Philosophy of History," in *Illuminations*, ed. Hannah Arendt, trans. Harry Zohn (New York: Schocken, 1969), 262.

5 Joseph Priestley, *Description of a Chart of Biography* in *The Theological and Miscellaneous Works of Joseph Priestley*, ed. John Towill Rutt (London: G. Smallfield, 1817), vol. 24, 476.

6 Priestley, *Description of a Chart of Biography*, 475.

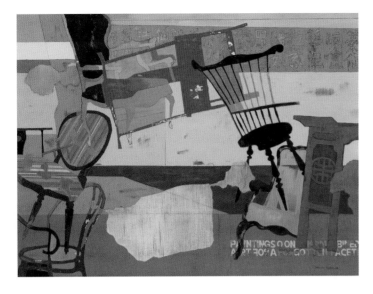

Duoling Huang

Time repeats itself. Music repeats itself. Image repeats itself. They all reproduce themselves in another level.

Floating Furniture; oil on canvas; 52" x 70"; 2008 (top).

Reprise; oil on canvas; 48" x 60"; 2008 (right).

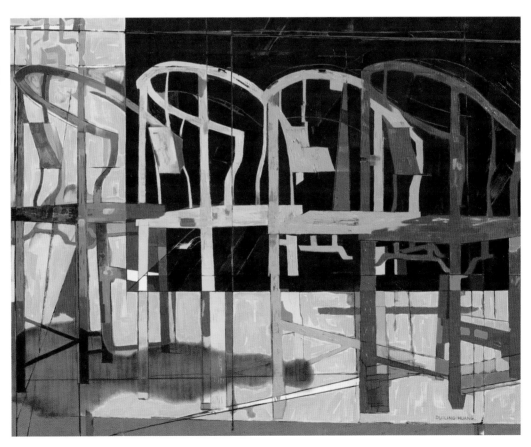

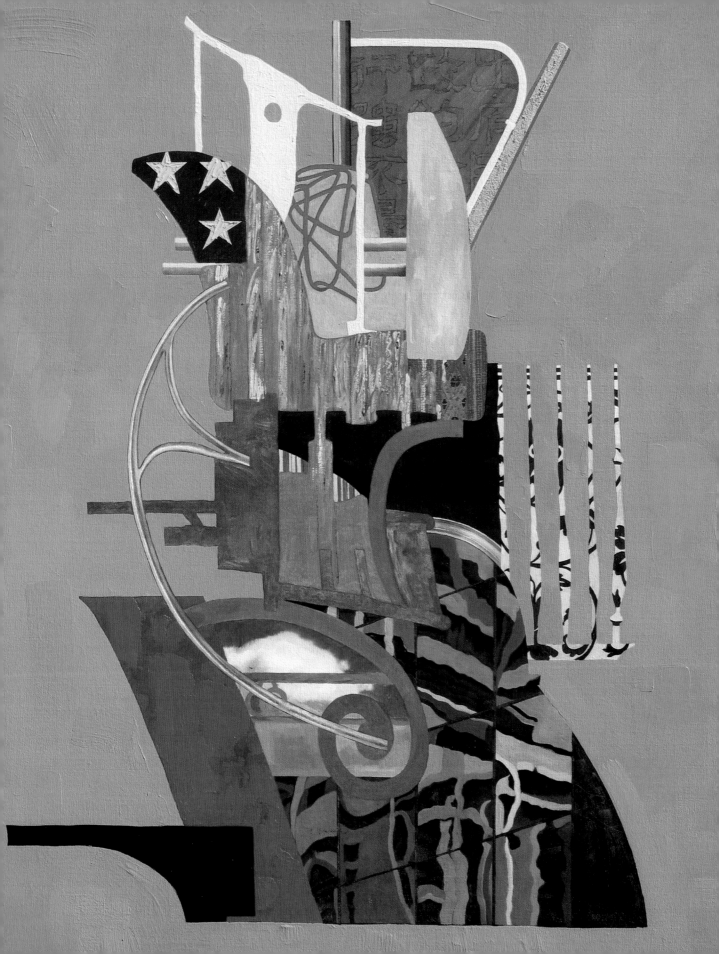

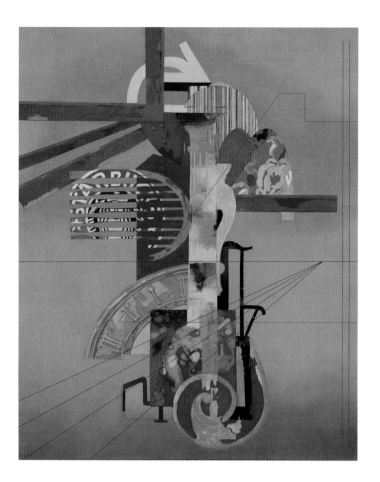

Duoling Huang

Time is running, like a turmoil on which history and cultures are floating.

Cultural Landscape-1; oil on canvas; 57" x 47"; 2008 (left).
Cultural landscape-4; oil on canvas; 57" x 47"; 2008 (top).

ART IN AND OUT OF TIME
OUT OF TIME

ART IN AND OUT OF TIME

Richard Leslie

It is a shock to many, especially those in the art world, that the best known reference to time and art comes from a scientist, and that he didn't mean it, at least not quite in the way most understand it. It comes in the first two lines of a Latin translation of an aphorism written by the ancient Greek physician Hippocrates ("father of medicine" is the general epithet), as "Ars Longa, Vita Brevis," commonly translated in English as "art is long, life is short." And lest we consider fourth century BCE Greece too far in the past, today this is one of the avenues art, as a category, uses to argue its difference against the temporality of popular media culture.

Of course, the Greeks did not have a separate name for art despite their development of the first art theory based on perceptual realism. The good Greek doctor used it (Greek: *techne* or technique/ability) to communicate that learning the craft of doctoring (read as "science and the acquisition of knowledge") is long and difficult. It is ironic but common that such an orderly and disciplined professional whose critical thinking made him an exemplar of the scientific mind and whose close perceptual observations and notes created clinical medicine should be so generalized by the art world. However, the concept of the timelessness of the arts lived a long life, for reasons discussed below. A variation was used by the Minimalist sculptors in the late 1960s and '70s to successfully argue for their type of art against the visual immediacy demanded by modernist art, while in the 1980s art's duration and extension in time into space proved pivotal for arguing an epochal change in the cultural superstructure called postmodernism.

In retrospect, the role of a doctor was commensurate with the way biological death helped convert the sense of time from the somewhat miserable and abbreviated lives of late Medieval Christian Europeans into visual expressions of aesthetic timelessness fused with the needs of spiritual proselytizing. Indeed, the field closest to art has always been religion. However, while Medieval Western Europe and the Byzantine East developed a litany of images that converted our biological end-of-time to theirs— even correlating prayers with chronological time in their beautiful little Books of Hours and carved in to the archivolts of cathedral entrances—they seemed far less interested in the biological metaphors that abounded in their sacred texts. Their concentration was on a measurable time that had run out and was

meaningless when seen, literally, against the spiritual and immeasurable time scale represented by using gold-leaf backgrounds in medieval manuscripts rather than the Greco-Roman greens and blues of earth and sky. It took death on a large scale, combined with the reawakened interest in the natural science of the world by the late Medieval scholars (schoolmen=scholastics) and the Renaissance, along with some technological advancements in print making (Gutenberg) to gradually re-apply the Greco-Roman biological metaphor and create the Renaissance fluorescence of image making whose ubiquity we now claim in the name of visual culture. Time could only matter, or be thoroughly invested in matter, after it had been at and come to hand, first literally and then figuratively.

Some argue it was the plague from the sixth and seventh centuries CE (the Plague of Justinian) that moved Europe from late antiquity into the so-called Dark Ages but less arguable were the consequences of its return in the fourteenth century when the Black Death (arguably bubonic plague) killed roughly half the population of Europe by 1400. Among the numerous dead were the Catholic church clergy at a time when they were needed most. By 1415 the famous *Ars Moriendi* (*The Art of Dying*) appeared as the first Western instruction manual to help move us into a good death. Since few could read, woodcuts were added as visual aids, their popularity summarized and exceeded (by sad necessity) the long line of death-bed scenes written in medieval literature and depicted in sculpture on the tombs of the empowered (known as cadaver or transi or memento mori tombs) and even over the use of the deaths of the Christian Christ and Virgin Mary. Add to that the development of oil painting (as different from fresco and tempera), with its consequence of the more mobile easel painting—not to mention in Europe a repopulation explosion, decent weather prior the later colder elements of Western Europe's little ice age, the rise of the mercantile class with the concomitant increases in church coffers, and the visual war between the Catholics and the newly formed Protestant faith—and the conjunction of Christian religion and time saw its greatest numerical visual representation.

But lived time, which had hovered in the background, slowly moved into the foreground as well as into portraits, landscapes, and still-lives, most of which were new (or at least revised) categories for the representation and embodiment of the new sense of time experienced (desired?) as personal and social time, which included and celebrated secular ownership. It is no accident that much of this newness flourished most in Protestant countries, where the organized reform churches exercised less direct concern in human daily affairs. Images of drunken Dutch peasants could be seen and avidly collected, along with the thousands of land- and seascapes, and still-lifes that we refer to as *vanitas* painting, because secular time carried aphoristic understandings in case human lives too frequently and quickly (un-timely) squandered their spiritual capital. As the spiritual demands merged more obviously with worldly concerns of more people and the secular interests of patrons and artists increased, first in the service of royal houses, then aristocrats, and finally within the rising fortunes of the bourgeoisies, secular and scientific forces also emerged to section time and place into knowable routes and pieces. It is the pace of the latter that created the "modern" change in time that we date in the visual arts to the mid-nineteenth century and usually more so to France, Paris in particular.

In a 1941 article, the historian George Boas argued the famous statement by the nineteenth century French artist Honoré Daumier that it was now necessary for artists to be of their own time. Such realization assumed that time was now known as differentiated epochs and that everyman/woman was (or could be) an agent in time. The phrase, *Il faut être de son temps,* became a rallying call and a philosophy at the heart of a modernism that began with the Romantics and, some argue, has not ended—a point I will argue. It was certainly the beginning of the equation of the avant-garde artists, those few who could lead via the obvious militaristic metaphor at the head of a new and perhaps more ruthless column, time, with its leading ("avant") edge now understood as progress.

Little does more to respond to this new imperative of time than the mid-nineteenth century invention of photography. Insofar as history is a progressive movement in time, as Hegel framed it, then photography not only froze time and made it instantaneous but handed it over to the middle class who had never possessed history, and to whom leisure time was about to be introduced. One way of visualizing the beautiful Impressionist canvases that celebrate

the middle class and their new leisure time is as an attempt through their bright, unmixed colors and quick notational strokes, to create a visual equivalent to the new sense of modernized world time with urban centers, grand (straight line) boulevards, and the quick movements and glances of the swirling crowds written into legend by the poets Edgar Allen Poe and Charles Baudelaire, whose newly urbanized strollers bordered on madness from their emersion in so much energy of their own—or at least that of capitalism's newly emerging—time. Interestingly, scientific interest in color theory emerged at this point and philosophers, many of whom influenced artists, began to concentrate on the issue of time. Could art be far behind in this new and soon to be Fordist mechanized time?

Time dominated the concerns of avant-garde artists during the first decades of the twentieth century to a degree not seen until digitization. Part of this concern derived from not only the idea of a new millennium but the technological advances. Horsepower now meant motorcars, with planes overhead and gas lamps replaced by electricity. Even World War I began on horseback and ended in tanks. The century was to be one of velocity, with all its attendant atomization and fragmentation. One thinks of Marcel Proust and James Joyce where time was not merely central but demanded new logics and formations. The French philosopher Henri Bergson was the most closely associated with artists, time, and this change in world view.

Many of Bergson's ideas aligned with the concerns of thoughtful young artists gathered in Paris; the historical power he gave to creativity, free will, intuition, and spontaneity, as well as his own use of metaphor to avoid intellectualism and the determinism of mechanistic ideas. Of particular appeal were his new formulations of space, time, causality, and the vitalist energy *(élan vital)* he felt was the driving force of evolution. The work of art and the unpredictability of the artistic processes fit his model and several of the Parisian avant-garde attended his lectures and offered visual parallels, just as Bergson called on examples of art to explain his views in lecture. Even today most graduate school film students are reading the work of the French philosopher Gilles Deleuze whose ideas on time and film were greatly influenced by Bergson's concept of duration. (See Deleuze's second volume of 1985/89, *Cinema 2: The Time Image.*)

For Bergson the experience of real, lived time was subjectively beyond the current ability of math and science to know because it never can be fixed. In its constant flow it endures, yet is ineffable, and can only be known through images. What one might perceive as a line in time is in fact a mobile tracing always self-extending, a changing force in motion that looks like a fixed state, qualitative in its extension, but, like matter at the quantum level, predictably immeasurable. He called it "duration." There could be no better match for the zeitgeist and Bergson gave it text and voice while the artists gave it image.

The painter Robert Delaunay, who apparently listened to and read Bergson, aligned his painting with the early analytic Cubist experiments of Pablo Picasso and George Braque to give us a series of paintings around 1910 of Paris's central icon of modernism, the Eiffel Tower. What first appear as images of the tower collapsing are intended to animate it via dematerialization by the dynamic, interpenetrating, and independent planes of bright color. Painting predicated on the abstract qualities and energy of light and color over time guide the history of all the modern arts from the nineteenth century and into the twentieth. Delaunay not only paints Bergson's "Duration" but gives us a new, visual comprehension of the enormous shift in architecture and sculpture of the twentieth century as it moves to replace mass with volume, mass hollowed by energy over time. Indeed, we often explain Cubism, the seminal art movement of the first half of the twentieth century, as an attempt to present multiple views of static matter over time in contrast to fixed points in space. Time now, literally and fundamentally, mattered in new ways as Cubist artists and commentators alike heralded their art as forays into the "Fourth Dimension" of time.

Bergson and the artists worked with an understanding of time fused with consciousness. Visually, it also presented an excellent equivalent to the atomized and fragmented world view that resulted as a social consequence of technological changes. Indeed, the sociologist Marshall Berman used the famous phrase from the *Communist Manifesto* for the title of his 1982 book *All That Is Solid Melts Into Air* to summarize this new modernism. In so far as modernism is the cultural equivalent of the economic process of modernization then its force and energy ("superabundant energy, an overflow of life" writes Berman) was moved by Marx into time whose "historical

drama and trauma" of dissolution covered and substituted for what capitalism destroyed. The bright side had a darker one. Yet another way of relating Cubism to time is by noting how Cubism both separated and united time and space through its opening of form into the surrounding space, thereby reconfiguring the Renaissance tradition of discrete objects set into and separate from space. This at roughly the same time Albert Einstein was making similar investigations.

Similarly, the Italian avant-garde was also reacting to the shifts in time and speed for the new millennium. Their visual forms were far more graphic in using light and color and the multiplication of forms to visually embody the "simultaneity" they saw as hallmark and harbinger of the future. They extended the concept of time into theatre with multiple actions, often outrageous, and without the chronological order of narrative sequence. Ironically, there was a new implicit narrative; energy over time destroyed and dislocated matter, the latter now a category conceived as oh-so nineteenth century. Everything was "out-of-time" or in a new time, one that semiotics was developing around 1912 in its distinction between typologies of time, the old diachronic (linear) order of sequenced time and causality and the new synchronic (all or simultaneous) time, one we now use to characterize the rapid time and distribution flows of the digital age and globalization, as plotted by theorists like Paul Virilio.

Equally anarchistic, the Dadaists, who unlike the Futurists opposed World War I as over-rationalized insanity, felt that the destruction of the forms and time sequences were appropriate to the era. Chief among them, and a god-like figure to much of post-1950 art and theory, was the French artist and master chess player Marcel Duchamp. In normative art history surveys his anti-aesthetic philosophy appears to rest mostly on his use of found objects, sans creativity or most other hallmarks of "art qua art." But not as ends. Rather the works, or non-works, were calibrated challenges to a linear world gone quite mad and based on not only art as a chessboard where strategy was all important to the category of "art" but on the mathematical challenges of time and space converted through his own thought experiments into social critique and commentary. Duchamp was such a serious student of the mathematician Henri Poincaré that their relationship has been the topic of

several books, countless articles (several in *Leonardo* magazine), and the topic of a three-day symposium in 1999 at Harvard University Science Center.

Like the English schoolmaster Edwin Abbott's satirical 1884 novel *Flatland: A Romance of Many Dimensions,* which remains dear to the hearts of students of math and computation, Duchamp poked psycho-social fun at those living constrained two-dimensional lives, in favor of the confusions caused by modern multiplicities based on time: the search for identity in a world of changes through perception based on non-Euclidean or four-dimensional geometry. Duchamp (along with others such as Francis Picabia) began to conceptualize humans as machines, a joke that made serious reference to the consequences of a regimented society, one famously echoed in the 1960s through Andy Warhol's well-know dictum of wanting to be a machine and producing (more-or-less) repetitive images through machine-like processes. Duchamp's "To Be Looked at (from the Other Side of the Glass) with One Eye, Close To, for Almost an Hour" (1918) not only now demanded a machine-like preset duration for viewing in its reference to measured society, but its central glass piece inverted the world, much the same way today's research on eye-tracking began and will lead to the newly developed lenses that allow "augmented" rather than "virtual" reality. In 2009, the Guggenheim Museum commissioned the South African-born filmographer Grahame Weinbren to literally focus on three 1913 abstract paintings by the Russian Vassily Kandisnky using computer assisted eye tracking, and a new, related musical score coordinated with an essay by Kandinsky, "Kandinsky: A Close Look (3 Paintings: 3 Investigations)." Currently, several artists are working to project performances in lensed space, catching up to the vision of the author William Gibson, the "noir master of the Web," who wrote in his 2003 post-modern novel *Spook Country* of a "video" artist who gave you the GPS coordinates and glasses for his work in spacetime that did not perceptually exist otherwise.

Probably the most famous examples of time in the static arts come from the Surrealists. Salvador Dali's 1931 "The Persistence of Memory" shows us both the decay of time and memory's relation to it. Today artists and curators alike focus on the time of memory as an "archive," the ways in which the visual and the preloaded unconscious create an embodiment

of time, while the French father of deconstruction, Jacques Derrida (*Archive Fever: A Freudian Impression,* 1996) returns us both to the history of psychoanalysis and his persistent theme of what constitutes truth within such differentiated realizations of time. Much of his work was inspired by the Surrealists' exploration into the time of the subconscious; its immeasurability is transfixed but also destroyed by time. Rene Magritte's well-known painting "Time Transfixed" (1938) freezes the forward progress of a locomotive as it emerges from a fireplace that holds a clock, while Surrealist photographers tried to meld negatives and images to emulate the fusions of dream-time, while also fixing the explosive moments of rupture caused by re-memory-ing.

Early filmmakers, more concerned with sequential narrative, had yet to arrive at similar consideration for the potentials of their medium. By the 1920s the Russian Constructivist Dizga Vertov's *Man With a Movie Camera* (the original Russian title is best translated as "person" rather than "man") finally began to catalogue and explore time in ways similar to the 1910 painterly experiments. His provocative use of the camera led to far more than cinema vérité, with its combinations of natural and staged shots, and to the eventual realization that time, here constructed around a single day in Odessa, a traditional biological time, could indeed be far more relative to the moving camera, thus multiple and complex. The obvious parallel in science would be not only to Einstein's famous visual thought experiment of a person in an elevator moving through space but also to Heisenberg's 1921 principle of uncertainty. These are issues explored from abstract painters at the turn of the century to abstract films from the Surrealists to 1960s experimental films—most fascinatingly documented in the 2005 traveling exhibition organized by curators at the Hirschhorn Museum and Sculpture Garden, Washington, D.C. under the title "Visual Music: Synaesthesia in Art and Music Since 1900"—as well as videographers of the early 1970s, such as Nam June Paik's concern with the viewer's consciousness of the passage of time—an issue we can now recognize as Bergsonian. Indeed, the use of film and video to explore our consciousness of identity in the 1990s and early twenty-first century through fiction and a multidimensional body, such as we see in Matthew Buckingham and Pipilotti Rist, are conceptually predicated on this new semiotics of time.

From the mid-1960s to early-1970s, Minimalists had already challenged a critical definition (established by American art critics Clement Greenberg, and Michael Fried) that used instantaneous recognition as their criteria for art, with a Bergsonian-like fusion of time and consciousness in duration that in the hands of artists (and much to both critics eventual displeasure) stretched art from the object under consideration into the environment and, via the feminists, into contextual and engendered social and economic systems. The New York-based Japanese artist On Kawara sent himself and others daily postcards with time and date, while the calendar (and time) was the central concern of many others such as Hanna Darboven, who used vast repetition, one characteristic of schizophrenic relations for people out-of-time. The openly clasped schisms used to escape the tyranny of consciousness by the Surrealists became, and to a large extent remain, the status quo, particularly with the advent of video tape-loops in the 1970s and today's world of unanchored digital free fall.

Such fusions and separations are what Fredric Jameson identified in 1984 as a condition of postmodernism, many of whose strategies such as pastiche and nostalgia were developed to recapture the organicism many felt to exist in past times. Perhaps before its time and in overly dramatic fashion, Jameson argued that our shift has been from historical time to a fully synchronic and subjective all-time, one that produces, using the French psychoanalyst Jacques Lacan for support, schizophrenic personalities scrambling to recoup their connection to a lost temporal flow now visible in the strategic techniques and end-products of art and popular visual culture of this new time. What happens after we have called this "time" home? Only time out of time will tell.

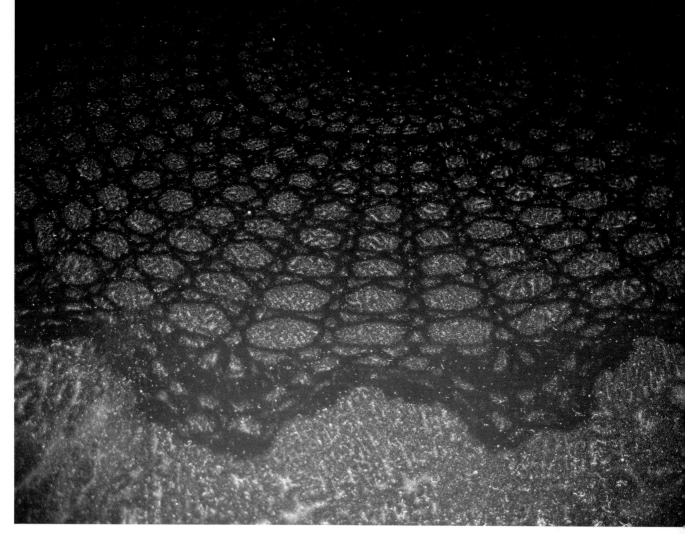

Dust Patterns (remake from 1995 original);
black board, doily, dust, time; 25" x 25"; 2010.

The word "accumulation" relates to time by definition. Accumulation of dust has a structural time element to it. Even though in some places dust accumulates faster than in others it still needs some specific time period: a day, a week, a month. At the moment we see the dust we automatically relate to time. This work is about an alternative art material, alternative aesthetic (beauty of cultural neglect) and media: dust creates unique artworks with the shortest lifetime span.

Irina Danilova

DUST PATTERN

Luba Drozd

OTIONUNMOTION

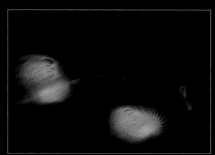

... to deviate from the overlaying of consecutive images that fade away as per the exponential nature of forgetting.

A strong connection comes in due to the spacing of the images in time and the visual curve it forms, which declines with time or fades away. In the animation the images usually are changed quickly and create overlapping of sorts that is superimposed on top of one another (motion within the screen format/fps). The tracing of the action, the focus, the center of interest therefore slowly fades off over time. The curve represented here is linear and the animation is within the the viewer's eye, tracing the images top to bottom, creating an organic curve within an organic shape intersected with the geometrical screen format. The curve is not guided by the frame rate and flows downward freely; tracing the attention of the eye creates a curve that is not superimposed over itself.

I wanted to remove motion from the motion piece in order to activate the perceptual mechanics and operation of the "film" through the movement of viewers themselves.

Unmotion; fragments of the Matrix of 46 images; 10" x 6.75" each; 2008.

VISUALIZING TIME

Camilla Torna

HOW DO YOU SEE THE PASSAGE OF TIME?

In the mid 1990s I started to ask friends, students, and acquaintances to answer this question with a sketch and the resulting drawings were later collected in the database Visualizing Time, an ongoing online research project by Icastic.

The very first idea is a private event and it occurred in a Bulgarian bank, while changing some currency. This event brought up the rendering of digits in space, the question being: How do you "see" the sequence of numbers 1 to 10? Through the transaction my husband would regularly and amazingly indicate a right turn after number 10. For me, number 10 was sitting comfortably on a cableway rising left to right instead. Surprising enough, some other people we asked would see 1 to 10 like stars in the sky, without any sequential order. Or rising from the ground to eye-level. A whole new set of horizons was unfolding.

The shift to envisioning time seemed only natural. Surprisingly, from the very beginning, the great majority of the people I asked drew something immediately and without giving it much thought. It was as if they had always had a crystal clear shape of time in their mind although, in most cases, they confirmed that they had never thought about it once.

Soon it was evident that what was going to show up was a wide variety of drawings. Instead of an expected collection of lines and circles, individual perception of time proved to range from minimalist abstractions to complex symbolic forms.

The Visualizing Time database is organized according to age group (per decade) or by six categories: abstract, cartoon, metaphoric, nature, sequence, symbolic. Also, the fifteen most frequent words in the captions are listed. For instance, in October 2010 they were:

Time	Always	Years
Life	Past	Different
Like	Days	More
From	Into	Passage
Will	Think	Clock

The abstract section is by far the most articulated, and it is probably what tells us more about the immediate and almost physical perception of time for many people. Perhaps it also shows us a glimpse of the intricate synopsis producing a picture of such an elusive subject.

Let's now take a look at a few examples, following a progression akin to Kandinsky's "Point Line Plane," moving from dot to line to circle to surface, all the way up to a very complex level of metaphor and beyond. All drawings are extremely fascinating, and it was not easy to compile a shortlist of samples.

DOT

Figure 1 shows the ultimate time unit: a dot. And this is where our journey starts, trying to find a narrative logic through the forest of this visual complexity.

1 – 0165

Section	Abstract
Age	30
Gender	Female
Country of Origin	Italy
Country of Residence	Italy
Education	Undergraduate
Profession	Student
Caption	-

Figure 2 gives the dot a closer look, giving it a still nucleus but also layers that move more and more the closer they get to the surface.

2 – 0154

Section	Abstract
Age	43
Gender	Female
Country of Origin	Italy
Country of Residence	Italy
Education	Art History / Graduate
Profession	Designer

Caption: *I feel like an onion. The outer skins move with time, and it is a social time that allows me to get in touch with others. But the more I go to the center of myself, the more time is slow and, in the very center, time is still. Only recently I realized that it is in the still center of an onion that the new plant buds.*

Figure 3 shows more dots interacting in space, and the energy brought by this movement. It reminds one of the 1914 painting by Italian Futurist Giacomo Balla, "Mercury Passing in Front of the Sun."

3 - 0099
Section	Abstract
Age	28
Gender	Male
Country of Origin	USA
Country of Residence	USA
Education	Art / Undergraduate
Profession	Student

Caption: *Dots can stand still, but also move around.*

Figure 4 instead delivers an astonishing and much more regular boustrophedon of dots, each one representing a generation through the history of humankind.

4 - 0060
Section	Abstract
Age	21
Gender	Female
Country of Origin	USA
Country of Residence	USA
Education	Illustration / Undergraduate
Profession	Student

Caption: *I feel I belong to a generation in a row.*

Figure 5 can hardly be categorized as dots, still the whirlwind of the present moment creates a focus on the "now" (And it just had to be here, being the very first drawing in this collection!).

5 - 0001
Section	Abstract
Age	25
Gender	Male
Country of Origin	Hong Kong
Country of Residence	USA
Education	Architecture / Undergraduate
Profession	Student
Caption	-

LINE

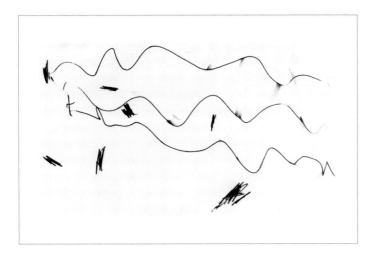

Once things get moving, the variety is increasing. The three-year-old author of Figure 6 had no doubts when given a pen and explained the task: maybe (and quite obviously) one of the "freshest" entries, it was handed to me with a large proud smile.

6 – 0006

Section	Abstract
Age	3
Gender	Female
Country of Origin	Italy
Country of Residence	Italy
Education	Kindergarten
Profession	Student
Caption	-

Lines can thicken (Figure 7), but as it happens, with alternating widths. The parallel motif recalls the topos of parallel universes ranging from Borges's The Garden of Forking Paths (1941) to the movie Sliding Doors (1998).

7 – 0255

Section	Abstract
Age	20
Gender	Female
Country of Origin	Germany
Country of Residence	Netherlands
Education	Educational design, management & media / Undergraduate
Profession	Student

Caption: *Time goes...*

In Figure 8 lines are similarly thicker and thinner, but seen in perspective. The knots along them are the several perceptions.

8 – 0123

Section	Abstract
Age	20
Gender	Male
Country of Origin	USA
Country of Residence	USA
Education	Architecture
Profession	Student

Caption: *Time across space is motion of many perceptions all from the same point.*

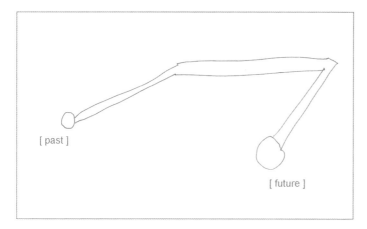

[past]

[future]

Figure 9: time depicted as a pipeline going from left to right on a path creating two angles. Very interesting information about the author is that this child has undergone colon surgery twice. Like a body memory, time takes the same shape of this organ. The same child when asked after one year, is already geared to a more dynamic vision of our position in the electric flow of things (Figure 10)

9 – 0053

Section	Abstract
Age	9
Gender	Male
Country of Origin	Italy
Country of Residence	Italy
Education	Primary School
Profession	Student
Caption	-

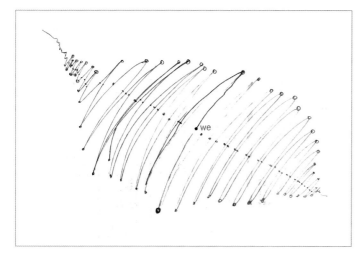

we

10 – 0231

Section	Abstract
Age	10
Gender	Male
Country of Origin	Italy
Country of Residence	Italy
Education	Primary School
Profession	Student
Caption	-

A humorous example closes our selection of lines (Figure 11), merging waves, peaks, ups and downs, boustrophedon path from birth to death, going back to the very beginning with the final cry of Mommy!

11 – 0239

Section	Abstract
Age	66
Gender	Male
Country of Origin	Lebanon
Country of Residence	France
Education	-
Profession	Writer

Caption: *Mommy! I love you girl - so good - I feel it - so intense - so far - I remember - I remember - love you all - no arrangements - still here - still alive st... - Mommy!*

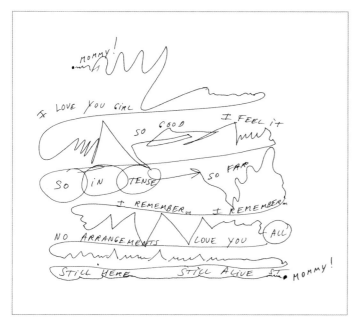

CIRCLE

Needless to say, the line bends very often into the shape of the circle. In Figure 12, a friend saw the Feynman diagram (quantum physics).

12 – 0024

Section	Abstract
Age	9
Gender	Female
Country of Origin	Italy
Country of Residence	Italy
Education	Primary School
Profession	Student

Caption: *Time is interesting because we never know what happens*

13 – 0217

Section	Abstract
Age	20
Gender	Female
Country of Origin	USA
Country of Residence	USA
Education	Undergraduate
Profession	Student

Caption: *Time is circular. As a human, I will only experience a small section of it. I enlarged my experience of time on the diagram so that it would be visible, but ideally it would be infinitesimal compared to the giant circle. My personal experience of time is circular too, it rotates around certain pivotal points and then comes back around to where it started.*

More often time is a circle, either closed (Figure 13) or unfolding in a spiral. Single moments can be more or less visible (Figure 14).

14 – 0149

Section	Abstract
Age	49
Gender	Female
Country of Origin	Italy
Country of Residence	Italy
Education	Undergraduate
Profession	Yoga Teacher

Caption: *In the tradition of yoga, the smallest unity of time is called ksana (one instant), the rhythm of our mind\'s perception of the interior and exterior world, like the photograms of a film running so fast that we do not perceive them as separate.*

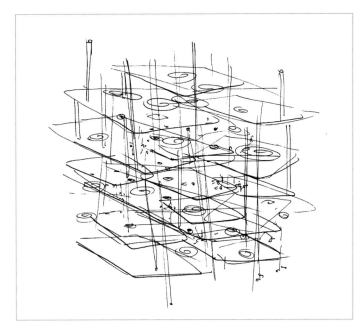

SURFACE

Once we get into the third dimension, time designs fascinating landscapes.

15 – 0087

Section	Abstract
Age	22
Gender	Female
Country of Origin	USA
Country of Residence	USA
Education	BA
Profession	Student

Caption: *"But I began then to think of time as having a shape, something you could see, like a series of liquid transparencies, one laid on top of the other. You don't look back along time, but down through it, like water. Sometimes this comes to the surface, sometimes that, sometimes nothing. Nothing goes away." (Margaret Atwood, Cat's Eye)*

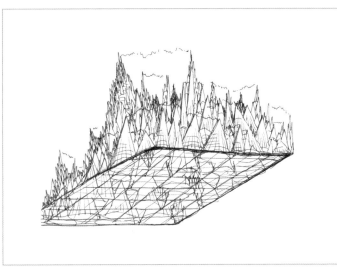

16 – 0108

Section	Abstract
Age	21
Gender	Male
Country of Origin	USA
Country of Residence	USA
Education	Graphic design and illustration / Undergraduate
Profession	Student

Caption: *I see time not as a linear sequence of events but as the manifestation of a moment from an infinite field of probability. Each spike represents a probable unit, and when combined with other units the spikes build themselves into a sort of spine which exists simultaneously with other parallel spines to create the universe that we perceive.*

TIME SPAN

Age, profession, cultural factors determine the chosen time-span: the present moment, a day, a week (this applies mostly to mid-life), a lifetime or even the entire history of humankind (Figure 4) are represented as time-frame. Let's compare the following two pictures from two women in their seventies. The first drawing (Figure 17) is a common representation for this age group: time is coming to the individual end.

17 – 0056
Section	Abstract
Age	73
Gender	Female
Country of Origin	Italy
Country of Residence	Italy
Education	Undergraduate
Profession	Retired

Caption: *The circle is almost complete.*

Figure 18 shows instead a reassuring daily routine, in a time of life when all days tend be similar.

18 – 0054
Section	Abstract
Age	70
Gender	Female
Country of Origin	Italy
Country of Residence	Italy
Education	Art School graduate
Profession	Retired Designer

Caption: *Energy decreases during the day.*

SYMBOLS AND METAPHORS

The symbolic approach seems less immediate and physically expressive than the abstract, and this independently from the age group. Figure 19 shows the most common—by far—symbol of time: nature. Many time as stars, a tree through the four seasons, the blooming to the rotting of a flower. In this picture, stars, moon, and sun combine in the effective synthesis of a five-year-old with the symbol of the clock. The same clock acquires a much more sophisticated look in the surrealist rendering of the stretching, forking, melting hand of Figure 20.

19 - 0043
Section	Abstract	Education	Kindergarten
Age	5	Profession	-
Gender	Female	Caption	-
Country of Origin	Italy		
Country of Residence	Austria		

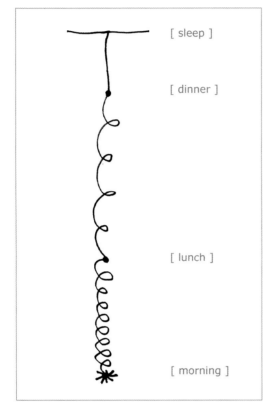

[sleep]

[dinner]

[lunch]

[morning]

20 – 0209
Section Abstract
Age 69
Gender Female
Country of Origin Italy
Country of Residence Italy
Education Junior High School
Profession Retired Secretary

Caption: *Time conceals all answers in itself.*

The powerful beat of a young heart with time gives way to a new strength made of intricate emotional connections (Figure 21).

21 – 0109
Section Abstract
Age 21
Gender Female
Country of Origin USA
Country of Residence USA
Education Undergraduate Student

Caption: *Subjective vs objective perception, organic vs scientific, simple/present/youth vs complex/future/adulthood, receding into distance but also shrinking. The weaker the heart, the richer it becomes with connections.*

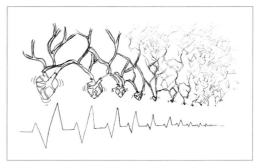

Floating in space in a freeze are the cells of Figure 22.

22 – 0259
Section Abstract
Age 21
Gender Female
Country of Origin UK
Country of Residence UK
Education Art

Caption: *My cancer cells.*

Time as something exquisite that needs a certain pace to be fully enjoyed is symbolized by the ice-cream cone in Figure 23.

23 – 0321
Section Abstract
Age 42
Gender Female
Country of Origin Bosnia
Country of Residence Austria
Education Economics and Marketing / Master
Profession Chief networking officer

Caption: *Time is like ice cream. Either you enjoy it while your speed of eating the ice perfectly matches its melting speed; or you are desperate while you are constantly trying to catch the sweet drops getting lost on the floor.*

The last two examples go beyond the icon and challenge our vision with a conceptual punch related to the picture itself (Figure 24 and 25).

24 – 0193

Section	Abstract
Age	72
Gender	Male
Country of Origin	USA
Country of Residence	USA
Education	Graduate
Profession	Accountant

Caption: *Timeline.*

25 – 0196

Section	Abstract
Age	40
Gender	Male
Country of Origin	USA
Country of Residence	USA
Education	BFA, MFA
Profession	Artist / Professor
Caption	-

The research is ongoing and we are collecting data. The database is growing through the website and also the contribution of every person that kindly agrees to be challenged on the subject.

STOPPING TIME: DANIIL KHARMS AND ALEXANDER VVEDENSKY

Matvei Yankelevich

"Woe to us pondering time."
— Alexander Vvedensky, *The Gray Notebook*

0) GENERAL STATEMENT OF INTENT

I propose the following generalization: Whereas the first wave of the avant-garde was taken with the idea of simultaneity, or the moment (i.e., the representation of space from multiple perspectives in a single moment), and of flux, or movement (i.e., the representation of time by the dynamic displacement of moving figures or forms within a unified space)— the second (and last, in the Soviet context) wave of avant-garde artists and writers (and especially the OBERIU group) examined and performed the incommensurability of the binary concepts of moment and movement, simultaneity and flux; or, investigated and enacted the gaps, caesurae, schisms, and seizures of a broken time, i.e., a time broken into discrete, disconnected units (or moments) through which figures and forms could not (or could no longer) move fluidly. The second-wave avant-garde embarked not on new paths toward more accurate representations of time, but rather it set out to question or even explode the very notion that time could be represented at all; moreover, these artists envisioned an art and a literature which would take as its starting point the feeling (and I emphasize that they had an intuitional rather than scientific basis) that the individual, subjective experience of time could not be represented by existing language (and therefore by any potential language), or understood outside of subjective experience, and therefore impossible to relate, or to *represent*.

1) OBERIU WHO?

The OBERIU, or Association for Real Art as they deciphered their own acronym, is the name now used for a group of enthusiastic young writers experimenting in poetry and theater in Leningrad, during the mid-to-late 1920s, which included Daniil Kharms, Alexander Vvedensky, Nikolai Zabolotsky, Igor Bakhterev, and several others, most of whom had studied (at times formally) with the (former) Russian Futurists and other early avant-garde artists. They became known in Leningrad for their eccentric, clownish behavior on and off stage, and for what the press called "literary hooliganism," "nonsense" verse, and "zaum" poetry, which Soviet reporters (and NKVD detectives), uninterested in the fine points of Futurist and post-Futurist aesthetic theory, saw as amounting to the

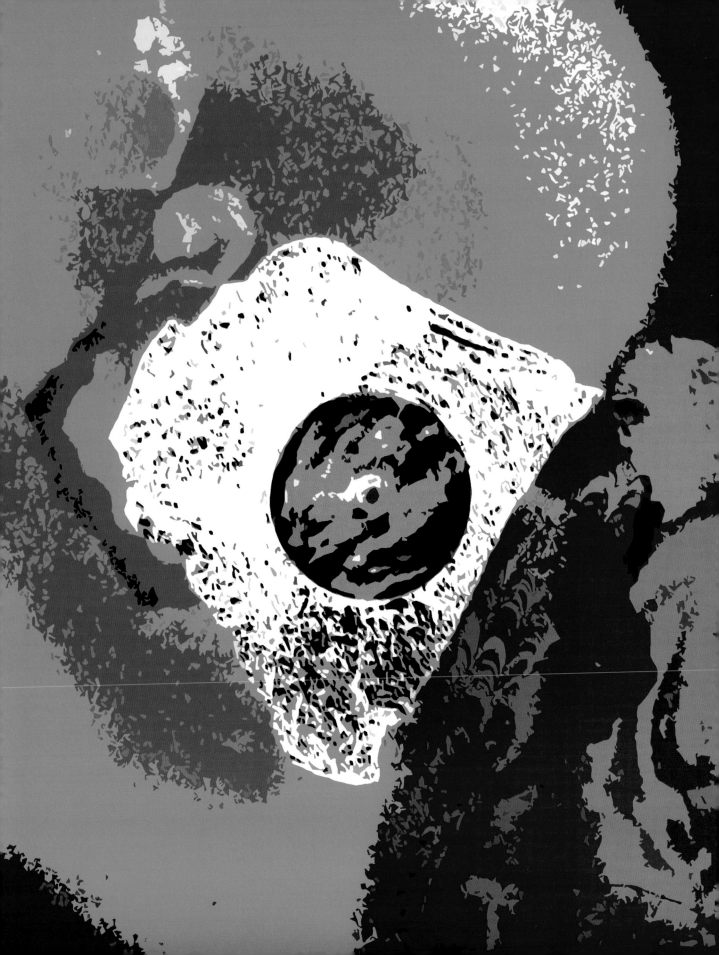

same thing: and that was "anti-Soviet." Although the group was officially disbanded by the early 1930s due to political and media pressures, some of the *oberiuty* continued to meet unofficially to share works and ideas at each other's apartments (in a variable grouping sometimes referred to as the *chinari*, or "The Club of Ignorant Scholars," and augmented by philosophers Leonid Lipavsky and Iakov Druskin and the poet Nikolai Oleinikov, editor at the state children's publishing house where most of them freelanced). Following ideological or aesthetic disagreements (as in the case of Zabolotsky), or later geographic displacement (as in the case of Vvedensky's move to the Ukraine), some of them went their separate ways, and by the late 1930s, with the "conversations" becoming more and more sporadic, no cohesive group can be discerned.

After 1931 the *oberiuty* had no public exposure for their literary work save their production for children's books and periodicals, yet they went on to write (in haphazard notebooks, on scraps, on the backs of forms, etc.) what they are now most known for after the dissolution of the OBERIU group itself, and are still referred to under that name (in popular and scholarly contexts) for the sake of convenience.

My view is that, in a strange way, this rag-tag group, truly post-avant-garde, is a historical lynch-pin between the idealistic (and often utopian) modernism of the early twentieth century (especially pre-Soviet avant-garde movements) and the neo-avant-garde— to use Thomas Bürger's distinction—of the years following World War II, especially in the late-Soviet unofficial (underground) arts scene. Moreover, and because of the distinction of having been the "last avant-garde" (a moniker put forward by Jean-Phillipe Jaccard), they display most perfectly the qualities of what I've called, perhaps simplistically, the "second-wave avant-garde" and outlined above. They adopted, and swallowed whole, avant-garde theories direct from the mouths of their idols and mentors (Malevich, Matiushin, Khlebnikov [via Tufanov], Filonov, Terentiev [and through him, Kruchenykh and Zdanevich]), and subsequently, while remaining shaped by these ideas into avant-garde posture, spat them out radically revised under pressure of their own thinking during changing times as well as (and as much as) the pressures of the increasingly homogenous, state-dictated, aesthetic strangle-hold of Soviet culture. Pushed to the cultural margins, the *oberiuty*, were relatively free to do as they liked,

especially in the conversations and writing that they never attempted to make public and which were saved for posterity by pure chance.

What has this to do with time? Daniil Kharms and Alexander Vvedensky, two of the most important and perhaps founding members of the original OBERIU, both also key "members" of the amateur philosophical circle of the *chinari*, were supremely interested in this very question, and all the subsequently necessary questions that come out of it. (In fact, time appears as a central concern in the "Conversations" written down at the group's meetings by Lipavsky, and in the philosophical writings of all the chinari members, especially Lipavsky and Druskin.) Both Kharms and Vvedensky were affected deeply by the short time they spent in jail (arrested under the same case) and by their fairly brief internal exile in the town of Kursk (in the same house). Kharms said that being in jail was a happy time for him, because— since pen and paper were taken away from him—he had no anxiety, in other words no sense of time passing. Vvedensky experienced the following:

"In prison I had a dream. A small courtyard, a field, a platoon of soldiers, they are about to hang someone, a Negro it seems. I experience great fear, horror and despair. I ran. And as I ran down the road I understood that I had nowhere to run. Because time ran with me and stood still with the sentenced man. And if we imagine its area, it's like one big chair on which he and I will sit down simultaneously. Afterward, I'll stand up and walk on, but he won't. But still we had been sitting on the same chair." [1]

From this point, it seems, time becomes one of Vvedensky's three self-avowed thematic pillars—God, Time, and Death.[2]

2) TIME STOPS

Time in Kharms's works, it may be said, is represented (allegorically, in the widest sense) by narrative. Unlike the Classical & Renaissance representation of time— and, consequently, of narrative—as undisrupted flow (see Roland Barthes), Daniil Kharms's work represents time—by analogy with narrative—as being made from "events" or "incidents" that do not form (or conform to) a continuum, but rather form a series of "stoppages" (to borrow from Marcel Duchamp), vertical stabs in the horizontal continuum.

The disruption of the narrative (i.e., of discursive writing) is accomplished in a variety of ways in his "pieces":

A) Through the interruption of (or obstacle to) the writer/narrator's ability to write, by the lack or loss of the ink, by lack of knowledge on the subject ("First of all, I know nothing about her..."), or by sudden amnesia ("I fell off my chair just now and forgot what I was going to tell you about..."), by pangs of hunger, by exhaustion, or by the sudden presence of a dead old woman in the narrator's apartment (in "The Old Woman").

B) Through the assembly of scraps or fragments that are not meant to cohere into a whole, as in *The Blue Notebook* which, in the style of an "album" or "scrapbook," consists of aphorisms, parodic meditations, short fictions, poems, dream narratives, and journal entries of both mundane and profound proportions poured into a "single" "work," thus provoking the reader to seek continuity (of theme, genre, narrative, or anything else) where there is none.

C) Through the writing of numbered series of events that have a parodied seriality (a chain of events in which no logical cause and effect can be discerned), for example, the series of unconnected deaths in "Events," or the series of unconnected "connections" in "The Connection." Similarly, a letter ("Dear Nikandr Andreyevich") parodies the order in which letters might normally be sent and received.

D) Through the emergence of an obstacle to the narration's movement forward due to a gap or caesura in a sequence, as when the neighbors argue over what comes after 6 ("7 or 8?" in "Sonnet"), or when the pseudo-event of the blind man receiving a gift of a knit shawl claims the attention of the narrator who was watching old women tumble one after another in a predictable sequence from the windows of an apartment building "out of excessive curiosity" (in "Tumbling Old Women").

E) Through the disappearance of the principal subject itself—as in the story of the red-headed man (in "Blue Notebook #10") who had didn't have red hair. Through a series of erasures, it turns out that he had "nothing" else. In conclusion Kharms writes: "So we don't even know who we're talking about. It's better we don't talk about him anymore."

F) It should be said that even the singular important event of a Kharms narrative may happen more than once, may be repeated, may start and stop and start again, reappearing in disorderly fashion as a ghost of continuity. For example, the death of the old woman in "The Old Woman" doesn't happen just once. As Mikhail Iampolski puts it, "Death turns out to be as if pushed out of the temporal picture of the world" (*Oblivion as Source*, 106). Similarly, in the play *Elizabeth Bam*, the title character is charged with murdering one of the men who have come to arrest her for the same crime, thereby doubling the event of the crime, as it has both happened already and is still about to happen. In an autobiographical sketch, Kharms tells the story of how he was born twice from inside his mother, and a third time in an incubator. In another story, "An Incident in a Tram," each seemingly unimportant event is repeated twice: "Liapunov walked up to the tram, Liapunov walked up to the tram." Repetition of an event may be the only dramatic subject, as in "Pushkin and Gogol," where the two classics trip over each other again and again, moving from one side of the stage to the other until they disappear behind the curtain.

G) Some events that would seem instantaneous are stretched out, operating at a different pace from parallel narratives in the same story. For example, in "The Falling," Kharms tells of two men falling from a roof.[3] A crowd gathers below to see the outcome and two women, both named Ida Markovna, watch the fall from their respective windows (which face each other, making the fall into a kind of mirror). In her attempt to watch the falling men, the second Ida Markovna remembers that she had nailed the window shut for the winter and goes to get a tool with which to open it; meanwhile, the first Ida Markovna, standing at her window, realizes that she is naked and backs away from the window and hides behind a wicker stand for a pot. All of this happens during the fall, which acts as a dissection of the reality of the two Ida Markovnas who know nothing of each other, connecting them as it were, forming the vertical line of the present stabbing through the horizontal continuum of time.

H) If all that weren't enough to convince us of the meaningful (both structurally and allegorically) role that time plays in Kharms's world, we might enumerate all the instances of the literal malfunction of time: watches break, clocks stop (permitting the

entrance of "messengers" from another dimension), some clocks don't have hands, one has a fork and knife instead of the hour and minute hands, and even Pushkin tries (and fails) to fix a pocket watch. Furthermore, along these lines, in the most developed of his stories, the aforementioned "The Old Woman," which itself begins with the clock sans hands, Kharms plays ceaselessly with narrative time: it may be 3 o'clock one moment, and 3:20 in the time it takes for the narrator to light his pipe; morning turns seamlessly into night so that we don't know whether the time is a.m. or p.m. The narrator decides he must act right away, but lights another cigarette instead, or falls asleep. This story reduces clock-time to a mechanical ticking, overlapping with knocks on the door, or the knocking of a wooden leg and a walking stick heard outside. Elsewhere, Kharms counts time in increments based on the material world: in cigarettes, the number of which diminishes instead of increasing (Iampolski, 123); in the number of old women tumbling one after another from their windows; or in dust and in water, as in this untitled piece from 1940:

[...] Or you can lie down on the floor and examine the dust. There is inspiration in this, too. It's best to do it on a schedule, in conformity with time. Although it's difficult to determine the time limit, for what are the time limits of dust?

It's even better to gaze into a tub of water. To look at water is always good for you and edifying. Even if you can't see anything in it, it's still good. We looked at the water and saw nothing in it, and soon we got bored. But we comforted ourselves that still we had done a good deed. We counted on our fingers. But what were we counting—we didn't know; for is water in any way countable?

Time's ticks and knocks are not continuous, rather they serve to underscore a lack of fluidity, a stopping and a starting, a break in the supposed linear motion of time. Each instant is on its own, disconnected from the rest.

3) THE SINGULARITY OF EVENTS

In the OBERIU manifesto of 1928, Kharms and Zabolotsky laid out the group's theatrical theory, which revolves around the singularity of the theatrical event unhinged from the motivation of plot or character. It stands alone on the OBERIU stage, unconnected by common sense logic; because art has its own logic, its own reality.

According to one of Kharms's (pseudo-mathematical) tracts, numbers are "not connected by order." There is no identity or equality in nature, only in arithmetic. So "two trees cannot be equal to one another." Kharms interrogates the basic Pythagorean idea of resemblance, of numbers as a notion of quantity taken from nature (that "numbers are something like trees or like grass"). He asserts the independence of numbers; they are their own species. "Trees are subject to the effects of time, but numbers are in all times unchanging."

Branislav Jakovljevic, in a new book on Kharms (*Daniil Kharms: Writing and the Event*), sums up the writer's mathematical experiment: "Kharms is interested in a specific, isolated event, not in a series; in randomness, not in randomization. He is not interested in the 'laws of thought' but precisely in that which escapes these laws: in that which is unpredictable, incommunicable, weak to the point of disappearance and in that which is ignored, dismissed, and considered unverifiable by logical algebra." In other words he is engaging in what Vvedensky calls "the poetic critique of reason." This critique comes from the position of an extreme subjectivity that is mistrustful of the ways in which things relate to one another and in the way that language—or any given means of representation—relates to reality. Vvedensky, in dialog with his friends at a gathering of the *chinari*, is reported to have said: "My predominant feeling has to do with the discontentedness of the world and the fragmentation of time. And since it opposes reason, it means that reason doesn't understand the world." Kharms's philosophico-mathematical tracts and pseudo-proofs deal mostly with obstructions to continuity: gaps, disconnections, intervals, impediments, and instants—singular events.

"Time freezes and accelerates," says Jakovljevic in his discussion of Kharms's story, "How I Was Visited by Messengers" (*Writing and the Event*, 247-248). All the action happens when the clock stops at quarter to four. The coming of the "messengers" is a singular event. The narrator, who seems indistinct from Kharms himself, confuses a calendar and a belt with a glass of water and tries to put these objects (which are all, as Jakovljevic has hinted, representation of time) into his mouth, to internalize them: he attempts to drink time.

"Only miracle interests me, as a break in the physical structure of the world," Kharms wrote in a diary entry in 1939. For Kharms, the miracle is a singular event, and thus comparable to the instant of "now," which he describes in his tract "On Existence, On Time, On Space" as an "obstruction" (or "impediment") between the past and the future: it is neither "this" nor "that." In the late 1930s, Kharms purposefully developed a tic—an involuntary gesture somewhat like a seizure or a hiccup. A friend later recalled that "Kharms not-quite-hiccuped, not-quite-snorted... For a number of reasons Daniil Ivanovich thought it helpful to develop a few oddities in himself." Like the interruptions prevailing in his stories, Kharms's self-inflicted tic, a physical manifestation of obstruction, brought the independent moment—the instant of "now"—to the foreground, breaking up the regular flow of time. Perhaps this was just one more way that Kharms sought to avoid a "mechanized" life: surprise and unpredictability created in the otherwise dull continuum, a "slight error"—a term critically important to Kharms (and fellow *chinar* Druskin) in his aesthetic theory and which, by extension, he applied to the real world. The slight error in time makes possible the miracle that is the independent existence of the instant.

4) TIME'S DEATH

The poet Alexander Vvedensky (co-founder of the OBERIU), in conversation with fellow *chinari*, described his poetic project in this way:

"I raised my hand against concepts, against generalizations that no one previously had touched. Thereby I performed, you might say, a poetic critique of reason—more fundamental than that other, abstract one [Kant's]. I doubted that, for instance, house, cottage, and tower come together under the concept of building. Perhaps, the shoulder must be linked to the number four. I did it practically, in my poems, as a kind of proof. And I convinced myself that the old relations are false, but I don't know what the new ones must be like. I don't even know whether they should form one system, or many." [4]

Vvedensky finds scientific "proof" for his theory through the practice of writing. (The employment of art for scientific—or hermetic—investigation and the trope of art as a secondary scientific method can be seen in Kharms's work as well, but this important aspect of the OBERIU project will have to be left for

another time.) A gray notebook found in Vvedensky's papers (and now referred to as *The Gray Notebook*), written shortly after his release from prison and possibly during a short exile in Kursk, (1932-1933), demonstrates this process.

"Before every word I put the question: what does it mean, and over every word I place the mark of its tense. Where is my dear soul Masha, and where are her banal hands, and her eyes and other parts? Where does she wander murdered or alive? I haven't the strength. Who? I. What? Haven't the strength. I'm alone as a candle. I'm seven minutes past four alone, 8 minutes past four as, nine minutes past four a candle, 10 minutes past four. A moment is gone as if it had never been. And four o'clock also. The window, also. But everything remains the same..."

We can see how Vvedensky makes his prose, as well as his poetry, through syntactical discontinuity, addressing not only a topic (time), but also the structure and norms of our language, forcing the language to do things it doesn't normally do in order to question the terms themselves. The prose asks, is a minute a noun? If so, does it behave like other nouns, can we count it like other nouns? Where does it physically exist (like a candle, for instance)? If we say "four o'clock," is it the same as saying "window"? What's the tense of a noun? "Masha" has a proper name, but does she have physical properties? Would she wander if she were murdered the same as if she were alive?

This connection (and opposition) between the living and the dead is examined in Vvedensky's poems, where dead men, frequently suicides, speak either before, or during, or after their deaths. [5] He is interested in that moment of death because it puts time in question: whether time is the same for living, those about to die, and those already dead.

This is how Svidersky, a character in the play that Vvedensky drafted in *The Gray Notebook*, describes the difference:

A road stands before you. And behind you lies the same path. You stood, you stopped for a quick instant, and you, and all of us, saw the road before you. But just then we all went and turned onto our backs, I mean backward, and we saw you, road, and we surveyed you, path, and all of us, all as one, declared it was right. This was a feeling—this was

the blue organ of the senses. Now let's take a minute ago, or estimate a minute ahead. Whether we spin around or look over our shoulder, we can't see these minutes. One of them, the one that has passed, we remember. The other, a point in the future, we imagine. A tree lies flat, a tree hangs, a tree flies. I cannot determine which. We cannot cross it out, nor can we touch it. I do not trust memory or imagination. Time is the only thing that does not exist outside us. It devours everything that exists outside us. Here falls the night of the mind. Time rises over us like a star. Let's throw back our mental heads, that is, our minds. Look, time is now visible. It rises over us like zero. It turns everything into zero.

In the *Tractatus,* Wittgenstein observed that (in C.K. Ogden's translation) "Death is not an event in life. Death is not lived through." This is partly what's going on in Vvedensky's work, around the same time (without knowledge of Wittgenstein's text), but the idea is turned on its head. As do other *oberiuty* and *chinari*, Vvedensky speaks of death as a *stopping of time* (at least a momentary one) and also as the *only* real event of life: "Something that has really occurred, that's what death is. Everything else is not something that has occurred. It's not even something that is occurring. It's a bellybutton, the shadow of a leaf, it's a skid on the surface."

In the essay found in the same notebook, Vvedensky examines the difference in the experience of death and time for a youth and an old man. He says that "each has only a second of death. They have nothing but that." Since the future "breaks apart" after death, we can't even say that one had more of a future ahead of him. This brings him to contemplate the nature of the addition of time:

...before every new second is added, the old one vanishes. This can be depicted so:

$$\emptyset\,\emptyset\,\emptyset\,\emptyset\,\emptyset\,\emptyset$$
$$\emptyset\,\emptyset\,\emptyset\,\emptyset$$

Only the zeros shouldn't be crossed out, but erased. And, dying, both of them have just such a momentary instantaneous future, or none of them has it, neither will nor can have it, since they are dying.

Our language about time, Vvedensky contends, does not actually reflect the real passage of time.

He writes: "Our logic and our language skid along the surface of time." After twenty-four hours we start counting from the beginning; after thirty or thirty-one days, we start back at day one of the next month. "In the case of time," Vvedensky writes, "its addition differs from all other addition. You can't compare three months you lived through to three trees that have grown again. The trees are right there, their leaves glimmer dimly. Of months you can't say the same with confidence." He suggests that for a purer representation, "every hour, at least, if not every minute, should get its own number, which, with every additional unit, either increases or remains the same."

The real passage of time is subjective; whereas our language wants to make time conform to pre-determined ideas about its objective nature. "The names of minutes, seconds, hours, days, weeks and months distract us from even our superficial understanding of time. All these names are analogous either to objects, or to concepts and measures of space. As a result, a week gone by lies before us like a killed deer." Because time does not "count space," it is also not "a mirror image of objects." According to Vvedensky "objects are feeble mirror images of time." And thus, when we experience time, the spatial world disappears: "There are no objects. Go on, try and grab them."

In this examination of the relationship of our language about time to the actual passage of time, Vvedensky is interested in the way that singular moments in time (like the single moment of death) are events that lie outside time as a continuum. It's not that time is absent in the works of Vvedensky and the other *oberiuty / chinari*, but rather that they are concerned with what Jakovljevic (in discussing the philosophy of Leonid Lipavsky in relation to Kant's idea of the sublime) calls "a disturbance of a linear understanding of time... a temporal jolt that suspends succession and brings forward the present moment." [6]

What happens, Vvedensky asks, if we "erase the numbers from a clock, if you forget the false names?" Would we have a better understanding of time without the deceptive language we use to talk about it? He offers the following thought-experiment:

Let the mouse run over the stone. Count only its every step. Only forget the word every, only forget the

word step. Then each step will seem a new move-ment. Then, since you rightfully will have lost your ability to perceive a series of movements as some-thing whole, which you had wrongly called step (you were confusing movement and time with space, you erred in superimposing them one over the other), movement as you see it will begin to break apart, it will arrive almost at zero. The shimmering will begin. The mouse will start to shimmer. Look around you: the world is shimmering (like a mouse).

Vvedensky proposes this shimmering as a more precise visualization of time: our understanding (or non-understanding) approaches the reality of time's movement, or rather its motion, or its lack of motion. In this unveiling, time collapses, time is in some sense stopped, but it has not disappeared.

The paradox, which Vvedensky finds useful in this discussion, is that once we break everything into its parts, the event disappears—it's no longer singular or instantaneous. The notebook ends abruptly, in mid-sentence, as part 7 ("The Sad Remains of Events") of the essay trails off:

Everything breaks down to its final mortal parts. Time swallows the world. I do not un

We assume this last phrase should be "I do not understand." But isn't that Vvedensky's goal—to acknowledge that we cannot understand time with reason?

Just prior to this ending, Vvedensky asks us to under-take another thought experiment:

Let's say it's the seventh hour and let it last. Then, to begin with, we must at least abolish days, weeks and months. Then roosters will crow at different times, and the intervals won't be equal, because that which exists can't be compared to that which no longer ex-ists, or maybe had never existed. How do we know? We do not see the points of time, the seventh hour descends upon everything.

The seventh hour must be the hour of shimmering, nothing moves, nor stands still. We can't see the "points," by which Vvedensky means the events as well as the markers of time. Writing itself seems to be the tool or vehicle by which this is accomplished, by which the thought experiment is enacted.

The lyrical pessimism of Vvedensky's philosophi-cal discussions revolves around a kind of obsession, though not a morbid one, with death, and the whole project seems cast into doubt by the author's preface to this abandoned essay:

[...] perhaps one can try and write something, if not about time—nor on the non-understanding of time—then at the very least to try to fix those few positions of our superficial experience of time, and, on the basis of these, the way into death and gen-eral non-understanding may become clear. [...] Woe to us pondering time. But then, with the growth of this non-understanding, it will become clear to you and me that there is no woe, no us, no pondering, and no time.

NOTES:

This essay, composed in Fall of 2010, is partially based on a talk I gave at the *ArcheTime* conference sat The Tank Space for Performing and Visual Arts, New York City, in the Sum-mer of 2009.

1 From The *Gray Notebook* (my translation), Ugly Duckling Presse, 2009. In his seminal book on Kharms (Bespami-atstvo kak istok [*Oblivion as Source*] NLO, 1998), Mikhail Iampolski discusses the doubling effect that occurs in Vvedensky's and Kharms's narratives as seeing oneself from outside, which he attributes to the atemporal quality of the dream as a parallel experience to death (pp. 128-130).

2 Recorded in Lipavsky's *Conversations.* Despite the ominous tone of his announced themes, Vvedensky's poetry is also whimsical in its grotesque mixture of childish play and arch abstraction.

3 See the discussion of "The Falling" in Branislav Jakovljevic's *Daniil Kharms: Writing and the Event* (Northwestern Univ. Press, 2009), 130.

4 Originally this statement was recorded in Lipavsky's *Conversations.* This translation is taken from Eugene Ostashevsky's introduction to *OBERIU: An Anthology of Russian Absurdism* (Northwestern Univ. Press, 2006), xxii. Substantial excerpts from the *Conversations* have recently been published for the first time in English translations in *Little Star,* Issue 2, 2010, pp. 160-212.

5 A discussion of Vvedensky's poems, especially "A Certain Quantity of Conversations," "Where. When.," "Frother," and the longer verse-play "God is Possibly Around," would be more than apropos here. However, due to constraints of time and space, I've limited my discussion of Vvedensky to *The Gray Notebook,* and the reader will have to trust that his other writings bear out my claims and the poet's stated concerns.

6 Jakovljevic, *Daniil Kharms: Writing and the Event,* p. 115.

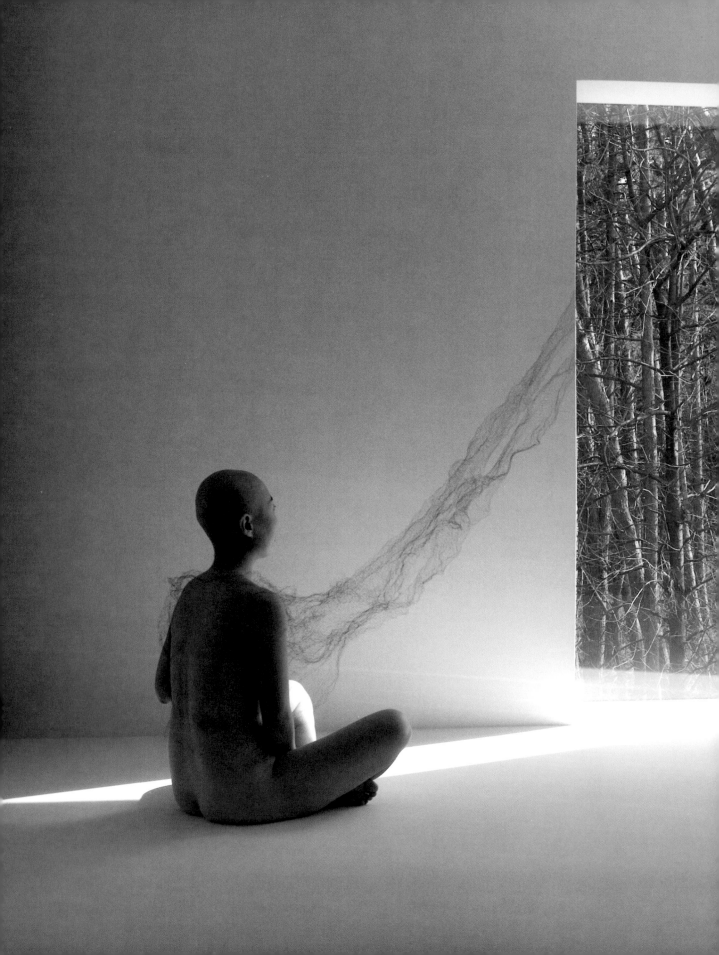

NOW AND BEING

Jayoung Yoon

I constructed a seamless and white space. I made a piece that combines the body with a wearable hair sculpture that represents invisible thought and mind.

Each video shows a duration of time and a specific single moment. I filmed the light changing from sunrise to sunset at an empty space for almost thirteen hours. I also filmed the performer unwrapping the hair-cloth, which represents the invisible mind in a specific moment at the same space in a few seconds. I compressed the first video and expanded the second video and made both approximately one minute. Therefore, I could compare "Time" to "Now."

Time is an illusion. In the Now, in the absence of time, I don't have any problems and I do not suffer because all of these come from the past and the future.

While the light symmetrically is changing in the same direction on the two videos, the performer starts letting go of the hair-cloth; mind from the body. It moves slowly and floats. When the invisible mind disappears in front of the performer, the image changes from black and white to color, which means the performer is becoming free from the mind and entering into Now.

AT THE END OF THE RUSSIAN AVANT-GARDE

Eugene Ostashevsky

TRANSLATOR'S NOTE

The poet Alexander Vvedensky and the philosopher Leonid Lipavsky were members of a small group of friends that lived in Leningrad in the 1920s and '30s. Vvedensky and some others in the group, including the poet Daniil Kharms, had led the avant-garde literary association OBERIU, which disbanded in 1930 under political pressure. The friends' subsequent unofficial meetings took place in their apartments; their discussions presented a unique combination of deeply intellectual issues and banter. One of the main issues that interested the group was time. Believing time to be the object of knowledge that most resists human language and human logic, they tried to describe its structure nonetheless, hoping to make out some more objective, extrapersonal truth about time in our experience of it. For both Lipavsky and Vvedensky, time constitutes the fabric of the world, to the extent that they regard objects as waves, or parts of waves of time, and consequently non-existent. Lipavsky's approach, I think, comes out of Einstein more than Bergson: time is heterogeneous in its dependence on the reference frame, and it divides into instants of different "duration" (presumably, as observed from another reference frame). Vvedensky, on the other hand, emphasizes the opacity of time, and consequently of the world, to human cognition.

I thought that it might be interesting to conjoin two Vvedensky poems "about" time with time-related excerpts from Lipavsky's *Conversations*, his somewhat abbreviated records of the group's interactions in 1933–1934. I selected sections of the *Conversations* where Lipavsky and Vvedensky are the interlocutors.

LEONID LIPAVSKY: THE CONVERSATIONS

LIPAVSKY: When you think of how many generations preceded you, how many people worked and researched, when you see the thickness of the encyclopedic dictionary, you start to feel admiration. But this is a mistake. Everything derivative and secondary has been investigated in every tiny detail, whereas the essential is as unknown today as thousands of years ago. ... Science has for a long time not looked at things directly; rather, it feels about, studies only the details, and that, obliquely. Evidently because, up to now, when they looked they didn't see anything. And it's clear why. It's because everyone accepted time, space, the object-ness of the world as something given, unanalyzable, what isn't worth talking about, but must be accepted as is. That was the distortion at the very beginning, closing off all the roads. ... Now, as always, one has to start over from the very beginning; and so, obviously, the defining trait of people who feel this way is their interest in what time is. For it's the lock on the door, it's what must be opened but, to open it, it must be unscrewed. Now you have to ask questions directly, remembering that the data for answering will be found if you look closely.

VVEDENSKY: Can art provide the answer? Alas, art is subjective. Poetry performs only a verbal miracle, not a real one. And how to reconstruct the world is not clear. I raised my hand against concepts, against initial generalizations, which is something no one has ever done before. Thereby I enacted a poetic critique of reason, as it were— more fundamental than that other, abstract one. I doubted that, for instance, house, cottage and tower link up and unite under the concept of building. Maybe the shoulder should be linked to the number four. I did it practically, in poetry, and that's how I was proving it. And I became convinced of the falsity of old relations, but I don't know what the new ones must be like. I don't even know whether there should be one system of relations or many. So my basic impression is that of the incoherence of the world and of the dismemberment of time. Since these contradict reason, that means that reason does not understand the world.

* * * * * * *

Next they spoke about Khlebnikov.[1]

LIPAVSKY: I can't read Khlebnikov without being sick at heart. And it's not because of his external fate, although that too is horrifying. What's even more horrifying is his total inner failure in everything. Yet he was not just a brilliant poet but, first and foremost, a reformer of humanity. He was the first to have sensed what ought to be called the wave structure of the world. He discovered our era as perhaps Da Vinci had discovered the previous one. He even sacrificed his poems to that effect, making them only commentaries to the discovery. But he proved unable to understand what he had discovered, to draw the right conclusions. He kept getting confused and making crude and stupid mistakes. His attempts at practical action are laughable, pitiful. He was the first to feel time as a string that bears rhythmic oscillations, rather than some arbitrary and amorphous abstraction. His theory of time, however, rests on mistakes and fibs. He was the first to feel the geometrical meaning of words, but he understood this geometry as if it came out of Kiselev's textbook.[2] He will always bear the stamp

of provincialism, of the cerebrations of an autodidact. He lost his way everywhere and got into every dead end. And even his poems, in general, fall short. Despite all this, he was also the first to perceive the style for newly discovered things: not just the style of art and science, but the style of wisdom.

* * * * * * *

Then they spoke about inspiration.

VVEDENSKY: It doesn't prevent errors, as people usually think; or rather, it prevents only particular errors, but as for the general error of the work, that's what it doesn't let you see, which is how it makes for the possibility of writing. Always, already the next day I see that I wrote neither what nor how I wanted. But also, is it even possible to write how you want? Kharms once was saying that art needs to act in such a way as to go through walls. But that can't happen.

LIPAVSKY: Nobody knows what inspiration is. But it recalls a scrupulous gaze, clarity and freedom. It's acute attention, admiration with the world. So then it's similar to tenderness, to vertigo induced by open spaces, to oblivion of self. And notice that it always has a natural ease, as if the usual resistance disappeared, and the consciousness of time has gone with it. Where does this come from, and does it result in truth? For now, one can speak of inspiration only approximately: it's to fall into the current of the world and to be swimming in it, as if in the current of a river. But whether it results in truth comes close to another unsolved question: in love, one sees all sorts of things in a woman; does one actually notice then what others can't, or is it just a weird illusion?

* * * * * * *

Next they spoke about Druskin.[3]

VVEDENSKY: He now writes in such a way that it's hard to express your opinion. You can't object, just as about poems or short stories you can't say whether they are true or not.

LIPAVSKY: It's that we listen to each other inattentively. You can get art by listening, but to evaluate thought requires effort, which we're too lazy for. Yet even so one can say about Druskin's pieces whether they are good or not, and that is an indication of whether they are right.

VVEDENSKY: I like "The Indications of Eternity." But I disagree that time is made palpable by difficulties and worry. It's more important when a human being gets rid of everything external to remain one-on-one with time. Then it's clear that every second divides without end, and nothing exists.

LIPAVSKY: When there are no events, no expectation, then there is no time either. A pause sets in, which Druskin calls the interval or eternity—a pause, a nonexistence. This seems strange—can one really stop existing and then exist again? But there are many sides to it: in one relation the existence stops, but in another it goes on. To expect is to participate in the flow of events. And only then there is time.

VVEDENSKY: Druskin says: when expecting something unpleasant.

LIPAVSKY: Yes, because then there is loss and resistance to the event. But when you feel pleasure, you become one with the event, you give yourself to it. So, for instance, when you're enraptured by music, it is impossible to say how much time went by. A hot-air balloon glides on the wind, and hence does not feel the motion; the wind doesn't exist for it. The train, however, does feel motion, because of the jolts and the shaking. There are, so to speak, two waves: your wave and the wave of the world. When your wave coincides with the wave of the world, then there sets in, what Druskin calls the interval or eternity (he noticed it during his brief break from class, in smoking). But when it does not coincide, then there's existence, there's tremors, there's time. But apparently there's also a third relation, when you get tossed from some aspects of existence to other ones, by the resolution due to different waves coinciding; this rocking back and forth plays with time, it is rhythm. One just

needs to keep in mind that we see the wave of the world as moving because we're looking at it from another wave: in itself, it cannot be called moving in the same way as our own wave can't.

VVEDENSKY: Notwithstanding all our reasoning, time stands there ineradicable, everything remains the same. We understood that time and the world are impossible according to our conceptions. Yet this is only the destructive part of the work. What happens in reality? We don't know. Yes, I've been interested for a long time in how to express ordinary views of the world. I think that's the hardest thing. The fact that our views contradict each other is just part of the problem. They are also motley, qualitatively heterogeneous. You aren't supposed to multiply oranges by glasses. But that's exactly what ordinary views do.

LIPAVSKY: Why are theories about time unconvincing, why can't they shake anything? Because time is much less a thought than a sensation, based on a real relation between things, between our body in the broad sense of the word, and the world. It is rooted in the existence of individuality, and so, in order to determine what time is, one must perform real changes, try out different variants of time. This can be done since we really do apprehend time differently in different physical states. But Druskin prefers to not to do it, satisfying himself with what he already has noticed, with hints. That's impressionism.

VVEDENSKY: It may yield results.

LIPAVSKY: Yes. The main thing to understand is that existence and nonexistence are relative. To exist means simply to differ. Hence you can have: it differs (exists) in relation to this, but does not differ (does not exist) in relation to that. But existence and nonexistence had been kept out of the field of inquiry, accepted rather as fundamental givens. The nonexistent seemed to be some kind of illusion, you couldn't say anything about it. They were pictured as a cliff and the chasm on the other side. But in actuality it's billows and the foam over them.

* * * * * * *

Then they spoke about the instant.

VVEDENSKY: Distance is measured by time, but time is infinitely divisible. This means that distances don't exist. Because you can't add nothing and nothing.

LIPAVSKY: Why did you decide that the instant is infinitely small? Freedom in dividing means the instant may be of any magnitude. They apparently do come in every magnitude, large and small, one included in another.

VVEDENSKY: If that were the case, then it's clear why, whatever might be thought about time, you still can't deny the alteration of day and night, waking and sleep. The day is a large instant.

* * * * * * *

Next they spoke about music.

LIPAVSKY: I am interested in what it is in music that influences a person. It is the most unmasked art, it doesn't depict anything. The other arts seem to be representing, conveying something. Yet obviously that's not how they produce effect, but rather in the same way as music.

VVEDENSKY: When people sail in a boat or sit on the seashore, they usually sing. Evidently it's appropriate, music being, as it were, the voice of nature.

LIPAVSKY: Yet in nature it doesn't exist at all... Music purifies man from accumulated aberrancies, poisons. It's like water to a withering plant. In fact, more than anything else, music recalls a liquid, its flow. Its effect also resembles the effect of the sex act; after it you feel calm and liberated, but an abundance of it inebriates and unbraces. Vibration and rhythm, the breathing of an instrument, whether wood or brass. Regular breathing that alters

the breathing of the listener, absorbs it, penetrates with its rhythm the life of muscles and tissues. It corrects the crooking of individuality with respect to the world; it is the absorption and discharge; the play with time leading to the annihilation of time. This is the essence of art.

Next, about neurasthenia.

What is neurasthenia? A constant hidden anxiety, as if there were some cramp inside, a petrified defensive stance. ...

Usually people think: a human being is the body. But that's the same as if a person weighing something thought "the balance is that cup I constantly deal with, that I put the weights in"; in fact, the balance is the relationship between the two cups. The human being is the relationship between the body and the world, he rests, so to speak, on two waves. Their rocking one another back and forth is what a human being is.

I am saying this because rocking can be quieted from different sides.

Nature helps heal neurasthenia; both air and water, as it were, blow through a human being, through his blood vessels, his respiratory and other tubes. Same for the brief light drowsiness, when breathing becomes longer; also weightlessness while swimming; wide, heterogeneous space; music; massage; in general, any rhythm. Why does work help heal neurasthenia? It brings the human being out of the stagnant side creek into the main channel, it renews man's exchange of force with the world.

You know that a nervous tic is treated not by straining to overcome it, but rather by the art of relaxation. Relaxation discharges the lump, frees the pure regular rhythm from distortions. That must be the benefit of hypnosis and electric therapy: they demand relaxation as their precondition.

Tension-removal techniques have not been well attended to, especially in Europe, since practical life calls for effort, for tension—it is they that yield results.

* * * * * * *

LIPAVSKY:
(to Kharms)
Vvedensky was once saying to me: the dismemberment of time that he performed makes one disinterested in any further inquiry; nor is there anywhere further to go; all that's left is to repeat everything over again, that time and the world do not exist, and hence not a single objective value exists either. The only thing that remains, says Vvedensky, is the power of wealth; he believes in the force of wealth, and dreams of bragging that he earns lots of money. It's a sad illusion, wealth, since sooner or later you realize that it, on its own, can't fill anything in your life, and when Vvedensky realizes this, his last illusion will disappear, there'll be nothing left.

* * * * * * *

VVEDENSKY:
I am reading Veresaev's book on Pushkin.[4] Interesting how witness reports contradict each other even where there can be no place for subjectivity. These aren't accidental errors. Openness to doubt, non-coincidence with our logical framework, are present in life itself. And I don't understand how there could have appeared such fantastical worlds with precise laws, worlds that do not resemble real life at all. For example, a committee meeting. Or, say, the novel. The novel describes life, time appears to flow there, but it has nothing in common with real time: there is no alternation of day and night, people remember their whole lives with ease whereas in fact it's doubtful one can remember even yesterday. Anyway, any description is just plain wrong. "A man is sitting, he has a ship overhead" at least has to be more right that "A man is sitting and reading a book." The only novel that is right in its principle is mine, but it's badly written.

LIPAVSKY:
But what you say applies to all art. Doesn't music, for example, have its own time? The only difference is that music isn't considered to be a description of life, but the novel is.

VVEDENSKY:	Maybe I'm an optimist, but I now think poems should be written infrequently. I, for example, am still living with that same poem about the hydrangea;[5] why should I be writing a new one as long as the old one is still making payments, so to speak?
LIPAVSKY:	All your theories have always been highly practical: they justify what you happen to be doing at the moment.
VVEDENSKY:	I understood what the difference is between me and other writers, in fact between me and other people. They say that life is an instant in comparison with eternity. I say: it's an instant in every way, even in comparison with the instant.

* * * * * * *

LIPAVSKY:	What does time resemble? The very question seems strange. We've become so used to thinking of time as singular; all-encompassing; unlike anything else; containing us in the same way as air does.
	No one even noticed it in the beginning—same as air. Yet air has its zones of condensation, rarefaction, it has its noncoincidences with human movement, it has wind. These features allowed air to become an object of study. Time is not uniform either.
	Had we managed, even in thought, to pump time out, we would understand how it is to be without time.
	We experienced an ineradicable astonishment—how is that possible, for something to have been, but not to be any longer. Either there always exists everything, or nothing ever exists. Evidently there's some kind of fundamental error we have to free ourselves from, in order to understand time. And we feel around among everyday objects for objects pregnant with significance, for points hiding passages inward. We want to untangle time, knowing that the world untangles along with it, and we ourselves also. Because the world isn't floating in time, but consists of time.
	Time resembles succession, resembles differing and individuality. It resembles a transformation that appears to vary but remains identical.
	Already now do we want to see as if we were not bounded by a body, as if we weren't alive.

1933-1934

Translated by Eugene Ostashevsky.

NOTES:

1 Velimir Khlebnikov (1885-1922) was a Russian Futurist poet and utopian thinker with highly unorthodox opinions about the role of periodicity in historical time.

2 *The Elementary Geometry* of A.P. Kiselev, first published in 1892, remained the standard high-school geometry textbook even into the Soviet period.

3 The philosopher Yakov Druskin, one of the seven participants in The Conversations, had recently read his essay "The Indications of Eternity" to the circle.

4 V.V. Veresaev's *Pushkin in Life*, a chronologically-arranged collage of memoir snippets about Pushkin by his contemporaries, displays the avant-garde multiperspectivalism and interest in documentary characteristic of its publication date in the mid 1920s. It still makes the impression it once made on Vvedensky.

5 See translation of "Rug / Hydrangea" by Matvei Yankelevich in my *OBERIU: An Anthology of Russian Absurdism* (Northwestern Univ. Press: 2006), 13-16.

THE CONVERSATION OF THE HOURS

The first hour says to the second,
 I am a hermit.
The second hour says to the third,
 I am an abyss.
The third hour says to the fourth,
 put on the morning.
The fourth hour says to the fifth,
 stars rush down.
The fifth hour says to the sixth,
 we are late.
The sixth hour says to the seventh,
 and animals too are clocks.
The seventh hour says to the eighth,
 you are friends with the grove.
The eighth hour says to the ninth,
 the coursing starts.
The ninth hour says to the tenth,
 we are time's bones.
The tenth hour says to the eleventh,
 it may be we are couriers.
The eleventh hour says to the twelfth,
 let us consider the roads.
The twelfth hour says to the first,
 I'll catch up with you in our endless race.
The first hour says to the second,
 have some human sedative, friend.
The second hour says to the third,
 at what point can we concur.
The third hour says to the fourth,
 I bow to you as if you were a corpse.
The fourth hour says to the fifth,
 we too are darkened treasures of the earth.
The fifth hour says to the sixth,
 I worship the hollow world.
The sixth hour says, seventh hour,
 it's dinner time, come home.
The seventh hour says to the eighth,
 I would have wanted to count another way.
The eighth hour says to the ninth,
 you too are like Enoch snatched up to the skies.
The ninth hour says to the tenth hour,
 you are like unto an angel engulfed in fire.
The tenth hour says, eleventh hour,
 for some reason you lost your moving power.
The eleventh hour says to the twelfth,
 and still we are incomprehensible.

An Excerpt from God May Be Around

1931

TWENTY-FOUR HOURS

Answer. A swallow runs in.
Question. But who are you, swallow of heaven,
 are you a beast or a forest.
The swallow's nonexistent answer.
 I am a clockmaker.
Question. And yet who met you here
 in this capital dark,
 where nests curl above me,
 where there are no green leaves,
 and suffers the terrestrial man,
 the lobsters sleep,
 where there's no sea?
 Where there's no meaningful quantity of water.
 Say who you are.
 The dark here is palatial.
The swallow's answer.
 I am a soldier.
 I am a soldier.
 The night flees down the mountain summit.
 The summit perseveres, black.
 A star descends from the firmament.
 The firmament lacks
 like a bush.
Question. Could you be sorry for the firmament
 when you blush on it like a planet,
 when you dash in place of the star
 that dove this minute
 into the grove.
The swallow's answer.
 The firmament became clear and clean
 like the firmament.
 God sent a massing of cool air,
 the day arises.
Question. One hour of time passes.
Answer. One hour of time passes.
Question. Is the wind at all like flowers,
 like daisies or tulips.
Answer. An old man sat.
 He manufactured blinds from his hands
 to save his eyes
 from glare.
Question. Is the wind at all like a bench?
Answer. Above us rises the comprehensible morning,
 we feel the urge to fly in search of food
 and sing,
 sagely reasoning.

Question. Say who surpasses,
 I
 or
 the summits of grasses.
 And who lies senseless like an apple.
Answer. We sense the stones are waking,
 they start their conversation,
 they fall like leaves
 from the summits of magnanimous mountains.
 Then empty numbers come to life
 because the moon that leaves us shines on them.
 The day appears,
 the world grows.
Question. O swallow you're a bird of prey.
 The capital is here.
 There's no world here.
 There's no sea here.
 Maybe I too should go somewhere.
Swallow. Isn't the sea a better world.
 Isn't the sea a better world.
 It has grown.
The questioner.
 O swallow what do we do?
 The question is your own.
 Your features alter.
 Say where are you?
Answer. In winter snow was number.
 It's multitudinous. Look,
 you can now nod your oar
 up and down the brook.
Question. One hour of time passes.
Answer. One hour of time passes.
Question. Are they not avoiding us.
Answer. The clouds swam by, blue as paint.
 A beetle locomoted. Grass moved but a point
 during this hour. An ant kicked with his foot
 the fallen star like an insignificant point,
 and in the sea a ship sailed, its motion
 as simple as simple gets.
 Who is it that avoids us?
Question. Are they not circumventing us.
 We are irrelevant places,
 what is dearer than death.
 Look, from an abandoned bridge
 I want to tell the waves, believe,
 I too will come to you O water,
 I too will be your guest.

Answer. Unerring river.
 It runs for bottomless years,
 it stands in place for an instant,
 it knows no sorrow.
 It lies beneath each valley of a house.
 It is lazy.
 It is spacious.
 It is proud,
 it is firm,
 it is incontestable.
 It is the absence of a ray.
Question. A taper falls into a brook
 without crying hooray,
 it hisses as its soul leaves it.
 The mole weeps, thrown into the water,
 reading the firmament with blind eyes,
 and, sitting where the river is, the fisherman
 invisibly becomes an old man.
 Maybe he's frightened of the glare.
Answer. Everything goes black,
 the day is over.
 One last time
 upon the place of battle
 where the battle had been taking place,
 again a prayer settles.
 The prayer is here performed.
 The dew flows down the summits of the grass.
 The beetle goes to sleep. The star
 is seen and isn't.
 The firmament again fills up with planets.
 The sea grows dark. Where is the ant,
 it contemplates the waves.
 It rubs its paw upon the point of sand.
 Swims the extinguished fish.
 Twenty-four hours have passed.
Question. Is the forest at all like the night.
 Trees are a particle of the night,
 the oaks are stars, the birds are moisture,
 the leaves are answer.
 Catastrophe is absent from the forest.
Answer. Twenty-four hours have passed.
 Twenty-four hours have passed.
 The foliage makes noise.

1934

Translated by Eugene Ostashevsky

THE UNIVERSAL KNOT: ON TIME, ON SPACE, ON EXISTENCE

Daniil Kharms

1. A world which is not cannot be said to exist because it is not.

2. A world consisting of something indivisible, homogenous, and continuous, cannot be said to exist, because in such a world there are no parts, and since there are no parts, there is no whole.

3. A world that exists must be heterogeneous and have parts.

4. Any two parts are not identical because one part will always be this and the other that.

5. If only this exists, then that cannot exist, because, as we have said, only this exists. But such a this cannot exist because if this exists it must be heterogeneous and have parts. And if it has parts it follows that it consists of this and that.

6. If this and that exist it follows that a not this and not that exist, because if not this and not that did not exist then this and that would be indivisible, homogenous and continuous and consequently would not exist either.

7. Let us call the first part this, the second part that, and the transition from one to the other let us call not this and not that.

8. Let us call not this and not that the "obstruction."

9. And so, the basis of existence consists of three elements: this, obstruction, and that.

10. Let us represent nonexistence with a zero or a one. Then we shall have to represent existence by the number three.

11. And so: dividing indivisible emptiness into two parts, we arrive at the trinity of existence.

12. Or: indivisible emptiness, experiencing a certain obstruction, splits into parts, forming the trinity of existence.

13. The obstruction is the creator that creates "something" out of "nothing."

14. If this by itself is "nothing" or a nonexistent "something," then the "obstruction" by itself is also "nothing" or a nonexistent "something."

15. In this way, there must be two "nothings" or nonexistent "somethings."

16. If there are two "nothings" or nonexistent "somethings" then one of them comprises an obstruction to the other, tearing it into parts and becoming itself a part of the other.

17. The same goes for the other, comprising an obstruction to the first, splitting it into parts and becoming itself a part of the first.

18. In this way parts are created that do not exist by themselves.

19. Three parts that do not exist by themselves comprise three fundamental elements of existence.

20. Three fundamental elements of existence that do not exist by themselves, all three together form a certain existence.

21. If one of the fundamental elements of existence were to disappear, then the whole would also disappear. Thus: if the "obstruction" were to disappear, then this and that would become indivisible and continuous and would cease to exist.

22. The existence of our Universe is comprised of three "nothings," or, taken separately, by themselves, three nonexistent "somethings": space, time, and something more, which is neither time, nor space.

23. Time, in its essence, is indivisible, homogenous, and continuous, and therefore does not exist.

24. Space, in its essence, is indivisible, homogenous, and continuous, and therefore does not exist.

25. But as soon as space and time come into a certain mutual relationship, they become an obstruction for one another and begin to exist.

26. Beginning to exist, space and time mutually become part of one another.

27. Time, experiencing the obstruction of space, splits into parts, forming the trinity of existence.

28. Time, once split asunder and existing, is comprised of three fundamental elements of existence: the past, the present, and the future.

29. The past, present, and future, being fundamental elements of existence, always stand in necessary interdependence. There cannot be a past without a present and a future, or a present without a past and a future, or a future without a past and present.

30. Examining these elements separately, we can see that there is no past because it has already passed, and there is no future because it has not yet come. It follows that there is only "the present." But what is "the present"?

31. While we utter this word, the uttered letters of this word become the past, while the unuttered letters lie still in the future. It follows that only that sound that is being uttered now is "the present."

32. But even the process of uttering this sound is possessed of a certain duration. Consequently, only some part of this process is "the present," while other parts are either the past or the future. But the same thing may be said about this part of the process, which seemed to us to be "the present."

33. Reflecting in this way, we see that there is no "present."

34. The present is only an obstruction in the transition from the past to the future, and the past and the future appear to us as the this and that of the existence of time.

35. And so: the present acts as the obstruction in the existence of time, and, as we said earlier, space serves as the obstruction in the existence of time.

36. In this way: "the present" of time is space.

37. There is no space in the past or in the future, it is wholly contained in "the present." And the present is space.

38. And since there is no present, there is no space either.

39. We explained the existence of time, but space, by itself, does not yet exist.

40. In order to explain the existence of space, we must take up the case in which time appears as the obstruction of space.

41. Experiencing the obstruction of time, space splits into parts, forming the trinity of existence.

42. Space, once split asunder and existing, consists of three elements: there, here, and there.

43. In the transition from one there to one here, the obstruction of here must be overcome, because if there were no obstruction of here, then one there and another there would be indivisible.

44. Here acts as "the obstruction" of existing space. And, as we have said above, time serves as the obstruction of existing space.

45. In this way: the here of space is time.

46. The here of space and "the present" of time are the points of intersection of time and space.

47. Examining space and time as fundamental elements of the existence of the Universe, we say: the Universe is composed of space, time, and something else that is neither time nor space.

48. That "something," which is neither time nor space, is the "obstruction," which forms the existence of the Universe.

49. This "something" forms an obstruction between time and space.

50. Therefore this "something" resides in the point of intersection between time and space.

51. Consequently, this "something" is located in time at the point of "the present," and in space at the point of "here."

52. This "something," being located at the point of the intersection between space and time, forms a certain obstruction, tearing "here" away from "the present."

53. This "something," forming an obstruction and tearing "here" away from "the present," creates a certain existence, which we refer to as matter or energy. (Let us from now on refer to it conventionally, simply as matter.)

54. And so: the existence of the Universe, formed by space, time, and their obstruction, is expressed in matter.

55. Matter itself gives us evidence of time.

56. Matter itself gives us evidence of space.

57. In this way: the three fundamental elements of the existence of the Universe are known to us as time, space, and matter.

58. Time, space, and matter, intersecting with each other in specific points and being the fundamental elements of the existence of the Universe, form a certain knot.

59. Let us call this knot the Universal Knot.

60. Saying of myself, "I am," I place myself in the Universal Knot.

ca. mid-1930s

Translated by Michael Goldman and Matvei Yankelevich

Anje Roosjen

Army of little red riding hoods; drawing on paper; 8.3" × 11.7"; 2004.

WAITING FOR go(dot)com

Julia Druk

I mainly snatch time to write between long bouts of procrastination. Even now, I am taking advantage of waiting on three websites to load: a Dear Abby-style column, an in-depth review of a newly-minted yarn for hipsters, and today's edition of *The Consumerist*, a blog for discerning *consommateurs* (or maybe *consommés*).

We all end up doing a lot of waiting these days. Wireless connections, "buffering" videos, Windows start-up sequences, credit card authorizations, video game loading screens, ATMs, anti-piracy DVD threats, helpfully long-winded ladies who dole out practical advice on how to leave a phone message. Those of us who were around in the 1990s might also remember waiting on the vintage Windows hourglass cursor, now abandoned in favor of not pointing out anything at all. It seems that waiting—that dreaded and redundant non-activity—has become one of the most predominant features of modern technology (see also: indestructible packaging and a penchant for water damage).

Our growing impatience with seconds-long wait times—so removed from the black-and-white notions of endless bread lines and long-distance love letters—has garnered the attention of the press. It seems that every week a new article appears bemoaning our shortened attention spans, which seems to go hand in hand with America's obesity epidemic and the corruption of our youth through sexting. Take, for example, a recent article by Tara Parker-Pope in the *New York Times* series "Your Brain on Computers," in which she writes that "excessive use of the internet, cellphones and other technologies can cause us to become more impatient, impulsive, forgetful and even more narcissistic."[1] Matt Richtel, another writer for the series, criticizes technology's effect on high school performance and students' studying habits, concluding— "bring back boredom."[2]

These are among the many slow-news-day items that treat attention with the same bias that dismisses comic books in favor of "real" art, and Lady Gaga in favor of opera. They seem to imply that we are becoming a nation of wimps and whiners, raised without the necessary skills for dealing with the grown-up world, the foremost of these being the ability to pay attention to boring things—such articles notwithstanding. "Bring back boredom," in-

deed. True, it takes much less time until we're bored enough to feel like we're *waiting* than it did for our parents and grandparents. But treating attention as a limited commodity that only "counts" when its subject has passed a "High Culture" boardroom review blinds us to the fact that the act of waiting itself has gone through a quiet but fundamental change in recent years.

I noticed it first when working for a consulting firm that turned research on how people use websites into oft-ignored recommendations for the website owners, such as "make sure that your Add to Cart buttons are easy to see" (which does not, in fact, translate to light grey buttons on medium grey backgrounds, no matter how many creative directors wish it so). My role was to observe how people used various websites, and record their comments, actions, and gestures, looking for patterns in their behavior. A moderator, meanwhile, would encourage the respondents to act naturally, as if they were at home without the presence of cameras or inquisitive researchers, and "put their brain on speakerphone" or narrate what they were doing and thinking.

Research is full of pauses, and internet research more so, as connection speeds in lab facilities are rarely consistent, and the computers provided rarely up-to-date. When site loading times slowed, I noticed that people would consistently do one of a few things: bite their nails, tap their fingers on the table, jab at the Enter button repeatedly, stretch, or moodily stare off into space. If a few seconds passed, savvier users would ask if the connection was down, at which point the moderator would apologize profusely then, in all seriousness, ask: "If this happened to you at home, how would you feel?" Less savvy users would ask if they had done something wrong, to which there was no one stock answer but a few soothing comments nonetheless.

When the connection was smooth, respondents expected immediate feedback from websites. If they had initiated an action—say, clicking on a link or a purchase button—they needed reassurance that the action "took." If nothing moved, jumped, or changed right away, they would try and repeat the action again and again, until they inevitably added eighteen copies of the same book to their cart.

In the space of a few seconds, people achieved the same level of boredom and frustration as someone who had waited in line no less than five minutes. The effect was the same, but the build-up completely different. What happened to make them—us—become aware of time in such short quantities?

I didn't think much about this question until, some years later, I read Natasha Schüll's essay about gamblers in Las Vegas, "Video Poker." She described the lives of people addicted to the screens and beckoning arms of video poker machines. Like misguided dieters, her subjects talk about entering The Zone—a state "in which a sense of time, space, the value of money, social relations, and even a sense of the body dissolves."[3] They lose money, days, and sometimes the control of their bowels (to clarify: just the gamblers, not the dieters) as they sit mesmerized at the machines.

Ironically, these players are not there to win—waiting for tokens to pay out takes time, and forces them to leave their semi-hypnotic state. "You're playing for credit," one says, "credit so you can sit there longer, which is the goal. It's not about winning; it's about continuing to play."[4] Many plan ahead to minimize interruptions—choosing a seat separated from other players to avoid chit-chat, wearing a diaper to avoid trips to the bathroom. "I'd win," says another player, "and I'd be ticked off because I'd have to wait for them to come pay me off."[5]

While the gamblers' behavior seems extreme, I was struck by how analogous it was to the average web or device user. Schüll's subjects lose sense of time entirely while playing poker; by contrast, they are hyper-aware of short periods during any kind of disruption. Similarly, we're ticked off by everything and anything that interrupts a smooth flow of web or cell phone activity—which makes us feel like we're waiting for *seconds* at a time.

In the past, waiting has always conjured up images of doctors' waiting rooms, airport lounges, lines of all shapes and sizes, taxpayer-supported institutions, etc. In all of these cases, waiting is its own activity that transitions you from either one action to the next, or one location to another. There is a designated place to wait, there is a clear expectation of how long the waiting will last (based on the flight time or the number of people in line), and there is

the possibility of turning your attention to something else while you wait. All in all, there are just some mornings when you get up and decide that it's a grand day to go stand in line somewhere in order to buy something, or wait for a taxi to take you to the airport to wait in the security line to wait for a plane to...

Ironically, as technology's speed accelerates, it creates a different kind of waiting, described succinctly by the axiom "a watched pot never boils." Instead of being its own activity, waiting now occurs during an interruption to something else you're already doing. You are suddenly forced to be idle while in the middle of a task, and you sense time more acutely if only because your attention is so focused on it. It's as if, while you're checking out at the supermarket, the cashier suddenly puts out a "buffering" sign and freezes for a few inexplicable seconds until, acting as if nothing was out of the ordinary, she regains movement and continues bagging your groceries. This is waiting without its own place, without a sense of duration, and without the possibility of diverting your attention to anything else.

What we're dealing with, then, is not a deficit of attention, but its surplus. In other words, the measure of our impatience with being interrupted is not the measure of our attention deficit, but of our engagement in a task. Of course, we have to put away our prejudice about the "proper" definition of an attention span—length of time spent reading textbooks, watching grandma knit, and waiting for the laundry to dry—and instead accept that reading Wikipedia or watching YouTube videos is just as worthy of accounting for.

If we do that, then we can begin to explore what the rise of *hyper-attention* means; whether, for example, becoming aware of minute amounts of time multiple times each day makes the day seem longer; whether our sense of flowing smoothly through time is becoming fragmented; whether 9-5 or 24-7 means anything anymore. So far, I've got no answers. But my new favorite Facebooker sums up the issue best: "Waiting in a txt and it feels like forever, but its rly only been a minute. I hate when that happens." I like this, and so do 286 other people.

NOTES:

1 Tara Parker-Pope, "An Ugly Toll of Technology: Impatience and Forgetfulness," *New York Times*, June 7, 2010, A13.

2 Matt Richtel, "Growing Up Digital, Wired for Distraction," *New York Times*, November 21, 2010, A1.

3 Natasha Schull, "Video Poker," in *The Inner History of Devices*, ed. Sherry Turkle (Cambridge, MA: MIT Press, 2008), 155.

4 Schull, 158-162.

5 Schull, 166.

Satomi Orita

TIME'S HULA-HOOP

HOW DO I RECOGNIZE TIME?

Time is restricted by the space of the sense of feeling, memory, and consciousness. It means that the idea is a combination of two ideas: Time's Hula-Hoop and Geo-Logic-Time.

TIME: TIME'S HULA-HOOP

Time's Hula-Hoop is based on ideas from *Time's Arrow, Time's Cycle* by Stephen Jay Gould and Time's Spiral suggested by Nathan Felde who is a professor at The Art Institute of Boston.

Some of my ideas about Time's Arrow stem from the lives of gonozooid and books. It has the beginning and the end. Seasons and a day are examples for Time's Cycle. Time's Spiral is a mixture of Time's Arrow and Time's Cycle. Time's Spiral builds up things on the past cycles of time. For instance, learning systems can indicate a spiral; learning is a process of building on memory and past experiences.

Time's Hula-Hoop is combination of both ideas that Time's Cycles (phenomenon) are going around Time's Arrow (the point where you are right now), moving based on Time's Spiral. The touching points of hula-hoops and the arrow create events. Hula-hoops have various sizes, speeds, and functions. Things happen based on the point where the arrow and cycle meet. The events may look like they happen not by chance but by necessity. The arrow does not go straight but spirals to make a hula-hoop go around. It creates the same function as Time's Spiral. Also, the hula-hoops are touching and affecting each other. It may cause changes of size, speed, and shape. The center of the hula-hoop creates movements of Time's Cycle and Time's Spiral. The control is made by the center of the Time's Hula-Hoop, which can be anything—your life, your country, or a problem you have.

SPACE

Space is everywhere. It goes everywhere and wraps us up. However, from my sense, the real space is only the space where I am. Where I am recognizing where I am or where I can feel, see, touch, listen, or think in that moment. In other words, some Space might not exist where I do not recognize.

RELATIONSHIPS BETWEEN TIME AND SPACE

Space and Time are infinite. They rely on each other and without one, the other cannot exist. As an image of Time and Space, time is piles of Space and Space is movement of Time. Time cannot move without making something move. When both Time and Space exist, things exist on a crossing point of the Time and the Space. Space gives Time space to move.

ABILITIES GRABBING THE WORLD OF TIME AND SPACE IN A WAY OF GEO-LOGIC-TIME

Geologic Time can be separated as Geo, Logic, and Time, which indicates Geo as Deep Space (memorizing), Logic as Logic (consciousness), and Time as Deep Time (thinking).

Deep Space: Memorizing has deep space. Memorizing is the storage of events. Memorizing is an action grabbing and holding Time.

Deep Time: Thinking has deep time. Time passes with new thought. Thinking is an action shaping Space.

Logic: Logic (you) is holding Deep Space and Deep Time. You are holding, memorizing, and thinking to be yourself right now. You are always the center of the world and you are holding everything.

GEO-LOGIC-TIME

There are Time and Space where we remember, think, or have consciousness. Otherwise, there is nothing. When we are born, we have nothing. We do not know where we are and what time it is now. Getting older, knowledge is getting stored as our memory, little by little; getting space wider and deeper and we can think from the memory with passing time; getting time wider and deeper as thinking of past, present, and future.

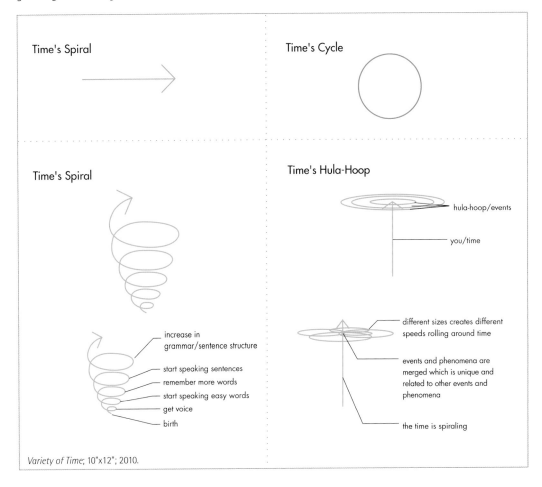

Time's Spiral

Time's Cycle

Time's Spiral

increase in grammar/sentence structure
start speaking sentences
remember more words
start speaking easy words
get voice
birth

Time's Hula-Hoop

hula-hoop/events

you/time

different sizes creates different speeds rolling around time

events and phenomena are merged which is unique and related to other events and phenomena

the time is spiraling

Variety of Time; 10"x12"; 2010.

// Space

place where I have been

place where I have not been

// Brain Abilities

memory

thinking

consciousness

unconsciousness

// Geo Logic Time

Geo — Logic — Time

deep space — deep time

momery — consciousness — thinking

// Space and Time; Memory and Thinking

spread of Time / Space
where you can sense

where you can be

bird's eye view

side view

where you are right now

Concept of Geo-Logic-Time; 10"x12"; 2010.

As long as Logic is tied together with Deep Space (memory) and Deep Time (thinking), we are free to go to any point we want to be. We can be in a past point, present, or future. However, the present point, right now, creates everything. The moment that we have right now creates the moment of past in a second. Then the moment that we have right now also creates the moment of future in a second. It indicates that the thought made in the right now effects both past and future.

WHAT TIME IS IT NOW?

The mixture of the concept of Time's Hula-Hoop and Geo-Logic-Time creates our life. Our life is created by the patterns of both concepts. The concepts are created based on how we think and what we believe from your Deep Space and Deep Time right now.

The answers for "What time is it now?" and "Where am I?" are the point where the Time and Space cross, touching at a single point. We are always in the single point of Space and Time, which is right now. How we call the time is decided by the beginning point of the time, the end point of the time, or both of them. The speed of the time is calculated by the division from the beginning and the end. Our calendar starts January 1, though it can be changed. When I am asked "What time is it now?" I can answer, "It is a moment that a rock gets in a sand."

What time is it now for you?

References

Nathan Felde, *Personal interview*, 2008.

Stephen Jay Gould, *Time's Arrow, Time's Cycle: Myth and Metaphor in the Discovery of Geological Time* (Cambridge, MA: Harvard University Press, 1987).

Illustrations by Satomi Orita. 2010.

28 DAY CYCLE

January 9

January 10

January 11

Melissa Potter

I am a multimedia artist whose work deals with the commodification of women and their rites of passage, from marriage to motherhood. In the series, "Maybe Mom Ovulation Test," I engage the measurement of time experienced specifically by women by depicting twenty-eight days of saliva ovulation testing in paintings. The female body as an object being "time-stamped, freshness tested" is explored in these works. In a society obsessed with choice, these works also test the power of time over our choices.

From series, "The Maybe Mom Ovulation Test 28-Day Cycle"; 2008.

Not Ovulating
(January 9)
12 inch circle, paint and ink on handmade paper

Not Ovulating 2
(January 10)
12 inch circle, paint and ink on handmade paper

Starting to Ovulate
(January 11)
12 inch circle, paint and ink on handmade paper

Ovulating
(January 13)
12 inch circle, paint and ink on handmade paper

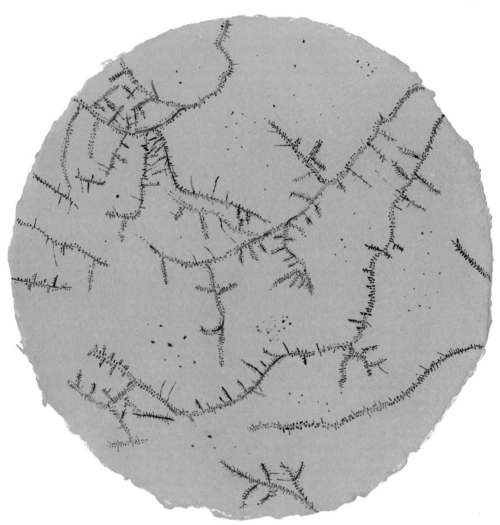

January 13

CYCLICAL TIME(S)

STRUCTURES

MUSICS

OF THE AFRICAN DIASPORA

Jesse Stewart

"Music makes time audible" Susanne Langer famously wrote in her 1953 book *Feeling and Form*. More recently, Jonathon Kramer has suggested that "music becomes meaningful in and through time." Elaborating on these insights, I would suggest that different forms of music make time audible in different ways, and the temporal structures and temporal processes through which music becomes meaningful are intimately connected to wider cultural paradigms and patterns of discourse. Two contrasting approaches illustrate this point, namely the notions of linear and cyclical time considered within the context of music.

The unidirectional flow of musical events from one moment to the next, usually implyng a sense of progress toward a musical goal, is linear. In contrast, musical patterns that repeat indefinitely, providing a ground upon which musical figures can be superimposed, rely on cyclical time structures. The emphasis on linear, teleological musical development that underpins the Western classical tradition resonates with the Aristotelian emphasis on teleology that informs so much of Western philosophy, as well as the linear conception of time in Judeo-Christian theology that theorizes the physical universe as having a beginning (creation), middle (humanity's time on earth), and end (the apocalypse). In contrast, many non-Western forms of music are organized around cyclical rhythms that can be seen as musical embodiments of non-linear, cyclical conceptions of time. In my view, it is no historical accident that two of the world's most sophisticated theories of cyclical rhythm—the *tala* systems of Karnatak and Hindustani music—can be traced to ancient India, birthplace of the *Vedas*, sacred texts that theorize existence as consisting of repeating time cycles called *yuga* and *kalpa* that last millions (and, in the case of kalpa, billions) of years.

I do not mean to set up a false binary between linear/cyclical musics and Western/non-Western cultures. There are a great many examples of Western musical practices that articulate a cyclical conception of musical time just as there are many non-Western musics that emphasize linear musical development. This has become increasingly true over the past century or so with increased contact between formerly disparate musics and cultures, and the intense circulation of mediatized representations of those musics around the globe. Moreover, many forms of contemporary music making incorporate multiple approaches to musical time, often simultaneously. Time's arrow and

time's cycle are increasingly in dialogue with one another in contemporary musical practice.

For the remainder of this essay, I will focus on a special class of cyclical time structures known as "diatonic rhythms," not to privilege them over linear conceptions of musical time, but rather because of their fecundity and influence on music making the world over and because of their importance to my own creative practice as a composer, improviser, and percussionist.

Figure 1 Eight-pulse cycle

As a drummer, I have often wondered if certain rhythmic patterns "groove" more than others. Of course, a sense of groove depends a great deal on performance practice and on a range of individually and culturally determined aesthetic factors. But is there something intrinsic to specific rhythm patterns that encourage bodily responses in the form of dancing, toe tapping, or head swaying more readily than others? Personal experience and a growing body of musical research suggest that some do.

Figure 2 Eight-pulse cycle with four sounded pulses clustered together

Consider Figure 1, which represents a cyclical eight-pulse framework. Along with cycles of twelve and sixteen pulses, this is one of the most common cyclical rhythmic frameworks in the world.

If we cluster four sounded pulses next to one another within this eight-pulse cycle, we end up with the time cycle represented in Figure 2.

Figure 3 Eight-pulse cycle with four maximally even sounded pulses

Beginning at the 12 o'clock position and moving clockwise around the diagram, we end up with a rhythm that can be notated as (♫ ♫ 𝄾 𝄾). To my ears, this is not particularly groove-oriented—the clustering of the sounded pulses creates a stilted

Figure 4 "3-in-8" diatonic pattern

rhythm that does not lead the ear (or the body) through the time cycle. This problem can be alleviated if we spread out the sounded pulses as evenly as possible within the cycle as shown in Figure 3.

This rhythm, which we can notate as a steady quarter note pulse (♩♩♩♩), is maximally even. That is to say, the sounded pulses are spread out as much as possible within the cycle. In addition to yielding a variety of compelling musical time structures, the quality of maximal evenness—spreading out as much as possible—provides a point of connection with many natural phenomena ranging from the distribution of electrons in atomic shells to the many plant species that distribute their leaves as evenly as possible around a central stalk, thereby maximizing exposure to the sun. In music, rhythmic maximal evenness contributes to a sense of groove. Indeed, maximally even temporal structures, such as the one represented in Figure 3, are very effective at leading ears and bodies through time cycles as evidenced by the pounding quarter-note bass loops that fill dance floors on a nightly basis all over the world. However, in addition to being maximally even, this particular time cycle is maximally redundant, a function of the fact that four sounded pulses divide evenly into an eight-pulse framework when they are spread out as much as possible.

But what if the sounded pulses did not divide evenly into our eight-pulse framework? In Figure 4 we have three sounded pulses, spread out as much as possible, within the eight-pulse cycle. Unlike the four-pulse rhythm in Figure 3, the three sounded pulses are maximally even without being maximally redundant due to the fact that three pulses cannot divide evenly into eight. There will always be a rhythmic remainder. This creates a dynamic asymmetry within the cycle, a sense of forward momentum and groove that tends to elicit kinesthetic responses from listeners and dancers in a wide variety of musical and cultural locations.

Beginning at the 12 o'clock position and reading the cycle clockwise, we have the following rhythm (♩. ♩. ♩) which we can describe as a 3-3-2 pattern, counted 1-2-3, 1-2-3, 1-2. This rhythm has a number of interesting properties, not the least of which is the fact that it is probably the most common dance rhythm in the world. It is particularly common among musics of the African Diaspora: it forms the bell timeline (or a part thereof) of numerous West African musical forms; it is a common bass-drum pattern in

the "second line" drumming of New Orleans funeral marches; we hear it in many styles of Cuban music where it is known as the *tresillo* rhythm; and forms part of the ubiquitous *son clave*. It also forms part of the so-called "Bo Diddley beat," which propelled its namesake to early rock and roll stardom. In short, this particular rhythm is as close to a rhythmic archetype—a musical "archetime"—as we are likely to find.

A number of music theorists have applied the term "diatonic" to rhythmic patterns of this sort (Brownell 2002; Rahn 1987, 1996). Normally applied to pitch, the term literally means "through or across the tones." By extension, a diatonic rhythm can be defined—

for the purpose of the present essay at least—as a repeating rhythmic pattern in which an odd number of sounded pulses are spread out as much as possible across the tones of an eight-, twelve-, or sixteen-pulse time cycle. Thus, we can refer to the rhythmic pattern represented in Figure 4 as a "3-in-8" diatonic pattern meaning that three sounded pulses are spaced as evenly as possible within an eight-pulse framework.

Other syncopated rhythms are encoded within this cycle as well, as shown in Figure 5.

Beginning at different time-points within the cycle yields the eight different rhythms labeled 5a-h), all phase transpositions of one another—rotations of the time cycle. Rhythms 5b-h) may not be as common as the 3-3-2 pattern notated in 5a), but these phase transpositions are amply represented in numerous musics with roots in the African diaspora. Jazz drummers, for example, routinely employ these rhythms and variations thereof in "comping" patterns, syncopated rhythms played on the snare drum, bass drum, and/or hi-hat that cut across the flow of time articulated by the ride cymbal rhythm, marking the time and complementing the melodic lines of a soloist.

If the sounded pulses within a time cycle are maximally even, it stands to reason that the non-sounded pulses separating them are also maximally even. This is another interesting feature of the "3-in-8" diatonic rhythm: its rhythmic complement, the five non-sounded pulses, also form a diatonic pattern. Consider Figure 6. Note how the two diagrams complement one another.

The diagram on the right represents a "5-in-8 diatonic pattern." Just as there were multiple rhythms encoded within the "3-in-8" diatonic pattern, there are multiple rhythms encoded within this cycle if we begin on different time-points as shown in Figure 7.

The rhythms labeled 7a-h) are all phase transpositions of the same underlying diatonic pattern. Once again, these rhythms are amply represented in many musics of the African diaspora. For example, the rhythm labeled 7h) (♩♪♩♪) is prominent in Haitian music and in many styles of Afro-Cuban music wherein it is referred to as the *cinquillo* rhythm. Note how this rhythm is related to the *tresillo* rhythm discussed above: cinquillo is a phase transposition of the rhythmic complement of tresillo.

Figure 5. "3-in-8" diatonic pattern and constituent rhythms

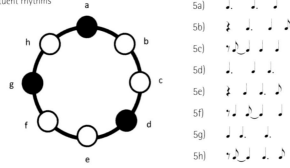

Figure 6. Complementary diatonic patterns: "3-in-8" and "5-in-8"

Figure 7. "5-in-8" diatonic pattern and constituent rhythms

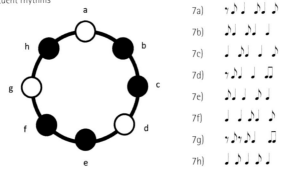

Figure 8. Right and left hand complementation in "3-in-8" diatonic pattern (right) and "5-in-8" diatonic pattern (left)

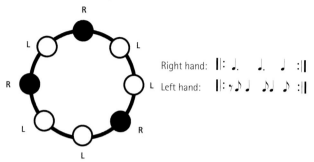

Right hand: ‖: 𝅘𝅥𝅭 𝅘𝅥𝅭 𝅘𝅥 :‖

Left hand: ‖: 𝄾𝅘𝅥𝅮𝅘𝅥 𝅘𝅥𝅘𝅥𝅮 𝅘𝅥𝅮 :‖

Figure 9. Cinquillo and tresillo rhythm together ("5-in-8" diatonic pattern combined with "3-in-8" diatonic pattern)

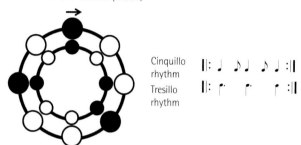

Cinquillo rhythm ‖: 𝅘𝅥 𝅘𝅥𝅮𝅘𝅥 𝅘𝅥𝅮𝅘𝅥 :‖

Tresillo rhythm ‖: 𝅘𝅥𝅭 𝅘𝅥𝅭 𝅘𝅥 :‖

Figure 10. New Orleans-style combination of "3-in-8" and "5-in-8" diatonic patterns

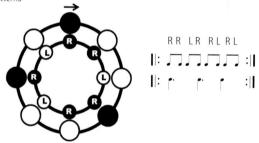

R R L R R L R L

‖: 𝅘𝅥𝅮𝅘𝅥𝅮 𝅘𝅥𝅮𝅘𝅥𝅮 𝅘𝅥𝅮𝅘𝅥𝅮 𝅘𝅥𝅮𝅘𝅥𝅮 :‖

‖: 𝅘𝅥𝅭 𝅘𝅥𝅭 𝅘𝅥 :‖

Figure 11. Cáscara rhythm (inner circle) with son clave (outer circle)

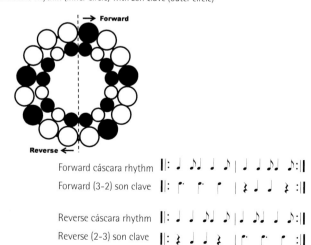

→ Forward

Reverse ←

Forward cáscara rhythm ‖: 𝅘𝅥 𝅘𝅥𝅮𝅘𝅥 𝅘𝅥 𝅘𝅥𝅮 | 𝅘𝅥 𝅘𝅥 𝅘𝅥𝅮𝅘𝅥 𝅘𝅥𝅮:‖

Forward (3-2) son clave ‖: 𝅘𝅥𝅭 𝅘𝅥𝅭 𝅘𝅥 | 𝄾 𝅘𝅥 𝅘𝅥 𝄾 :‖

Reverse cáscara rhythm ‖: 𝅘𝅥 𝅘𝅥 𝅘𝅥𝅮𝅘𝅥 𝅘𝅥𝅮| 𝅘𝅥 𝅘𝅥𝅮𝅘𝅥 𝅘𝅥 𝅘𝅥𝅮:‖

Reverse (2-3) son clave ‖: 𝄾 𝅘𝅥 𝅘𝅥 𝄾 | 𝅘𝅥𝅭 𝅘𝅥𝅭 𝅘𝅥 :‖

The relationships between these diatonic patterns are not just theoretical abstractions. These rhythms are fundamentally linked with one another in performance practice as well. For example, drummers routinely juxtapose variations of the "3-in-8" and "5-and-8" diatonic patterns through right and left hand complementation. That is, when one hand plays a "3-in-8" diatonic pattern, the other hand will frequently fill out the rhythm, articulating the complementary "5-in-8" diatonic pattern as shown in Figure 8.

Furthermore, permutations of the "3-in-8" and "5-in-8" diatonic patterns are often combined with one another, with both rhythms starting on the same downbeat. For example, the tresillo and cinquillo rhythms are often played together as shown in Figure 9. Note how the two patterns reinforce one another, creating an interlocked groove with a strong sense of forward of momentum. The arrow marks the downbeat of the cycle as well as the direction in which the rhythms are played in this and subsequent diagrams.

Nested diatonic rhythms of this sort are quite common in a variety of musics rooted in the African diaspora. Figure 10 shows another example involving the 3-3-2, or tresillo, rhythm and a different phase transposition of the "5-in-8" diatonic pattern, a combination that is common in New Orleans "second line" drumming. Contemporary New Orleans drum set performers such as Johnny Vidacovich and Stanton Moore also make frequent use of this rhythmic combination, playing the "5-in-8" pattern with the right hand and filling it out with the left, voicing this sticking pattern around the kit in different ways.

Different phase transpositions of the "5-in-8" diatonic pattern are often combined with one another to form sixteen-pulse time cycles. For example, the rhythms labeled 7c) and 7f) in Figure 7 are combined in the two variations of the Cuban cáscara rhythm shown in Figure 11 along with their corresponding clave rhythms. The inner cycle represents the cáscara rhythm and the outer cycle represents the son clave. The dotted line in the diagram represents the division between the two constituent eight-pulse rhythms (represented by the bar-line in the notated version of these rhythms). Note that the only difference between the forward and reverse versions of these patterns is the starting point within the cycle as indicated by the arrows.

In a similar way, combining the rhythms labeled 7a) and 7f) in Figure 7 results in the bell timeline of another Afro-Cuban style, the so-called *Mozambique* rhythm shown in both its forward and reverse manifestations in Figure 12. Note that the corresponding clave rhythms in this case are of the rumba variety, which differ from their son clave counterparts by one pulse, a displaced eighth note indicated by the dashed arrow in the diagram below.

Figure 12. Mozambique rhythm (inner circle) with rumba clave (outer circle)

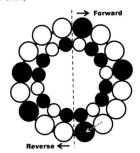

Forward (3-2) Mozambique rhythm

Forward (3-2) Rumba clave

Reverse Mozambique rhythm

Reverse (2-3) Rumba clave

If music makes time audible, and temporal structures in music are indeed connected to wider cultural paradigms and patterns of discourse, what are we to make of the fact that diatonic rhythms are so widespread among musical cultures of the African diaspora, including cultures that are separated by vast spatial and temporal distances? On one hand, these rhythms might be seen as a testament to the power of musical rhythm as a site for musical and cultural memory and transference across time and space. I am inclined to see diatonic patterns as a fruitful metaphor for the African diaspora itself, a way of theorizing the threads of continuity that exist between the many disparate musics and cultures that have shared African roots, but have been profoundly altered by the passage of time and cross-cultural contact and hybridization [or "fusion"]. The term "diaspora" comes from the same root as the word "disperse," which is another way of saying "to spread out." Recall that maximal evennesss—being spread out—is one of the conditions of rhythmic diatonicism. Furthermore, diatonic patterns yield multiple

constituent rhythms depending on which time point we begin on within the cycle. These rhythms are combined with one another in multiple ways in diverse African diasporic musics. Much like the myriad communities that constitute the African diaspora, each of these rhythms is distinctive and unique. And yet, at a deep structural level, these rhythms, like the communities that produced them, are fundamentally connected to one another. Like so many things, exploring those connections is a matter time.

References

Brownell, John. "The Changing Same: Asymmetry and Rhythmic Structure in Repetitive Idioms." Ph.D. diss., York University, Toronto, 2002.

Butler, Mark J. *Unlocking the Groove: Rhythm, Meter, and Musical Design in Electronic Dance Music.* Bloomington: Indiana University Press, 2006.

Doffman, Mark. "Making It Groove! Entrainment, Participation and Discrepancy in the 'Conversation' of a Jazz Trio." Language & History (italic) 52, no. 1 (2009): 130-147.

Iyer, Vijay. "Microstructures of Feel, Macrostructures of Sound: Embodied Cognition in West African and African American Musics." Ph.D. diss., University of California, Berkeley, 1998.

—. "Embodied Mind, Situated Cognition, and Expressive Microtiming in African-American Music." *Music Perception* 19, no. 3 (2002): 387-414.

Keil, Charles. "Motion and Feeling Through Music." *Journal of Aesthetics and Art Criticism* 24, no. 3 (1966): 337-49.

—."Participatory Discrepancies and the Power of Music." *Cultural Anthropology* 2, no. 3, (1987): 275-83.

Keil, Charles and Steven Feld. *Music Grooves: Essays and Dialogues.* Chicago: University of Chicago Press, 1994.

Kramer, Jonathan. *The Time of Music.* New York: Schirme-Books, 1988.

Langer, Susanne. *Feeling and Form.* New York: Scribners, 1953.

Madison, Guy. "Experiencing Groove Induced by Music: Consistency and Phenomenology." *Music Perception* 24, no. 2 (2006): 202-208.

Monson, Ingrid. "Riffs, Repetition, and Theories of Globalization." *Ethnomusicology* 43, no. 1 (1999): 32-65.

Pressing, Jeff. "Black Atlantic Rhythm: Its Computational and Transcultural Foundations." *Music Perception* 19, no. 3 (2002): 285-310.

Rahn, Jay. "Asymmetrical Ostinatos in Sub-Saharn Music: Time, Pitch, and Cycles Reconsidered." *In Theory Only* 9, no. 7 (1987): 23-28.

—. "Turning the Analysis Around: Africa-Derived Rhythms and Europe-Derived Music Theory." *Black Music Research Journal* 16, no. 1 (1996): 71-89.

Temperley, David. "Meter and Grouping in African Music: A View from Music Theory." *Ethnomusicology* 44, no. 1 (2000): 65-96.

Jesse Stewart

Untitled (detail); 2009.
365 clock hands, collected over a period of four years, mounted on a blank piece of paper.

Untitled (detail); 2006.
Thousands of pieces of glass, rounded by water, collected from beaches over a period of 15 years. Arranged into concentric circles on a bed of black sand. 365 or 366 pieces of glass per ring. One piece of glass for every day of the artist's life. 11, 553 pieces as of January 13, 2006 when the work was last shown.

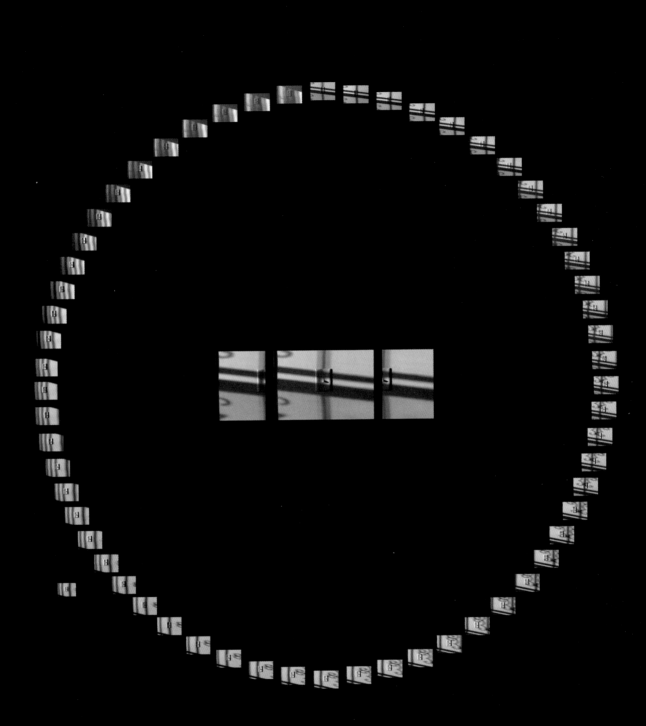

FLOW

FLOWW FLOW VF

Kai-Min Hsiung

Flow is a multi-channel video installation manipulated by a custom MAX/Jitter patch. There are sixty screens rounding an outside circle representing seconds, sixty screens rounding an inside circle representing minutes, and several big screens in the center representing hours.

Flow; multi-channel video installation (prototype); 1920 x 1080 dpi; 2008.

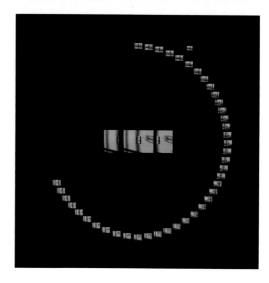

ON THE ORIGIN OF FORMS

Olga Ast

Our knowledge of the universe is fragmented. We have assigned it to the sciences, mathematics, visual art, music, literature, poetry, religion, philosophy, and so on. All these disciplines have developed their own languages to study and describe the universe. Even within a single discipline, experts create their own languages of understanding.

We have come to the point where specialists from different fields—and even those from the same field—understand one another with difficulty, if at all.

Yet the universe is not divided arbitrarily into specialized areas of mathematics or physics or poetry. It exists as a whole, and its contents encompass the knowledge that we have segregated into different disciplines. We have not created a language that can describe the universe as it exists, and still be flexible enough to write a poem, a symphony, or a segment of DNA.

The only language we have thus far that connects rather than divides us is conversational. Even the most respected practitioners of their respective disciplines revert to common speech with their families, their friends, and strangers on the street.

What follows is an attempt at a cross-disciplinary approach to the problem of time. I have attempted to avoid specific jargon so as not to lean one way or another into particular cultural or social territories. I have to reconcile myself to all the imperfections and imprecision of conversational language, and yet I recognize that this is the form of language that gave birth to all others. It is the cradle of all languages. It is the cradle of how we understand one another, the world, and our place in it—from birth to death.

TIME AS FEAR

The question "What is time?" has been considered to belong to physics or philosophy. To me, the question becomes more psychological, "Why do we experience changes in information as time passing?" More accurately, what we ask ourselves is "Why do we age? Why don't we live forever? Why do we have to die?"

We connect the abstract idea of time with our fear of death. As a consequence, the concept of time transforms into a powerful myth that places an unbearable psychological burden on us that we cannot overcome. We are afraid to investigate time because we are afraid of death. Instead, we look in the opposite direction. We strive to reverse our decline—go from old age to youth. We are on a never ending search for the ultimate elixir of youth—a cream, a pill, or a surgical intervention.

Time and age are inextricably linked in our collective consciousness. We have created the myth, and we are afraid of our creation. This fear is the reason for our interpretation of informational change as an irreversible passage and decline.

Time seems too overpowering to deal with.

TIME AS SENSE

Humans have complex tools for collecting information from the environment—the senses. Is there a sensory tool for sensing time?

Perhaps the answer is obvious. Among its other functions, the brain collects, encodes, stores, analyzes, and decodes information that comes from the sense suppliers of the body. It produces new information. It does not touch, smell, or feel anything, but deals solely with the encoded information the senes provide. It is a tool that never directly communicates with the outside world, yet is essential to us if we are to notice changes in our surrounding informational field. It records these changes as linear and sequential, and stores them in memory.

Our understanding of cause and effect depends on the linearity we assign to change. We know from experience that if we put water in a pot above a fire, it will boil and evaporate. If we cover the pot, the vapor will condense back into water. With reference to the human body, the same process has different results. A human body placed over a heat source will burn, but it will not condense and it cannot be re-used.

We designate as cyclical those processes that we can observe from beginning to end, like the change from water to vapor and vice versa. We see linear processes in those of human life and death. Our egocentric tendencies win over our objective obser-

vations that tell us that when humans are burned or buildings destroyed, their same atoms remain, simply rearranged. Yet we tend to perceive human life and the existence of man-made objects as linear, and connect these to our understanding of time.

Upon death or destruction, the space that had been structured as a human or a building remains, but changes the principles of its structure and the connections between its parts. The component parts of humans participate in much greater cycles of transformation than we can observe in water.

All informational systems are part of lesser or greater cycles of transformation, even as our brains sometimes only perceive a localized, limited portion of these cycles and encode them as straight, directed lines.

TIME AS MEMORY

If we did not have memory, would time exist for us?

Our conception of time is wholly dependent on our ability to see the current state of a given object and compare it to what we remember of its previous state. We look to objects and events in search of patterns and associations.

Yet when we recall information from memory, it is not necessarily sequential or linear. We sometimes have trouble remembering. Even if we have perfect recall, there are complications. One person sees a man running and, a few moments later, hears a loud sound. Another hears a loud sound and looks up to see a man running. Both of these people recall a different sequence of events. What's more is that the running man and the sound may be entirely unconnected, yet they can become linked in their observers' memories. Despite our brain's ability to find causal patterns in the events around us, a perceived sequence of events does not necessarily help us understand whether they actually depend on one another.

To deal with the sloppiness of memory, we have developed abstraction. This is reminiscent of the causality dilemma—"Which came first, the chicken or the egg?"—that has entertained us for thousands of years. More complex questions require the intervention of an abstract outside observer, someone independent of our entire informational system.

Problem solving requires another kind of recall. When we try to find a solution to a problem, the brain does not sift through all of our experiences from birth to the present moment. Rather, it calls forth only that information which it recognizes as necessary for the task at hand. This is the natural tendency of our recall. If we want to instead remember events in a linear, sequential order, we must impose on the brain to do so against its inclination. Remembering—and remembering in sequence—is not the main function or evolutionary strength of the brain. It evolved not to simply register events, but to produce new ideas and new encoded information.

Sequential thinking is not an efficient process for the fabrication of new ideas, yet it is taught and reinforced through social education. We need to remember sequences so as to create objective, social narratives that do not depend on the perception of a single individual—for the survival of society and of the species.

So we teach children to methodically organize knowledge in a logical order, from the simple to the complex. We no longer try to understand nature as a whole. Instead, we learn to see it as a linear sequence of distinct fragments.

As we become socialized, sequential thinking comes to seem natural, and we start to see time as a sequence of elements—seconds and minutes—that follow one another in a precise, eternal order, in one direction and along an imaginary line.

TIME AS ABSTRACTION

Humans develop complex languages with which to codify information and produce new encoded information. Language is the instrument through which such information exists and is transported in human society. To develop language, we have to divide what is around us into separate units through abstraction and simplification. We take apart and simplify nature, separating information into distinct groups of abstracted objects or phenomena. We then re-configure these groupings to produce new ideas and apply them to change our environment as it suits us.

We have realized that it is easier to work with abstractions—encoded information—than with the physical world. We favor making models, plans, and drawings to moving physical bodies. One favored abstraction is numbers. We simplify complex objects and concepts into numerical values. Money is the ever-present testimony to this.

We love numbers and geometry: squares, rectangles, triangles, straight lines, and so on, over irregular and ambiguous shapes, which we consider chaotic. So we favor abstraction over the chaotic reality of nature, and look for regular patterns in order to explain its irregularities with regular principles.

We love patterns as Plato loved perfect geometrical bodies, the Platonic Solids.

TIME AS A LINE

As we love regularity and simplicity, so do we love the arrow—our visual metaphor of time. This image likely came into our collective consciousness along-side the xyz coordinate system. After abstracting the complex spatial environment around us to three straight lines, we took the next logical step of mapping time along a line.

This was an irresistible mathematical temptation.

The ability to create straight lines and regular patterns is, to us, one of the signs of intelligent life. We distinguish ourselves from the universe and from nature by straight lines. A straight line is our signature.

TIME AS THE FOURTH DIMENSION

Does the Cartesian coordinate system exist in the physical world? It is purely imaginary, abstracted from natural phenomena. As legend would have it, analytic geometry came to Descartes as he watched a fly "crawling about on the ceiling near a corner of his room." But the corner of a room does not stretch indefinitely in all directions in the same way as the coordinate axes do. We can generate a coordinate system from any point in space as it suits our cal-culations, but the corner of a room is anchored to a single place.

As popular opinion has it, time is the fourth dimension—an extension of the straight lines of the Cartesian coordinate plane. In 1907, mathematician Hermann Minkowski was the first to connect time and the fourth dimension. Twenty-one years later, Sir

Albert Eddington articulated the metaphor of "time's arrow," cementing it not only as a concept but as a common visual metaphor.

THE MOST COMMON SHAPE IN THE UNIVERSE

Outside of cities, the straight line is rare. Looking out at the infinitely vast universe, we see the sphere as nature's most common shape. NASA photos of planets, stars, and other cosmic bodies show shapes that are almost perfect spheres. They follow elliptical, curved orbits. It is likely that we will never find a square among galaxies, planets, and stars.

Comparing spherical cosmic bodies to the shapes we see in the natural world around us, we can say that the shape of a planet is less complex than that of a living being. At the same time, we can argue that the shape of a worm or a snake is hardly complex, while a snowflake or a crystal may be much more intricate.

Then, we may notice that a planet has central, mirror, and rotational symmetry while most living beings have only mirror symmetry. This leads to the observation that living creatures have uniquely shaped body parts: a distinct top, bottom, back, front, left and right. They are spatially oriented.

THE EVOLUTION OF SHAPES

The shape of the simplest living organisms—viruses, for example—is not very different from a sphere. A virus has central, mirror, and rotational symmetry.

Slightly more complex, a jellyfish has only mirror and rotational symmetry.

Larger organisms like fish and snakes have mirror symmetry, but begin to lose rotational symmetry. They fight central and rotational symmetry to make their orientation in space possible.

Most insects, birds, and mammals have mirror symmetry only.

The main characteristic that differentiates the shape of a spherical cosmic body from that of a living creature must then be direction. Living beings are directed. They can move and change direction at will. Planets cannot. They follow trajectories defined by gravitational forces.

SENSE OF DIRECTION

It is nonsensical to ask in which direction our planet moves around the sun. Is it from right to left or from left to right? There is no right or left or top or bottom to the universe. Yet living beings have developed a sense of orientation, and can consciously move in a particular direction: toward resources and away from danger.

How is it that this indifferent universe, lacking any sense of its own direction, produced such a multitude of directional, spatially oriented shapes on the surface of one planet? Is there a directional movement or force that might be the cause?

First, light always moves away from its source. Gravitational force also seems to move in a single direction—toward the center of a mass. If living matter did not try to overcome the pull of gravity, there would be no shapes other than spheres or their variants, ovals and spirals. Biological organisms developed while trying to escape gravity and, crawling, pull themselves to light and energy.

The aforementioned virus is still trying to find its direction, but the jellyfish already knows the difference between front and back. It has figured out where to go. Plants generally divide their foundational sphere, the seed, into two opposing directions to reach the resources they use—down for the roots, and up for the crown. Most mammals direct themselves along the plane of the Earth. They have developed a sense of front, back, left and right, but still lack an intuition for top and bottom. Humans can intuit their spatial orientation in all directions.

FORM AS A MESSAGE

The main feature of our bodies is direction. We have a sense of direction—we feel it, and can intuitively move our bodies on a particular route. We determined our shape out of the directional force of gravitation and our desire to escape it—it is the result of our struggle with and resistance to gravity. Our bodies developed as a result of a constant, violent conflict between our desires and the resistance of the space into which we have grown.

We have reached out to sunlight, to food, to sexual partners for millions of years. These efforts have

shaped our bodies, little by little. This shape is the result of an indeterminately long conversation between our bodies and their environment. We send a constant message to our surroundings: our body can resist and conquer you. Our every movement is a communication to our environment in response to its communication to us.

The more complex the environment, the more complex the messages that are passed between it and the bodies within it. With increasing environmental complexity, bodies too become more complex. An ecosystem is built of a countless number of such messages.

The spherical shape of a virus can develop anywhere in the universe. The complex, spatially oriented shapes of animals can grow and evolve only in the presence of a directional force. In our case, this force is the pressure of gravity.

DIRECTION AS PATTERN

Our sense of orientation is essential to our survival. No movement is possible without it. The vestibular system of the body is tuned to the direction of the gravitational force—we balance our bodies relative to it. As we discover new environments which have no gravity, we see that the lack of this force negatively affects human bodies. Astronauts working in zero gravity experience the deregulation of their organ functions, a decrease in their immune response and other effects.

We are naturally trained to assign absolute meaning to that which we experience for a long enough duration—our brains look for such patterns. We have assigned such meaning to the direction of the gravitational force. We have to force ourselves to conceptualize it as relative to our local, limited portion of the planet's surface. Yet across from us, on the other side of the planet, this force points in the opposite direction, as absurd and funny as that sounds.

LOVE FOR THE STRAIGHT LINE

I want to return to the straight line—our human signature. What are the semiotics of the straight line and the arrow? What do they represent? To what class of objects do they belong?

An arrow is first of all a weapon. Looking at the shape of most weapons, it becomes obvious that they belong to a class of objects that can be called phallic extensions. The knife, the rifle, the bomb, the rocket—whenever we want to conquer a new area, we penetrate it with these tools.

Our culture has an eternal love affair with the erect phallus. It represents the direction of our will, the compass that directs us to the unknown. We want to conquer unknown spaces and penetrate their mysteries. The phallus is an outward, direct, visible, straightforward, simply organized and trustworthy. The vagina is a dark and dangerous mystery, a black abyss. We as a civilization cannot trust it, and are inclined to suppress it.

From the moment humans have endowed the penis with this symbolic power and associated it with the natural curiosity of the human will, we have directed it toward not only searching for food, mate, or territory, but also toward explaining the unknown. Our intention to move forward has become linked with the masculine; the mysteries we wish to investigate have become linked with the feminine.

There is an easy way to witness this. From an email inbox: "Big dignity can satisfy her," "Put your sword in her scabbard."

ADVANTAGES AND DISADVANTAGES

When we move to investigate the unknown, we want to do it quickly, so we try to move impatiently along straight lines. If this is possible at all, it is possible only over very short distances.

Moving along a flat plane of the Earth, we are moving along an arc on the surface of a sphere. Even man made spaces prohibit straight movement; in a city of straight lines, moving diagonally along a grid is impossible. In both constructed and natural environments, there are obstacles to overcome and move around—people, cars, trash cans, trees, stones, hills, rivers and so on. In space, planets, stars, other cosmic objects and gravitational forces stand in the way. Only in an imaginary, abstract, perfectly symmetrical space is it possible to move along a perfectly straight line.

Trying to recreate such motion in actuality is an exercise in absurdity. A classic example in Russian history

is this: in 1842, Tsar Nicholas I charted a route for the Moscow-Saint Petersburg railroad by taking a ruler to a map and drawing a straight line between the two cities. This created enormous engineering challenges during construction. Even after undertaking a great effort to tame the natural obstacles along the route, engineers were forced by the natural relief of the landscape to make detours in several areas along it.

Tsar Nicholas I demonstrates our innate desire to force nature (and time) into straight lines. This is an imposition on the natural order, where straight lines occur only along miniscule distances, such as in crystals that form planes with straight edges. A perfect straight line is a product of our collective imagination.

TIME AS WILL

Our will to conquer and dominate along with our ability to create abstract concepts gives us the potential to manipulate encoded information and apply it to our real surroundings, to actualize it in physical space. Yet with the desire to dominate comes the desire to accept only one point of view. Civilization is oriented toward competition, struggle and conquest. Only one vision can dominate.

By narrowing our conceptual horizons as we solve problems, we are moving in a straight line toward one visible goal. This is how we have come to create a technological civilization. Yet technology is too powerful and cruel a tool to exist alongside a fragile nature. Our impact on our environment has become too straightforward, inflexible and brutal. We appreciate the advances brought about by the combination of science and the instincts traditionally assigned to the male gender, but at the same time bemoan its disastrous impact on the Earth.

Our increased ability to suppress our surroundings clouds our understanding of the natural way things work. Forcing nature into squares, cubes and straight lines will eventually turn it against us. We ourselves are irregular; we are part of nature.

Yet our psychology is wired for directionality. Our sense of direction overwhelms our natural senses, and we cannot help but apply it to what surrounds us—including time. We create an imaginary line between the dark past and the bright future (or, just as strongly, between the "Golden Age" of the past and

the Apocalypse). This is, in fact, a relative assignment based on our limited orientation in the universe. It does not belong to the universe. We see a local process, and assign to it an absolute meaning.

The straight line reflects not an absolute law, but the ruling principle of our will to move forward.

TIME AS SHAPE

Our bodies actualize in space and grow into it as part of a conversation with the changes in their surroundings. They develop complex relationships with everything around them and inside of them. They orient themselves in a complex informational system with the perception of themselves at the center. Without this perception, they would not have developed their complex, spatially oriented shape. Our body puts itself at the center point of the informational system, and makes all its calculations referring to itself as the center of the system. Our central position gives us a frame of reference with six prime directions our body can recognize: front, back, left, right, bottom, top.

If time is an indicator of change and resistance to change in information, then our bodies and all the biological organisms around us are different forms of response to informational transformation. Therefore, we can say that time forms and molds the shape of actualized information.

Every shape in the universe is a unique record of its time. The form of a particular stone reflects its response to change, the form of a human body similarly reflects first its change along our human evolutionary path and second, its change during its own existence and experience.

Edited by Julia Druk and Buzz Poole.

Excerpts from Fleeing from Absence: four cross-disciplinary essays on time, its nature and its interpretations.

Keith Brown

Timeforms_03 is an eleven-minute and thirty-seconds computer-generated animation modeled and animated in Autodesk's 3ds Max. It was generated using what I consider to be the most versatile of generic primitives, the torus knot.

The animated sequence begins with two identical pairs of mirrored tori. Initially the work comes into being with a shared zero start point for all of its components. One pair of tori commences with zero X,Y,Z dimensions and the other, at full size, begins with 100% transparency. In the opening passage of thirty-second duration, the transparent pair assumes full opacity while the zero dimensional pair, being opaque from the first instance, increase to full size. They reach full size at the same instant the other pair achieves full opacity, and at which point all four tori nest together sharing the same dimensional extremities. In the following sequences, the dimensions of the tori pairs are given varying sizes, while one pair remains at full opacity the other pair varies in both size and opacity. Throughout the animation the pairs of tori revolve in different directions around the same axis; directions change at each revolution and further duplications are introduced as the sequence develops.

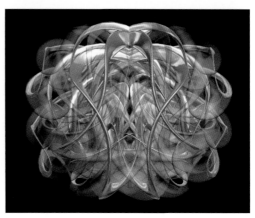

Throughout this process apparently solid three-dimensional virtual forms are seen to intersect, sharing the same space at the same time, and appear to be flowing through each other. Manifest three-dimensional objects cannot behave in this way in the physical world. For instance, fish may pass through water but displace it as they move. The water and the fish do not share the same place simultaneously. In Timeforms_03, virtual objects are seen to simultaneously share the same space at the same time suggesting an extra dimensional time/space.

Still images from *Timeforms_03*;
animation; DVD; 2002.

January 1, 1924

Whoever kissed time on its tormented head
With filial tenderness shall again
Remember how time lay down to sleep
Into the wheaten snowdrift outside.
Whoever lifted the century's sickly eyelids—
Two large and round sleepy apples—
He always hears a din—how rivers roared
Of times false, deaf and dead.

Two sleepy eyes, two apples has the headman
Century, and a lovely earthen mouth,
But dying he'll adore
The mildly recoiling hand of his senescent son.
I know: each day life's exhale becomes fainter.
A little longer—they will break
This simple song about earthenware sorrows
And seal the lips with lead.

O earthenware life! O dying of the century!
I fear you may be known
Only by someone with the errant smile
Of those who've lost themselves.
What an ache it is—to search for the word lost,
To lift up sickly eyelids,
With quicklime in the blood to pluck
Night-blooming grasses for an alien tribe.

Time: century. Lime sediment grows thick
In the sick son's blood. Like a wooden coffer
Moscow slumbers. There's nowhere to run
From the headman century. Snow smells of apples
As in the old days. I want to run from my threshold.
But where? It's dark outside
And, like salt sprinkled over cobblestones,
Conscience gleams white before me.

Along the byways, starling houses, roof eaves,
Not far to go, barely ready,
I, private passenger in a fish-fur coat,
Keep trying to button up the sleigh rug.
One street, another flickers past,
The sleigh's crunch in the frost sounds like an apple,
The buttonhole resists all efforts
And slips out of my grasp.

As what metallic ironmongery
The winter night clangs down Moscow streets,
Raps like a frozen fish or whistles pockets of steam
From pink teahouses—like silvery schools of roach.
Moscow. Moscow again. I say, hello,
Don't be so judgmental, it's not so bad now,
We go way back, and I accept the terms
Of bone-deep frost and pikefish justice.

The pharmacy flares raspberry on the snow.
Somewhere an Underwood clicks and clacks.
A cabman's back. Half-a-yard of snow.
What else do you want? No one shall touch you,
No one shall kill you. Gorgeous is winter,
The goat sky star-scattered and glistening
Like milk. The sleigh rug rubs its horsehair
Against the gelid runners, ringing.

Who was it blackened crooked lanes with kerosene,
Gulped down snow, raspberry, ice?
They'll ever rasp their scaly Soviet sonatina,
With nineteen-twenty on their tongues.
Could I commit to foul equivocation—
Again the frosty air smells of apples—
Oaths of allegiance to the fourth estate
And vows so great we wept?

Whom else shall you kill? Whom else, celebrate?
What other lies shall you invent?
There's the Underwood's gristle—quick, rip out a key!
And you'll find a pikefish bone.
That sediment of lime in the sick son's blood
Shall then dissolve. And out spurt rapt laughter.
Yet these typewriters' simple sonatina
Is just a shadow of sonatas other, greater.

1924, 1937

Translated by Eugene Ostashevsky

A TABLE OF
UNIVERSAL ASPECTS

TIME WITHIN WHICH WE OBSERVE AN
ITEM OF INFORMATION SENT FROM A
MITE OF MATTER WITH ANY CAUSE TO
EMIT SIGNIFICANT ENERGY EFFECTS

THE FLIGHT OF THE BULLET

The Chinese philologist Jun Lin Gou, who specialized in the post-modernist writings of Jorge Luis Borges, was busted with a large quantity of narcotics. As mandated by rigid Chinese law, he was sentenced to execution by firing squad.

The judges were indescribably shocked when Jun—a comparatively young and healthy thirty-year-old—received the news of his sentence with great joy. He thanked the judges for a long time, until he was escorted from the courtroom to "the afterlife."

But the convict understood that for him, life was just beginning. For the longest time, he had been hoping to experience for himself the plot of one of Borges's short stories, "The Secret Miracle," in which Jaromir Hladík, a Czech playwright, is similarly sentenced to death. In the story, Hladík successfully petitions God for a year's stay from execution, so that he can finish his play "The Enemies." And when Hladík is finally led into the prison courtyard to carry out the sentence, the soldiers with their rifles trained on him freeze, and the mind of the playwright is free for a full year to finish the genius work.

So Jun asked God for two hundred years, so that he could edit the Bible, adding a modern style and cleaning out the many errors that had built up over the centuries. Of course, Jun intended to edit under God's strict supervision, with multiple rounds of drafts and approvals.

Jun was absolutely sure that if God would stop time for a year for the writing of some insignificant play, then He would not be a tightwad when it came to such a magnificent effort. And Jun, therefore, would live two hundred and thirty years before the bullets reached him, achieving a longevity known only to select Biblical figures. He'd live without worrying about earning his daily bread, without being sick or suffering, but rather enjoying a creative euphoria and, perhaps, also smoking a little weed, because nowhere in the Scriptures is that frowned upon.

When he was led into the prison courtyard and faced with a line of young soldiers, he was sincerely sorry for them. They would die so soon—only in fifty or sixty years—and without even sampling the wisdom of the newly edited Bible.

The officer raised his right hand, and filled his lungs with air to yell out the terrible word, "Fire!"

But what happened next is impossible to determine, because Mao Zedong launched the Cultural Revolution in China, and the country blocked itself off from the world with an iron curtain which not just information, but even sunlight could not penetrate.

June 21st, 2010

A PARADOX OF BEING

There was a thief named Sergey on my floor, in the apartment across the hall... Two years back he died.

And today I discovered that a cop lives by Sergey's old place. Seems normal - in a uniform, on his way to being a sergeant, with ruddy cheeks

I wonder, how would they co-exist, if they crossed in time?

Feb. 23rd, 2009

Translated from Russian by Julia Druk and Alex Reid.

STATEMENT OF THE CASE

An amended information was filed charging appellant with assault to commit rape (count 1, Pen. Code § 220), forcible oral copulation (counts 2 and 3, Pen. Code § 288a(c)(2)), penetration by a foreign object (count 4, Pen. Code § 289(a)), assault on a peace officer (count 5, Pen. Code § 245(c)), and false imprisonment by violence (count 6, Pen. Code § 236). A Penal Code section 12022, subdivision (b)(1) enhancement was alleged as to count 6; sections 1170.12, subdivisions (a) through (d), 667, subdivision (a)(1), and 667.5, subdivision (b) prior convictions were alleged as to all counts. A section 667.71 prior sex offenses allegation was alleged as to counts 3 and 4,[1] and a section 667.61, subdivision (b) tying and binding allegation made as to counts 2, 3, and 4.[1] Appellant pled not guilty. (CT 1:59-60, 1:82-88, 1:13)

On June 21, 1999, appellant was found guilty of counts 1, 2, 3, 4 and 6 as charged. (CT 1:59-60, 1:82-88, 1:13) On August 6, 1999, appellant was sentenced to a total of 225 years to life, credit for 341 days precommitment confinement, including 44 days conduct credit. (CT 1:107-110) On October 27, 2006, in *Scott v. Lamarque*, Case No. CV 03-2003-GAQ(ATW), appellant's petition for writ of habeas corpus was granted, and his conviction reversed, pursuant to the magistrate's finding under *Gibson v. Ortiz* (9th Cir. 2004) 387 F.3d 812, that appellant's jury had been improperly instructed as to the prior sex offense evidence. (CT 1:112-130)

Appellant was retried. The court denied appellant's pretrial motion to exclude preliminary hearing testimony. (CT 1: 169-177; RT 2:308-309) Appellant's motion to exclude prior offense evidence was also denied. (RT 2:309-311) Appellant was found guilty as charged; in a bifurcated proceeding, the priors were found true as alleged. (CT 2:278B-287, 2:289-295; RT 3:2102-2106, 3:2133-2139) Appellant's motions for new trial were denied. (CT 2:398; RT 3:2403)

Appellant was sentenced to a total of 278 years, plus 4 life terms: count 1 – 25 years to life, plus 2 years for the prior prison term and 5 years for the serious prior, run consecutive; count 2 – 75 years to life, plus 7 years for prior prison term and prior conviction allegations, run consecutive; count 3 – 75 years to life, plus 7 years for prior prison term and prior conviction allegations, run consecutively; count 4 – 75 years to life, plus 7 years for the prior allegations, run consecutive; and count 6 – years, plus 7 years for the prior allegations, stayed pursuant to section 654. Appellant was credited with 3,340 days precommitment confinement. (CT 2:397-401; RT 3:2405-2410) This appeal from a final judgment of conviction is timely. (CT 2:402)

[1] The prior convictions stemmed from appellant's Case No. A642036. (CT 1:86)

AT THE BANQUET OF OF ALPHABETIC

AT THE BANQUET OF ALPHABETIC FORM

Kara Rooney

The symbolic value attached to the visual forms of letters dates back to antiquity. So strong was the power of text that the Greek, Jewish, and Islamic traditions all imply divine origins for the invention of writing. According to these ancient cultures, the physical forms of the alphabetic scripts contain fundamental elements of the cosmos as well as divine knowledge, as is demonstrated throughout mystic and Kabbalistic doctrines as well as in Gnostic and Humanist traditions. While the primary accomplishment of the alphabet has been defined by its use and representation of phonetic forms, (as opposed to representation in pictorial terms such as hieroglyphs) this codified and mystical heritage is threatened by modern-day visualization, by the forward march of time.

Grammar, syntax, and the semiotic breakdown of language all play a crucial role in the interpretation of these works. As such, I have chosen Gregg Shorthand as the writing system employed in the visual representation of the aforementioned themes. Its history extends almost as far back as writing itself, but its current format, used exclusively in the present-day court system, also incorporates language's incommunicable shortcomings. In restoring the visual image to its textural form, (specifically an illegible form) one's reading of consciousness instinctively returns to its "tabula rasa," the method of thought utilized prior to the invention of linear writing systems. In this illusory return to oral tradition, I hope to re-present the human fascination with codes, illuminating writing's aesthetic strength but more importantly, the system's propensity for non-linear interpretation and the subsequent reclamation of meaning as triumphant over its temporal limitations.

At the Banquet of Alphabetic Form, No. 3; mixed media; dimensions variable; 2008.

TIME LINES AND TIME SCALES

Ilya Bernstein

SEQUENTIAL TIME VS. SCALING TIME

There are two ways of thinking about time: in terms of sequences of moments, and in terms of time scales. In the first case, each moment is conceived of as having a "before" and an "after"; it is categorized as part of a linear sequence and distinguished from other moments by its position in that sequence. In the second case, there is no "before" and "after": moments are conceived of as occupying different time scales and distinguished from one another by being associated with durations of greater or lesser magnitude. Any phenomenon in time can be described from either of these angles, as a sequential process or as a scaling event. The flow of time itself may be seen alternatively as an unfolding succession of moments (second 1, second 2, second 3) or as a progression of overlapping moments on expanding time scales (second, minute, hour).

MONDAY, TUESDAY, WEDNESDAY

When we come to look at time, two roads diverge before us. We must choose either the sequential vision or the scaling one. Either Monday, Tuesday, Wednesday or hour, day, week.

What can we say about relationships between events that take place sequentially? What can we say about relationships between events that take place at different time scales and contain one another? We end up with two completely different sets of relationships in time.

AGAINST STATIC AND DYNAMIC TIME

When philosophers argue about time, they often describe it as either static or dynamic. Static time is conceived of as existing as a given from beginning to end; dynamic time is thought of as unfolding from an unknown to a known. While it is not entirely clear what either of these concepts means, what is clear is that both are based on a sequential vision of time. In both cases, time is conceived of as a series of like-sized units, a sequence of moments. In the static case, they are all already "unrolled" or "present," just not known to us. In the dynamic case, there is something about future moments that somehow remains undetermined.

For me, the key distinction to be made about time is not whether or not relations between moments in the past, present, and future are somehow "pre-given." Rather, it is the distinction between scaling and sequential paradigms of time. Since both the static and dynamic notions of time are rooted in a sequential paradigm, I would group them together and oppose both of them to concepts associated with the scaling paradigm.

In the scaling paradigm, there is indeed a dynamic unfolding in time. But what unfolds is not future moments. Rather, it is larger and larger time scales, of which incoming future moments constitute the expanding edge. The unknown is not what will happen at a given future moment. Rather, the unknown is how the future moment will join the past that already exists. It is a question of formulating the nature of what is unknown in the right way. When a future moment arrives, events that exist now will enter a new, greater time scale, and they will be changed by it—their meaning and value will change as a result. What is unknown is how an event that exists in the present will be transformed by becoming part of an event with an event that now exists only in the future.

PAST AND FUTURE

The usual distinction between past and future is grounded in a sequential vision of time. Translated into scaling terms, past and future would no longer refer to events that take place in a linear sequence. Rather, they would refer to events that take place at different time scales, one of which encompasses the other.

ACHILLES AND THE TORTOISE

Consider Zeno's paradox in terms of time scales. Do Achilles and the tortoise illustrate the difference between a sequential and a scaling view of time? As Achilles tries to catch up with every smaller and smaller segment that the tortoise covers, we focus on smaller and smaller time scales. Within this shrinking series of time scales, it is indeed true that he will never catch up. If we were to take any one of these time scales and consider the whole race in terms of it, as a sequence of events, then Achilles would overtake the tortoise immediately. But what Zeno is making us consider is not a sequence of events but actually

a sequence of time scales. Perhaps the paradox—the trick—comes from passing off what is a sequence of time scales as a sequence of events. Thus, if the conclusion of Zeno's paradox is that "Achilles will never catch up with the tortoise," everything hinges on a double entendre in the word "never." What is meant here by "never"? If "never" means "never in the sequence of events," then Zeno's conclusion is a patent lie; if "never" means "never in the sequence of time scales," then it is an obvious truth.

EVENT AND PROCESS

The distinction between an event and a process is a permeable one. A process, which is made up of many little events, can also be described as one big event. The difference between the little events and the big event is that they take place at different time scales. Conversely, an event can be broken down into many smaller events that make up a process. The difference, again, is one of time scales.

But whether we call something an "event" or a "process" determines how we think about it. Processes are thought of in terms of a before and an after. They have a past and a future. They unfold in a linear and sequential fashion. Events are thought of in terms of time scales. At different time scales, they take place all at once. Is it an event that occupies a long period, a short period, or a period of medium size?

POINT

Wherever it appears, the phrase "a particular point in time" is problematic. Problematic not because one person's point doesn't correspond to another person's point because of their different coordinates, but because of the unspecified scale of the point. Is it a twinkling of an eye, a human lifetime, an eternity? Each is equally a point, as long as it's considered as a single episode, not as a sequential process.

THE ARROW OF TIME

Physicists sometimes argue about time. Some of them say that it is reversible and that there is a symmetry between moving forward in time and moving backward, as far as physical laws are concerned. Future and past are so symmetrical, according to them, that if they changed places, all of the laws of physics would still hold.

Other physicists say that while this description may apply to some observed phenomena and to some of the laws of physics, there is in reality an "arrow of time" that renders time irreversible and makes the categories of future and past absolute rather than relative. According to them, movement forward in time and movement backward are completely different things, and physical law dictates that processes can unfold in one direction but not the other.

The notion that time is reversible and that future and past are symmetric is grounded in a sequential vision of time. It refers to movement in time that takes place in a linear fashion, passing from moment to moment, so that different moments are distinguished from one another only by their positions with respect to each other.

But consider the flow of time not as a sequence of moments, but as a transition between moments at different time scales. Thus, we no longer think of one second giving way to another, but of a second becoming a minute becoming an hour. Movement forward in time, in this case, constitutes a progression to longer and longer moments, and movement backward constitutes a progression to shorter and shorter ones. For all the symmetry that might exist between movement forward and movement backward in the sequential vision of time, it is clear that transposed into time-scale thinking, such movements correspond to processes that are in no way identical to one another.

Perhaps the arrow of time—and the various physical notions associated with it—is implicitly oriented around time-scale thinking. And perhaps the conceptual difficulties associated with it stem from the fact that people try to describe it by fitting it into the sequential paradigm of time.

In other words, perhaps the arrow of time should be seen as the result not of movement forward from one moment to the next, but of a transition to moments at increasingly larger time scales. It is clear that a second-long situation and a minute-long situation are two completely different kinds of beasts. The proposition that what happens during one second and what happens during another second may be reversed is believable. The proposition that what happens during a second and what happens during a minute are interchangeable is not.

Any sequence of events may be reconceptualized as a sequence of expanding time scales. Perhaps such a sequence of expanding time scales is what we are talking about when we talk about the arrow of time.

DUALISM

Many of the difficulties associated with thinking about time—and about processes that take place in time—stem from the fact that time can be thought of in the two ways I have described here. All of our ways of describing time and processes that take place in time are grounded in either one or the other of these approaches. The distinction between them is obvious and familiar, but it is also fundamental and constitutes a kind of dualism—more tenacious, perhaps, than other kinds of dualism—that must be grappled with whenever we think about time or things that occur in time.

The two visions of time are clearly related and each presupposes the other. To conceive of the flow of time as a sequence of moments, one must first define the time scale at which each of these moments takes place. Thus, the sequential paradigm immediately sends us back to the scaling one. Conversely, to conceive of the flow of time in terms of multiple time scales, one must first have some way of comparing time scales and determining their relative sizes. Thus, one must go back to looking at time scales as longer or shorter sequences of moments. The scaling vision of time is therefore indissociable from the sequential one.

Nonetheless, the different aspects of time that are emphasized by the two approaches are at variance with one another. Many conceptual problems derive from confusions between them, as when some notion associated with time is defined with reference to a scaling vision and then subjected to an interrogation along sequential lines, or vice versa. Moreover, because the distinction described here is such a broad one and applies to anything that exists in time, many of the ideas that we have about the world are implicitly oriented around one model of time or the other without our necessarily being aware of this fact and without the temporal template on which the idea is based ever coming into question. For this reason, making explicit the unstated assumptions about time contained in our descriptions of various phenomena can be illumi-

nating and can suggest more fruitful questions to ask about those phenomena.

WAITING

Here is another illustration of the distinction between conceiving of time in terms of a sequence of events and conceiving of time in terms of distinctions between time scales. When things are happening to us and we are doing things, we go from event to event in sequence and the events carry us along. All this stands in contrast to the act of waiting and doing nothing. Waiting feels as a kind of weight to us. But this, I would submit, is because in the act of waiting we do not pass from event to event, but rather from one time scale to another time scale. What is salient about the act of waiting is not that one minute of waiting feels different from the one that came before it or the one that comes after it, but that a minute of waiting feels different from an hour of waiting. When we wait, we feel all of the transitions between these two time scales precisely as transitions through different time scales of waiting, rather than a sequence of events. It would not be very illuminating to analyze the process of waiting in terms of event A followed by event B, although this is a natural way to analyze all kinds of other processes. In the act of waiting, it is not some event A that is replaced by some event B, but some time scale A that is replaced by some time scale B.

But waiting is just an example of the kind of situation in which it makes more sense to apply the scaling paradigm of time than the sequential one. Time scales become conspicuous when we have to wait. But they are just as conspicuous, for instance, in the act of learning. When we learn something, be it a physical skill, a language, or something as abstract as learning to think about things in terms of a distinction between the categories of scaling time and sequential time, it is again not particularly illuminating to think about the steps in our learning process as a sequence. What we are dealing with, rather, is a series of time scales at which we have been in contact with the materials. We do not ask of someone who learns a language: What did you learn on the first day, what did you learn on the thirty-first day, and how were these two different? Instead, we ask: How long have you been learning the language—a day, a month, or a year?

To generalize from learning to development in general, of which learning a skill or a body of knowledge seems to be an example, we can apply the same thinking to processes in biology. Gestation will be seen more illuminatingly not as a sequence of days but as a series of time scales. Just as in learning, it's not the difference between the first and the thirty-first days of embryological development that constitute the salient difference, but the difference between the first day of embryological development and the first month.

We stop here, for the time being, without generalizing further. But we will leave an open question: What is it about a process that determines whether it will be more fruitful to look at it in terms of a scaling conception of time or in terms of a sequential one? The distinctions between the specific examples given above are clear. What underlying patterns are these distinctions expressions of?

To be sure, to emphasize it once again, any process in time can be looked at in terms of either of the two paradigms. But the concepts that we actually use happen to be framed either in terms of one or the other. Moreover, the processes that we actually look at happen to lend themselves better to one or the other of these paradigms as well. Why?

THE DEPTH OF TIME

By focusing on different time scales, we discover a kind of depth in time, a kind of new dimension in time. We can have relations between events and processes in time; but we can also have relations between processes and events that take place at different time scales. It is through scaling that time suddenly stops looking linear and that new dimensions in time come into view.

TOWARD A HISTORY OF TIME-SCALE THINKING

What about a history of time-scale thinking? "People only gradually came to recognize the fact that processes take place at different time scales, and that interactions between processes taking place at different time scales were vital to the structures of various things that they were interested in explaining ... "

Andrea Liu

For four hundred years, Western Renaissance-engendered art made a pact with the devil. The devil said, "If you promise to engender this institution called fine art based on the convention of the 'oil painting,' I'll assure painting a place in the rarefied niche of fine art and luxury commodity objects." The devil explained further, "If you agree to take this arbitrary convention of using a canvas in a rectilinear shape, enclose it with a border called a 'frame,' and then use this rectilinear canvas as a stand-in for a window—that is to say, make images with oil paint on this canvas that make it seem as if we are looking through a window, with the goal of being as 'realistic' as possible, to make the things depicted as recognizable or close to 'reality' as possible, I will give your institution of the painting unquestioned ascendancy in defining what constitutes skill, virtuoso, talent, and masterpiece in the visual arts."

As John Berger notes in *Ways of Seeing*, it was so important for oil paintings to realistically depict things—cattle, riches, luxury items, women, landscape, food—as these paintings were circulated as status symbols, attesting to the richness and luxury of their owner's estates and their possessions. Possessing and a way of seeing were incorporated into the oil painting:

It is this avid and ambitious desire to take possession of the object for the benefit of the owner or even of the spectator which seems to constitute one of the outstandingly original features of the art of Western civilization.

For Renaissance artists, painting was perhaps an instrument of knowledge, but it was also an instrument of possession. And we must not forget, when we are dealing with Renaissance painting, that it was only possible because of the immense fortunes that were amassed in Florence and elsewhere, and that rich Italian merchants looked upon painters as agents, who allowed them to confirm their possession of all that was beautiful and desirable in the world. The pictures in a Florentine palace represented a kind of microcosm in which the proprietor, thanks to his artists, had recreated within easy reach, and in as real a form as possible, all those features of the world to which he was attached.

Oil painting did to appearances what capital did to social relations. It reduced everything to the equality

of objects. Everything became exchangeable because everything became a commodity.
Ways of Seeing, John Berger.[1]

The aesthetics of Western painting came out of an ethos of philistine materialism. Western aesthetics as realized through painting were a glorification, mystification, and rationalization of private property relations between bourgeois elites. Berger notes that rather than a window onto the world, the oil painting could more aptly be compared to a safety deposit box into which an individual's valuable possessions were deposited.[2]

This representational straitjacket on Western art saw its first tethers unraveling with Cezanne and Manet. Manet paintings drew attention to their means of representation, to the constructed rawness and texture of a brushstroke. No longer claiming to be a transparent window to the world with a smooth finish and deep illusionistic space of the Salon paintings, Impressionism was concerned with fleeting, subjective, and fragile perception, not an authoritative static reality. "The death of painting has been on order since Manet, and the task of every modern artist is trying to achieve it," said Yve Alain Bois.[3] Modernism (Fauvism, Expressionism, Cubism, Impressionism) drew attention to the productive tension between the content or subject matter of the depiction and the depictive elements of the painting itself; between the materiality of the medium and the subjectivity of the representation. Modernism lay bare the fact that "a picture of a pipe is not a pipe; it is a piece of paper with an image on it. In other words, a painting is not its image; it is most likely some wood with canvas stretched over it and a bit of gesso and paint applied to it."[4]

Photography furthermore freed painting from the yoke of representation—ergo, the onset of modernism in the visual arts, and the liberation of painting to be about its own materiality, the construction of its own opacity, as opposed to being about the illusionistic representation of things. For the first time in Western art, monochrome paintings become mainstream. The edge of the painting, once secured by gilded frames, was coming under pressure from the increasing shallowness of the space of the painting's surface.[5] Ryman's all white paintings and Reinhardt's all black monochromes showed that the painted sign is a coded structure that cannot be an unmediated "expression."

However, perhaps no other movement up until the 1960s posed a sustained refutation of the pictorial, illusionistic preoccupations of Western art quite to the degree of minimalism. The minimalist movement was inspired by a critique of, and exhaustion with, the Western infatuation with pictorial representation and its conventions. Minimalist artists like Carl Andre, Sol Le Witt, Donald Judd, Dan Flavin, and Robert Morris sought to change the picture frame from imitating an illusionistic space that you enter into, and instead literalized the actual physical plane on which the painting was made, such that pictorial space loses its "inside" and becomes all outside. They sought to interrogate the relationship between objects and the sites they were in, as well as the conditions of a spectator's viewing, as opposed to the modernist myth of the self-contained, autonomous art object that exists in a vacuum. Minimalist work dispensed with traditional sculpture's "base" and traditional painting's "frame." Instead we had Andre's "floor-hugging" bricks, Judd's cubes, and LeWitt's modular labyrinthine structures.

No longer pictures of things in frames with "figure-ground," minimalist art was a thing, a literal object, in and of itself. Minimalism constituted a paradigm shift from an ocular to a bodily realism, from a pictorial to a tactile way of engaging with art. By inducing a dynamic interaction between the spectator and the object, it changed the temporality of viewing an art object from an instantaneous time to a durational one, slowly pushing the art object more into the realm of being a "time-based art."

* * * * * * *

No discussion of temporality and minimalist art can avoid addressing the notion of "theatricality" as argued by Michael Fried. Fried's 1967 essay "Art and Objecthood" makes the distinction between *presentness*, which is an instantaneous, yet eternal and unchanging time attributed to the modernist art object (abstract painting), and *presence*, which is the unfolding of "real time" (minimalist objects). A distinction is made between the spatial arts (architecture, painting, sculpture) and the temporal arts (literature, theater, music).

The temporal arts have a set start time and end time. You cannot come to see a play whenever you want—you must be there at a certain time for the beginning, and it ends at a certain time. Visual art, according to Fried, should not be burdened by such a temporality.

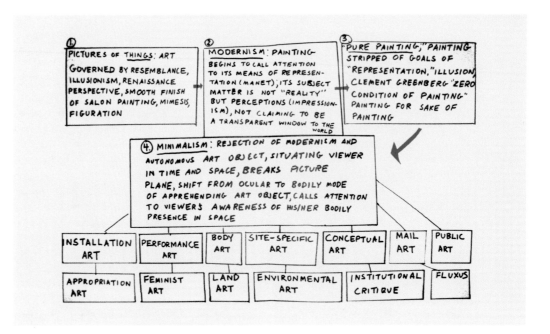

There is no prescribed start time or end time at which you start to look or stop looking at a painting. Fried's argument is predicated on his assertion that the temporality of looking at a painting is both instantaneous and endless. It is instantaneous because, unlike reading a book, listening to a piece of music, or watching a play, it does not take time to complete—it happens all at once. You look at a painting and in an instant you have seen the entire thing. Its temporality is also endless, because unlike watching a play in which there is a start time and end time, the viewing of painting (according to Fried) is in a separate endless time for which there is no beginning or end. Furthermore it is an idealist space of eternal time, closed off from real world concerns, bodies, people, and histories.

It is because of minimalism's alleged submission to the temporality of the time based arts—that is, having a start time and a finish time, as opposed to an instantaneous time—that Fried attributes to it the epithet of "theatricality." He accuses minimalist art of indulging in "theatricality" because minimalist objects, no longer isolated in an aristocratic gesture of separation that previous works of art were (paintings isolated by their frames, sculptures by their base), confronted the spectator without mediation. Curiously, Fried launched a full-scale diatribe against the invasion of this so-called "theatricality" on the purity of visual art that shaped the discussion around minimalism for more than four decades thereafter.

Fried demonizes the notion of "theatricality" outside the context of what it actually means to those in the field of theater, and caricaturizes elements of theater; he then tacks them on and mistranslates them out of context into the realm of visual art. With the venom of a xenophobe's hatred of "outsiders," he then demonizes those elements to be a contaminant of the "purity" of mediums, the seed of ruin for the modernist autonomous art object. His obsession with "purity" and the simultaneous repression and insipid hagiography embedded in his use of the term "purity," as well as his paranoiac fear and public call to arms against "contamination" of purity, cannot but conjure up the discourses against miscegenation and the intermarriage of whites and blacks.

Fried construes an over-simplistic binary: theater equals bad; modernist autonomous art object equals good. As notes Danielle Blackmore Lemmon, "Fried completely excludes from his definition of theater the Duchamp-ian or Dada notion of performance or performance genres in visual arts."[6] For Fried, theater is static, homogenous, and monolithic; it exists only to fail all Fried's existential expectations, to show its deficiency in comparison to the visual arts. "Fried defines theatricality in order to verify the purity and autonomy of the art object."[7]

Let us unpack Fried's accusation of minimalism being "theatrical." Fried fetishizes and abstracts this one

aspect of theater—its temporality, and the fact that it has a start time and end time—to stand in for the *entirety* of what theater is. Theater is a structure, a narrative, a mode of storytelling. Its temporality is a function of a complex web of interlocking and inter-penetrating factors (mimesis, plot, characterization, denouement, counterpoint, pathos). Faulting theater for its durational temporality is like faulting water for being a liquid. If water was not a liquid, it would not be water. Theater's temporality is a means, not an end—it is a means to achieve a series of reality effects in the form of mimesis, narratives, characterization. Fried evaluates theater on the terms of visual art (that is to say, his puritanical prescription of what visual art "should" be), and finds theater coming short. This is not the fault of theater for coming short, but the fault of Fried for trying to pigeonhole theater to be a medium that it is not (visual art). It exemplifies a breathtaking audacity that one can only surmise could come from a philistine ignorance, for Fried to make such a travesty out of the profound, centuries-old, formidable institution of theater.

As for Fried's corollary assertion, that minimalism engages theatricality because it acknowledges the spectator, is furthermore fallacious. Theater's "fourth wall" is an imaginary boundary between the audi-ence and the performer that allows for the illusion of the reality of the situation on stage to take hold. Without this fourth wall, theatrical mimesis would not work. This was the radicality of Brecht-ian distanciation, in that it drew to the attention to the artifice and the illusion of the play. That Brecht is considered such a radical in theater is indicative of how taboo and how ironclad the rule is in theater to not acknowledge that what is being created is arti-fice, and to not acknowledge that what is being cre-ated is being produced for an audience—i.e. engaging the spectator. Therefore, far from acknowledging the spectator, the nuts and bolts of theatrical mimesis would not be able to operate were it to acknowledge the existence of the spectator. Fried shows a gaping hole in his understanding of the fundamentals about what theater is and how it operates.

Furthermore, one must further probe Fried's slapdash assumption that painting exists in an instantaneous time; and if it is true, what the ramifications of this are. Certainly a painting can be seen in toto in an instant in a way that a book cannot be read in an instant, or a play seen in an instant, or a piece of

music heard in an instant. However, whether a paint-ing is apprehended, absorbed, and understood in an instant is an entirely different matter. Were it to be apprehended and absorbed in an instant, would that be an asset, or a shortcoming? If it were apprehend-ed in an instant, is this not because the "conventions of mimetic representation—the visual and spatial ordering systems that had defined pictorial produc-tion since the Renaissance"[8] were so ossified as to become automatic, by rote, "second nature"? Was it not this automatic by rote desensitization that the first wave of modernists, such as Joyce, Kafka, and Duchamp wished to disrupt, a la Roman Jakobsen and the Russian Formalist theory of "estrangement" and making the familiar strange?

Finally, I want to bring up the issue of micro-time vs. macro-time. It is curious that there is this contradic-tion, or paradox, that Fried claims a painting exists in both an instantaneous yet eternal time. An instant is over very quickly, yet eternity lasts to infinity. There is the issue of micro-time, which is the experiential moment of perceiving and apprehending a painting, which Fried claims is instantaneous. But there is also an unspoken macro-time of which nobody is refer-ring to aloud, but which is implicit in Fried's theory. A painting or work of art is historicized, immortalized, reified, and canonized, which Fried adulates as a de-sirable "eternal time." How, might I ask, is this eternal time created? Does it just come out of the air like a mist that mystically coalesces around a "masterpiece" like a Rembrandt? No: Fried's sacrosanct eternal time is created by relationships with institutions, museums, curators, art historians, and art critics. Socially con-structed, eternity or eternal time is manufactured by the discourse of the genius, the "grand narrative," the bourgeois inculcation of art history as a cavalcade of isolated geniuses, ideologies about how things should be represented, which modes of representation are desirable/prestigious/valid and which are not, and the complex institutional mechanism of canonization. Eternality or immortality is not a natural feature in-trinsic to formalist modern painting, or any painting.

To which time does minimalism belong—modernism's teleological utopian unidirectional time, or post-modernism's sheared fragmented, spliced, looped, disoriented time? As both Ranciere and Buchloh point out, any discussions of the modern/postmodern divide should be prefaced by distinguishing between two waves of modernism: the first of the 1910s and

'20s that is subversive, disrupts automatic perception and the assimilation of signifiers, and seeks to fuse art and life; and the second wave of modernism, retrospectively articulated in the '40s by Greenberg and Adorno, that advocates "purity" of mediums and becomes codified, rigid, empiricist, and positivist[9]. It is this second wave of modernism—the institutionalized modernism—that postmodernism is rebelling against. Given this paradigm, I believe that one of the gravest misunderstandings of minimalism is that it is part of modernism. If we define modernism as the modernism that was hijacked by Clement Greenberg and advocated by Fried, predicated on the discourse of the "purity of mediums," then we can say resoundingly that minimalism is not part of modernism.

Before making any positive statements, much less theorizations, about the temporality of minimalism, one must raze the popular misconceptions about minimalism, amongst even educated and well-informed people: (A) that it is part of modernism (B) that it is sculpture (C) that it is primarily a formal style.

NOTES:

1 John Berger, *Ways of Seeing*, (London: British Broadcasting Books and Penguin Books), 86.

2 Berger, 87.

3 "The Mourning After," *Artforum*, March 2003, p. 206.

4 Danielle Blackmore Lemmon, "Responses to Michael Fried's Theories of Theaticality in the Visual Arts: From Modern to Postmodern Criticism" Ph.D diss., 1997), 25.

5 Brian O'Doherty, *Inside the White Cube: The Ideology of the Gallery Space* (Berkeley University of California Press), p. 23.

6 Lemmon, 26.

7 Lemmon, 29.

8 Benjamin Buchloh. "Figures of Authority, Ciphers of Regression: Notes on the Return of Representation in European Painting," *October* 16, (1981): 25.

9 Jacques Ranciére, "You Can't Anticipate Explosions," *16 Beaver Journalisms,* " September 21, 2007. www.16beavergroup.org/journalisms/archives/002302.php

John Boone

4 Time Pieces, from series of 180 paintings; gouache on paper; 26" x 28.5"; 1995.

AD HOC VOX:

ON TIME

Panelists:

Sean Carroll

David Z. Albert

Stephanie Clare

Dan Falk

Ad Hoc Vox is a series of events without a fixed location that address a wide range of issues in the arts, organized by Colleen Asper and Jennifer Dudley.

Beginning with their first panel in 2007, Ad Hoc Vox has been hosted by museums, galleries, and non-profits in New York and Los Angeles. Ad Hoc Vox responds to the work currently installed in each space, or some aspect of the space itself, with events that range from panel discussions to performance series.

Ad Hoc Vox dialogues center around a topical or structural consideration of the work, privileging an expanded idea of what constitutes a conversation about art. This is grounded in the conviction that art is an inherently interdisciplinary practice that benefits and is benefited by dialogue with other fields; consequently Ad Hoc Vox places no restrictions on the range of subjects they address.

Ad Hoc Vox's twelfth event, *On Time*, brought together experts in the sciences and humanities to explore scientific and cultural understandings of time. The event took place at Galerie Zurcher in New York City on April 15, 2010. The following is a brief excerpt from that conversation.

Jennifer Dudley: You are all experts in your fields and many of you have transdisciplinary research interests. Why can no single understanding of time satisfy all disciplines?

Sean Carroll: It's complicated. I don't think it is necessarily the case that a single understanding of time can't satisfy all disciplines, but it would be so incredibly cumbersome that it would be not very useful. Even just within what I do for a living, theoretical physics, we think of time using a certain set of words and concepts when we're being absolutely clean about the fundamental laws of physics at a microscopic level and, as David said, when we get to messy things at a macroscopic level we start using different words and different concepts because its just more useful, more applicable to that situation.

So I'm a cheerful, unapologetic reductionist, and I imagine that we could start understanding time in terms of the fundamental laws of physics; we could understand how it works at a different level (with approximations) when we have many, many things going on and macroscopic systems and then we try to understand more or less, the mechanical things—about how records are formed, how photographs are taken, how influences propagate through time. And then we try to understand how human beings work with time—how our heart beats and how we form memories and how we think about things. Then we try to understand how those human beings put their notions of time to work in the service of narratives—a story unfolding forward in time where you have flashbacks and you have unreliable narrators and, within history—you know how certain people think about their history—which parts of the history are more useful and less useful.

I think that it is all one untorn tapestry. It is useful for us to think about that tapestry piece by piece because we are finite beings and we gain insight by looking at things one piece at a time, but I don't think there is any fundamental disconnect or incompatibility or even incommensurability between how a physicists, an author, or a historian would think of time.

J. Dudley: Do we have any variations on this?

David Z. Albert: I share Sean's reductionist sympathy and this isn't anything he's going to disagree with...

S. Carroll: He's predicting the future.

D. Albert: The difficulty any one discipline has with saying everything one wants to say about time isn't different from the difficulty any one discipline has with saying everything one wants to say about cars, for example. There is an approach to cars which has to do with their mechanical structures, with their physical properties, with mechanical explanations of how they manage to go at the speeds they do and maneuver in the ways that they do and so on and so forth. And there is no doubt a fairly distinct, very rich, very complicated cultural narrative to relate about cars and the role they play in our lives and the role they play in structures of power and in the role they play in how we think about ourselves and how we relate to other people and how we relate to space and so on and so forth.

I guess there is an interesting distinction to make here between the category of ontology and the category of explanation. Ontology is a matter of what "it" is out there in the world and there had better be, on some principled level, a seamless unified account of that because the world is, after all, one thing.

Explanation is a much more pragmatic matter. Explanation is a matter of having stories to tell ourselves that bring relief from certain states of perplexity. And what is going to bring relief from a particular state of perplexity depends very much on what kind of perplexity it is, the background in which it arose, and what the assumptions are that seem to be colliding with one another. It's perfectly appropriate to tailor explanations to those circumstances.

There are facts, at the end of the day, about what's out there. It seems much less clear to me that there are facts about what it is that explains *x*. What it is that explains *x* is a function of where you're coming from and what you started with and what it is that needs to be brought to your attention in order to make *x* appear less anomalous than it was when you asked the question.

Stephanie Clare:
I wonder if our conversation here could show something of the different approach from science to the humanities. Bruno Latour's *The Politics of Nature* and Eduardo Viveiros de Castro's "Cosmological deixis and Amerindian perspectivism" talk about multinaturalisms, which is a term that I've just recently encountered. It's an interesting idea, so let me try to explain it.

I think many of us share the idea that we have different perspectives from which we experience the world, but that there is one world behind there. We can't necessarily get to that world, we can't get to, let's say, the numinal, all we have is the world of experience. We have multiple cultures, so there's multiculturalisms-multicultures and one nature that holds it together, one materiality.

There are some ethnographers who are asking whether we can flip that understanding—and historians of science too. So, instead of understanding that there are multiple points of view, we share a spirituality and then multiple natures, so *multinaturalisms*. What could that possibly mean and how could we work through that?

One of the ways that some people have looked at this is to say that there are multiple natures—we have to understand the world as made up of entities that don't have properties unto themselves, that properties were developed in relationships. You can think of kinship: I am someone's daughter and someone else's sister. Now, it's not just that I know them differently depending on who's looking at me. It's that I actually *am* different depending on which relationships I'm interacting in.

That seems to be true, right? I relate differently to my friend than I do to my mother. So then, I don't have defined properties. My properties are an effect of the actual interactions that I'm engaging in and I get the other in the other relationship. Because there are all these inter-relations going on at the same time, we have multiple beings. Multiple ontologies, so multinaturalisms.

That's as far as I have gotten in understanding the idea so far, but it's interesting. In the humanities now, we're really skeptical of the idea of one, ever. Whereas in the sciences, we want to get one explanation, perhaps. So maybe this is the conversation we're seeing here.

Dan Falk:
I guess as everyone else has said something. I'll be very, very brief. I just want you to know that I tend to be a little skeptical on some of those ideas because of course, we are all welcome to use different terminology and different names to describe different things. I just can't prove this but I have a funny feeling the thing still *is* whatever it is. I don't know if anyone strongly disagrees with that but I suspect there is... Einstein asked something slightly along these lines, "Well, what's the point in doing astronomy if you don't think the moon is really there," and I realize that we all agree that the moon is really there. Although we can call it different things.

I'm not trying to say anything profound. I do suspect there is a reality out there but, of course, we struggle in trying to explain just exactly what its nature is and how it works and, of course, we are welcome to come up with many different explanations and then disagree with each other about which is the best one.

Ken Jacobs

Cinema, like dance, is considered a time-based art. I was once told that the ballet stage ripples with the whispering of numbers, the dancers keeping time and place, each number corresponding to a location onstage and the gesture composed for it.

Meaning all those swans are really clock-faces. The music is a clock. And, as my friend put it, the film projector—ticking away the passage of film twenty-four-frames per second—is undeniably a clock. Meanwhile, an excellent contemporary painter insisted that painting is outside of time. We argued that nothing is outside of time, that painting the painting and then the seeing of it are processes in time. Not clocked, but does that put it outside time? The clock, we know, is not arbitrary but connected to the day, week, month, the turning of the year, the turning of the planet in its passage around the sun. We operate on atomic clocks that keep time to circling satellites. All the noise associated with factory work is essentially a ticking. Mussolini made the trains run on time. I was scheduled to speak today for fifteen minutes at 4:20 pm exactly.

The same painter said that painting is flat. We won't go into that, but of course we all understand what she meant in her refutation of painting as a time-based art: it exists, not as canvas and paint but for what an effective painting actually is for us, unbounded experience, the experience it affords us in the familiar realm of subjective time. The mind—functioning within a three-meals-a-day body—can think circles around clock-time. Joyce's *Ulysses* is the tracking of time as we experience it. It's not only jazz musicians that resort to imbibing the smoke of the sacred marijuana plant in order to open the beat for exploration. Subjective time is an amazing achievement, the breakaway development that is synonymous with the human. Our cat Freddy, staring between meals into the infinite, for all we know is a stranger to time. She doesn't reminisce, doesn't seem to dread or anticipate. She doesn't complain but I suspect she's marooned in the present alone.

Cinema is a visual art unlike painting or sculpture in that its presence depends on machinery. And as it goes digital—tick tock, zero one, don't let the silence and no moving parts of the computer fool you—it is a machine, The Superclock. As a tool of moviemaking it conjures worlds, let's say light years beyond the camera tricks of King Kong. Yet clock-time has

always been as welcome to the cinema experience as it has been to the sex act. When we were kids especially, we had to come back from a movie. All fictions have the ability to lift us out of time. The myths that lift religions are no more transcendent than Betty Boop. Griffith's cuts to here, there, then, now, are the way we think all the time. What Griffith did was bend cinema to the ways of the mind. (Better to infiltrate his racist message, my dear.)

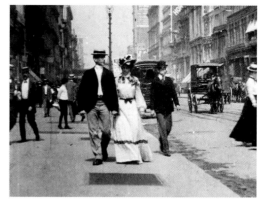

Digital is forever. What kind of time is that? Film would at the least respectably deteriorate. Dust, carrying their own stories of asteroid visitations, of once belonging to mighty boulders, would burrow into film emulsions. Scratches would bear a message of use, of having been around. The film-strand, in short, had a body that could accumulate a history. Movie actors told us the time in their procession from movie to movie, from being delectable to supporting roles, then nameless flunkies.

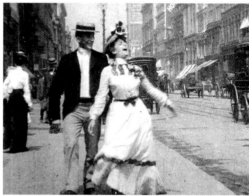

As a medium that tells time, the historical drama remains a pernicious habit of cinema. Detailed realism is another way of saying lie, while adroit deception remains the sine qua non of cinema. The film camera always records the present and shows us the past, so that when we see 1776 depicted in a 1935 movie what we can learn is just a bit of some very local thinking of 1935, dependably, but no more. Republicans can't get enough of *Gone With the Wind*. From the first escapist love stories and adventure films backgrounded by dreamy music, from the slow-motion opening of flower petals (a longer ribbon of film speeding through a camera to document an action, maybe 100fps, and then projected at the fixed speed of 24fps) to the obvious contractions and expansions and shuffling of time by the teenage geniuses of the early Soviet cinema thinking to make mechanical manipulation apparent, audiences conscious (young artists forging cinema as a modern art, the equivalent of showing paint on canvas and not convincing pictures of cows or sunsets or wars or breasts, until Stalin decreed that the films of paradise were to be just like Hollywood's), subjective time has been the province of cinema. The clock makes it possible but movie time has always been fantastic time. Nothing to rely on, a concoction. The surveillance camera will have to become even more ubiquitous to change all that.

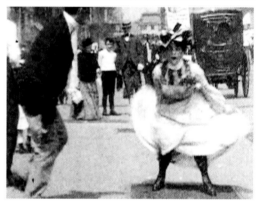

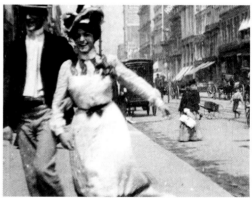

WHAT HAPPENED ON 23RD STREET IN 1901

It was a set-up. A couple walks towards the camera, a sidewalk air-vent pushes the woman's dress up. Layers of cloth billow and she is mortified. The moving-picture camera, already in place and grinding away, captures the event and her consternation becomes history, now transferred to digital and shown everywhere.

In this cine-reassessment, the action is simultaneously sped up and slowed down. How can that be? Overall progression is prolonged, so that a minute of recorded life-action takes ten minutes now to pass onscreen. Slow-motion, yes? No. Instead, the street-action meets with a need to see more, and there descends upon the event a sudden storm of investigative technique in the form of rapid churning of film frames, looping of the tiny time-intervals that make up events. Black intervals enter and Eternalisms come into play meaning that directional movements continue in their directions without moving, potentially forever (hence the eternal factor, something possible to cinema however inconceivable in real life). Further, the two-dimensional reality of the screen is contested. Are things now appearing in depth? Flat they are not. Can there be a 2½ D?

The young woman steps past the air-vent and laughs.

Stills from 13-minute black and white silent film *What Happened On 23rd Street*, 1901.

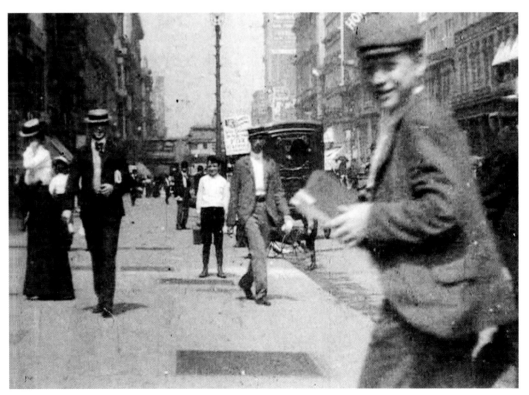

HE THE ART OF TIME ART OM E TIME HEART HEART

The Art of Time

Hallie Cohen

Urged on by mortality, the creative capacities of the human mind grapple with the concept of time. French philosopher Henri Bergson looked at time as a flow, its demarcations representing little more than inventions of the imagination while Einstein abandoned the familiar view of absolute time when he introduced the notion of time/space.
—Francis Levy, *co-Director, The Philoctetes Center*

Time present and time past
Are both perhaps present in time future,
And time future contained in time past.
If all time is eternally present
All time is unredeemable.
—T.S. Eliot, *"Burnt Norton," The Four Quartets*

How subjective is time? How objective is art? Artists live in and out of time. They spend many hours in the process of creating. Yet their work can be experienced in an instant or revisited over many instances. Artists bring their experiences, visions, interpretations, and skills to visualize a sky, the movement of water, the illustration of scientific and cosmological laws, and grammatical texts. Artworks about time include the techniques of framing, focusing, sequencing, and conceptualizing. The ingredients are mixed, blended, and apportioned in varying formulas and recipes. Like mad scientists or new age chefs, artists invent multiple ways of conceiving and denoting units of time.

Curating "The Matter of Time," along with Olga Ast and our associate Adam Ludwig, felt like a romp in a Borges story. Infinite possibilities had to be distilled into a finite series of themes and images. Fitting time into a limited exhibition space was one of the central challenges in mounting this show.

In creating any exhibition that is thematic, the dichotomy between figuration and abstraction becomes a criterion of selection. I wanted to include examples of both. The abstract work would attempt to hint at the ineffable, almost troubling idea of describing time. As Brian Greene, the Columbia University physicist, asks: "Did time have a beginning?" Was there such a thing as time before the Big Bang? If so, what would it look like? These ques-

tions resonate for us at the Philoctetes Center, a place for the exploration and study of the imagination, the interior life, and the relationship between the arts and the sciences.

All artists struggle with the reality and illusion of time. They seek to subsume the known to the becoming-known. Each movement of the pen or brush and the focus and click of the shutter propose a state of capture. The visual artist relies on the translation of experience through perception and memory in order to create a synthetic and seamless image. These images are perceived by a viewer, and then become a memory that exists in thought and recollection. The experience of time is as personal and subjective as the experience of art. The exhibition at the Philoctetes Center was a meditation on the artistic process and its relationship to temporality.

A vast ocean of images, ideas, and references from the history of humankind was the inspiration; contemporary artists known to us were the palette, and the Philoctetes Center the canvas upon which we developed our ideas. We looked for visual analogs to philosophical, historical, scientific, and spiritual precepts. Numerology, cosmology, mythology, calendars, maps, journeys, diaries, and memoirs all entered into the framework. Each choice of artist and artwork became a way in which to embody a notion of this illusive topic. We wished to include a variety of media and ways of working from "handmade" drawings and paintings (the first truly "digital" practice—as in five digits per hand) to computer driven algorithms and three-dimensional modeling.

Some of my earliest memories of time were fashioned from both life and art experiences. As a child the simplicity and mystery of the sundial in my father's garden fascinated me. I was intrigued by watching my own shadow change shape as the sun moved across the sky. Early in my art training Salvador Dali's melting clock and his technique of mining imagery from his dreams became a touchstone to which I often return. Eadweard J. Muybridge's sequencing of human and animal movement mesmerized me. His synthesis of art and science and the new modality of motion photography and his invention of the zoopraxiscope were prescient of the concerns dealt with in this exhibition. Later,

Andy Warhol's serializing of static/iconic photographs of celebrities and electric chairs compelled me to rethink the fundamental singularity of a work of art.

Finally, as an artist and curator, I am attentive not only to the final product, but to the process of making art. Process reveals itself over time, while artistry is timeless. As for the finished product, I find myself asking how do nature and time change works of art and our understanding and appreciation of them? I have come to recognize the enormous subjectivity of time and in particular how art can illuminate both the most prosaic and mysterious aspects of it.

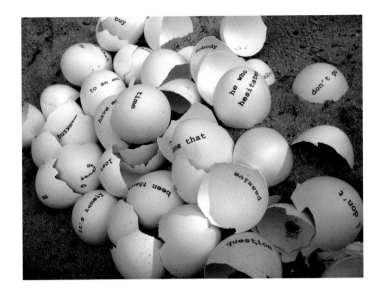

Ula Einstein

The Unwinding Destiny Project.
Ongoing installation/photography project; 2008.

Pervasive Messages; temporary installation, C-print; 8" x 10" (top).
Incubatory States; temporary installation, C-print; 8" x 10" (bottom).
Time; temporary installation, C-print; 8" x 10" (right).

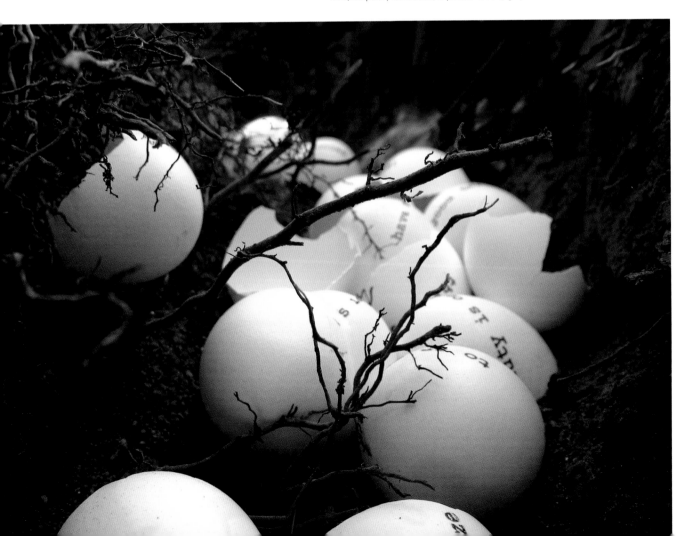

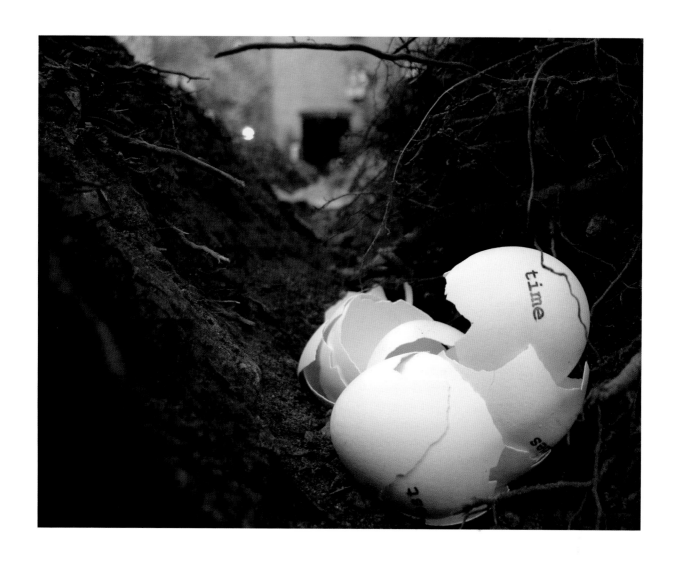

THE UNWINDING DESTINY

THE INNER SENSE OF AGE

Aleksandr Kronik
Evgeny Golovakha

The biblical first man, Adam, supposedly lived for 930 years[1]. Other biblical figures lived for centuries as well. Today, in Abkhazia, legends exist about 600-year-old brides and 900-year-old grooms[2]. How long can a person live, evading evil fate, war, or even sickness? Gerontology, the science of aging and the longevity of life, proposes that the natural limit of life ranges from 120 to 180 years of age. The biblical answer was the following: "One hundred and twenty years."[3] Moses' longevity was apparently the same,[4] but it was three thousand year ago. If true, would it really be possible today? Yes, according to the *Guinness World Records 2009*, the current champion of longevity is Jeanne Louise Calment of France who lived 122 years and 164 days.[5] On February 21, 1997 she celebrated her very last birthday.

Let us grant for a moment that such limits are indeed a reality for all people. Is it really true that everyone lives for the same period of time? If life's years were solely measured by the earth's rotations, it would not be necessary to write this. Rather, we will discuss psychological age, e.g. lost and discarded years, experienced as both lengthy and inconspicuously flashed through life.

Take, for example, the instructive parable in which a gravestone was inscribed: "Born in the year 1910... Died in the year 1970...Lived for three years." On the other hand, it is often said that one person's life can be equal to the lives of several people. Such a life is saturated with riches, substance, and value. Rudolf Balandin successfully addressed this idea while writing a biography:[6] "To measure the duration of human life in years is the same as estimating a book in pages, a picture in square meters, a sculpture in kilograms. Here the scales are different and the values are other: the achieved, the experienced, and the thought."

It is good when a person, at the conclusion of life's journey, says that their life has been filled with hundreds of years. What about a person who is thirty, forty, or even eighty years old who realizes that they are already psychologically two hundred years old? Is it possible that the more a person has done—the more intense life is, the more profound feelings and thoughts are—then the more hopeless and swift the aging process is?

Rather, the opposite is true. The lives of many artists attest to this: even in old age they are able to feel youthful.

Let us attempt to understand this contradictory situation. The simplest issue will be addressed first—the self-appraisal of age.

HOW OLD ARE YOU?

We propose that you participate in a mental experiment. Imagine that you suddenly learn that the age written on your passport, birth certificate, or driver's license is incorrect and you are uncertain whether the age shown is older or younger than your real age. Now try relying solely on an inner sense of your age, to answer the following simple question: How old are you actually? We can surmise with certitude that the "true age" (shown on documents) does not always coincide with a person's appraisal of their inner feeling of age.

We asked eighty-three highly educated people, age twenty-one to forty-four, to participate in the above experiment. Only every fourth person's subjective appraisal of age concurred (within one year) with their fixed date of birth. The greatest number of experiment participants (55%) felt that they were younger than their birth certificate indicated, while

every fifth person felt that they were older than they truly were.[7]

It is interesting that after placing themselves in the given situation (described above) of "uncertain age," most participants reported feeling younger. Hence, there is some truth to a comedian's method for regaining youth:[8] "To become younger, it is necessary to abide by the following instructions. Simply seize the entire population's watches and calendars and heap them all in a pile on an embankment. As a result, we will then find ourselves without age. Who would know what age we are? She is twenty, he is forty? Who could count?"

The comedian hardly claimed that his method was practical. Even without destroying all the world's watches, calendars, and documents—many feel that they are younger than in reality. Half the participants in our study under thirty years of age felt that they were, on average, four years younger while 73% of the participants over thirty years of age also felt that they were younger. Moreover, these participants felt younger on average by eight years.

A person may feel younger for a variety of reasons. The simplest reason is to be flirtatious—the goal being to preserve "eternal youth." Economists have observed that clothing styles designed specifically for young people are enjoyed and in demand by an older age group. For example, the Ford Motor Company developed a sporty Mustang for a younger generation. The company was astonished to discover that people of all ages purchased their car[9]. Is it possible that a person who indulges in products and styles associated with youth, preserves their youthful feeling? Material items are only symbols of one age or another. A person's behavior, words, lifestyle, and position in society are the indicators that other people use when judging maturity. For each age, there are social norms and appropriate behavior.

American sociologists clearly state that most of the population thinks that the best age range for men to marry is from twenty to twenty-five years old, while between nineteen and twenty-four years old is the best range for women. A majority thinks that the best age range to begin a professional career is between twenty-four and twenty-six years old, while hitting the peak of your career should be reached when you are between forty-five and fifty years

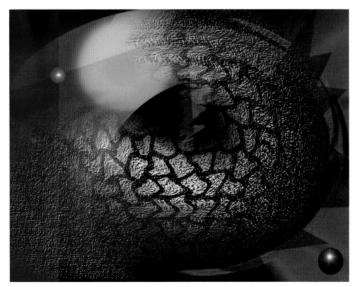

Kat Kronick; *At First*; digital image; 2000.
The winning piece of art for the cover competition for the book, *Psychological Time of Personality* (by E.Golovakha and A.Kronik, Moscow: Smysl, 2008).

old, and retirement should occur between the ages sixty and sixty-five years old.[10] It was in 1960s and, of course, these relative norms vary from culture to culture, from generation to generation. It seems that deviations from such norms, as a rule, lead to stressful situations. For example, if a person were to marry at a very young or old age, that person would not be following the normal "timetable of life" and most likely would experience intense difficulties. Early marriages may experience financial trouble, while late marriages could experience psychological difficulties.

Oriented by universally accepted age norms for different life events, a person senses whether they are young or old. Ukrainian sociologist Natalie Panina hypothesized that people who have not attained the typical social position for their age group will feel younger.[11] We verified this supposition by comparing the self-appraisal of age of two groups: married and unmarried people, ranging from twenty-three to twenty-five years old. Our research was conducted in the former Soviet Union, 1982 (Kiev, Ukraine). At that time, the most common years of marriage for Soviet men and women was the period between ages twenty-three and twenty-five[12]. It followed that marriage was expected by society for a person of this age. How does this person feel about himself? When a person had not settled down and married, they almost always felt younger (79% of the time). On the other hand, a person who had married felt older (63% of the time).

So far we have discussed the connection between a person's feeling of age and their achievements and social position. This combination is a person's "social age." For psychologists, the "internal system of appraisal" is more significant. It has become evident that the same achievements or events are evaluated differently by different people. Two people of the same age, who were both married at an "appropriate age," may weigh events differently. One of them may be interested in sacrificing for family and achievement, while the other may desire to maintain a bachelor's lifestyle and gives marriage only secondary importance. In the first case, marriage brings immediate "aging." In the second case, it is unlikely that marriage will bring simultaneous "aging." Over the course of our research, we came across twenty-three to twenty-five-year-old men and women who felt younger than twenty years old.

It is true that the feeling of youth does not depend on a person's ability to remain socially immature and infantile. Socially infantile personality types are not a rarity. Character traits of this personality type include egocentrism as well as being overly outspoken and opinionated. These people often end up bothering themselves and others alike. Then why does each of us, at various ages, wish to be younger? Immaturity is not the only characteristic associated with youth. Youth, which is admired and sought out, does not consider how many years a person has lived, but considers how one views the future (perceiving the future to be more valuable than that which has already been experienced and achieved). A person's psychological age is similar to a two sided scale. On one side is the past and on the other is the future. When the past outweighs the future (proving to be more significant)—a person feels older. When the future outweighs the past—a person feels younger.

Thus, it is possible to feel younger and younger as time advances. This occurs when the future does not contract, but opens to new prospective developments as the years go on. At this point, a person does not stop with what they have achieved to date, but they continue to aspire to more significant accomplishments. If the most important events have already occurred and are realized, a person feels older and their psychological age no longer corresponds to their driver's license.

HOW CAN PSYCHOLOGICAL AGE BE MEASURED?

The easiest method to figure out the degree of life's realization is by answering the following question: "If all the substance of your life (events of the past, present, and future in full) is considered to be 100%, then what percent would you allot to the substance experienced to date?" We have heard many answers to this question. The answers ranged from 10% – 90% (the average was 41%).

With the knowledge of how a person evaluates what they have done and experienced, it is possible to determine their psychological age (PA). To do so, it is necessary to multiply the personal "index of realization" (R) by the number of years that a person expects to live (L): PA = R x L. Let us make the computation using a person whose life is only half realized and expects life to be 120 years. This person's psychological age would be sixty years old (0.5 x 120).

CHECK
YOUR PSYCHOLOGICAL AGE

This figure is not influenced by the person's actual age, whether forty or eighty years old. It follows that, the longer a person expects to live and the less he or she expects to accomplish, the higher the psychological age. If you wish to check your PA, you can do so by completing the on-line test at PsychologicalAge.com

You may not be pleased with the results of the test. Did you hope to be psychologically younger or older? Do not despair—psychological age can fluctuate. To accomplish this, it is necessary to alter your attitude on life.

BECOMING YOUNGER OR GROWING OLDER?

A person is often dissatisfied with their age. As a child or teenager, a person wants to look and act older. At a mature age, they look back on their youth with nostalgia. While growing older, people search for various remedies that enable them to become younger. If psychological age is understood as a measure of realized life, a person has the opportunity (at any chronological age) to escape from the limits of their predetermined destiny. Nevertheless, the possibilities are clearly limited. At a young age, the interval of the chronological past is too small to be filled with many life experiences. At an old age, all of the reserves of the future have been exhausted so that "perspective lines" become shorter.

On the other hand, due to the ability to visit the past or the future in ones imagination, a person can sometimes successfully outwit chronological age. For example, to reduce the weight of the past (the specific weight of one's life), the past is made into the present or even the future. A person reverting back to the past lives there to compensate psychologically for biological and social old age. Absorbed by memories of youth, a person makes actual connections out of events that have been experienced earlier. As a result, their sense of age grows younger. In his time, Epicurus substantiated the benefits of studying philosophy in a similar fashion[13]: "As he grows old, he can look back with satisfaction over his past and let the good things he has gained keep him young." A similar rejuvenation is evident when a person is fatally ill. The person attempts to find shelter in the past and constantly reverts back to impressions of their youth before dying.[14]

The displacement of the "self" in the future may lead to various effects. When "living in the future," the past becomes larger and a person feels older than when "living in the present." Inadequate maturity in a teenager can be hidden in the fact that their personality is located in a future that is overcrowded with plans, projects, and the experience of accomplishment. Therefore, they often perceive a long journey to these plans that have not yet been realized.

There is still yet another method to determine psychological rejuvenation and aging. This is the re-evaluation of the importance of the past and future.

It is certainly true that people can view a particular moment differently from the way in which that moment has been viewed in the past. The most recent appraisal reveals either a new and differing doom that previously went undetected, or a clouding by suddenly realized mistakes and estimated losses. During moments like this, a person grows psychologically older as the past gains significantly more weight in their eyes. If a person does not display a fresh attitude toward life, premature psychological aging can occur. At times, signs of aging are viewed as the desire to attain an inflated self-importance, an illusion of knowledge, an earlier conservatism, or a skeptical view of the future. In an extreme case, a kind of "personality numbing" follows—a psychological death when a person needs nothing but rest. As the years progress, it becomes more difficult to resist the past. Often a temptation arises to revert to the past and recapture the pleasures of younger years.

In order for this not to happen, we need to work on our future—to be patient, to hope, to dream, and to plan.

Once a person has become exhausted in one area of activity, it is important to attempt to find a new area. The search must consider the principles of those scientists who, after several years, have switched from solving previous problems to the statement and solution of new problems. Goals and plans make a person younger, not just psychologically. The former Yugoslavian agricultural scientist, R. Savich, computed that the average horticulturist's life is longer than the lives of people in other occupations[15]. He explains this phenomenon by observing that such a person must wait for a long time (possibly decades) to attain his or her goal of developing a new type

of plant. It is possible that lofty goals not only contribute to people's youth, but increase the duration of their life as well. Maybe you do not have enough long-term goals?

As the crown of a tree cannot live without roots, a personality does not exist without collective experience. Completely rejuvenated, the oblivion of the past leads to "childhood at a mature age." At birth, there is the childhood illusion of a limitless future. However, with time, hopes are replaced by a feeling of lack of fulfillment and a distrust of personal strength. A mid-life crisis follows in those who have yet to find themselves.

To escape a mid-life crisis, do not feel that you are wasting your time by reflecting on your accomplishments. Although your life may contain many mistakes, it is necessary to respect the past. The past should be valued because "maturity reached slowly and against many obstacles, illnesses cured, griefs and despairs overcome, and unconscious risk taken; maturity formed through so many desires, hopes, regrets, forgotten things, loves. A man's age represents a fine cargo of experiences and memories."[16]

What is better—to feel younger or older than our true age indicates? It is probably most desirable when chronological age and psychological age are not far apart. If it is natural for a teenager to wish to be older and for older people to wish to be younger, then it is most important for middle-aged people to have harmony, perspective, and experience.

NOTES:

1 *Tanakh: A New Translation of the Holy Scriptures According to the Traditional Hebrew Text*, Genesis 5:5 (Philadelphia, New York, Jerusalem: Jewish Publication Society, 1985).

2 S.D. Inal-Ipa, "Motivi Dolgozhitelstva v Abkhazskom Folklore" [Motives of Longevity in Abkhazian Folklore], in *Fenomen Dolgozhitelstva: Antropologo-Etnograficheskii Aspect Issledovaniia* (Moscow:Nauka, 1982), 41-46.

3 *Tanakh*, Genesis 6:3.

4 *Tanakh*, Deuteronomy 34:7.

5 *Guinness World Records 2009* (New York: Bantam Books), 207.

6 R.K. Balandin, *Vladimir Vernadsky*, trans. A Repyev (Moscow: MIR Publishers, 1982), 42.

7 E.I. Golovakha and A.A. Kronik, *Psikhologicheskoe Vremia Lichnosti*, "Psychological Time of Personality," 2nd ed. (Moscow: Smysl, 2008), 163-164.

8 M.M. Zhvanetskii, *Vstrechi na Ulitzach*, "Meetings on the Streets" (Moscow: Iskusstvo, 1980), 15.

9 Philip Kotler, *Marketing Management: Analysis, Planning, Implementation, and Control*, 9th ed. (Upper Saddle River, NJ: Prentice Hall, 1997), 258.

10 Bernice L. Neugarten, Joan W. Moore, and John C. Lowe, "Age Norms, Age Constraints, and Adult Socialization," in *The Meanings of Age: Selected Papers of Bernice L. Neugarten* (Chicago: University of Chicago Press, 1996), 26.

11 N.V. Panina, personal communication, 1982.

12 A.G. Kharchev, *Brak i Semya v SSSR*, "Marriage and Family in USSR" (Moscow: Mysl, 1980), 204.

13 Epicurus, *Letter on Happiness*, trans. Robin Waterfield (San Francisco: Chronicle Books, 1994), 21.

14 I. Hardi, *Vrach, Sestra, Bolnoi: Psikhologiia Raboti s Bolnimi*, "Physician, Nurse, and Patient: Psychology of Patient Care" (Budapest, Hungary: Akademiai Kiado, 1981), 80.

15 Savich's observation as cited in V. Zhuravskyii, "Zolotoi Pochatok" [Golden Corn], *Pravda*, November 21, 1980, 4.

16 Antoine de Saint-Exupery, "Letter to a Hostage," trans. Norah Purcell, in *Wartime Writings 1939-1944* (San Diego, CA: Harcourt Brace and Company, 1986), 114.

Michaela Nettell

Under Skies; single-channel video; 2008.

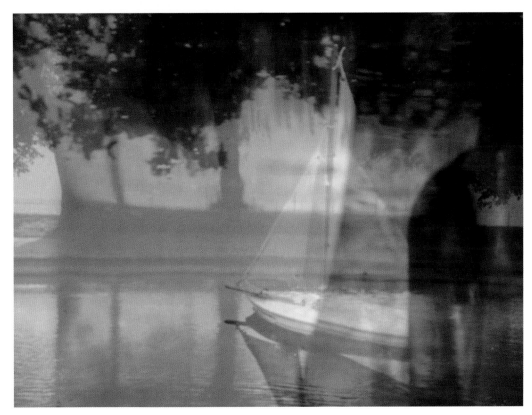

Lisa Tannenbaum

LEISURE, THE PARASYMPATHETIC NERVOUS SYSTEM, AND RESETTING THE BODY

We live in a time devoid of leisure, yet we don't know it, and this is significant for our health and the health of our culture. Leisure, according to twentieth century philosopher Josef Pieper and ancient Roman stoic writer Seneca, is silence, awareness, and the absence of activity. Today, however, all of our time is spent in motion, rarely at rest, and we have lost the ability to experience true leisure. The physical body, moreover, is affected by this cultural shift, as are our mental and emotional states. We treat our bodies as machines, yet we never shut them off. How do you tune a moving machine? Siegfried Giedion, modernist art historian, and Moshe Feldenkrais, a scientist and mind-body pioneer, provide tools for resetting the body daily, which include the timeless activities of bathing, breathing, and sex.

Leisure gives us the opportunity to shift the balance of our bodies back into alignment with its own natural rhythms and those of the cosmos. Just as we reset a mechanism from rest to active mode, there are ways to reset our organism. The many moving parts of the body need adjustment to bring ourselves back into harmony with the universe and equilibrium. A way to do this is to balance our body's parasympathetic with the sympathetic nervous system to engage in relaxation and recuperation. Today, our society engages in activities in the name of leisure that damage our bodies instead of spending time on maintaining our balance for health and wellness. Leisure and balance are intimately associated, which examples from ancient and modern sources will illustrate.

WHAT IS LEISURE? ON LEISURE VERSUS WORK

Currently, our society prioritizes activities and habits that masquerade as leisure when in the true sense of the word they are not actual leisure, in fact they are they opposite of leisure: work. The true meaning of leisure is a topic explored by philosophers of both ancient and modern times. Josef Pieper, a philosopher writing in Germany after World War II, defined leisure as a mental and spiritual attitude, an attitude of the mind, a condition of the soul. In his 1952 essay "Leisure: the Basis of Culture," Pieper explained the switch in meaning of leisure and work from ancient to modern time, and warned of the resulting decline in culture associated with this shift. Pieper identified the

philosophical definition of twentieth-century Western society of *work* as good, the positive quality, and conversely leisure being the negative quality, the opposite, what is left when work is subtracted from the equation of time. According to Pieper, this opposition contrasts with the ancient definitions of leisure, *otium* in Latin and *scola* in Greek, which were negated to form the words for work, *neg-otium* and *a-scola*. The relationship between work and not work was reversed: leisure was the positive quality, and work the negation of leisure. Leisure was a thing in itself,

... not the inevitable result of spare time, a holiday, a week-end or a vacation... Compared with the exclusive ideal of work as activity, leisure implies an attitude of non-activity, of inward calm, of silence; it means not being "busy," but letting things happen.

So leisure is a state of mind, a time when the mind is not occupied in thought, not just that the body is at rest.

LEISURE AND PERCEPTION OF TIME

According to Seneca, Augustus Caesar was so busy with expanding the Roman Empire and making peace that all he could do was dream of his (nonexistent) leisure time:

Everything he said always reverted to this theme—his hope for leisure... So valuable did leisure seem to him that because he could not enjoy it in actuality, he did so mentally in advance. So he longed for leisure, and as his hopes and thoughts dwelt on that he found relief for his labors: this was the prayer of the man who could grant the prayers of mankind.

Augustus spoke frequently of his longing for leisure and took pleasure in the thought alone, without actually having time to enjoy it. For Seneca, the first century AD stoic philosopher, writing in an essay translated as "On the Shortness of Life," leisure was not just a pleasurable preoccupation of the mind and, if not used with awareness, could be misused to cut one's life short. The categories of "spending" away leisure he classified as self-indulgence, preoccupation, and idleness, which are work in and of themselves. If one's mind is occupied in any of these ways, then leisure is precluded, and one is incapable of leisure, for: "the man who is really at leisure is also aware of it." What happens when we are not aware of how we

spend our leisure is illustrated by the case of Catullus, who died prematurely at age thirty.

LEISURE AND TIME

For Catullus, the Roman lyric poet of the first century BC, leisure was torture. His patrician life of leisure was consumed by preoccupation with his unrequited love for the married temptress, Lesbia. Catullus did have the self-awareness to know that how we spend our leisure time can become an all-consuming passion, and lead to the downfall of great leaders and civilizations.

Catullus wrote poem 51b to address himself:

Otium, Catulle, tibi molestum est.
Leisure, Catullus, is what bothers you.

The next phrase can be interpreted two ways:

Otio exultas nimiumque gestis.
You riot in your idleness and wanton too much.
or
Leisure is what delights you and moves you to passion.

Otium et reges prius et beatas
Perdidit urbes.
Leisure has before ruined both kings and thriving cities.

Otium can either ignite or consume one's passion depending on whether one "works his leisure" as Aristotle put it or lets idleness ensue. Leisure and idleness are mutually exclusive in fact. Joseph Pieper wrote:

Idleness, in the old sense of the word, so far from being synonymous with leisure, is more nearly the inner prerequisite which renders leisure impossible: it might be described as the utter absence of leisure, or the very opposite of leisure. Leisure is only possible when man is at one with himself, when he acquiesces in his own being...

When one acquiesces in one's own being, is comfortable with oneself, this is the prerequisite of leisure: being able to do nothing or to train the mind on a singular focus of stillness, such as meditation. Pieper reiterated Seneca's sentiments that an occupied mind precludes leisure. Even idle activity is consuming,

and makes leisure impossible. It is a major point that is not well appreciated in our society: the occupied mind is not at rest; the active body is not relaxed. This is why leisure was Catullus's torture and even today stillness, quiet, and "doing" nothing, or non-activity, is one of the great challenges in our society. We are always occupied with an array of menial activity, such as watching television, playing video games, emailing, instant messaging, twittering, facebooking, activities which in regards to the above make life short. However, we become habituated to such activities, and no longer know how to relax, experience leisure, or listen to our bodies. Our apprehension of reality suffers; we are not able to taste fully the experience of life, and thus culture suffers and even declines.

THE MECHANIZATION OF LEISURE

Siegfried Giedion, an art historian of the mid twentieth century whose work *Space, Time and Architecture* became the canon of modernist architectural history, addressed the topic in terms of bathing as a measure of culture. He wrote in his final chapter of *Mechanization Takes Command: a contribution to anonymous history* of 1948 that the way a society bathes offers insights into its values as a civilization, and the value that is placed on the individual in the community: "The role that bathing plays within a culture reveals the culture's attitude toward human relaxation. It is a measure of how far individual well-being is regarded as an indispensable part of community life." For Giedion, the decline of public bathing practices was linked to the rise of mechanization, and he predicted the emerging mechanized view of the body accordingly. Giedion lamented the lost values of ancient civilizations that created the baths as a public institution as necessary to "restore the body's equilibrium once within its twenty-four-hour cycle."

THE AUTONOMIC NERVOUS SYSTEM—OUR BODY'S ON/OFF SWITCH

What does it mean to restore equilibrium? This brings us back to the autonomic nervous system. The nervous system has two branches, the central nervous system, which governs conscious action, and the autonomic nervous system, which controls automatic and unconscious action. The autonomic nervous system has two subsets, the sympathetic and parasympathetic nervous systems, related to the Pingala and the Ida of the yogic tradition. Sympathetic governs

acts of will, self-assertion, and the fight-or-flight response, such as causing the heart to beat faster. Parasympathetic is for rest, digestion, recuperation, and orgasm, and causes the heart to beat slower. Of the sympathetic and parasympathetic nervous systems, only one can be dominant at a time, and the dominance of one inhibits the engaging of the other. The parasympathetic is the system that allows us to sleep, rest, and restore the body, and without fully engaging this system by inhibiting the sympathetic, the system of willful action, then we are never at leisure, never truly at rest. If we think of our systems as a pendulum, it would be swinging only in one direction, never to achieve balance. The parasympathetic, like leisure, can only be engaged if the sympathetic, and work, are suppressed. Leisure is necessary to activate the parasympathetic and swing the pendulum fully in the opposite direction; the parasympathetic is also necessary for leisure, and both of these are linked to the body's own ability to heal itself.

In a healthy individual, shifting the balance between parasympathetic and sympathetic is a continuum of excitation and inhibition. In our world, we are "on" all the time, constantly engaging our sympathetic systems, treating our bodies as a machine without an off switch or a maintenance contract. If we never switch gears, and reset the balance, we will constantly grind our bodies into a stress- and anxiety-ridden state where fight-or-flight mode produces free-radicals causing cortisol stress hormones, leading to premature aging. We never allow our bodies to recuperate until we are forced to stop by injury, illness, and disease, which are all the inevitable result of ignoring the balance. So how to reset the balance in an unbalanced world, where imbalances are cultivated, encouraged and even rewarded?

SYNCHRONIZATION OF NOSTRIL BREATH

There are ancient mind-body techniques of resetting the balance of the parasympathetic and sympathetic and coordinating body functions with celestial cycles. Synchronization of the nostril breath with brain activity and the phases of the moon is a practice recommended by Swara yoga, the yoga of breath, as taught by InnerTuning Systems and detailed in Harish Johari's *Breath, Mind, Consciousness*. In fact, on the day this paper was presented at the ArcheTime Conference in New York City on June 7, 2009, there was a full moon at 2:12pm. This came as a surprise

to the audience, for most people pay little attention to such celestial movements. The full moon is chance to synchronize the body's energy with the celestial bodies, another way to *soak in time*.

THE POTENT SELF

For Moshe Feldenkrais, pioneering mind-body therapist who practiced in the 1960s and '70s, sex was the answer. In Feldenkrais's view, the dual purposes of sex are for reproduction and balancing the organism, and the latter was the most important, affecting the entire workings of the body's structure and emotional make-up.

Feldenkrais explained in his book *The Potent Self: A Study of Spontaneity and Compulsion* that imbalance in the parasympathetic/sympathetic relationship is visible in the position of the pelvis within the skeletal frame. The Feldenkrais method of exercises is based on small movements to adjust the body's alignment, for which he created an entire system of minute movement exercises. According to *The Potent Self*, control of the parasympathetic is not only possible, but also necessary to inhibit the sympathetic impulses of self-assertion, competitiveness, and protection that create the physical impossibility of achieving orgasm and full release necessary to balancing the nervous systems. Any attempt to direct physical contractions or mental intention to moderate the orgasmic process cancels out the possibility of reaching full orgasm because this causes conscious activation of the sympathetic nervous system, disabling the parasympathetic functioning that governs orgasm, rest, and recuperation necessary to fulfill this state of balance. In essence, the body's reset function must be activated to maintain the mechanism, and nature provides many different means to do so on a regular basis if we only discover how and devote time to it.

The issues discussed here all speak to one's ability to live in one's body, be present, and *soak in time*. By soaking in time I mean being able to sit still, be quiet, be engaged fully in leisure of the mind, which our contemporary society and lifestyle habits make so challenging. The first romantic poet Catullus made famous the hardships endured in a life of leisure. Leisure is our chance to reset the body, but how many of us take this chance or know how? How do we spend our leisure time?

SOAKING IN TIME

Practices, beliefs, and habits that can help one soak in time, relax, engage in total regeneration and true leisure have been described here. There are numerous ways to soak in time, as diverse as cultures are they always create an outlet for this purpose.

For me, the architecture of bathing is the focus of my research. Bathing in thermal mineral hot springs is a way to activate the parasympathetic to restore the body's equilibrium, and puts one into an alternate dimension of time. The hydrostatic pressure of the dense mineral water forces the body into a deep state of relaxation, where you cannot help but rest, and alternating between bathing and resting is part of the ritual. With all of the senses engaged in the singular act of soaking in the water, the mind is focused, empty, and in a meditative state; my experience is that the body soaks in time as well as the calcium, magnesium, sulfur and negative ions dissolved in the aqueous solution. There, time is contained in the memory of the water, water that traveled great distance and depth to reach the spring, its point of release, and those molecules are continually recycled through the water system. There is a timeless quality to the spring, an infinite sense of time that the body absorbs of the eons that the water has been flowing and the past cultures who bathed in it. The Romans appreciated the timeless power of the thermal baths, and located the entrance to the underworld, an alternate realm of time, at the site of a sulfur spring.

REGENERATION

How to balance the organism and keep our body in adjustment in the face of leisure lost? The question is how we spend our time, occupied with distraction, activity, entertainment, or seeking out ways for soaking in time.

Regeneration is something that cannot arise in isolation. It is part of a broader concept: leisure... Leisure, in this sense, means a concern with things beyond the merely useful. Leisure means to have time. Time to live. Life can be tasted to the full only when activity and contemplation, doing and not doing, form complementary poles, like those of a magnet. None of the great cultures has failed to support this concept. —Siegfried Giedion, Mechanization Takes Command (1948)

In going home, we are able to connect with a space that allows us to reconnect to an earlier self.

This series is about the joining of past and present. Sitting at my mother's kitchen table, I found myself staring at a basket as my mind wandered. I had a sudden sense of déjà vu. I reverted to a younger self, sitting in that exact spot, staring at that same basket, pondering very different things. At that moment, I uncovered the true magic in going home: the ability to experience the world again before our present boundaries were formed, to be given a chance to see things anew again.

Eliza Lamb

From "Home Series: Everyday Epiphanies";
ultrachrome prints;
20" x 20"; 2005.

Ceramic Flowers. (left)
Rooster. (bottom)
Basket. (top)

TOO FAST OR SLOW FOR THE EYE TO SEE

Julia Morgan-Leamon

CORNUS CANADENSIS

In the *Guinness World Records* there is an entry for the world's fastest flowering plant. The entry acknowledges biologist Joan Edwards and her Williams College research team for discovering and documenting the explosive speed at which a common Bunchberry dogwood (*Cornus Canadensis*) propels its pollen.[1] As observed in a high-speed video clip at a frame rate of 10,000 frames per second, each flower in a cluster of tiny flowers takes less than 0.5 milliseconds to fling pollen trebuchet-style, high up into the air. Remarkably, these common flowers shoot their pollen faster than a rifle fires a bullet.[2]

As an adjunct faculty member, I've taught interdisciplinary courses on the subject of Motion and Time Perception using the High Speed Imaging Lab at Williams College. My students have drawn and animated Edwards's exploding flower sequence, and used the high-speed video camera to document ordinary events too fast for the eye to see. Occasionally we've assisted in filming other "fast flowers" such as alfalfa and jewelweed.

A TEA-SELLER'S GIFT

During a college winter break, my family traveled around Egypt and rode a bus across the Sinai Peninsula to the Red Sea. From the highway, we rarely saw anything green, mostly craggy rock formations, dry brush, sands, and plastic bags snagging on brush and signposts.

In the town of Dahab, where I bought a parcel of Bedouin tea and peppercorns, a shopkeeper handed me a "special gift," a sure sign, I thought, that I had overpaid. The gift was a broken-off piece of desert brush, stuffed into a clear plastic bag with a label in English that read "Hand of Mary." The branch was apparently dead, yet it was not uninteresting: through the plastic I could see finger-like branches clenched together, like mummified hands in prayer. The shopkeeper explained, "The Hand of Mary looks dead, but it will come alive again. Give it much water." He paused, and added, "Then take it out of water and it will die again. Keep it many months, years perhaps, put it in water, you will see that it lives forever!

TIME LAPSED

I brought the Hand of Mary into the lab to show Edwards, and to document what would happen when I immersed the plant in water. In the campus greenhouse, I positioned the plant inside an aquarium filled with water. Setting up two video cameras from different angles, I programmed them to take one-second recordings every five minutes. I scribbled a note, "Experiment in Progress; Do Not Disturb." I had no idea how long the process would take, assuming there would even *be* a process.

RESURRECTION

The Hand of Mary, as we discovered, has other names. While its Latin name is *Anastatica hiericunta*, most of the names we came across alluded to its regenerative capacity as a religious signifier: Rose of Jericho, *Kaf Maryan* (Palestine), and Resurrection Plant. The Sinai's Christian Monks purportedly call it Rose Marie: they believe that this flower first bloomed at the birth of Christ.[3] Apparently the plant takes in water yearly with the not-always-predictable winter rains; it's dry and skeletal at least most of the year. It's an organism that knows how to wait out time.

MOTHER MARY

The beauty of the time-lapse film startled me. Soon after submersion, the Resurrection Plant unclenched its branches, opening and expanding as the hours went on. The film spans a period of about eight hours, from mid morning to dark. The plant fills the center of the frame; its graceful gesture through the aquarium water causing pin-sized bubbles to re-arrange themselves in every frame. Yet the background of the images is also striking. The painterly reflection of the landscape through the greenhouse glass creates a new context for the transforming Hand of Mary. Spruce trees, a lamppost, cars that appear and disappear time-lapse-style, and a sky whose light intensifies through the afternoon, then fades to black—the story of one New England day – is going on behind the sinewy motion of the Sinai plant unfurling.

Over the next few days, the Hand of Mary loomed into an umbrella-like armature supporting hundreds of green sprouts. *Guinness World Records* purport

the slowest-flowering plant as a Bolivian giant bromeliad, the *Puya raimondii*. It grows for 100 years or more before flowering.[4] However once flowered, the bromeliad dies. There is no resurrection. But my desert gift lives unnumbered exuberant lives, oblivious to the rules of biology textbook life cycles. Its dormancy phase also immeasurable, the Resurrection Plant's autonomy hints at an as-yet-to-be-explained botanical consciousness.

NOTES:

1 http://community.guinnessworldrecords.com/_Chelsea-Flower-Show/BLOG/2348650/7691.html

2 http://www.williams.edu/biology/explodingflower/index.html

3 http://books.google.com/books?id=KI8DAAAAQAAJ&pg=PA428&lpg=PA428&dq=Anastatica+Hiericunta&source=bl&ots=DQNOnRUS1J&sig=S6DwodYJdJ0mCBI_Gkzb7AJR2es&hl=en&ei=jC2zTO6AL408lQfZ7d2DAw&sa=X&oi=book_result&ct=result&resnum=1&ved=0CBIQ6AEwAA#v=onepage&q=Anastatica%20Hiericunta&f=false

4 http://community.guinnessworldrecords.com/_Chelsea-Flower-Show/BLOG/2348650/7691.html

Resurrection Plant; stills from time-lapse video; size variable; 2009.

This system provides light and food for the plant in the form of hydroponic solution. The plant reacts to the device by growing. The device in-turn reacts to the plant by producing a rasterized inkjet drawing of the plant every twenty-four hours. After a new drawing is produced the system scrolls the roll of paper approximately four inches so a new drawing can be produced during the next cycle. This system is allowed to run indefinitely and the final outcome is not predetermined. When growth rendering device was installed at the Rochester Art Center from May 22 through August 27, 2007 it produced a fifty-foot scroll of drawings of a pea plant as it grew, thrived, withered, and died over a three month period.

David Bowen

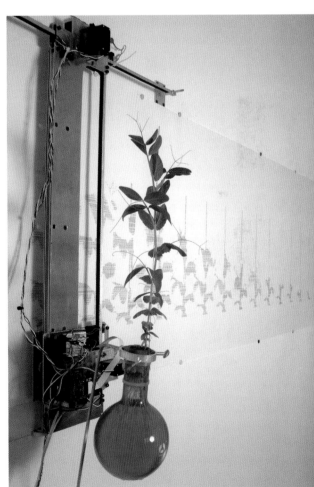

Growth Rendering Device (detail);
aluminum, plastic, pea plant, hydroponic solution; 2007.

Edward Johnston

From series, "Experiential Extensions"; 2006-2009.

Looking At Clouds – Variation 2; white nylon; 8" x 6" x 4"
Looking At Clouds – Variation 2; digital print; 16" x 20"

According to John Langone's *The Mystery of Time*, humanity has been recording time for about 30,000 years. It is hypothesized that Ice Age European hunters began digging lines and holes in bones according to the moon's phases in order to mark the passage of days. Huge stones were erected about six thousand years ago at what is known today as Stonehenge, possibly intended to track eclipses and solstices. About two thousand years ago, Syrian sandstone sundials were used to track the movement of the sun's shadow across marked increments. Since then, humanity has devised more complex and accurate forms of time-keeping through technology. Precise durations such as the minute and second have been incorporated into devices which people carry with them every day. These recording methods have enabled people to track events such as birthdays, holidays, and anniversaries. Human history has been tracked in books according to these methods. All of this is evidence of humanity's interest in using mark-making systems to record moments and deem them significant.

In this body of work entitled *Experiential Extensions*, I mark moments of my existence through complex, aesthetic means. While going on walks, I take photographs of curious shapes that I see in my environment. After the walks, I collect the photographs on a computer and stack them. Using 3D computer graphics software, I create a proportional distance between each photograph in that stack to the time at which I took each photograph. This creates a virtual column of floating photographs, which resembles the floors of a building. After stacking and spacing the photographs digitally, I extrude a surface through the collected shapes in each photograph, creating a virtual pathway or tunnel. Depending on my extrusion method, these forms can resemble vines, veins, and sometimes buildings. Finally, I take these virtual forms from the computer and fabricate them as physical objects using machines.

The method by which I extrude a virtual pathway through stacks of photographs can change. Quite often, I return to my initial setups of shapes and spaces to construct *Variations*, which formally express thoughts related to concepts of time, including the growth of human memory throughout life and scientific theories regarding existence. Collectively, these *Variations of Experiential Extensions* stand as metaphorical objects of the complex marking of moments that define everyday, human experiences.

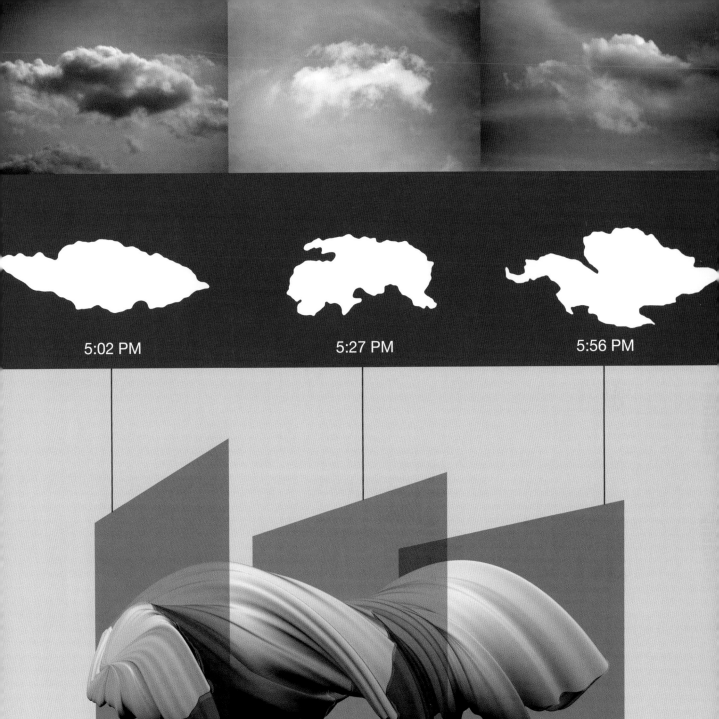

5:02 PM

5:27 PM

5:56 PM

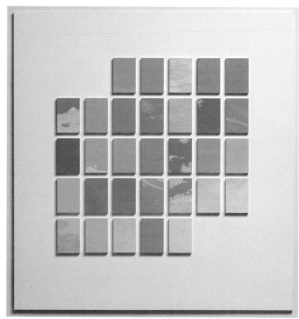
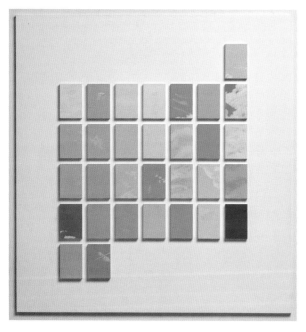
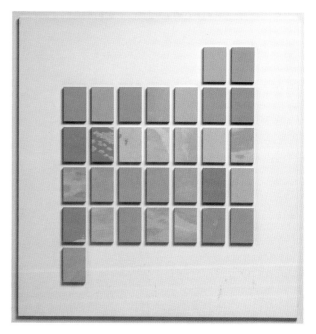

Linda Stillman
From "Daily Paintings"

Clockwise from top left:
May 2006, August 2006, December 2006, July 2006;
acrylic and gouache on paper; 26"x25"x3/4", each panel.

2007;
acrylic and gouache on paper and panels; 41.5"x77"x3/8".

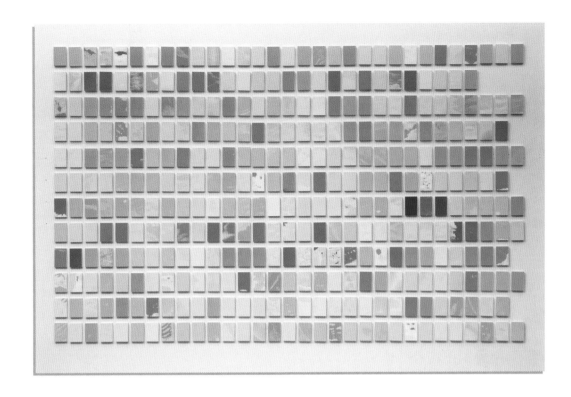

Linda Stillman

I paint a small panel of the sky every day in an ongoing series, started in August 2005 and continuing indefinitely.

The portion of the sky is based on the view through one pane of my studio window, so no matter where I am, I picture that same shape and angle. The date, time, and place are recorded on the side of each panel. Each year the "Daily Paintings" are grouped in different arrangements: either as individual months as they appeared on the calendar or all in one line, or by year. Each panel is considered a detail of the entire work.

This daily process of capturing a fleeting moment in paint is contemplative—taking time every day to stare at the sky—and the result is a diary of my art making and my place on earth. This series relates to my interest in the ways we attempt to hold onto the ephemeral memories of everyday life and try to experience time more fully.

Emanuel Pimenta

Over thousands of years, the concept of time wavered between different poles.

Aristotle created the conceptual support for this conflict with the mathematical principle of the *excluded middle—a* or *non-a—*which William Shakespeare transformed into the classic formula: *to be or not to be.* The *excluded middle* principle put generations of philosophers in great difficulties when they tried to harmonize the vision of an eternal world with the existence of miracles, or even with an Apocalypse, an end of times. But the emergence of *real time* has transformed that ancient world of oxymoronic oppositions into a condition of a different nature. The concept of time passed to be, simultaneously, relative and absolute, in an apparent paradox.

Still in the nineteenth century, Arthur Schopenhauer already challenged the possibility of the existence of a *telecausality—*that would designate part of the characteristics of time according to the *Superstring Theory.* In the late twentieth century, Ilya Prigogine pointed to the fact that we experience what the Sumerians named with their word *ti*: the irreversible arrow of time and life. But John Wheeler would give the answer: everything would depend on the scale. In very large or very small scales, time would be symmetrical, past and future would coincide. Depending on the scale, time passed to be symmetrical or asymmetrical.

Being something like matter, time became absolute—but, simultaneously, totally relative. If speed is increased, time is decreased; if the scale is changed, the nature of time is immediately transformed. François Jacob, recipient of the 1965 Nobel Prize in biology, said that "the representation of the world built by the human being is always largely a product of imagination."

And what we are dealing with here is exactly about imagination—aesthetics. How our imagination—and this is an aesthetic issue—has been changed over the centuries, and with it also everything we know. Imagination does not mean reverie without method—but image and action in a coherent process of memory. During the twentieth century we saw the disintegration of what could be called "normal standards" established by the Aristotelian principle of the "excluded middle." To understand how that happened, it is important to refer to the work of the brilliant Romanian physicist and philosopher Stephanne Lupasco.

In 1951, Lupasco laid the foundation of one of the great revolutions of Western thought, already announced—although not directly—by Charles Sanders Peirce and Arthur Schopenhauer. Over the centuries, our entire reality has been coined by the principles of local causality and the excluded middle. But, then, Lupasco launched the principle of the *included* middle as an essential element for the understanding of reality. In his book *Le Principe D'Antagonisme et la Logique de L'Energie* Lupasco posited:

to any phenomenon or element, or any logical event, and therefore the judgment that thinks it, to the proposition that expresses it, to the sign that symbolizes it: and, for example, should always be associated, structurally and functionally, to a anti-phenomenon or anti-element, or a logical anti-event, and so to a judgment, a proposition, a contradictory sign: not and; and in such sort that and or not-and can never cease to be potentiated by the actualization of the not-and or of the and; but they do not disappear so that; being not-and, being and, they can suffer themselves from an independence and, therefore, from a strict non-contradiction—as in any logic, classical or other, based on the absolute of the non-contradiction principle.

This is about an evident event in the phenomenon of the existence of the photon, simultaneously particle and wave, or even in quantum physics, which served as the basis for his thoughts. Basarab Nicolescu rightly said that for Lupasco "the whole system is a system of systems." Now, it no longer is the question of to be or not to be, but yes, to be *and/or* not to be.

If we recall the basic principles of the method created by Charles Sanders Peirce, taking time as sign, we can understand how this apparently paradoxical universe happens. Charles Sanders Peirce developed the *General Theory of Signs*, a method for the understanding of the phenomena of language. The essential principle of such method—which is not based on the verbal language, as it happens with Ferdinand de Saussure—establishes that every sign, a kind of *informational quanta*, is articulated by three poles, three categories of signs, which merge with each other and become one in the sign. In fact, Peirce's method is a strongly fractal process, because the meaning of a sign is another sign of a different nature. He called his categories, which we could also consider as poles or singularities, *one, two* and *three*.

To the *one* he attributed the nature of the relations of quality, for which there is no possible opposition. That is the nature of the present, for which there is no opposition and, in a certain sense, even possible intellection, because when we perceive and understand it is already past. To the *two*, Peirce designed the relations of existence—because everything that exists has its opposite. Light and darkness, sound and silence, in short, every relation of existence is established by opposites, it is about the concrete world, and that's the past. But when we think on it, the past becomes, in some sense, future—because it is projected ahead of its time. It is the reason, the number *three* for Peirce. The same happens to any sign. But a sign never can be only one of its parts, a single category. The three categories are paradoxical and, simultaneously, a single thing. Even so, each category also cannot have its own existence. The logic to understand the sign according to the theory elaborated by Peirce is that of the included middle.

Simultaneously, to be and not to be. Few people understand this and the formidable leap that Peirce's ideas represent. But, in an article published in *The Monist*, in October of 1905, where the original title *The Consequences of Pragmatism* was later amended by Peirce himself to *Issues of Pragmatism*, Peirce gives us an even more direct view about the reality of time: "What is time? It is not proposed to attack those most difficult problems connected with the psychology, the epistemology, or the metaphysics of Time, although it will be taken for granted, as it must be according to what has been said, that time is real. The reader is only invited to the humbler question of what we mean by time, and not of every kind of meaning attached to past, present and future either. Certain peculiar feelings are associated with the three general determinations of time; but those are to be sedulously put out of view"—as if he was writing a message to John McTaggart, his contemporary.

What is the intellectual purport of the Past, Present and Future? ... That Time is a particular variety of Objective Modality is too obvious for argumentation. The past consists of the sum of faits accomplish, and this Accomplishment is the Existential Mode of Time. For the Past really acts upon us, and that it does, not at all in the way in which a Law or Principle influences us, but precisely as an Existent object acts. For instance, when a Nova Stella bursts out in the heavens, it acts upon one's eye just as a light struck in the

dark by one's own hands would; and yet it is an event which happened before the Pyramids were built. A neophyte may remark that its reaching the eyes, which is all we know, happens but a fraction of a second before we know it. But a moment's consideration will show him that he is losing sight of the question, which is not whether the distant Past can act upon us immediately, but whether its acts upon us just as any Existent does. The instance adduced (certainly a commonplace enough fact) proves conclusively that the mode of the Past is that of Actuality. Nothing of the sort is true of the Future, to compass the understanding of which it is indispensable that the reader should divest himself of his Necessitarianism,—at best, but a scientific theory,—and return to the Common-Sense State of Nature. You never say to yourself, 'I can do this or that as well tomorrow as today'? (...) Be true in theory or not, the unsophisticated conception is that everything in the Future is either destined, i.e., necessitated already, or is undecided, the contingent future of Aristotle. In other words, it is not Actual, since it does not act except through the idea of it, that is, as a law acts; but is either Necessary or Possible, which are of the same mode since Negation being outside the category of Modality cannot produce a variation in Modality. As for the Present instant, it is so inscrutable that I wonder whether no skeptic has ever attacked its reality. (...) How, then, does the Past bear upon conduct? The evidence is self-evident: whenever we set out to do anything, we only draw upon our memory. (...) In short, the Past is the sole storehouse of all our knowledge. (...) Thus, from whatever point of view we contemplate the Past, it appears as the Existential Mode of Time. How does the Future bear upon conduct? The answer is that future facts are the only facts we can, in a measure, control; and whatever there may be in the Future that is not amenable to control are the things that we shall be able to infer, or should be able to infer under favorable circumstances. ...the conclusion of a Reasoning proper must refer to the Future. (...) What is bearing of the Present instant upon conduct? Introspection is wholly a matter of inference. One is immediately conscious of his Feelings, no doubt; but not that they are feelings of an ego. The self is only inferred. There is no Time in the Present for any interference at all, least of all for inference concerning that very instant. Consequently the present object must be an external object, if there be any objective reference in it. The attitude of the Present is either conative or perceptive. (...) The consciousness of the Present is then that

of a struggle over what shall be; and thus we emerge from the study with a confirmed belief that it is the Nascent State of the Actual. (...) Time is unique and sui generis. In other words there is only one Time.

According to his General Theory of Signs, Peirce takes the past as relation of existence, par excellence, and therefore a secondness; the future as a product of reason, of control, and thus a thirdness; and the present as firstness, icon, relation of quality. But time is the fusion of these three categories—and therefore can only be one. That is the reality of real time. We are and we're not, as Heraclitus said.

In one of his lectures of 1898, in Cambridge, Massachusetts, that initially had the title of Time and Causation, and was eventually changed to Causation and Force, Peirce made a further reflection on time: "What is Time? Shall we say that it is the form under which the law of logical dependence presents itself to intuition? But what is logical dependence objectively considered? It is nothing but a necessitation which instead of being brute is governed by law. Our hypothesis therefore amounts to this, that time is the form under which logic presents itself to objective intuition; and the signification of the discontinuity at the actual instant is that here new premises not logically derived by Firsts are introduced." Even if we may consider time as unique—incorporating the whole diversity of our bodies and our societies—even so, what we think about it, what Husserl defined as phenomenon, is a constant metamorphosis, based on what Peirce defined as necessity.

Reality of what is necessary in a world taken as technocratic or technological through the effervescence of what we might call degenerated techniques. The entire planet, from the richest to the poorest places, passed to be constituted by virtual tools. For the first time, the use of techniques no longer depends on direct action. Touch a button and automatically trigger an action without direct involvement or even knowledge of how to do by the person. When someone uses a computer, for example, he doesn't know how it works, he has no knowledge of how to do. He only knows that touching its surface will cause an indirect action, like prosthesis. They are degenerated techniques because they happen in a second instance. But, paradoxically, they are immediate—without mediation—because the outcome of their operation takes place in real time.

The act of to do and the time implicate another interesting concept: the *sacred*. The word *sacred* has ancient etymological roots in the Indo European **sak*, showing us the idea of *non-opposition*. The radical of this root is **s* that indicated the ideas of *connection, neighborhood, union, interface, contact*.

It is the oldest known root of the Latin expression *sum*, which means *to be* and shows us how existence is nothing but a complex network of symbiotic relationships. Other words also appeared from that same root, such as similarity, consecration or even saint—illuminating their usual meanings. Thus, the *sacred* is what binds us, not only to ourselves, but with things and with others.

On the other hand, the word *profane* comes from the root **fes* which, in its turn, may be linked to the Indo European **dha*, which indicated the idea of *light*. The root **fes* also indicated the idea of the *temple*, giving to the word *profane* the meaning of something that is *outside the temple, outside the sacred*. Some relate **fes* to the Latin *fari*, which gave rise to the word *fable*. All these expressions related to the profane are directly associated with vision. Anything that involves the profane is related to division, to departmentalization, and to classification.

While hearing is especially inclusive, vision is a strongly departmentalizing sensory faculty—and that is the very first nature of the *systasis*. We cannot close our ears. There is no real opposite for a song—play it backwards does not mean to invert it, but to reverse it. The intensive use of vision produces what we call *stereotype* and *format*. The word *stereotype*, which literally means *solid type*, was born from the use of the Gutenberg press and was the term used to designate the printing mode using a solid plate, previously recorded.

Stereotype is generated by uniform behavioral routines established in a strongly hierarchical framework of values, that is, in a *format*. For example, when we follow the sightseeing process the tour guide always makes the same movements, with measured time. The same happens when we follow a manual of operations or a recipe. There we meet in high definition all steps and their order, with a specialized purpose.

Routines are a reference to time. When the repetition is transformed into a diagram, and from it a map of

action is defined, we have the stereotype: the map of the action in time. Everything is made predictable. When we don't have such a diagram and we have time free from routines, we have the sacred—then everything is connected by the unpredictable.

Therefore, the most diverse societies worship fire as a sacred element. And also because of this, many of us feel the sacred when we are inside an empty temple. It is not the temple in itself what produces that sensation, but the time free from the bonds established by norms and social rules.

Visual societies tend to be more stereotyped and more profane. In an acoustical society all tend to be more "alike" to each other—which is interestingly revealed in Byzantine mosaic and sculpture. Everything related to time. Profane societies have time counted. Societies oriented to the sacred have free time. When we ask about the form of time, the concept of time, it is, in fact, the concept of our own world, our lives.

The great Swiss philosopher René Berger said:

The so defined sensory experience is permanent, from our birth to our death. It corresponds to a placing in perspective the world that contains our identity and our duration. But our perception very often passes not through the 'direct contacts', but through images that work 'in substitution' (...) ...every technical invention also involves the establishment of new behaviors, new contents and new audiences (...). Let us add that, as we recur to technical devices, we also recur, usually unconsciously, to mental devices, which might be called cultural patterns, widely studied by linguists, ethnologists and anthropologists. (...) This relation also involves a 'time factor' that was made decisive nowadays. Before, it was produced according to durations and experiences corresponding to our classical culture. Today, it explodes in many numerous places we can get almost instantly.

For each one of us, time only happens in the *present*, which is nothing but the boundary between perception and memory, while consciousness, spreads to every cell of our bodies. What reminds us of John Archibald Wheeler and Jean Piaget when the first said that "the boundary of a boundary is zero," and the second that "to understand time is to get freed from the present."

SUNRISE OF SUNRISE OF SUNRIS

Don Relyeaelyeaelyea

A single image of the sun rising is generated using a digital slit scan process that allows for the sun to appear in two places in the same picture.

This work is ten minutes of HD video compressed into a single print image. A digital slit scan process is employed to sample a column of pixels from each frame of video and compose a single image.

With *10 Minutes of Sunrise*, the single pixel column scan begins at the right of the video frame and moves left across the sun until it reaches the left of the video frame approximately five minutes into the video. After the scan reaches the left of the screen it changes direction again until it passes across the sun a second time.

ASTRO-TIMESCALES AND CONSCIOUSNESS

Sean Wrenn

Let's consider the Collective and Individuated experiences of:

- ∞ a passing transformative present
- ∞ historically indebted memory structures from the past
- ∞ the creative impulse to project future visions.

And then ask: Where has our consciousness of time come from, conditioned and totally standardized? Many of us have likely experienced uncanny instances of fluctuating senses of the present and variable passing time.

The motions of the heavens have been most obvious to man (both past and present) as a sign of passing time. Our ambition and intellectual inheritances have both given and perpetuated the shaping and measurement of time. Parabolic sub-division of intervals (over linear history) seems the only difference between ancient and contemporary man's conception of time. Cycles in the celestial-sphere patterned sky can now be understood as a key to understanding implications of Einstein's mathematically proven theory of relativity and the limitations of (and distances measured by) the speed of light.

"Looking back into time" with space telescopes, we are able to observe (in an accelerated photo-exposing reverse of "real time") the transformations of nebulae, births of stars, the formation of proto-planetary accretions discs, and a fundamental understanding of the infinitely unique potentials within an observably unfolding, vast, twelve billion-year old, expanding universe. We can see the light, energy, and illuminated atomic particles (as matter and radiation) extending from our place in the Milky Way to the edge of the known universe. We are finding some of these particles to be visible, while others exist beyond the visible spectrum as infrared emissions, radio waves, or x-rays. Much of this "universe" is otherwise empty, composed of light traveling vast distances to and from potential observers that might exist intergalactically.

Limited by the speed of light's boundaries on time and space, galaxies thus have the potential to exist as universes unto themselves, separated from each other by the paradoxes implied by Einsteinian relativity, and, in some cases, also by "dark" matter. Although unexplainable within the laws of (our) three

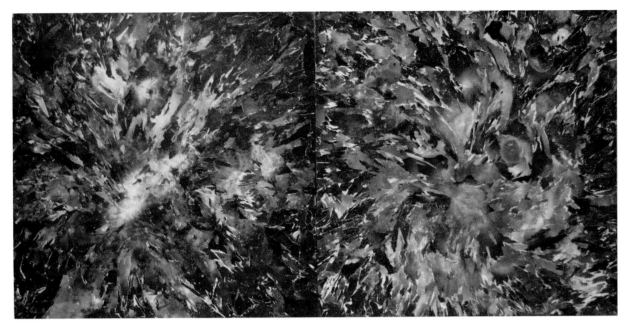

Nebulae; acrylic medium and paper on panel; 48" x 96"; 2010.

spatial dimensions that contain matter responsive to electro-magnetic light (including our physical eyes and thus empirical world-view), this so-called dark matter was "proven" to exist in August of 2006. We are skidding into the final years of the 26,000-year precession of the equinoxes cycle. This Circle ever slightly shifts our terrestrial angle relative to deep space—serially aligning our view of the "rising" sun with our earthbound view of the black hole at the center of the spiraling galactic disc (nearly 30,000 LY across) at but one point in this long, subtle, and margin-of-error causing "great cycle."

Perhaps some answers to pressing contemporary ecological, social, and eco-political challenges lie within comprehensions of the long phase motions of the universe (such as the precession of the equinoxes) and the archetypes throughout history that have referenced connections between deep geologic time, cosmologies, and human insight.

The civilized, built environment (including our gadgetry, libraries, archives, and exponential capacity for innovations) has resulted over progressing millennia—since mankind "ascended" from passing days as wanderers. Settling into urban centers marks the conscious effort to create structures that reflect "progress" over cumulative time as a triumphant reflection of intellect and power. Generations inherit and strive

to preserve interconnected systems and societies. The complexity of contemporary systems is awe-inspiring, but we are reaching a breaking point—critically overextended and near to the point of collapse due to unsustainable mental-mechanical logic.

Our progressed architectures, technologies, and epistemologies rely on the day-to-day carry over of reality, paradigms, senses of security, and memory (for cognitive learning and understandings of "life-span"). Having surpassed survival mode, our sensory reactions evolved to register nuances additional to the motions of predators and rivals. Gaining an intellectual awareness of the heavens rotating around oneself sparked an interest in creating within it, also in service and appreciation of "it" (via ideas and the engineered mathematics of monuments and mounds such as Stonehenge ca. 2500 BC and New Grange, ca. 300 BC). Human intellectualism (within our most recent concept of history) has continuously aspired toward comprehending the heavens, mastering various craftsmanships and load-bearing architectural designs, and developing technical systems and devices for acceleration.

Man has moved quickly through masteries of properties in physical materials and chemical elements: first for protection and then for conquest/exploitation/stock-piling. The "wandering" celestial bodies that

were determined to be co-solar planets revolutionized dimensional perspectives upon proving of the Copernican worldview. While the Renaissance also introduced a new paradigm of "finance" concepts, the philosophical brain has always sought to control, find order, and establish security via enhanced resources and tools. We have gradually progressed from creating metallic alloys, to achieving optical devices, to developing light sensitive photo-recordings, and to un-raveling atomic particles. One might even deduce that digital systems and high-energy quantum physics find root in humans attempting to fix and measure time—both for monetary value and for global exploration. By establishing the Prime Meridian for measuring global "time," socialized humanity entered a highly calculative intellectual phase. However, it is now through the weaknesses of these constructions (over progressed linear 'time') that we are coming to understand ourselves *as the self-referring awareness of the universe itself.*

The Michelson and Morley experiment (1881) had discovered that light could be fired in many directions, but the speed stayed constant at every angle. Einstein's equation proofing arrived at a profound insight in relationships between man, knowledge, and nature. Physics was not the study of events and observations; but rather, as relativity, it is an understanding of the world (and time) as 'relations.' Ultimately, all understandings of the visual universe find root in the paradox that Einstein discovered in his theory of general relativity. As an "impossible" question he asked: "What would the world look like if I rode on a beam of light?"

If a train (or body moving vessel of any kind) were moving away from (for example) a clock at the speed of light, the passage of time would appear to stop. The clock would appear fixed because the light focusing an image of the clock would be meeting our eyes at the rate we were moving away from it. Receiving the visual information as a constant now, time itself would seem to come to an end for the person in "the train." If moving at the speed of light, it would be almost as if the light-based observer within a light-based material dimension were being pulled apart simultaneously from the light based material reality of the space and time being traversed. Warping the limits of time-space duality, the yet impossible feat of moving faster than approximately 186,282.397 mi/sec. is interesting to consider when thinking about deep space imaging and/or high energy physics observations.

If a train (with 'me' in it) were moving away from a clock at the speed of light, the train car (and 'I') would be fixed in time (to 'me'). If I were moving on a beam of light, time "for me" would come to an end. As I approach the speed of light, I am alone in a box of time and space—a "bubble" that is increasingly departing from the norms around me. Such a hypothetical scenario leads to additional impossible conclusions:

There is no universal time.

Experience must, therefore, run very differently for the 'high-speed' traveler, the 'stay at home' observer, and thus, possibly also
 for each of us on individuated paths
 in space-time.
 (out side of any distorting
 psychological perceptions).

However, experiences in the "bubble" are consistent. The 'high-speed' traveler observes the same laws: the same relations between time, distance, speed, mass, and force that every other traveling or 'stay at home' observer discovers. But the 'actual' values that the traveler measures for "time distance" are not the same that the observer (left on the land beside the "train track") experiences and/or observes.

What if we are "all" moving at 'a' metaphoric frequency (speed) of light, meeting in the "bubbles" of individuated conciousnesses' time-space experiences, overlapping and running into one another to share an idea of 'common reality' that seems anonymous and separate, but personal and unique—because it is both—and also, psychically entangled (collective social and quantum interaction).

When we exchange signals, we always discover that information passes between us always at the same rate; we always get the same value for the speed of light—even in the near-instantaneous transmissions of fiber optic data. Like the relativity of time, so might the magnetic poles be considered 'relative,' shifting throughout deep geologic time as evidenced by lava cores drilled deep from within the records of rock layers found in slowly cumulative islands such as Hawaii.

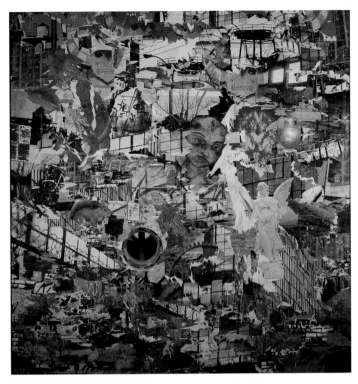

Scrapworm Kachina; acrylic medium and paper on panel; 52" x 48"; 2010.

Having undergone innumerable migrations and cycles of destruction, having survived repeating iterations of civilizations and quests for truth; now we perpetually interface with fractal dimensions of information processing (internal/external, and neurological/technological). We think in superfluous interconnecting layers, as optical information systems and digital tools exponentially extend the very cognitive capacities that initially led to cumulative advancements (self-perpetuating evolutionary technocracy). Because our minds have evolved of a symbiotic relationship with the natural world, how can we biologically and psychologically meet challenges into the future? The crisis may require a break-down of former perspectives, but 'permacultural' local economies can be created and networked efficiently when considering living systems models and deep space inspired concepts on time. Our universe undergoes great cycles of creative destruction. Space telescopes redefine our perspectives on time and scale, twisting relativities by peering beyond the speed of light and terrestrial concepts of 'place.'

Our contemporary moment is poised to reconsider existing world-views. Creating humanist discourse on philosophical questions aspires to facilitate the evolution of perspectives on TIME via comparative explorations of emerging quantum, holistic, and sustainable part-to-whole synergistic paradigms. We are being called to collaboratively attempt to avert global ecological, financial, and social collapse. Light years might therefore be seen as a macrocosmic example of a "lapse phenomena" between consciousness, the motion of light, conditioned memory formation, and/or transformative actions on material and bodies over time. The passing moment remains without content. When moving from 'there' to here,' 'you' are also within from 'there to here' (as in Einstein's "bubble").

Consciousness is constant in the bio-machinery of all living things, but it is difficult because its electricity jumps between the synapses of accumulated structures in the physiological processing center itself. Whereas brain synapse structures accumulate and habitually develop structures over time (reflected in the projected, engineered built environment), the living systems of ecosystems have become fragmented, pressurized, distorted, and unsustainable "in time" when controlled by calculative, extortionist methods of thinking.

Most of the stars we observe could have theoretically already exploded, become nebulae, or disappeared into pulsing neutron stars or black holes. If everything in the universe is made of matter and/or living energy, then everything in the universe has the potential to decay into dust and/or undergo transformative 'loss of living energy.' Dualized, linear time underscores human experience, and we are cyclically living and dying to uphold closed archetypal metaphors. Particle physicists have a similar predicament as artists. They know that the extra dimensions are required by string theory equations exist, and want to see/prove them, but 'we' (in our physical bodies) exist in a reality that keep us separate from any 'reality' other than 3 spatial dimensions + time (as perceived during developmental biological lifespan).

The stars that we observe from earth-proximity (other than the sun) are, at closest, four light years away. The light from only one such star, Alpha Centauri, reaches us within 4 years. Most stars and galaxies are over hundreds, thousands, millions, and billions of light years away. Experience of the universe thus exists outside of daily, human life-span, and societal

concepts of time. Our observational experience of 'the present' is largely disconnected from celestial timescales. All the light we see was initially emitted inconceivably long ago. Should Alpha Centauri (or even Sirius— 9 light years away) suddenly explode, we would not see it for over 4 years in the future.

Black holes are hyper dense objects from which even light cannot escape. They exist within the center of most galaxies, including ours. Like pulsars/neutron stars, they are mysterious singularities where space and time break down. Mathematically modeled as trans-dimensional portals, the Aboriginal Rainbow Serpent and the Mayan Serpent Rope might be interpretations (from within ancient paradigms) of a cyclical, cosmic-electrical anomaly similar to the effects of an electrical charge fired through plasma. Whereas Aboriginal land is geologically quite old compared to other continents, the Aboriginal *Dreamtime* and *Songline* concepts might be reinterpreted as insights into the "long-phase" phenomena governing our cosmological senses of space, time, and involvement in reality.

Earth changes may or may not precede galactic alignments (such as implied by the 2012 precession of the equinoxes). However, geological balances within the Earth itself are interconnected with the gravitational relationships of cosmological bodies on the macrocosmic scale of the "known" and "unknown" expanding universe. Gravity is considered a "weak force" by physicists and could potentially be a the link between "braneworld" theories postulated by m-theory and string theory. CERN's Large Hadron super-Collider is capable of accelerating particles to near the speed of light. Perhaps the *(s)particles* sought by high-energy physicists will prove to be totally other than we can intellectually expect. The motions of stars, nebulae, and planets observed in outer space have consistently informed our placement of ourselves within a series of fixed reference points to create, systemize, and profit from the world that we inherit through intellectual advancement, social constructions, historical progressions, *and* in psychological conditionings.

The density of neutrons contained in the pulsar rotating at the center of the Crab Nebula is considered impossible even by contemporary understandings of physics. Gravity's inconsistencies could similarly be a key to unlocking unforeseen visions on time

and space. As individuated people growing up in a hyper-complex materialist society, we are politico-emotionally institutionalized and media proliferated. Our technocratic world-view confines perception and is ultimately indebted to accumulation and cyclical revolutions. As a species, we seem to always be seeking to enhance our lives through outward (power) and inward (spiritual) searching for betterment. This manifests over time— through lives tied to *time*. In *The Unknown Spirit*, Jean Charon mentions Teilhard de Chardin's insight that some of the particles in physics are micro-universes consisting of a peculiar space-time also reclosing itself; [and] having reached the extreme of their analysis, "physicists clearly do not know if the structure they reach is the essence of the matter they are studying or the reflection of their own thinking."[1]

Like relativity, the sublime might be described as that beyond absolute knowledge. Philosopher Robert Frodeman explains that, "our [traditional] sense of temporality [as ill defined and un-self-conscious as it may be] determines the type and manner of things that strike us as real."[2]

I then have to ask:

Are we traveling through time, or are we trapped by time? Do paradigms power perception, or does perception power paradigms? Can thought recognize that which does not exist within it? Can we be aware that we are aware, and what (without closing down on an 'idea') might that mean to a future paradigm shift?

NOTES:
1 Jean Charon, *The Unknown Spirit* (Sigo Press, 1983).
2 Robert Frodeman, *Geo-logic: Breaking Ground Between Philosophy and the Earth Sciences* (State University of New York Press, 2003), 124.

Hélène Lanois

I perceive time as a non-linear concept. In my mind, I visualize my body moving along a "U" shape where the twelve months are strategically placed.

My eyes gaze toward the left or right of the "U," depending on the time of the specific event (past or future). From January to June and September to December I perceive the "U" horizontally but vertically during July and August.

Is the "U" shape referring to the earth's rotation or is it part of an atom's ellipse?

Is time matter?

Are we time?

Time Superimposed; acrylic on canvas; 4.5' x 8'; 2005 (top).
Non Linear Time; Conté on Canson paper; 22.5" x 30"; 2009 (middle).
Time in Motion; acrylic on canvas; 30" x 36.5"; 2005 (bottom).

SPACE-TIME IMAGERY
IN ART AND SCIENCE

Norman Zabusky

SPACE-TIME IMAGERY IN ART AND SCIENCE

"From the invisible atom ...everything is movement. ... All movement is the product of two factors: time and space." Introduction to *La Methode Graphique dans les Sciences Experimentales*, 1878. Étienne-Jules Marey (1830-1904)

I want to share a journey, a moveable feast from science to art. The scientist knows that reality is embodied in understanding and utilizing theory and experiment. The classic example is Newton's formulation of calculus that led to classical mechanics and an understanding of aspects of planetary motion. Such processes have been refined over the centuries and with the help of computers they provide the backbone for predicting planetary or particle motion. Technological developments are also revolutionizing the approach to data-intensive environments with a technique I have named "visiometrics" and will discuss below in the context of evolving space-time phenomena.

The artist has progressed in different cultures from primitive early beginnings, through innovating new forms and techniques and, finally, taking avant garde steps. Success seems to reside in what the younger generations want and have the power to mediate over time . Not being an art historian, I will consider for the purposes of this paper Etienne-Jules Marey (1830-1904), Eadweard Muybridge (1830-1904), and Marcel Duchamp (1887-1968).

Edweard Muybridge[1,2] was the first to systematically develop equipment and techniques to photograph the movement of quadruped and bipedal gait along with a variety of other movements, motions, and human athletic activities. Muybridge's work has often been discounted as merely "art," but it was an important qualitative look at movement. Modern texts have detailed diagrams of normal and abnormal gait that look like they were sketched from his plates or photographed using methods similar to his. He influenced many artists and inspired Marcel Duchamp to paint "Nude Descending A Staircase."[1] Clearly there is inspiration, emotion, and art in Mubridge's work. By using scientific analysis and invention he was at the forefront of creating techniques that were later used to quantify motion and gait analysis. His work had a great impact on animation and led to the development of film.

Figure 1. Marey's visualization for flow around a sphere.

Étienne-Jules Marey (1830-1904)[3,4,5] "was a physiologist, doctor, biomechanics engineer, and inventor in 1882 of chronophotography, a technique anticipating stroboscopic photography. He was obsessed with motion and its *visualization*. He undertook to make *movement* visible by 'graphical' recording. He studied walking and did research on muscular forces and applied them to physical education..."[4] His research allowed the establishment of techniques that optimized human muscle movement. He also studied the gait of horses and humans, birds and insects achieving flight. At the end of his life, he was engrossed in photographing movements of air, flow around bodies, e.g. the sphere in Fig. 1. He could be considered the "father" of flow visualization.

He lacked scientific *sitzfleisch* and so left to others the task of quantifying and analyzing the pictures.

Marcel Duchamp (1887-1968) was a painter, tinkerer, inventor, and chess player.[7] He was a creative spirit who knew instinctively when to "move-on" for his greater good. In his final years, he earned his living selling other artists' works, especially paintings. As Robert Lebel notes, Duchamp, " was more than 70 years old when he emerged in the United States as the secret master whose entirely new attitude toward art and society, far from being negative or nihilistic, had led the way to Pop art, Op art, and many of the other movements embraced by younger artists everywhere. Not only did he change the visual arts but he also changed the mind of the artist."

Duchamp is arguably best known for his "Nude" and his "readymades." In an interview with Katherine Kuh,[7] he remarked "You know at that time, in 1912 ... I think the idea of describing the movement of a nude coming downstairs while still retaining static visual means to do this, particularly interested me. The fact that I had seen chrono-photographs of fencers in action and horse galloping (what we today call stroboscopic photography) *gave me the idea for the Nude*. It doesn't mean that I copied these photographs ... *The whole idea of movement, of speed, was in the air* [italics mine]." Furthermore, when asked by Kuh, "Why do you think the "Nude Descending a Staircase" caused a greater furor than some of your other works?" Duchamp responded, "Probably because of the shock value due to its title..." So he was also a master of what today in public relations is called "spin."

When I first saw a picture of the Nude (prior to discovering Muybridge and Marey), I was not shocked by the title, or gratified by the "violent coloring" and "touch of deliberate distortion," as Duchamp remarked about his portrait of Dr. Dumouchel (1910). I was amazed by the fact that a non-scientist attempted to communicate the excitement and challenge of representing complex kinematics (the descending motion of a human) in *space-time*. But now I realize it was a kind of cartoon of the works of Marey.

SPACE-TIME IN STEM (SCIENCE, TECHNOLOGY, ENGINEERING AND MATHEMATICS) STUDIES

For the uninitiated, whenever one mentions "space-time," one usually thinks of Einstein and the curved space of gravitational phenomena. This shows up if one searches for "space-time" in Google images. My meaning is entirely different. It has to do with how to represent complex information from data-intensive "evolutionary" experiments and particularly computer simulations. Let's examine how space-time (ST) imagery helps to unravel the information contained in large-scale computer simulations of nonlinear and complex phenomena.

MY BEGINNING IN PHYSICS

When I began studying nonlinear lattices in the early 1960s, I produced the first ST diagram of the solution of a nonlinear partial differential equation (PDE), the Korteweg-de Vries equation,[8] first derived in 1895 to describe the movement of surface waves on shallow water. This diagram was obtained laboriously by observing computer simulation print-outs made by me and Gary Deem. We plotted by hand the location of maxima of the solution on the spatial (horizontal) coordinate versus time (vertical coordinate). Gary and I also made the first computer-generated 16 mm film of the KdV and nonlinear lattice.

1. COMPUTATIONAL PHYSICS

The computer is used by *STEM* people to make simulations of ideal and practical systems. Through various kinds of visualization and quantification techniques, these people eventually obtain a deeper understanding of the emerging natural or techno-logical phenomena. This computational approach applies to all disciplines and requires mathematical equations to represent the system, whether a space craft going into a moon orbit or the short-term weather prediction of our planet. In the former, a few ordinary differential equations (ODE) suffice, if the planetary motions are prescribed. In the latter, many partial differential equations are required to describe the ocean-atmosphere interaction with solar energy forcing and internal feedbacks, e.g the effect of: a massive volcano, changing area of snow cover in arctic regions, etc.

Easy to use software has been developed and engi-neering undergraduates are regularly taught how to set up simulations for non-complicated problems in a matter of minutes to hours. For example, the motion of a single "point" mass attached to an ideal *linear* spring can be described by a *linear* ODE and it undergoes a so-called "harmonic oscillation." If many such springs and masses are tied together on a one-dimensional line, the motion of this "lattice" is much more complicated, but it can be analyzed and understood. This situation changes immedi-ately if the springs are made *nonlinear*, for then the motion is "anharmonic" and the principle of *linear* superposition cannot be used, so the motion is best found by means of simulation.[11] Another example of a nonlinear oscillator is a swing undergoing a large-amplitude motion, which can be idealized as a point mass pendulum.

The first computational study of the dynamics of the nonlinear lattice, namely N identical masses coupled by identical *nonlinear springs* arranged on a line (one-dimensional), see Fig. 2, arose in the early 1950s. Physicists Enrico Fermi, John Pasta and mathematician Stanislaw Ulam , (FPU),[9] were overjoyed to obtain sufficient computing time at Los Alamos on the "MANIAC", one of the first digital computers. Such a lattice system supports left and right going "longitudinal" waves (like sound waves in a metal) and for their initial location of the particles the results were unexpected and paradoxical, as described in their 1955 report. A breakthrough in understanding came about ten years later with the discovery of the *soliton* by Kruskal and myself, as described in many books and websites.[10,11] This led to a remarkable mathematical breakthrough by Kruskal and colleagues[15] and many scientists around the world, which I will not discuss here.

Lets examine what FPU found, and in particular, how *visualizations and quantification*s of the non-linear lattice simulations evolved over the years. An obvious way to represent the motion of N masses is to plot the curves (functions) of the displacement of each mass on the line at discrete (or sampled) times. These graphs weren't very revealing. Another way, very commonly used by *STEM* workers, is to plot curves of the *energy* of the harmonics versus time, as shown in Fig. 3.

That is, a completely equivalent way to represent the particle displacement and velocity is by a sum harmonic amplitudes of the sine-plus-cosine func-tions of the space variable *x*. Here they were quick to observe that the initial generation of higher energy harmonics reversed itself much later in time and the system returned almost to its initial condition, in their case a single sine wave. This *near-recurrence* was counterintuitive, for the commonly held belief was that the system would evolve to a state of *equilibrated energy*. That is, the average energy in each mode is the same.

Kruskal and I decided to view this discrete system as a *dispersive-and-nonlinear continuum* (or "string"). Kruskal derived what was felt to be a model equa-tion to give the observed phenomenon, namely the Korteweg-deVries (KdV) partial differential equation. We changed the parameters somewhat, but the re-sults in terms of energy sharing and near-recurrence were the same and we produced the first ST diagram in our 1965 publication, as mentioned above. Fig 4, shows a version, produced by a student on a desktop computer circa 1995.

Figure 2. Lattice of masses coupled by nonlinear springs. The masses can move only in one dimension and the two ends of the chain were assumed to be fixed, i.e. $u_0 = u_N = 0$

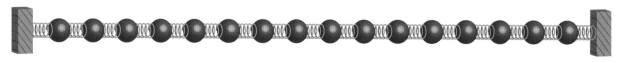

Figure 3. FPU near-recurrence of the energy in the low modes for a nonlinear lattice with N=32 and fixed ends.This is a colorized representation of the original hand-drawn figure, where modes are: 1 (magenta); 2 (red); 3 (green); 4 (blue); 5 (yellow).

Such quantification approaches can be generalized to two, three, and higher dimensions. Diverse applications are now being made: aircraft wake control,[12] weather prediction, etc . Note, the observed robustness of solitons during interaction allowed us to ask mathematical questions that had not been raised previously and insightful transformations were found that allowed an exact mathematical solution to the KdV problem, which verified the numerical solution. So to paraphrase Louis Pasteur, who said of his experiments: "In the field of observation, chance favors only the prepared minds." I say of computer simulations, "In *STEM* research, discovery favors optimal visualizations and quantifications for they prepare the mind."

This appreciation led me to emphasize Ulam's idea of the synergetic assistance that meaningful computer simulations can give to understanding and finally to introduce this mode of working with the term, "visiometrics," namely the visualization and quantification of evolving amorphous objects. Much work has also been done by the computer graphics group at TU in Delft.[13,14]

Here the amplitude of the dependent variable of the KdV is represented in rainbow-color: red,-orange for positive to dark-and-light blue for negative plotted versus space (horizontal) with time downward. The wobbly "streaks" moving to left and right are the unexpected translating and interacting solitons or coherent wave packets. The solitons interact and undergo a "phase" (spatial) shift but otherwise remain unchanged in shape and amplitude. For our chosen initial condition the streaks focus at regular time intervals at different points along the horizontal. This is another manifestation of near-recurrence.

Figure 4. Space-time diagram for Korteweg-de Vries Equation. Time is upward and two near-recurrence periods are shown.

Fig. 5, shows a ST diagram for the nonlinear "cubic" *lattice* obtained recently for N= 256. Here, for the first time, we have transformed (converted) the displacement and velocity of each particle into a discretized version of the continuum, so-called Riemann invariant, that exposes wave-like behavior. We found similar patterns in the simulations of the KdV model of the nonlinear cubic lattice.

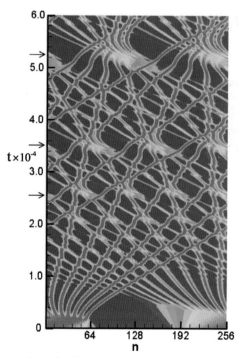

Figure 5. Space-time diagram of the discretized Riemann invariant for the FPU cubic lattice in a right moving frame of reference. Time is upward and one -half of a recurrence period is shown. The arrows indicate increasing times where the soliton streaks focus on the horizontal (spatial) axis at 4,3 and 2 places, respectively.

SPACE-TIME IN ART

What kind of art are these space-time images? For me the aesthetic experience is the element of revelation and surprise through optimal choice of variables, enhanced by choice of color and juxtaposition of data sets. The KdV and nonlinear lattice ST images preserve for me the eureka excitement I felt that evening that the soliton idea emerged to Kruskal and me as the possible answer to the near-recurrence paradox. In some sense the ST diagram, although abstract when dealing with 2D and 3D data sets, is a "low-complexity" form and according to Jurgen Schmidhuber's beauty postulate, they are beautiful. Perhaps we can call this new form *"Visio-art."*

Finally, all this led me to explore my interpretation of the meaning of science and art. In 2000, I gave the keynote talk at a Science and Art symposium, ScArt3,[15] and also showed a computer animation, "Cosmic Vortex Projectiles", made by Pittsburgh artist , Hilary Shames with verbal input from me. (I benefited much from my association with Hilary during 2000-2005). I organized the follow-up conference , ScArt4.[16] In 2003, I was interviewed for a Research Channel show on art and modern science[17] and in 2005 gave an invited American Physical Society lecture on visiometrics.[18] (The URLs at[15,16,17,18] are worth a visit).

NOTES:

1 Rebecca Solnit, *River of Shadows: Eadweard Muybridge and the Technological Wild West* (New York: Penguin, 2003).

2 Pribut, August 3, 2010, "Muybridge: Art, Motion and Biomechanics," 98.6: *Pribut's Blog*, http://www.drpribut.com/blog/index.php/2010/08/muybridge-art-motion-and-biomechanics

3 Marta Braun, *Picturing Time: The Work of Etienne Jules Marey* (Univ. of Chicago Press, 1992).

4 Marey and Muybridge are discussed in, http://www.univie.ac.at/cga/history/enlightenment.html

5 Mouvements de l'air, Etienne-Jules Marey, photographe des fluides, joint edition Gallimard / Réunion des musées nationaux, Collection "Art et artistes", 2004.

6 Figure from E. J. Marey: le mouvement en lunière, an exhibition in January, 2000 at the Fondation Electricite de France, Espace Electra was devoted to his works.

7 Marcel Duchamp, interview broadcast, *Monitor*, BBC, March 29, 1961. Also published in The Artist's Voice (italic), ed. Katherine Kuh, 1983.

8 "Soliton," Norman J. Zabusky and Mason A. Porter, *Scholarpedia*, http://www.scholarpedia.org/article/Soliton (2010).

9 Norman J. Zabutsky, "Fermi-Pasta-Ulam, Solitons and the Fabric of Nonlinear and Computational Science: History, Synergetics, and Visiometrics," *Chaos* 15 (2005), doi:10.1063/1.1861554.

10 Norman J. Zabusky and M.D. Kruskal, "Interaction of 'Solitons' in a Collisionless Plasma and the Recurrence of Initial States," *Physical Review Letters* 15 (1965): 240-243, doi:10.1103/phys.rev.lett.15.240

11 Norman J. Zabutsky, "Computational Synergetics and Mathematical Innovation," *Computational Physics* 43 (1981): 195-249.

12 "Secret Life of Vortices," CSElab, http://www.cse-lab.ethz.ch/

13 F.H. Post, B. Vrolijk, H. Hauser, R.S. Laramee, H. Doleisch, Feature Extraction and Visualization of Flow Fields, in: D. Fellner, R. Scopigno (eds.) Eurographics 2002: State-of-the-Art Reports, pp. 69-100. See http://visualization.tudelft.nl.

14 D. Silver, F. Post, and A. Sadarjoe, "Flow Visualization," (1999), http://graphics.tudelft.nl/publications/silver1999.pdf

15 Norman J. Zabutsky, "Scientific Computing Visualization - a New Venue in the Arts," Science and Art Symposium (2000): 1-11.

16 ScArt4: 4th Science and Art Conference, Supported Rutgers University, New Brunswick, N.J., 2005. Conference website: http://mechanical.rutgers.edu/scart4/.

17 "From Art to Modern Science: Understanding Waves and Turbulence, an interview with Norman J. Zabusky," by Paul Leath, *By The Book*, Research Channel, July 24, 2003.

18 http://www.mechanical.rutgers.edu/scart4/LaPorte.APS,DFD.Soli,VPasSHOWN112303.pdf

Catinca Tilea

MY TIME

MyTime emerges from the idea that time is subjective.

Subjective time means that time is something relative, determined by how each individual perceives and relates to different events. The concept follows the time of all those little things that construct one's personal experiences.

MyTime is placed in a context of an urban lifestyle in which people live in a permanent rush and have no moment for self-reflection. Therefore, the idea overcomes conventional time underlining a prominent contemporary problem: the lack of time.

MyWatch, the object emphasizing subjective time, is living with you for a short while. An alga grows inside of it, faster or slower, depending on the amount of heat it receives from the body and external light it absorbs. Its functionality derives from the hypothesis that you take as much care of yourself as you take care of your surroundings. The life of the object relates to the user, namely to the connection between one's biorhythm and the plant's development. The direct dependency of the life form to its owner enables the latter to contemplate the relationship between him/her and other life forms. This contemplation would trigger an emotional type of self-reflection.

The object is composed of two main elements: the greased come-and-go shape tube, which helps the alga develop inside of it, and the elastic bracelet that serves as a support for the tube while measuring the plant growth. The elastic bracelet is charged at both ends with a basic electronic watch mechanism. At the beginning tag, it scores the date when the alga was first assembled. At the ending tag, the bracelet scores the current date and time, until the moment when the plant will reach the end of its germination. Therefore, current time stops when the organism fills-in the whole tube. At this particular moment, the only thing that could reactivate the time count would be replacing the old tube for a new one.

MyWatch works as a psychological stimulant. Consequently, it has a short life expectancy. The object is meant to be the engine that makes you reflect more on yourself.

CONSIDERED: TIME FRAGMENTED

Katherine Davis

The following four works are visual expansions on the theory Time Fragmented. This theory is an attempt to reconcile the issues brought up with Special Relativity for dynamic models of time. Time Fragmented is centered on the four premises: there are single "here-now" points that define the present and definite past; reality is reflexive; reality is not symmetrical; and for there to be the definite reality, there must also be indefinite unreality. A pillar of this theory is the idea that temporal becoming does not require a spatially extended now; this being the means of avoiding issues with simultaneity and relativization.

1. *Infinite Fragments and Absolute Becoming*: There are an infinite number of "here- now" points in space, each with an individual past light cone that determines a specific reality. Each unrelated fragment has a unique path of absolute becoming, growing with the passage of time. The empty infinity lines, signifying the future, enforce a key premise to the time fragmented theory—for the existence of the definite reality there must also be a certain indefinite future.

2. *Crossover Reality of Individual Fragments*: Two "here-now" points are depicted as coexisting despite the limitations of the Time Fragmented theory to illustrate the crossover in reality of two individual past light cones generated by separate here-now points. Although to each other they are nonfactual, these points share portions of their pasts and have some degree of similar reality, dependent on the distance between the two points.

3. *Cone Presentism*: This idea is an alteration of the Time Fragmented theory in that the entire past light cone of the decided now point comprises the present moment. This present, defined by the light cone, contains many other space-time points and their pasts. This version of presentism coincides with the phenomenology of perception in the present: one sees many different times at once just by looking into the sky at stars from thousands of years ago.

4. *Absolute Becoming in Two Views*: This is an illustration of the absolute becoming of two points side by side, highlighting the momentary shift of reality point by point with the passage of time. With the progression of each moment, the degrees of shared reality between points is enlarged and altered. As new presents become, the here-now points are a new addition to the past.

All works India ink and water on paper; 2009.

THE MUSIC OF HYPERTIME

Paul Doru Mugur

1. TIME PUZZLES

For humans, there is always something that moves, that changes outside or inside our bodies. Even when no movement is perceived outside our bodies, the thoughts come and go and the heart continues to beat so there is always movement and change associated with existence. We derive the notion of "time" from the perception of movement. Time is like the scattered pieces of a puzzle, or several puzzles, that we try to fit together: our perceptions and our immediate, short- and long-term memory capture different aspects of change from which we build up a concept encompassing all these elements. The perception of movement is a basic irreducible human experience like the color red. The notion of time is based on this experience but we never perceive time directly.

Time has different meanings in different conceptual models. On one hand, there is the conventional psychological meaning of time where we talk about the flow of events, changing from being future, to being present, to being past, and about the "now." On another hand there is the meaning of time in contemporary physics that follows Einstein's idea that *"the distinction between past, present, and future is only a stubbornly persistent illusion"*[1] considers the flow of time a misleading metaphor: *"Time exists, things change, but time does not flow objectively. There may well be some objective feature of our brains that causes us to believe we are experiencing a flow of time, but the flow is not objective".*[2]

The paradoxical nature of time that combines in one notion movement and rest, presence and absence has fascinated the minds of philosophers since Zeno of Elea with his "arguments against movement." Aristotle defined time as *"the number of motion with respect to earlier and later. But we apprehend time only when we have marked motion, marking it by 'before' and 'after'; and it is only when we have perceived 'before' and 'after' in motion that we say that time has elapsed."*[3] In this definition, Aristotle got away from the purely qualitative aspect of movement to find something that he could pinpoint, an objective quantity that is measurable. The development of physics to our date is a continuation of his idea that *"time is the number of movement"* bluntly ignoring the fleeting aspects of time and concentrating only on its measurable aspects.

Steve Witham; *Computer Generated Escher Grid*; digital PS file; 2009.

From this idea of numbers, or strings of numbers, separated only by the distinction between "earlier and later" comes the image of time as a point on a straight line and as time running monotonously and continuously as it does in a clock.

Einstein's revolutionary insight was that time as an independent flow does not exist, only a consensual co-dependent evolution of phenomena in the world is possible: his theories of relativity state that there is no single history, no unique timeline in the physical world. His approach is pragmatic: in order to study a phenomenon first you isolate it from the rest of the world and then you look at it as you would do with a culture of bacteria in a Petri dish under the microscope. As Edward Arthur Milne pointed out, Einstein's model eliminates the meaning of a universal time "if time means different things for two different observers,[...] no meaning can be attached to a unique temporal ordering of the totality of events." [4] In a cosmos with a multitude of observers progressing at different speeds Milne's conclusion is that the world *"contains an infinite sequence of observers for whom it is arbitrarily young. The world is thus a continuing system; each particle or nebula has an evolutionary experience behind it and in front of it, with ultimate decay as its goal, yet the world as a whole cannot be said to decay. It is not the same in an observer's today as in the observer's yesterday, but it is the same forever. Creation never recedes into the past; it is only just beyond the limit of observability in our own present. Time advances for each separate observer, but the universe as a whole knows no definite age at an assigned event; the worldwide instant of the observer to whom this event occurs contains experiences which assess the age of the world at all values from that assigned by the given observer down to zero."* [4]

If clocks give us the illusion of a monotonous objective time, clearly subjective time does not flow monotonously because as G.J. Whitrow noticed *"our conscious awareness of time depend on the fact that our minds operate by successive acts of attention and, moreover, is influenced by the tempo of our attention."* [5] Events may be perceived shorter or longer according to the attention we give them and the relevance attached to them. "Put your hand on a hot stove for a minute, and it seems like an hour. Sit with a pretty girl for an hour, and it seems like a minute," [6] Einstein famously said. Also, the perception of time is different for people of different ages.

As the poet Guy Pentreath (apud 5) wrote:

"For when I was a babe and wept and slept
Time crept;
When I was a boy and laughed and talked,
Time walked;
Then when the years saw me a man,
Time ran,
But as I older grew,
Time flew."

2. PSYCHOLOGICAL HYPERTIME

Time is not only a concept in our heads or a theoretical model, it is present both inside our minds *and* in the outside world, it is both real and illusory. How can we conciliate these seemingly irreducible aspects?

We take for granted that all moments are of the same quality regardless of their position on the timeline, that the rate of time passage is uniform. But is this assumption correct? And what "time passage" are we talking about anyway? If we follow Einstein's argument there is no universal time and only local time can exist. Could time itself possibly change?

Aristotle's opinion was that "change is always faster or slower, whereas time is not: for 'fast' and 'slow' are defined by time—'fast' is what moves much in a short time, 'slow' what moves little in a long time; but *time is not defined by time*, by being either a certain amount or a certain kind of it." [3]

When Aristotle thought that "time is not defined by time" he was referring to "external," "objective" time. On the other hand, subjectively, when we think about time, *we never perceive time itself*; we collect sensory data and we synthesize information, we perceive movement and we use our memory to compare flows, but we do not feel, we do not hear, we do not see the passage of time. As G.J Whitrow citing Gaston Bachelard wrote: *"Our direct experience is always of the present, and our idea of time comes from reflecting on that experience."* [5] Then, several pages later, *"we have no direct experience of pure time but only of particular sequences and rhythms since it is not time itself but what goes on in time that produces effects."* [5] What we call time is always a derivative, a second order concept. Derived from the perception of movement, subjective time is never independent, it is always related through interactions or comparisons to other actual or

memorized events *and* to a specific external temporal context. Contrary to what Aristotle thought, in our human experience *subjective time is defined by time only*, and different aspects of subjective time—succession, simultaneity, duration—are all created by comparing and integrating different temporal components, some external, acquired through the mechanisms of perception other internal, present in our memory or imagination. In our conscious, subjective experience, an event has to be compared to another event (or events) in order to be acknowledged as distinct and the comparison itself takes place in time.

I introduce here for the first time the notion of "hypertime" in order to point toward the composite and relational nature of subjective time and suggest the metaphor of a network-like structure of time as opposed to the classical image of a continuous line. I believe that the image of time as a uniformly monotonous flow of identical moments is not an accurate description of our inner temporal experience. Inside our consciousness, time mutates, evolves, changes and we are aware of these changes only in/because of the existence of hypertime.

We mentioned before that subjective time is a concept derived from the perception of movement. This derivation is not direct and it involves a complex scheme of comparisons between three co-dependent elements: a memorized past movement/event, an observed movement/event, and the context of the comparison between the two. All three components of this triad interact continuously and a hyper-temporal structure is generated through their interaction/integration. Temporal meanings appear inside this triad that resemble, in more than one way. The semiotic triangle of Ferdinand de Saussure.

Similar ideas have been proposed before. In an article published in 1982 in *Mind,* [7] George N. Schlesinger wrote that "not only would it make full sense to speak of time as moving, we could also assign a definite value to the speed with which it was moving." More recently in "Chronosophia"[8] Mihai Dinu defined the "speed" of subjective time as the proportion between *t* (subjective time) and *T* (objective time), i.e. how much objective time flows in parallel with the subjective time flow. He was reluctant to consider it a real "speed" of time, preferring to think of it as the "speed" of consciousness sliding along the axis of universal time. In our view, the existence of this "speed" of consciousness that integrates subjective and objective aspects of time is an indirect proof of an underlying hyper-temporal structure.

What we commonly called psychological time is, in fact, psychological hypertime. In our minds, events are always interrelated: every perceived moment is interdependent with other preceding and following moments: this interdependence makes each moment unique, different from the others and generates hypertime.

Given the plastic nature of this hypertemporal network it is conceivable that what we call "now," "duration," "past," "present," and "future" may suddenly change in some type of "subjective time singularity" and a *noo-temporality* or *noo-sphere* may emerge integrating in a novel way our conscious experiences.

3. PHYSICAL HYPERTIME

In philosophy and physics, the idea of times with more than one dimension/direction has been around for many years and there are several alternatives to the Kantian a priori model of a unique time responsible for both change and causality.

For example, in order to explain the birth of the universe and the apparition of time in the Big-Bang model Stephen Hawking and James Hartle proposed in 1983 the notion of a secondary timeline, called *imaginary* timeline, perpendicular to the direction of the real time, like the latitude and the longitude on the surface of the sphere.

It is important to point out that a physical model with more than one time dimension has to solve some problems: like the difficulty of predicting because it is ultra-hyperbolic (Tegmark, 1997) and it may be unstable.

4. HARMONIA

Living organisms are symphonies of tightly regulated biorhythms. These biorhythms not only integrate different populations of cells and body functions into a functional whole but they also facilitate the adaptation of the individual organism to its environment. The primary biorhythm present in many organisms, including plants, animals, fungi, and cyanobacteria, is called the circadian rhythm (from the Latin circa, "around," and diem or dies, "day," meaning ap-

proximately a day). In humans and other mammals the structure responsible for this "master clock" is located in the suprachiasmatic nucleus (SCN), a pair of groups of cells in the brain's hypothalamus and it regulates many bodily functions, including sleeping, body temperature, feeding, and hormone production. Outside the SCN other clocks called peripheral oscillators are present in different organs (skin, liver, skin, etc) and also cells from many parts of the body appear to have free running rhythms regulating different functions (cell division, protein secretion, etc).

The idea of rhythm as a glue has been developed by Francisco Varella on his work on neuronal synchrony via coupled oscillators. The neuronal synchronization hypothesis that "a specific cell assembly of neurons emerge through a kind of temporal resonance or "glue" and postulates that it is the precise "coincidence of the firing of the cells that brings about unity in mental-cognitive experience." Different aspects of time as for example the perception of the "now," the "lived present," emerge as a consequence of this "frame or window of simultaneity"10 of activation of synchronized neurons.

We can extrapolate the models of chronobiology and the synchronization hypothesis of Varella and imagine a cosmos in which all the events are bound harmoniously together through rhythmicity in a vast temporal network. No temporal islands can exist outside the grid of co-dependent events. This vision of time and rhythm as a cosmic glue is not original. In the Ancient Greece, for Pytagora and his fellow searchers of the hidden harmony of the spheres, time was also some type of cosmic glue. In fact, *harmonia* the key word of the Pythagoreans meant primarily the joining or fitting of things together. Aristotle criticized the Pythagorean as having reduced all things to numbers or elements of numbers, and described the whole universe as "a harmonia and a number." Alexander of Aphrodisias, commenting on a passage in Aristotle's "Metaphysics" (Book 1 Part 5) wrote: *They said too that the whole universe is constructed according to a musical scale (...) because it is both composed of numbers and organized numerically and musically. For the distances between the bodies revolving round the center are mathematically proportionate; some move faster and some more slowly; the sound made by the slower bodies in their movement is lower in pitch, and that of the faster is higher; hence these separate notes, corresponding to the ratios of the distances,*

*make the resultant sound concordant. Now number, they said, is the source of this harmony, and so they naturally put number as the principle on which the heaven and the whole universe depended.*12

The connection between different events may not only be horizontal (through synchronicity) but also vertical (recurrence of the same time structure at different time scales). For example, we can find similarities between the timeline of the Big-Bang model of the universe and the timeline of embryological development of the living organisms and we can imagine that time itself may contain self-similar sequences on different time scales and thus it may have a fractal-like structure. In biology there is the Haeckel law, "ontogeny recapitulates phylogeny" to which we may possibly add: "ontogeny recapitulates phylogeny recapitulates cosmogony."

The same music that created the cosmos day by day is playing right now within us.

An earlier draft of this text was presented on 06.07.09 at the Tank Space at a multi-disciplinary conference on time in New York.

NOTES:

1 Letter from A. Einstein to the family of his lifelong friend Michele Besso, after learning of his death, (March 1955) as quoted in "Science and the Search for God: Disturbing the Universe" (1979) by Freeman Dyson Ch. 17 "A Distant Mirror".

2 Internet Encyclopedia of Philosophy, http://www.iep.utm.edu/time/

3 Aristotle Physics Book IV Parts 10 and 11. http://classics.mit.edu/Aristotle/physics.mb.txt.

4 E.A. Milne, "Some Points in the Philosophy of Physics: Time, Evolution, and Creation," *Philosophy* 9, no. 33 (1934): 219-238.

5 G.J. Whitrow, *The Natural Philosophy of Time* (Oxford Univ. Press, 1980).

6 Alice Calaprice, ed., *The Expanded Quotable Einstein* (Princeton Univ. Press, 2005).

7 George N. Schlesinger, "How Time Flies," *Mind* 91, no. 364 (1982): 501-523.

8 Mihai Dinu, *Chronosophia* (Bucharest: Romanian Cultural Foundation Publishing House, 2002).

9 Max Tegmark, "On the Dimensionality of Spacetime," *Class. Quantum Grav.* 14 (1997): L69-75.

10 Francisco Varela, "The Spacious Present: A Neurophenomenology of Time Consciousness," in *Naturalizing Phenomenology* by J. Petitot, F.J. Varela, B. Pacoud and J. Roy, eds. (Stanford Univ. Press, 1999), 266-329.

11 W.K.C Guthrie, *A History of Greek Philosophy: The Earlier Presocratics and the Pythagoreans* (Cambridge Univ. Press, 1962), 296.

Glen River

My attitude toward creativity described as Zen Process takes the art to a new resolution, which freezes time as well as parts of separate visions. The Big Picture installation is thirty panels, which are 20" x 30" each hung in a configuration of six columns and five rows. Some of the source materials are paintings originally created from 1965 through 2007. Between dissection and repainting, the original context is drastically altered. My overview of a greater vision was realized in the compression of time. Part of my concept of art is art as intentional artifact of its time.

Big Picture 2; mixed media on 30 panels; 13' x 11'; 2008.

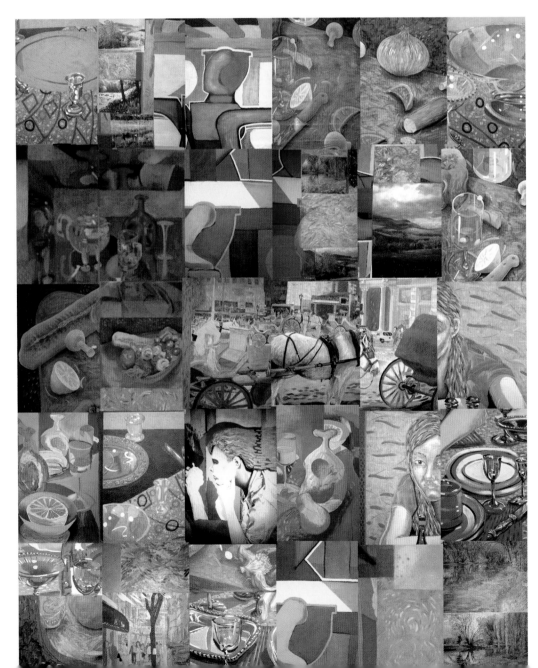

Gary Nickard

The tachyonic anti-telephone is a hypothetical device in theoretical physics that can be used to send signals into one's own past.

Such a device was first contemplated by R. C. Tolman in 1917[1] in a demonstration of how faster-than-light signals can lead to a paradox of causality (a.k.a. Tolman's paradox). The problem of detecting faster-than-light particles (a.k.a. tachyons) via causal contradictions is considered in D. L. Book and W. A. Newcomb's 1971 article.[2]

To use the tachyonic anti-telephone, the user must aim it at the position in space occupied by the earth in 1930. The user then must dial the telephone number 2807 and the device will transmit a beam of modulated tachyons back into time. When the beam arrives in 1930 the telephone will ring at the University of Berlin and none other than Albert Einstein will answer to help the caller with his or her physics questions.

The theoretical tachyon particle is mathematically derived from Einstein's equations for General Relativity; its possible existence can be described from a model called a light cone.

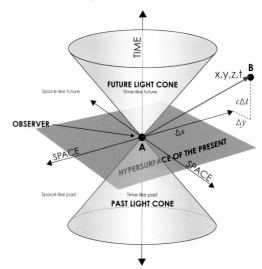

The edges of this cone are where the velocity of a particle or wave is equal to the speed of light. Events on these edges are called, logically, "light like." Within the cone, velocities are always less than the speed of light and are called "time like." Outside the cone, theoretical events must occur at speeds greater than the speed of light and are called "space

Tachyonic Anti-Telephone; 2006.

like." Also important to note is that mathematically as a particle approaches the speed of light its mass approaches zero. Light beams, or photons, have zero mass. The mathematical derivation for the tachyon shows that for its speed to be greater than that of light its mass must actually be imaginary!

$$E = \frac{mc^2}{\sqrt{1 - \frac{v^2}{c^2}}}$$

Time Machine; 2009.

The other problem with the tachyon is that it disobeys a principle fundamental to general relativity—causality. This is simply that the cause of an event must not occur before the effect. For example, a photon cannot be absorbed before it is emitted. Within the light cone the past and the future are divided so that the past is behind now and the future is in front of now. Outside the light cone in the domain of the tachyon, however, there is no such division and therefore the tachyon can break the law of causality.

References

1 Richard Chace Tolman, *The Theory of the Relativity of Motion* (Berkeley: Univ. of California Press, 1917), 54.

2 G.A. Benford, D.L. Book, and W.A. Newcomb, "The Tachytonic Antitelephone," *Physical Review D* 2, (1970): 263-265.

Photos by Biff Henrich
Image by Mike Massett & Renee Ruffino

PHOTOGRAPHY AND FREUD

Gary Nickard

PHOTOGRAPHY AND FREUD

"Humankind lingers unregenerate in Plato's cave, still reveling its age-old habit, in mere images of the truth."
—Susan Sontag, *On Photography*

"Society is very much concerned with taming the photograph, to temper the madness that keeps threatening to explode in the face of whoever looks at it. To do this it possesses two means. The first consists of making photography an art, for no art is mad... The other means of taming the photograph is to generalize, to gregarize, banalize it until it is no longer confronted by any image in relation to which it can mark itself, assert its special character, its scandal, its madness."
—Roland Barthes, *Camera Lucida*

1. PHOTOGRAPHY AND THE UNCANNY

Freud describes the uncanny as "that class of frightening...". Does it seem too extreme a term to apply to the medium of photography? If the examples of uncanny that Freud cites are applied to photography, then parallels can be quickly established. Freud's first example is taken from a quotation in Jentsch: the automaton whose presence "raises doubts whether an apparently animate being is really alive; or conversely, whether a lifeless object might not in fact be animate." The camera is itself just such an automaton. It is an artificial eye—a machine that sees and creates "realistic" pictures. In relation to the purported objective "truth value" of the photographic medium, (since "the camera never lies"), this artificial eye has even managed to usurp the primacy of the human eye. Thus, its objectifying gaze can be seen as uncanny, reducing all three-dimensional time-based events, situations, and subjects placed before its gaze into contrived "realistic" but "frozen" two dimensional representations. Susan Sontag reminds us in *On Photography* that "...the photographic image is also an object," that it is an *inanimate* object derived from an animate world. Since the camera is an instrument of mechanical reproduction, the operator has only limited control over the resulting image—a factor that has engendered the myriad historical arguments against the eligibility of photography for status as an art (e.g. one of the medium's foremost proponents, Peter Henry Emerson, ultimately declared that it was not an art because of the uncontrollable sensitivity of actinic agents). In fact, regardless of the era, the technology employed, or the sophistication of the operator, the apparatus, once animated by its purpose, seems to

take on a life of its own: "The daguerreotype is not merely an instrument which serves to draw nature... [It] gives her the power to reproduce herself."

The second example of the uncanny that Freud provides is "the idea of something fateful," a concept related to photographic practice that he elucidated in *Totem and Taboo*. Perhaps best seen in relation to Henri Cartier Bresson's "decisive moment," this is clearly an artifact of the element of chance affecting both the random vicissitudes of the subject depicted, as well as the elements of the imaging process that the photographer cannot control. A photographer stalking subjects in search of the "decisive" (or as my teacher, theorist, and photographer Nathan Lyons describes it, the "incisive") moment—that fortuitous instant when everything in the visual field falls into place and "the picture as Duchampian readymade" offers itself up for the taking by an astute and sensitive observer with a camera—is actually in a situation that implies that the photographer has an unconscious knowledge that a picture will present itself, regardless of whether or not the camera is directed toward it. Thus chance becomes fate and the photographer's rarified skill touches upon what Freud called "the omnipotence of thoughts."

In relating photographic chance to the idea that photographs can be found objects—what Sontag calls "unpremeditated slices of the world," "chance" can actually be seen to be a misnomer when we consider Freud's concept of "the compulsion to repeat." Hal Foster has pointed out that the found object is in fact the lost object regained: "an unconscious compulsion associated with a real event is seen instead as a real event that produces an unconscious effect." In other words, found objects are found precisely because they are (unconsciously) looked for. A found object can therefore appear uncanny, due to it already being strangely familiar to the unconscious of the photographer, who after actively (though unconsciously) seeking it, suddenly "recognizes" it and takes the picture.

2. PHOTOGRAPHY AND THE MIRROR STAGE

If, as Mladen Dolar states in his reading of Otto Rank's *The Double: A Psychoanalytic Study*: "the shadow and the mirror image are the obvious analogs to the body," then perhaps this idea could logically be extended to photography, since this medium also produces "immaterial doubles, and [is] thus the best means to represent the soul." There are innumerable anecdotes where, among "primitive cultures," photography has been regarded as a feared "stealer of souls." It is precisely such "primitive" fears as these that remain repressed in the unconscious that produce the uncanny. Furthermore, if as Dolar states, "the shadow and the mirror image survive the body due to their immateriality—so it is that reflections constitute our essential selves," then we must take into account that a photograph is just such a shadow or reflection, captured by a lens and projected onto a light sensitive surface. If the photograph is now recognized as a form of double, then Dolar's discussion of this form of the uncanny, when seen in light of Lacan's concept of the mirror stage, brings to mind some interesting implications regarding the parallels between the mirror image and the photograph. These implications are particularly compelling in view of the fact that Daguerreotype was commonly known in the 19th century as "the mirror with a memory." In looking at a photograph of one's self, our point of view is from an objective position (outside of oneself)—as in looking at a mirror image—an entirely uncanny experience:

"But imagine that one could see one's mirror image close its eyes: that would make the object as gaze appear in the mirror. This is what happens with the double and the anxiety that the double produces is the surest sign of the appearance of the *object a* [that thing that sets *both* desire *and* the drive into motion]. Here the Lacanian account of anxiety differs sharply from other theories: it is not the anxiety of losing something (the firm support, one's bearings, etc.). On the contrary, it is the anxiety of gaining something too much, of too close a presence to the *object a*."

For Lacan the mirror stage occurs approximately between the ages of six and eighteen months and corresponds to Freud's stage of primary narcissism. That is the stage of human development when the subject is in love with the image of themselves and their own bodies that ultimately (in healthy subjects) is transferred into the love of others. During the mirror stage the infant begins to recognize its reflection in any reflective surface (e.g. mirrors, photographs, it's mother's face, etc.) and is initially associated with fascinated playful pleasure. For Lacan, this process signifies the point at which the infant has moved out of the imaginary and has entered into the symbolic

realm and has begun to employ language. Although the child initially confuses the image with reality, the infant soon realizes that it has its own properties and ultimately accepts that the image is a reflection of itself. What is important is that the infant identifies with the mirror image because without this identification, the child would never perceive itself as a complete human being. Yet, at the same time, the image is alienating in the sense that it is outside of the subject and becomes confused with the subject—the child's recognition of a whole self is, in reality, a *mis-recognition*. As a result, any sense of a unified self is acquired only at the price of this self becoming an other to itself (i.e. we become our own mirror image). For Lacan, the ego emerges at the moment of this simultaneous alienation and fascination with one's own image, in other words, the ego is a direct result of mis-recognition—of refusing to accept the truth of our actual fragmentation and alienation.

That seeing a photograph of one's self is also an occasion of the mirror stage is borne out by the fact that many people are quite uncomfortable when confronted with such images. Since Freud views the double as a source of the uncanny, Dolar is correct to reference Rank's discussion of the relationship between reflections, shadows and sprits to "the belief in the soul" (the initial double of the body) and "the fear of death". Rank points out the original function of the double was to serve as an "energetic denial of the power of death" and that belief in a soul arises from "the primary narcissism that dominates the mind of primitive man"—a remainder of the self that continues to exist after death. Thus the double can therefore be symbolically inverted into "the uncanny harbinger of death", just as "after the collapse of their religion, the gods turn into demons". As a result of this inversion in photography, the friendly face of the image that doubles reality, in actuality returns from the repressed as an uncanny thing of terror.

That photography is a mirroring double of reality should seem obvious—as Hal Foster reminds us, it is clearly "a usurpation of the referent by the sign, or of physical reality by psychic reality. The apparent "natural" veracity of the medium gives it the aura of "transparency"—a sign that in semiotic terms purports "objective exactitude" in representing the signified, without calling attention to itself as a signifier. The subject of a photograph is most often seen *through* the photograph—quite literally as if the opaque two-dimensional representation was instead a transparent window affording a view to "a world outside:"

"An uncanny effect is often and easily produced when the distinction between imagination and reality is effaced, as when something that we have hitherto regarded as imaginary appears before us in reality, or when a symbol takes over the full functions of the thing it symbolizes and so on".

Accordingly, photographs are commonly regarded as embodying a certain essence of the subject represented, as if the distinction between reality and representation were collapsed into one in the image. Roland Barthes asserts that:

"...photography's referent is not the same as the referent of other systems of representation. I call the photographic referent, not the optionally real thing to which an image or sign refers, but the necessarily real thing that has been placed before the lens, without which there would be no photograph".

Thus Barthes seems to find the uncanny in the way the photograph disconcertingly insists that we focus our attention upon its referent rather than upon its actual nature as representation:

"a specific photograph is never distinguished from its referent (what it represents) it is not possible to perceive the signifier [...] but it requires a secondary action of knowledge or of reflection".

Thus, the "indexical" aspect of photography means that it is an object existing in reality that puts the viewer in the present into a direct relationship with another reality, that exists in another (past) time. Photography unnerves us by its uncanny distortion of both reality and time in that it is an instance of the frozen past exiting in the present—a condition that Barthes noted with considerable melancholy explicitly struck him in relation to the portrait of his mother as a little girl—it serves as a powerful *memento mori*.

3. PHOTOGRAPHY AND DEATH

In *Camera Lucida*, while Barthes ruminated extensively upon the uncanny nature of photography, most of the narrative is concerned with the centrality of death and its semiotic implications for the photograph. He staunchly defends the medium's veracity:

"Photography never lies; or rather, it can lie as to the meaning of the thing, being by nature tendentious, but never as to its existence".

Whatever vicissitudes of meaning may be derived from a photograph—something has necessarily been fixed by the camera—something was evidently there before the lens. As a result, Barthes concludes that, due to the actinic agency involved in the photographic process, the camera's gaze is actually touched by the body of the subject of the photograph and he maintains that it is light that serves as the haptic link that connects the subject, something *that has been* before the lens, to the viewer through "radiations that ultimately touch me." This follows Sontag's assertion that "the photograph of the missing being will touch me like the delayed rays of a star." There is obviously an intertwined relationship between these two thinkers on this subject, for example she also stated that:

"the photograph is also a trace, something directly stenciled off the real, like a footprint or a death mask... a photograph is never less than the registering of an emanation (light waves reflected off objects)—a material vestige of its subject".

It is precisely due to this haptic link between the subject and its image—the certainty of an existence within the past—that within this past, the photograph is thoroughly permeated by an aura of "an asymbolic death". Margaret Iverson's reading of *Camera Lucida* explicates this:

"The nature of the medium as an indexical imprint of the object means that any photographed object or person has a ghostly presence—an uncanniness—that might be linked to the return of the dead".

This understanding is predicated upon Sontag's statement that: "A photograph has both a pseudo-presence and a token of absence." For example, in discussing Alexander Gardner's haunting 1865 photograph of Lewis Payne (one of the Lincoln assassination conspirators) sitting on the deck of a Union ironclad shortly before his execution, Barthes describes the image as "*this will be* and *this has been*," an anterior future—a future past and that future is death:

"In front of a photograph of my mother as a child, I tell myself: she is going to die, I shudder... over a catastrophe that has already occurred. Whether or not the subject is already dead, every photograph is a catastrophe".

This realization is, according to Barthes, "more or less blurred" in modern photographs, but is quite acute in historical examples:

"There is always a defeat of time in them: that is dead and that is going to die".

Extending this observation, Sontag similarly states that photography is an "elegiac art" and that the photograph has become the modern *momento mori*: with the concept of time, for the subject of the photograph, ultimately resolving itself in death). This point is supported by Freud who observed:

"many people experience the feeling [of the uncanny] in the highest degree in relation to death... our thoughts and feelings have changed so little since the very earliest times, and in which discarded forms have been so completely preserved under a thin disguise, as our relation to death".

So death is the ultimate incarnation of the abstraction that is the uncanny: both undeniably familiar and undeniably repressed. In that the photograph embodies the uncanny, no matter how superficially cheerful it may be, it is always remains a representation of death repressed. Thus, despite the fact that death is rarely explicit in photographic images as an overt presence, it remains totally implicit in the very nature of the medium.

References:

Barthes, Roland. *Camera Lucida*. London: Hohnathan Cape, 1982.

Dolar, Mladen. "'*I Shall Be With You On Your Wedding Night*': Lacan and the Uncanny." *October* 58 (1991).

Foster, Hal. *Compulsive Beauty*. Cambridge MA: MIT Press, 1993.

Freud, Sigmund. *The Uncanny*. London: Penguin, 1985.

Freud, Sigmund. *Totem and Taboo*. London: Penguin, 1985.

Freud, Sigmund. *Beyond the Pleasure Principle*. London: Penguin, 1985.

Iverson, Margaret. "What is a Photograph?" *Art History* 17, no. 3 (1994).

Sontag, Susan. *On Photography*. New York: Farrar, Strauss and Giroux, 1978.

Artists and thinkers typically characterize the flux of experience as an undifferentiated continuum of sensuous particulars, haphazard, unorganized, a "raw stuff" to be ordered and structured by our sense organs and the cognitive structures of the mind.

This video work of visual flux seeks to counter the traditional notion of flux. It is based on a phenomenological investigation in which flux is explored, not as a random sequence of unstructured percepts, but rather as a concatenation of rhythms. Even at the level of raw sensory perception there is a high degree of repetition at work, and these repetitions overlap. Not only are there the repetitions of the body—breathing, blinking, heart beats, walking, chewing, and the perception of wavelengths of light and sound (regularly repeating and thus identifiable)—but the environment is also ordered in layers of repeating vectors—dawn and dusk, seasonal changes, waves crashing into a beach, the repeated calls of animals and insects.

This work is composed of very brief fragments of overlapping visual pulses—each pulse being a momentary articulation of the body. This work engages in something of a temporal polemic with the approach to time and change found in Stan Brakhage's work, which so often ignores the minute repetitions to be discovered in even the most fleeting of perceptual experiences. The video is part of a series named after Maurice Merleau-Ponty's concept of the interworld.

INTERWORLD

Michael Filimowicz

COMPLEX TEMPORALITY OF INTERACTIVE ARCHITECTURE

Christian Friedrich

1. TIME-BASE OF ARCHITECTURAL DESIGN MEDIA

Developments in architectural design media have challenged architects to revisit the design process, toward an increasingly non-linear, networked, algorithmic endeavor, eventually incorporating real-time, collaborative design interactions.

Absorbent media, for example pen and paper or clay, are the earliest kind of design media. They absorb the manipulations of the designer who can read back the effect and development of the design action. These media have each their own material logic that sets the mode of design exploration. For example, in sketching the design act is constrained by the need to recognize the lines as representation of a three-dimensional object of certain proportions, hence only forms that can be comprehended from a fixed point of view can be effectively sketched. Clay modeling is constrained and guided by granularity and cohesion. Absorbent media act purely as reflective devices; all input is absorbed by the medium but cannot be actively transferred by it, in a sense all input is lost and has to be read back by means of copying, scanning, re-sketching, in order to serve as guide for reformulation on another level. Next to the material logic of each absorbent medium, which can act as design guidance, absorbent media are very direct to work with, immediately showing the applied changes. They allow the designer to enter a state of flow, similar to playing a musical instrument, in which the design intention can be tested against possibilities of formulation. This kind of exploration may help the designer to become more aware of the task in a reflective manner and to explore design possibilities within the material logics of the chosen medium.

Early digital design media often mimic material absorbent media as reflective one-way input devices, but generally lack the immediacy of input as they force the designer to follow a restrictive mode of input modalities and operations. Applications as AutoCAD mimic the drawing table, and the drawing entities defined by the designer are originally meant to end up in a printed plan, even though the tools digitally exchange the information, quickly create different versions, and make multiple prints with little effort.

Algorithmic tools offer a very different mode of design exploration. They are script-based and have a clear distinction between script editing and *run-*

time, where the first allows the designer to formulate pre-conceived rules of design formulation and the second involves no interaction until the script has run completely.

The possibility of running the algorithm again with different parameters on demand makes it a reactive medium, entering the realm of parametric design tools. Parametric design tools generally only update the design model in reaction to user input, completely regenerating the model based on the new parameters. In this way, they work as algorithmic tools that compute fast enough to give a split-second update and provide an interface for applying multiple interconnected operations in a visual manner. Recent examples favored by architects are the Grasshopper plug-in for Rhino3D and Generative Components, which runs on Microstation. With parametric design tools we enter the realm of interactive media, which include a feedback loop fast enough to let the user experience the relation between input and outcome and to establish an interaction that allows for flow-states to occur.

A further evolutionary step of digital design tools leads to behavioral media, as developed by Hyperbody on the basis of the game authoring platform Virtools. These are continuously, iteratively computing the effect of design rules applied to the model, in an ongoing stride to optimize according to the set of rules formulated and used by the designer. These tools offer the most direct mode of interaction, and let the designer interfere even during the optimization process. The result is a tool that lets the designer develop a haptic sense for the behavior of design models, which can be seen as computer-generated equivalent of material logics. The possibility for formulation of these logics together with the immediate feedback do enhance the designer's facilities to develop design awareness. This can even be furthered by the possibility of digital tools to accurately handle spatial computation and giving specific visualizations of the ongoing process and spatial setup.

There is another aspect to the way in which behavioral design tools challenge prior digital media. Each behavior is running as distinct continuous process, fed by both the user and the other running processes. It is up to the designer to define when or under which circumstances the processes run, whether they are working sequentially or simultaneously.

Examples for behavioral design tools are Smartvolumes and SpaceGraphs. Design applications employed by architects generally do lack awareness of spatial depth, which means they do not actively create a topological map of spatial relations between objects as points, lines, and surfaces, and the spatial partitions and volumes they establish. In this article, a tool set is presented that has this awareness embedded and lets the designer explore design opportunities by filtering subsets of the design topology in deep space. The tool set is based on behavioral point cloud modeling. Based on the point cloud formation, from the real-time updated complete topological mapping of the space layout subsets can be filtered to function as reference for the construction of building geometry. All these operations, from the behavioral shaping of point clouds, to the mapping of topologies, the filtering of topology subsets, and to the construction of geometry, can be applied in real-time, simultaneously or partially constrained. The result is a tool set that allows for multi-directional design exploration of actual deep space, instead of modeling with and on boundary surfaces only. The possibility for interaction with real-time feedback, intentional application of temporal constraints, and concurrent operations let the designer engage in a design process of high temporal density and complexity.

The real-time design process is opening up the range of design temporalities toward faster feedback loops. The position of temporal boundaries within the design process and the division of design process temporalities is partly at the hand of the designer, partly at the hand of the developer of the software. Here, design application thinking has to move from a stepwise break-up, from the sequential perception of the design process as a flow chart between nodes toward the perception and inventive determination of temporal extension and duration of occurring operations.

2. BUILT INTERACTIVE ARCHITECTURE

Behavioral digital design tools provide malleable, fluid worlds for developing and evolving models in a flow of dynamic interactions. These dynamic interactions, however, often cease to exist as soon as the fluid digital models are to be built. Interactive architecture allows for a continuation of real-time interactions in the realized buildings. Such buildings are assembled of components that have processing power, can sense and actuate, are designed as a holistic interactive

population forming a performative architectural environment that can adapt over time. While such constructs at first glance may seem futuristic and in need of not yet invented materials, it does not take much knowledge or very advanced materials to realize such building constructs, as Hyperbody has proven repeatedly in the 10-weeks bachelor course.

Here behavioral design environments prove to be of additional value, as they can be used to not only design but also to control and form the behavior of the dynamic construct. Coupled with the material construct, fed by parameters received from sensors and giving output in the kinetic and media behavior

of the construct, they become part of a digital-material hybrid in which the design action continues in the perpetual adaptations taking place in use of the building.

3. IMMEDIATE ARCHITECTURE

Immediate Architectures is an exploratory investigation into the possibilities of immediate constructive interaction with the built environment supported by digital technologies. The aim is to realize interactive reconfigurable architectural objects that support their informational and material reconfiguration in real-time. The outcome is intended to become a

SmartVolumes is a tool for finding structures and generating geometries based on volumetric and behavioral demands. Each change to the generative point cloud simultaneously affects structure, building physics, details, aesthetics and other performances of the design. These complex interrelations demand for a tool to efficiently explore possible solution spaces. SmartVolumes is intended to meet these demands.

Spacegraphs represent design space as network of its partitioning into generic elements nodes, edges, facets and cells. Spacegraphs are a description of spatial relationships of generated, actuated or sensed sets of elements, which facilitate generation of aware informational or material structures. As such they are a generic tool for architectural design exploration and to inform the behavior of interactive environments.

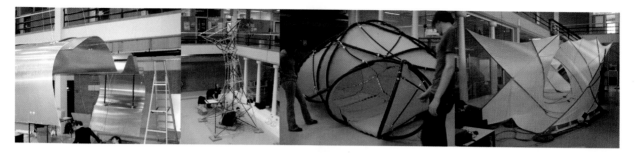

Hyperbody BCs6
Muscle Projects

synergetic amalgam of interactive architecture, parametric design environment, automated component fabrication, and assembly. These emergent technologies are to be combined by computational and material strategies that are developed specifically to approach the state of architectural immediacy, and applied in material prototypes.

Multi-linearity in architectural design processes and in the encounters with interactive environments is a major theme of the contemporary discourse on digital architecture. The next step includes production and reconfiguration, to reach a process where the building is not just informed by emergent processes but in its entirety is undergoing an open-ended emergent process. Immediate Architecture is, by virtue of collapsing the phased timeline of the architectural process into a singularity in time, a radical challenge to conventional notions of architecture.

The digital design and fabrication toolbox then is used as a device for linking spatial experience immediately to action, design, and production. Digital design environments and fabrication devices then are applied for orchestrating in real-time concurrent, simultaneous operations of usage, design, planning, fabrication, construction. In this combination of interactive architectures and digital design environments with computer-controlled production techniques, the designer's dialogue with the built environment may reach an unprecedented state of immediacy. To this goal, a series of techniques are developed providing a tool framework for handling real-time architecture throughout the mentioned fields. The techniques do not divide the design and construction process in phases, are orchestrating a state of now, which can be directed by designers as well as users.

In order to approach this state of immediacy, unifying principles of digital architecture have to be found and applied as basis for the realization of prototypes.

These principles should allow for handling the informational domain, modeling information, executing code, and having a spatial representation that goes beyond description of surfaces. They should also offer ways for binding the informational structure to actuating material elements of the material structure as well as into the fabrication and assembly process of new elements.

The still common notion of virtual reality as separate worlds detached from the inhabitable material world does not hold. Virtual mediation is not opposed to the material world but rather a way of inhabiting the built environment, resulting in digital-material hybrids. These hybrids are no substitute for the material world but do revise it, changing in radical ways our notions of space, time, and perception. Marcos Novak's explorations of *transArchitecture*, which stem from his earlier investigations of *liquid architecture*, are original forerunners to this research. According to Novak, "transArchitecture attempts to mend the rupture between knowledge and architectonic exploration. It brings knowledge that has been put on standing-reserve back into the realm of poetic experience. transArchitecture [...] has a twofold character: within cyberspace is exists as liquid architecture that is transmitted across the global information networks; within physical space it exists as an invisible electronic double superimposed on our material world."

4. COMPLEX ARCHITECTURAL TIME

Prior discussions on temporality in architecture mostly refer to either short-lived buildings, or the experience and appropriation of static built structures by users. Temporality is also factually considered when sustainability is addressed and the lifetime and lifecycles of building materials, components, and building uses are taken into account. Real-time interactive architecture, however, enables buildings to act dynamically and brings the speed of change in buildings down to split-

seconds. Adaptations become an essential part of user experience, and the building of a pro-active environment persuading users into interaction. As Novak explains, transarchitectures "lead to the re-problematization of time as an active element of architecture at the scale of the cognitive and the musical, not just the historic, political or economic event."

Complex architectural time is to be understood as the time taken by a time-based architectural system, as its space is the space that it takes. This kind of organization provides the architectural time and space with definitive specific properties. Space in architecture is organized as the filling of a certain volume with as system walls, stairs, doors, aisles etc. These introduced elements create a system of separation and connections, enclosures and exclusions, turning the real shortest way between two points from a straight line into a broken one or, into a fractal or a curve. As spatial organization is thus a system of barriers, similarly temporal organization has constraints, or hard barriers. Temporal barriers in interactive architecture are given by the characteristics of both material and digital artifacts, the speed and frequency with which they can adapt, whether their operations are reversible, and whether they can act simultaneously or have to share space and time as limited resources in a concurrent manner.

Architects have to consider in their temporal design the organization of manifold interlinked processes that are unfolding over time and at different timescales. Interactive media developers have applied a series of chrono-tools that could aid in this process. The timeline, derived from video editing, acts as absolute measure for placing events in temporal duration. Flowcharts on the other hand define the order of sequences of events, without any notion of duration. In computational music, tools for handling ongoing real-time streams by means of filtering are applied. Advanced game authoring tools allow for sketching as well as for applying behavior in temporal extension and sequence, as they are made for creation of immersive experiences. Yet, it is up to architects to develop and apply their own methods and tools that are suited to elaborate complex time scenarios in architecture.

References

Friedrich, H.C. "SmartVolumes: Adaptive Voroni power diagramming for real time volumetric design exploration." In *Proceedings of the 13th International Conference on Virtual Systems and Multimedia*, ed. Theodor G. Wyeld, 132-142. Berlin: Springer Verlag, 2007.

Leupen, Bernard, Rene Heijne, and Jasper van Zwol, eds. *Time-Based Architecture*. Rotterdam, the Netherlands: 010 Publishers, 2005.

Mikhailovsky, G.E. "Biological Time, its Organization, Hierarchy, and Representation by Complex Values." In *On the Way to Understanding the Time Phenomenon: The Constructions of Time in Natural Science*, by A.P. Levich. London: World Scientific, 1995.

Novak, Marcos. "Transmitting Architecture: The Transphysical City." *CTheory: Theory, Technology and Culture* 19, no. 34 (1995): 1-2.

Novak, Marcos. "transArchitecture," Telepolis, http://www.heise.de/tp/r4/artikel/6/6069/2.html (1996).

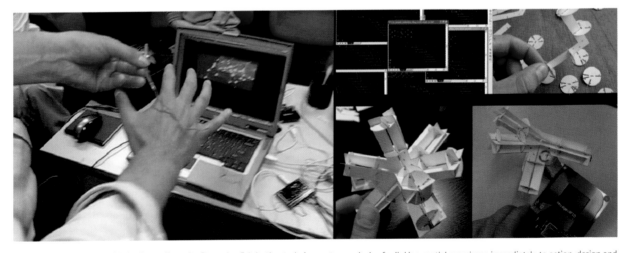

Developed as a design and fabrication toolbox, the Streaming Fabrication technique acts as a device for linking spatial experience immediately to action, design and to production.

Chris Basmajian

For the generative artworks of the series Graphemes and Mathemes, the viewer stands before a video camera and computer screen. Algorithmically manipulated real-time video captures of the viewer produce temporal variations of the real-life sequences.

Time is the distorting effect that animates the images. Symbols define the borders between pairs of sequences of the viewer in varying states of temporal flux. The symbols themselves have no positive appearance, but are only recognized as a difference between the changing images. These differences do not reveal the entire symbol in any one moment, but appear cumulatively over time, allowing the viewer to mentally constitute an image of the symbol (however imperfectly) through memory.

One might ask, Is time a limiting factor of perception, or its enabler?

Squared Square, from the series "Graphemes"; installation view and screen captures; 2007.

BRIEF REMARKS ON THE SOCIAL PRODUCTION OF TIME

Costica Bradatan

"Everyone is a practitioner and theoretician of time. Time 'dwells' in us—through the biological rhythms to which we are subject, and because we are social beings who are born into a society with changing temporal structures and learn to live in its social time." [1]

One does not necessarily have to be Heideggerian to admit that time, temporality, history, and historicity are categories central to human existence. Most important, we are deeply immersed in the dialectics of time not only biologically, but also socially. This is why the culture of every single community encapsulates a certain understanding of this social time, a certain "style" of producing, managing, and spending the social time available in that community. As the refined result of an interplay between a community's available technology, its economic practices, scientific pursuits, and religious rituals, the social time simply imprints itself on the minds, feelings, and patterns of behavior of those living in that community. In other words, one cannot escape the style of social time prevalent in the community to which one belongs: it pervades one's life through all his or her encounters with the external world. As Helga Nowotny expressively puts it, even "the time of the lonely is merely a lack of jointly spent, or shared time. And the lack of time, in turn, is proportionate to the wealth of socially molded expectations and the standards of one's own behavior." [2] Even when one is completely alone, his or her solitude is subtly haunted by memories of past social engagements, and undermined by premonitions of future encounters.

A detailed discussion of how social time is produced and lived in various cultures is beyond the aims of the present essay. Instead, just as a brief historical contextualization of the issue of social time, it will suffice to say a few things about the transition from pre-modern to modern time, and then about the issue of simultaneity and global time as it emerged at the end of the nineteenth century. To put it very crudely, while pre-modern time was seen as unfolding itself only through natural phenomena and concrete events (movements of celestial bodies, alternation of seasons, vegetal cycles, etc.), modern time was seen above all as an abstract factor, *separated* from what happens in nature, something simply measuring the duration of these events. In "traditional cultures, by and large, time is conceived of as concrete, tied to the flow of actual events; in modern societies, by contrast, time appears as abstract, a kind of universal grid against which the duration of all particular events

can be measured."[3] For the pre-modern man, time meant time to plough, time to milk the cows, harvest time, and so on. For the modern man, instead, time is a homogeneous, always equal to itself, abstraction, mathematically divisible into abstract units: seconds, minutes, hours. A banker lending money or a businessman planning the amortization of his investment cannot use celestial movements or natural cycles as their points of reference: they need a rigorous and reliable system of time measurement, one beyond the variations occurring in natural conditions, human perception, or local styles of life. The industrial revolution in Europe was made possible precisely by, among other things, the use of an abstract (if merciless) time against which a wide variety of things were measured: productivity, competence, skillfulness, efficiency, even good manners (the lack of punctuality is first of all economically disastrous). This new way of understanding time as an abstraction, as something you cannot "negotiate" with, became one of the distinctive features of modernity. As a result, a vital principle was enforced that people have "to adjust to the idea that the rule of abstract time is inexorable; work must therefore be steady and disciplined and 'free time' kept within strict bounds."[4]

An interesting development in the history of social time occurred at the end of the nineteenth century and beginning of the twentieth, with the emergence of the notion of *simultaneity*. In 1884, in order to avoid the difficulties created by the existence of numberless "local times,"[5] a system of "world time" was established, taking Greenwich as the zero meridian. Even if large classes of people and geographical regions were still left behind, economic elites from all over the world, and coming from different cultures, came to realize that, through what they did, thought, or felt, they were living within the *same* temporal horizon. In other words, they realized that they were truly contemporary and the system of global time they implemented was just the institutional endorsement of this situation. Needless to say, this simultaneity—which we experience today as a matter of routine, through, for example, the possibility to "transport, exchange and generate world news and stock market prices, financial transactions and television pictures via satellite transmission"[6]— emerged at the end of a long series of developments in science, technology, institutional practices, social organization, geographical discoveries, and economic behavior. What we see today is only a refined result of a long painstaking history of emancipation, adaptation, surrender, and dramatic transformation of time-honored patterns of life.

Yet, once realized, this simultaneity became one of the distinctive marks of a life lived in the twentieth century. As a result, foundations were laid for a drastic change people experienced in the sense of time and space. It was as if the technological, artistic and scientific achievements of this epoch converged to break down the well-rehearsed spatial and temporal structures of social perception and transform them into a broad experimental field, in which new ways of seeing, different spatial forms and, not least, new, more democratic, social and political relations were to be tested and rehearsed.[7]

At some point people found themselves moving faster, working faster, enjoying themselves faster—in short, living faster. Eventually all this acceleration of social life caused what Nowotny calls an "intoxication with time,"[8] with some people suffering from speed-related neuroses, anxieties, and uneasiness. The "American way of life," which—with its speed-driven social life and generalized "social hurry"—was seen as the very embodiment of this new global tendency, was sometimes regarded by non-Americans with a certain reserved attitude. Yet, at exactly the same time, this general speed up of the social rhythms at the beginning of the twentieth century provoked, in intellectual circles, a new cultural awareness of time, which took shape in a complex movement of ideas in the spheres of arts, mathematics, literature, music, and which was clustered precisely around the idea of temporality and our experience of time. Not only did the traditional arts become more and more interested in the issues of duration, change, decay, the "instant" (Impressionist painting is only the most obvious example), but a completely new art appeared, an "art of time" *par excellence*: film. Similarly, in literature authors ranging from Proust to James Joyce are unconceivable in the absence of this new obsession with temporality time or, which amounts to the same thing, timelessness, and so are the philosophies of Bergson, Husserl and Heidegger, or Einstein's "theory of relativity." One might even say that psychoanalysis is nothing else but a sophisticated "art of memory" and, ultimately, the whole avant-gardism in the first part of the twentieth century might be seen as deriving from the same obsession with time.

This whole movement of ideas centered on the experience of the European economic, artistic, and literary elites. What happened in the rest of society? How did ordinary people experience the new rhythms of social life? Nowotny observes how this discovery of the simultaneity and acceleration of the social time was perceived by the ordinary "bourgeois individual." According to Nowotny, the ordinary individual, encountering the new social rhythms brought about by the use of telegraph, trains, or newsreels, "was suddenly confirmed in his or her very own, subjective experience through the use of pieces of technological equipment which allowed him or her to establish a link of simultaneity with other individuals in other places."[9] Precisely by being confronted with the general speedup of the century, they discovered they had to be more careful with how they spent their social time, more specifically, that they had to "save time" for themselves; and it was in this rather oblique way that they came to (re)discover themselves, themselves *as individual consciousnesses*. In this task they were alone: nobody saves time for you. It is you that has to take care of "your" time:

What positively exploded through the discovery of simultaneity was the temporal objectivization and legitimization of individual consciousness... From then on, there was not just one historical 'world-time'...; its disintegration into something that was a kind of co-presences was comprehensible to subjective existences which were objectivized because technologically linked with one another and constituting public time. There were as many subjective times as there were thinking, feeling, knowing, communicating individuals.[10]

Thus, despite the numerous individual crises and social disruptions that it caused, the "intoxication with speed" was eventually healed and what emerged instead was a new, more acute, awareness of the limitedness of one's lifetime and of its volatile nature. Benjamin Franklin said that "time is money," but never until now have people realized the precious nature of time. As it often happens, one needs to take part in some external event in order to learn more about the complexity of one's inner life: it was precisely against "the background of a growing international integration by means of transport systems and business relations"[11] that people came to discover their deeper subjectivity and how it was related to time and space, temporality and history, to other people, other cultures, and otherness in general.

The social time that people lived at the beginning of the twentieth century was, no doubt, a social construct, but the most important thing to keep in mind is that no single factor (economy, politics, technology) had an absolute monopoly on producing this social construct. In other words, this time was the complex result of a multitude of technological, economical, intellectual, political, and religious factors. This allowed a certain "space of freedom" in spending one's social time, in setting personal agendas (separated from the system's agendas) and finding significant ways of safeguarding one's autonomy.

By contrast, in Communism, time was pre-eminently a political construct. The communist regimes were always concerned with having a direct access to the ultimate constitution of people's sense of social time, and made tremendous propagandistic efforts to maintain control over this sense, to alter or divert it in order to manipulate it most profitably for their own political interests. This practice was so important for the communist ideologists and practitioners that Stephen Hanson, in a book dedicated to how Soviet ideologists and institution-builders administrated social time,[12] views "the entire history of Marxism and of the Soviet Union, from the writing of the *Communist Manifesto* to the disintegration of the Soviet bloc, as constituting an unprecedented, often highly coercive, and ultimately unsuccessful 150-year revolutionary experiment in reordering the human relationship to time."[13] In other words, people's social time was not anymore the result of a free aggregation of forces and factors, but the planned outcome of a certain *politics of time*, the consequence of a quasi-absolute monopoly of the political factor on the construction of the social time.

The central temporal category on which the whole communist project is based is, of course, the future. Above all, communism is a promise. In the communist "political imaginary" the future is the privileged temporal category, the supreme standard, against which all past and present actions are conceived of, assessed, and given meaning. It is the future that validates everything that we do now, and have done in the past. The past and the present might get a meaning only insofar as they have some role to play in the unfolding of the future state of things. Now, while the future can be manipulated because it is not yet, the past can be manipulated and recreated because it is not anymore. After the years he spent in Spanish com-

munist circles George Orwell was able to document how this sophisticated practice of recreating the past is, in a communist regime, an essential part of the process of generating, preserving, and increasing the power. Caught between a Messianic future, designed in such a way that it will never be reached, and a past suffering a process of perpetual re-designing, the individual living in a Soviet-type society is forced to content himself with the present. Yet, the present is in its turn subjected to specific forms of aggression. For example, around such phrases as "planned heroism," "revolutionary self-sacrifice," "plan overfulfillment" a whole propaganda system was created in the Soviet Union in the 1920s and '30s (and then exported to the other countries of the socialist bloc, after WWII); in all spheres of life, from agriculture or mining to classical philology and mathematics, the new theme was *speed up, increase the tempo!* (Significantly, most of the metaphors used for describing this increase in tempo were taken from the military vocabulary: battle, victory, heroes, sacrifice, etc.)

This is precisely why, after the collapse of the communist regimes in Eastern Europe and Russia, one of the major problems for any post-totalitarian society comes precisely from people's disruption of the sense of time, and the loss of an adequate temporal orientation. This is the result of a long process of sophisticated political manipulation, through stirring and maintaining pseudo-Messianic expectations, systematic alteration of the past, and staging fake outbursts of public frenzy and enthusiasm, as well as creating systematic delays and lack of structural functionality. Of course, the specific forms of manifestation, the intensity and scale of this process differed from country to country and from period to period.

First of all, there is the notion of "facing the past" or "settling accounts with the past" (il faut régler ses propres comptes avec le passé[14]). After the fall of communism (just as it happens after any major historical disaster), an idea emerged that, in order to be able to move forward and be better prepared for the future, past deeds needed examination to see what went wrong, to see who was responsible, who was the victim and who was the victimizer. This idea is based on the more general and commonsensical assumption that in order to solve a problem one must first admit that there is a problem. This is rightly seen as a first and absolutely necessary step, without which a basis for the future is in no way possible.

Undertaking such an examination is not only a matter of pure scholarship; it is above all a matter of social and moral hygiene. Certainly, the ideas of "confrontation with the past," of "necessity of facing the past," are important notions, crucial to the post-communist conversation about what should be done in order to create a better understanding of how societies work, what kind of past mistakes should be avoided, and of what it means to be better prepared for the future.

Yet, in this process of examination, the essential fact that must be taken into account that is people's sense of temporal orientation. And precisely because the communist experiment destroyed the roots of a normal sense/perception of time, people in postcommunism are faced with a painful impossibility of properly understanding their communist past. One of the cruelest gifts that came with the communist heritage is that people cannot manage to settle account with the past precisely because that past itself—at a time when it was not yet a past, but an inescapable present—deprived them of the proper tools for doing so. They find themselves burdened with something that they never knew they could have, and now that they have it don't know what to do with it.[15]

NOTES:

1 Nowotny, Helga (1994), *Time: The Modern and Postmodern Experience*, trans. Neville Plaice (Cambridge, England: Polity Press, 1994), 6.

2 Ibid. 8

3 Hanson, Stephen H. (1997), *Time and Revolution. Marxism and the Design of Soviet Institutions* (Chapel Hill: Univ. of North Carolina Press, 1997), 1-2.

4 Hanson, 7.

5 Gosden, Christopher (1994), *Social Being and Time* (Oxford, England: Wiley-Blackwell, 1994), 3.

6 Nowotny, *Time*, 19.

7 Ibid.

8 Ibid., 26

9 Ibid., 27-8.

10 Ibid.

11 Ibid.

12 Hanson, *Time and Revolution*.

13 Ibid., 10.

14 Todorov, Tzvetan, *L'homme Dépaysé*, (Paris: Editions de Seuil, 1996), 69.

15 This paper is a fragment from a much longer article I published few years ago: "A Time of Crisis—A Crisis of (the Sense of) Time. On the Political Construction of Time," *East-European Politics and Societies* (Sage Publications, 2005), 260-290. Thanks to the Sage for kind permission to reprint.

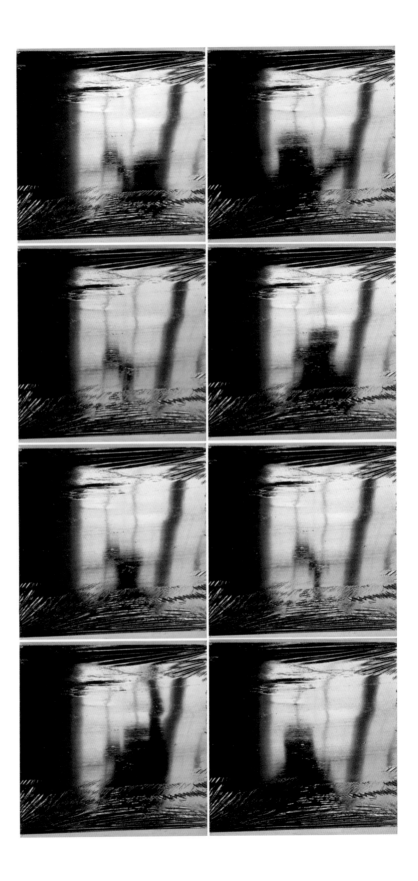

Sarah Bliss

Bliss

This inkjet print is composed of eight photographic images of a painting constructed of shrinkwrap mounted on stretchers. The reflectivity of the shrinkwrap is exploited to capture and record time through the changing quality of light as reflected on the surface of the painting. The resultant image plays with the viewers' grasp of what they are seeing: Painting? Sculpture? Photograph?

Time/Light (AA5) (detail); inkjet pigment print; 24.75" x 12.25" x 12.25"; 2009.

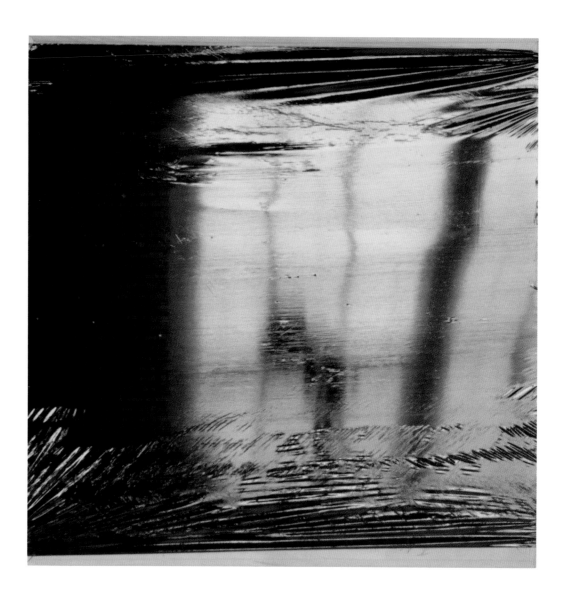

AN A-TEMPORAL ACCOUNT OF TIME

Patrick Călinescu

I know this sounds quite scientific; but it is not. In fact, I do assure you that what follows is the intentionally fragmented thought, in order for it to look like it has always been part of a unitary text, of a man who, in doing so, has risen himself high above time, to look into it, and high above all temporal demarcations, to look at them.

What follows below is, then, this man's line of thought in the form of more than one line being enough to comprise this very line. So, all the necessary lines that his line of thought covers will have to be dialogue-like because this is the only way all the inner lines of his line of thought can communicate with each other to form his singularly positive line of thought on his a-temporal account of time.

This man thus stands against, and in front of, this man, he himself, for the following inquiry into time's lack of temporality in a world that should not miss it at all.

"My dear temporarily alienated self, let's then embark on our dialogic expedition by simultaneously beginning and ending time and its temporal course through the world."

"Notwithstanding my acceptance of your proposition, I must ask you why you think we should have this talk at all about time and its becoming a-temporal by means of a simultaneous entry into, and exit out of, time itself?"

"For it is precisely in this simultaneity of time's points of existence (the beginning being its point of existence through which it comes into existence and the end being its point of existence through which it goes out of existence), which might also be referred to as the mutual annihilation of its points of existence, that time can truly be a-temporal. If you deprive it of this simultaneity, or annihilation, time will then always be fated to bear its own temporality with dignity and, consequently, fatally bear on its very temporality."

"I understand now. So, time has to begin and end its temporal course, as it were, at the same time in order for it to become a-temporal. Oh, I think I get you now even more than when I used to: if it annihilates both its beginning and its end, time can then be a-temporal because it no longer has any point of existence either to come into existence or to go out of existence; so, by actually ceasing to exist, it becomes a-temporal."

"Very correct: time can only be a-temporal if it completely ceases to exist. Out of its existence, or, as some might argue, beyond its existence, time is superiorly a-temporal."

"I understand... but this in itself and by itself raises two difficult problems to overcome, and I am afraid that what you have just said, your solution to time's need to be a-temporal, which is equally mine, as I am *your* yourself, will get complicated exponentially by its under-running, and intellectually stalking, aporias. *One* is, if time becomes a-temporal only upon its going out of existence, since it then no longer exist, how can it still be one way or the other, temporal or a-temporal? By ceasing to exist in order for it to exist in just one specified way, doesn't it cease to exist at all, including in the way in which it has been prescribed to exist if it ceases to exist? Of course, this would necessarily imply that, in order for time to exist—in one way or the other—it doesn't have to cease to exist at all, but only partially. Time, if it wants to become truly a-temporal, does need to cease to exist, by annihilating both its beginning and its end into a simultaneous taking out of existence of both its beginning and its end, but it merely has to cease to exist partially, and not completely, when it would actually no longer be able to be either temporal or a-temporal simply because these two modes of existence have become invalid, owing to its going (or having recently gone) out of existence. Time thus needs only a partial going out of existence in order to cease to exist thoroughly if it truly wants to become a-temporal. And *two*, logically out of *one*, is, if time only needs a partial going out of existence in order to cease to exist completely so that it may acquire a real a-temporal nature, does this mean there can generally be two ways of going out of existence: a partial one, which ultimately takes nothing out of existence if it still exists to be one way or the other, and a total one, which would positively take out of existence everything that has so far existed, letting thus nothing of prior existence still to exist to be one way or the other? So, you see, my good self of mine, these are the two difficulties that might stop you, while you're still not me, from making time genuinely a-temporal for all eternity or, at least, for the duration of this brief account of time's lack of temporality. How do you respond to these two aporias and what is your solution to circumventing their illogical grip?"

"My good self, thank you for your not being myself yet. If you had already been myself, I would never

have taken notice of these two hurdles in the way of my attempt at making time truly a-temporal. And, of course, thank you for showing them to me in as bright a light as only the light of prolix arguments can offer. If, in what I have to say next, in conclusion to your having found many a fault with my attempt at making time a-temporal, and until the conclusion of our debate on time's lack of temporality, you look for two counter-aporias, which, in their turn, would *ad infinitum* propagate other rows of aporias, I must then inform you this is not my current line of thought, and it will not be mine as long as we are still disjointed into my independently self of yours and, respectively, your equally independent self of mine. My line of thought does not lie in countering one already revealed set of aporias with another one just about to be revealed. Instead, I will go on pursuing my attempt at making time duly a-temporal and giving it a proper account of how it has become so, irrespective of how many other aporias I will still be running into."

"You have all my attention and my net of logic is extensively cast to catch any other illogical glitch that might rise from your positively free line of thought."

"So, I have originally stated that time can be made a-temporal if its beginning and its end are simultaneously suppressed. I have also said that it is only in this simultaneity (or simultaneous annihilation of both its beginning and its end) that time gets what it needs to become truly a-temporal. But, in stating all this, which you have plainly disagreed with by affirming the logical impossibility of time's becoming really a-temporal on the grounds of its not being able to cease to exist partially in order for it *not* to cease to exist completely, have I also said why time has to do away with both its beginning and its end if it wants to become purely a-temporal?"

"You seem to have only given an insight into how time becomes a-temporal: by taking out of existence its beginning and its end, and by depriving itself of its temporal birth and death."

"Indeed, I have so far been quite scanty in providing a good explanation of time's reason for wanting to become a-temporal; but I seem to have been even scantier in giving the true mechanics of time's becoming a-temporal. I think it doesn't really matter why time wants to become a-temporal; we all know, while we're still different from each other, that time only

wants something as long as we want time to want something. So, to be honest, it is us who wish time would be this way or the other way: in my case, while it's still mine, a-temporal. As for how it is become so, or can indeed become so, based on my solution to this problem, I need not talk much. The mechanics of time's lack of temporality is quite simple."

"They follow a pattern very much in line with this temporal insufficiency that makes time truly a-temporal: a different dearth, which is not temporal, but rather of proportion. Time seems to become a-temporal only if parts of it—its extremities—are cut off of its body. Apparently, the time that is a-temporal is a mutilated time. A time that is incomplete: a time that is missing something from its body. Then, if this is the case, I can ask myself, feeling now en route to rejoin you, my former, primal and basic self, how can time be both incomplete and mutilated (that is, a-temporal, at least according to my definition), and also whole (that is, of time; it being, a-temporal or not, of an evenly distributed substance)? Seemingly,

only out of, and *beyond* time, if it is to become truly a-temporal. This means that time, when a-temporal or in its a-temporal habiliments, is either incomplete and mutilated (hence handicapped and not able to run and pass) or whole and fully able to run and pass. Rather than being in, and belonging to, this time, which borders on its past (a beginning that always ends) and its future (an end that always begins), is actually out of, or even beyond it.

In conclusion, it having finally arrived at the last line of my line of thought, now almost indiscernibly yours, time can only be a-temporal if it does go out of existence. However, this is neither partial, nor total, for this going out of existence does not mean extinction, but rather mutation. So, time can only become a-temporal if, by going out of existence, and instead of ceasing ultimately to exist either partially or completely, it mutates itself out of its temporal existence, which is limited by a beginning and an end to time itself, straight beyond its temporal confines, in the purest lack of temporality I will ever wish to know."

MaryAnne Laurico

Mathematics of Blue Time Before Kiss; acrylic paint, charcoal, and oxidized metal flakes on canvas; 4' x 3.5'; 2008.

Pensive Gaze Back into Purple Past;
acrylic paint on canvas; 6' x 5.5'; 2010.

PURPLE PAST

OUR PLACE IN ETERNITY

Matthew Fritze

First and foremost, Time isn't the linear moment-to-moment thing many think it is. It is not over with in the Past and it is not something that hasn't happened in the Future. Time marks our place in Eternity and wherever we think we are in Time, whether in memories, dreams, or presence, we're indeed there.

Memorable past events make a mark as a deep impression in Time: being present for a loved one's passing, moments spent as a child in the house we grew up in. The impressions draw attention to themselves as strong basins of attraction in dreams and waking reality. They are deeply meaningful, inextricable parts of the structure of ourselves, a structure spreading through all Time and space that is more beautiful than we can imagine. Wherever we observe Time as such it is there, otherwise there is Eternity.

The Future exists for us as a pattern of probabilities and tendencies that might come to be as the forms of Time coalesce into the most coherent and vital actualities.

The pattern of Time exists in the Past, Present, and Future, beyond differentiation, beyond a specific causal logic that would insist only the Past created the Present and the Present creates the Future.

Time exists and its influence flows in all directions. We and our experiences are the only differentiation there is. In our presumed movement from here to there, in a clock hand's movement over its face, or liquid crystal numerals changing repeatedly, we've created intervals to measure out eternity. Because we can't see someone existing in all times and places at once, we say, "You were there, now you're here." It's the best most of us can do. Thoughts about death become ensnared in our interval-oriented perception of Time. We mark Death as a traitor, in league with Time as co-creators of some final end-state of decay.

I challenge you to think about Time without interval, without *whens*, and without a means to measure it. I urge you to undertake the daunting but most urgent task of stepping just outside of an interval, a moment, an hour, a day. You can step outside the perfect, immutable crystal we've made of Time and into its true timeless essence. The more you try it, the better at it you will get. To relax, breathe, not worry, and watch time unfold with you is Time's most sublime gift.

Time and Telemetry; assemblage with found objects and
magazine fragments; 11" x 10"; 2009.

FUTURE NOW IN RETRO-TIME

At the end of the future light cone
I lay dreaming
of the beginning and the ending
Every time I look at you
I dream you to be
Through deep longing to touch
Here and now
Skin and eyes
Through deep dreaming
Acausal causing it now
Rippled forever every
Memory with foresight in your smile
Glinting off unexplainable movement
Above and below
and all outward to where
I lay dreaming

ALL OF THIS IS THE LANGUAGE

In moments when your eyes meet mine
We stand against all the ruinations of Time
and declare them phantoms of worry
I know this now: You are a gift given again and again
though interval falls away and Eternity
 shines through

As my macroscopic self contemplates and dreams
 my microscopic self
I'm assured there is no me and other, there only Is
I submit for now: this human brain is enough
Arrayed for the meaning of everything
 that comes in waves
as a wind-scattered string of photons
 through all my cells
for as long as this body lives and dies

I know as I suspected then as a child
lying in bed at night, contemplating
 an infinity of stars
grasping for an end
My stomach sinking as I moved past endings
only to find more beginnings
There is no end
Yet the infinite is everywhere inside me and outside

Words tumble from your tongue as water and fire
flow the same
They might coalesce into objects
And you might finally say: 'All of this is the language.'

As physics books stumble through metaphors of
 strings and fields
and mechanisms of where and why are shed
they still fail to describe
I need look no further than your eyes

THE COLLAPSE OF SPACE-TIME

Jeremy Levine

1.0 INTRODUCTION

Quantum particle systems possess the ability to communicate instantaneously with each other, defying our classical understanding of space, time, and distance. This feature of the quantum world, known as non-locality, is often used to describe the World Wide Web, which collapses space into mouse clicks and hyperlinks.

2.0 NON-LOCALITY AND QUANTUM SYSTEMS

In classical physics no two objects can communicate faster than the speed of light. But now there is experimental evidence that suggests quantum systems violate this law of locality—a law that is central to our understanding of space as an objective medium. Locality imparts uniqueness and individuality to things by fixing them with a unique location in space/time. Two objects cannot occupy the same space in time, or we must assume that we are actually observing one object. And that is exactly what quantum mechanics tells us about entangled particles and quantum systems. No matter how much space is between two entangled particles, they will communicate with each other as if there is no space at all. This is impossible in the classical world to which our senses have evolved, but not in the quantum world for which evolution has left us both perceptually blind and cognitively unprepared.

The feature of non-locality was an unstated aspect of the Copenhagen interpretation of quantum mechanics proposed by the four godfathers of the new physics: Niels Bohr, Max Born, Werner Heisenberg, Pascual Jordan. Yet non-locality had no means of empirical verification. This was not merely a technological limitation, but rather a limitation of the quantum model itself. Or so it seemed. In 1965, the black box of quantum locality cracked, when John Stewart Bell published his so-called *"Bell Inequality."* The Bell Inequality gives a limit for the highest degree of correlation one can obtain in experiments involving pairs of particles, if one assumes a completely local and deterministic universe.

Bell teased out a violation of random probability as an explanation for the correlated behavior of entangled particles. Bell showed that according to Quantum Mechanics entangled particles separated by enormous distances communicate instantaneously with each other. No lag time. Not even a billionth of a

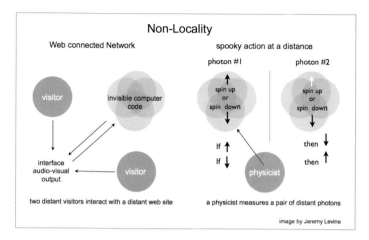

Non-Locality

Web connected Network

visitor

invisible computer code

interface audio-visual output

visitor

two distant visitors interact with a distant web site

spooky action at a distance

photon #1

spin up or spin down

photon #2

spin up or spin down

If ↑
If ↓

then ↓
then ↑

physicist

a physicist measures a pair of distant photons

image by Jeremy Levine

billionth of a billionth of a nano-second. But instant communication between particles was a relic of the Newtonian world. This was exactly what Einstein had overturned with his theories of relativity. This violation of the speed of light limit provoked Einstein to call such correlations "spooky action at a distance."

Einstein was convinced that the Copenhagen interpretation proposed by Bohr and his followers was missing vital information—hidden variables that the particles contained when they left their source—that would explain the phenomenon in classical terms. Einstein was wrong. This didn't happen very often so it's important to understand why he got it wrong. The answer lies in Einstein's inability to accept the premise of ontological dualism: the existence of a non-physical element of reality that is outside time and space. Anton Zeilinger warns philosophers that the spooky correlations of quantum mechanics will leave them "terminally puzzled" if they dig further (see Figure).

Since 1982, numerous experiments have been conducted by Alain Aspect and others verifying Bell's Inequality. In 1997, Antoine Suarez and Valerio Scarani proposed an experiment subsequently carried out by Nicholas Gisin and his collaborators at his Group of Applied Physics at Geneva University, which is crucial to understanding this feature of non-locality in quantum systems. The experiment separated photon pairs and shot them off in opposite directions at the speed of light. The two photons were then measured in regions far away from each other. For each photon the outcome of the measurement was one of two alternative values, say either spin up or spin down. What Gisin and his fellow physicists discovered was not only that the outcomes the photons produced

were correlated, but also that this correlation originated from outside of space-time. The results show that "it is not possible, even in principle, to distinguish which measurement is the independent and which is the dependent one" (Antoine Suarez). In other words there is no way to distinguish "before" from "after" as independent space/time regimes.

If the speed of light limit is not violated, then non-locality points toward something truly profound: quantum holism. "In Nature there are connections happening faster than light and without propagation of energy. This is the quantum mechanical non-locality assumption" (Nicholas Gisin, Andre Stefanov, Antoine Suarez, and Hugo Zbinden). The connections Suarez speaks of should not be interpreted as a violation of the laws of classical physics. The classical laws hold. Einstein's speed of light limit holds. But only for the macro-objects that form the physical observables of our world. There is also an invisible non-physical level of 'reality': a quantum reality. This sub-atomic world plays by different rules.

"Einstein's frames have no effect on "spooky action", even though we cannot use this fact to establish an absolute time. So what Quantum Mechanics actually implies is that in case of space-like separated measurements the connection the correlations reveal does not correspond to any real time ordering and, consequently, is not tied to any experimentally distinguishable frame" (Antoine Suarez).

Neither the 'long range order' of complex systems, nor the 'spooky action at a distance' of entangled particles should be understood as instantaneous transmission.

"If the meaning of "quantum non-locality" is unclear to you, quantum holism has the huge advantage that it does not suggest any kind of "instantaneous transmission", but explicitly refers to the existence of global properties that are not contained in the properties of the subparts" (Philippe Grangier).

Non-locality is the indivisible property of a system that gives it an identity that is more than the sum of its parts. The "quantum potential's instantaneous dependence on all features of the whole experimental apparatus" (Anton Zeilinger) requires us to accept that our notions of space and time are constructions rather than discoveries. The notion of discrete objects separated in space is not only challenged by our un-

derstanding of quantum mechanics, but also by our experience with many kinds of new media art.

"What good is analytic reduction when entanglement—a form of strong coupling—lends 'more reality' to a composite system that to its parts" (Grangier). But what is really meant by this notion of 'more reality'? In quantum terms, "'reality' simply means a quantum state according to our definition" (Grangier). But perhaps it is more useful to say that "holism" constitutes another 'order of reality.' The composite or higher (hierarchical nesting) order of reality of holism that we find in works of interactive art and entangled quantum particles are a challenge to the reductive, binary logic of classical physical dualism. Instead we need to adopt a conceptual dualism where the components of the system have one reality, while their organized relationship with one another constitutes another reality (see Figure).

3.0 NON-LOCALITY, MEDIA ART, AND THE WORLD WIDE WEB

Our encounter with a Rothko painting in a museum has a short-range character, but a work of art that is networked can connect us to elements of the system that are thousands of miles away from each other.

"Networked new media art existing in the public space of networks — be it internet art or art involving mobile media such as cell phones and PDAs — can be understood as a new form of public art. Compared to more traditional forms of public art practice, Internet art, which is accessible from the privacy of one's home, introduces a shift from the site-specific to the global, collapses boundar-

ies between the private and public, and exists in a distributed non-local space." (Christian Paul).

The non-locality that Christian Paul speaks of is a function of the internet's elision of our sense of distance or spatial separation. Instead of geographic space, we have network space. "The computer is a connection machine. A lot of new media art, especially network-based work, doesn't have spatial dimensions per se, but nodes and levels of connection" (Steve Deitz). Regardless, as Antoine Suarez points out in an e-mail to this author, "the concept of quantum non-locality does not apply to interactive art in the same technical sense: the interaction in art happens always via internet, and therefore not faster than light."

Non-locality is a metaphor for what Albert-Laslo Barabasi calls the "small worlds" property of networks. Barabasi asks us to imagine a circle strung out with nodes, separated by short links like pearls on a necklace. "Yet thanks to the long bridges they form, often connecting nodes on the opposite side of the circle, the separation between all nodes spectacularly collapses" (Barabasi). Cyber theorist Manuel Castells describes the modern character of networks as "the space of flows...[which] links up distant locales around shared functions and meanings on the basis of electronic circuits and fast transportation corridors, while isolating and subduing the logic of experience embodied in the space of places" (Castells). The "space of flows" concept is a metaphor for the non-locality of the modern telecommunications networks. Freed from geographic limits, a work of networked art can glow on the screens of thousands of computers at the same time.

Richard Vickers helps Warhol keep his promise of future fame, in "15x15," which allows anyone in the world with a web cam to upload their live feed, becoming part of a grid of videos from visitors to the site. Vickers manages to collapse fifteen different locations into the space of your browser window while encouraging visitors to become participants. Maciej Wisniewski's *Instant Places* utilizes the non-local experience of the internet to connect different computers to form a matrix that was free from the constraints of geography, time, and place. *Instant Places* featured predators (hawks) and prey (mice), which were able to move between different data places and communicated via instant messaging." (Brian Greene)

Space-Time Interaction Model

space-time

passive visitor / physicist — subject → Object — painting / classical particle

active visitor / physicist — subject ⇄ object — interactive software / quantum particle

image by Jeremy Levine

Telepresence utilizes the internet to challenge the notion of a localized self trapped in its organic container. The tacit laws of proximity that give greater relevance to those things that are physically closer to our bodies is turned upside down by the non-locality we can experience through telepresence art. This is the affect of Eduardo Kac's *"Teleporting An Unknown State."*

"The installation Teleporting An Unknown State creates the experience of the Internet as a life-supporting system. In a very dark room a pedestal with earth serves as a nursery for a single seed. Through a video projector suspended above and facing the pedestal, remote participants send light via the Internet to enable this seed to photosynthesize and grow in total darkness." (Eduardo Kac).

The visitors to Kac's project share responsibility for tending the plants, creating a virtual community of "telegardeners" that are oblivious to the physical location of any individual.

Will Pappenheimer's "search for you" uses interactive web cameras with mounted searchlights to probe a dark room in search of human contact. The beam of light is not merely a tool for surveillance and illumination, but instead functions as a virtual avatar. The light becomes a projection of one's self. The implications of non-local technology are just beginning to be felt.

"Our private sphere has ceased to be the stage where the drama of the subject at odds with his objects and with his image is played out: we no longer exist as playwrights or actors but as terminals of multiple networks. Television is the most direct prefiguration of this, and yet today one's private living space is conceived of as a receiving and operating area, as a monitoring screen endowed with telematic power, that is to say, with the capacity to regulate everything by remote control." (Jean Baudrillard).

4.0 CONCLUSION

The collapse of physical distance that one experiences in art that utilizes high-speed communication networks is evocative of the behavior of entangled spatially separated quantum particles, which seem to communicate as if there were no separation at all. Non-locality describes a state in which we have information about spatially disconnected components

of complex systems. Quantum particles are 'points of intersection' of certain relations" (Ernst Cassirer).

The exchange and manipulation of information without regard to distance is one of the dynamic variables of both quantum systems and interactive media art. Whether literal or metaphoric, our experience with these interactive systems reveals the holes in our intuitive understanding of space. For both quantum systems and interactive networked art, space is always relative to the perceiving subject. In both cases, our experience of non-locality is a product of our interaction with virtual phenomena: invisible communication networks or the immaterial probability wave.

Though the speed of light limit is not broken during our web-mediated interactions, we often experience an immediacy that erases distance, creating a *"confounded sense of place and proximity" (Vince Dzekian).* But non-locality is more than a challenge to our intuitive sense of space: it is an indication of a deeper virtual realm outside of space/time— a holistic dimension, which is stubbornly recalcitrant to our scientific investigation.

The great physicist Sir Arthur Eddington (1882-1944) wrote about the limits of the scientific method:

"We should suspect an intention to reduce God [ultimate reality] to a system of differential equations. That fiasco at any rate [must be] avoided. However much the ramifications of [physics] may be extended by further scientific discovery, they cannot from their very nature trench on the background in which they have their being... We have learnt that the exploration of the external world by the methods of physical science leads not to a concrete reality but to a shadow world of symbols, beneath which those methods are unadapted for penetrating." (Sir Arthur Eddington)

Reality is more than pointer readings and differential equations. We need other means of understanding: enter the artist whose techniques of understanding are not limited by the need to quantify analytically, but rather are motivated and inspired to poetically synthesize. The full implications of non-locality may be beyond our grasp, but artists that utilize modern telecommunications networks are able to evoke aspects of the phenomenon. Here art fills the gaps in our scientific understanding of the world.

Practicing archeology

How do I know that we are alive?
How can I tell the living medley
From the caverns of Herculaneum?

So I walked on the river's banks,
I entered into people's conversations
And I admired the primordial form
Which was ready to be a house or a palace.

To imprint cold furrows beneath a tractor
On the fresh dirt of the early molds,
Ripping out rags
From a dark working jacket under a bush.

Barely to blow away the orange dust
 from the eyelashes
Dyed with Egyptian ochre,
And to gather from everyone a ribbed
 drapery of color,
Of the blue backyard sunset.

To look through the thickness of the slime
Not above the vicinity of Mycenae's gates,
But underneath and through the grid
Of a dry insipid pavement under the lion gates
Of the former grids of the English Club,
To read the schedule of the night: yes, we are
 closed on Saturdays.

You can write endlessly about it:
Because I myself write a scroll and I myself read it:
Like a prewar whisper in a gateway
And the conifer trumpet voice of war roses,
And a dream of postwar mausoleums,
So to cross a swamp
One should fasten a general's epaulets to boots.

Do not be in a hurry in inventorying things,
(Do not forget yourself among the others...)
The handshakes, firm as cement,
And the kisses—spots on granite —
And the twinkling of those lights of illuminations
And the hatred of nameless days.

To take full, sharp-sighted, old-man breaths,
So that not dust but the pollen of
 the golden serpent
Would emanate from your right hand
And become the earth's heavy matter.

Everyday Immortality

Your voices are heard from the dome of the sea,
Things of things
And all of my friends...

As if there is an echo in the hot-burning rocks
You... and you... and you
The voices are dying down in the silence of August
Like the smoky fading leaf of a jellyfish

How should I name you
So that all of you sink into time,
So that one day you should not escape from it
 with the thundering pebbles of the
 foot of the mountain?

Haven't your crystalline glasses
With the igneous panorama
Been in the world previously,
And aren't they older than jellyfish
Made of parachute silk?

These spiky trees,
Aren't they the children of your golden hair?
And the hill of Genoa's fortress above your
 summer shoulder?

The word keeps silence,
And time is dreaming between portholes.
Like the grey digital jellyfish
Invisible ship blinds its defending torso.

The plywood wings of the butterfly
 are pierced by the other moisture and the pollen
 near the exit from the seaside garden...

And there is no place to leave
The water with a transparent cheek
Under the plane basin of money...

And the thyme's receipt in
 the timelessness of the word.

Translation by
Tatyana Bonch-Osmolovskaya & Vladimir Aristov

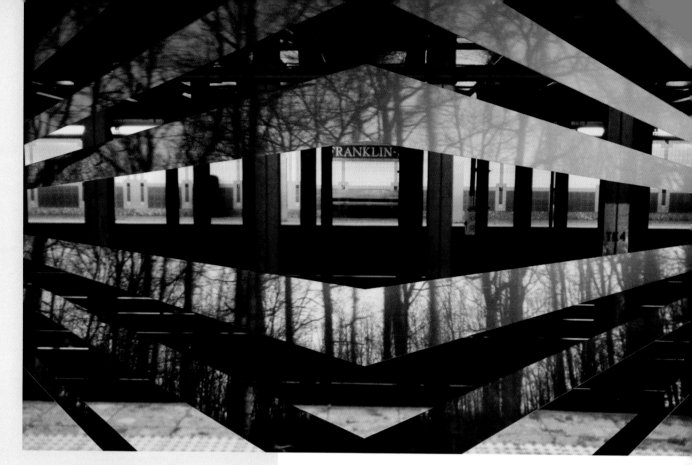

Franklin Street 1, 9 / Palisades Parkway; two C-prints; 8" x 12"; 2004.

Brandon Neubauer

COUNTERING HISTORY'S GRAVITY: NARRATIVE'S PROLEPTIC TIME FUNCTION

Craig Morehead

Narrative—a cognitive mode of thought and representation for ordering events around spatio-temporal frames—encodes and exhibits a plurality of temporal expression that contests traditional conceptions of itself and historicity. Narrative's proleptic function shifts our desires for the gravity of history to pull the past to present and maintain a linear, temporal progression. Extending Mark Currie's provocative analysis of prolepsis—narrative's teleological retrospection, or the idea of the anticipation of the present as a future memory—I want to begin to offer a reevaluation of the relationship between history and narrative, past and present, by incorporating narrative's anticipatory operable futurity in conjunction with its retrospective modality.

The retrospective model of narration asserts that in the process of constructing and reading a textual narrative, the past is localized into a narrative present through a double process of "presentification" whereby the narrator's narration of past events into a present locutionary act—the act of telling the story—is read in a reader's present-time frame, so that the past through its narration and the narration's subsequent consumption becomes what Currie calls "quasi-present." But this narrative present is also ontologized into a projected future through narration, in anticipation of its use as a future-memory. In other words, we register our subject-state in the present as material for a future narration, so that the present becomes future oriented in the anticipation of its retrospective narration. Textual narratives position futurity as its principal concern, replacing narrative's traditional prioritization of a retrospective temporal orientation.

A localized past, narrated in the present, is useful in its anticipation as a future-past, and the narrated past necessarily becomes useful and retrieved only in its present becoming, or the continual, anticipatory projection forward for use as a future-memory. Thus, with every present narration and reading, the narrative-present, the present created by and for the narrative, offers the possibility of retrieval and forward projection in its structural confluence of past and future time-frames.

Jacques Rancière sees the division between our desire for a single meaning and direction for the historical progression of time and what the arts reveal about the reality of multiple time-frames: "The idea of modernity would like there to be only one mean-

ing and direction in history, whereas the temporality specific to the aesthetics regime of the arts is a co-presence of heterogeneous temporalities."[1] For Rancière, modern narrative expression—a "new way of telling stories"—follows the methodology of what he calls "new ficitonality." Narrative's new mode of fictionality privileges proliferation of meanings and unstable relationships of significance, so that the "[f]ictional arrangement is no longer identified with the Aristotelian causal sequence of actions 'according to necessity and probability.'"[2] Thus, the Aristotelian model of causal, temporal sequencing of narrative plot is replaced by an apparatus of narration that employs heterogeneous temporalities and possibilities of significance and a shuffling of images, time sequences, and reference frames.

Currie writes that "fictional narrative ... forges together anticipation and retrospect, as the anticipation of retrospect. Prolepsis ... does this by incorporating into the present a future from which that present will be viewed, whether that future is a fictional event or the event of its reading."[3] Narrative structure thus encodes and employs varying internal and external temporal frames. Currie claims "the model of time which is offered by narrative does its work by crossing the boundary between actual and potential futures to produce a hermeneutic circle between narrative and time, which encourages us to envisage futures on the model of teleological retrospect." [4] Through the act of reading a narrative text, which we know has an established ending, we experience both the open potential of the future—not knowing what will occur on the next page—at the same time we experience the actual future written and established by the author as we come to the already-determined future end of the text. Therefore, textual narratives enact the principle of teleological retrospect, a function of prolepsis. Currie defines teleological retrospect as "a kind of instruction in the significance of events in the light of later events or outcomes."[5] Therefore, narrative's modeling of teleological retrospect demonstrates that we register present experiences with a proleptic anticipation of the possible meanings and uses of the presented past in the future.

Mnemosyne, the Greek goddess of memory, the mother of the nine muses, still serves as the organizing figure for narration's grounding on its early, epic form and its reliance on the re-telling or recall of past (fictional) events. This narrative model exhibits the desire for narration to function as historiography: to transmit the past into present in a proper, causal relationship that maintains the accurate representation of the past in its present tense. This mode of narration also presumes the ontological situation of an empirical and objective past as a fixed entity of people, events, and actions that the present has access to through Mnemosyne: both as internal and external memory. Mnemosyne functions as a figure for internal and external memory in that she is the external keeper, or rememberer, of past events and through her divine inspiration she inhabits and speaks through the subjective, internal memory of the individual inspired artists. In this way, Mnemosyne also functions as a figure for the archival element of written narratives because of the narrative's own internal spatio-temporal causality—its own logic of rhetorical sequence, remembrance, and arrangement of events—and its external material existence as written record of a past locutionary event; the written narrative is both made of, and makes, history.

Jacques Derrida speaks of the dual existence of making and being made for the archiving archive, or the external record and memory of the past—as in a narrated text: in its very structure the archive determines the "archivable content even in its very coming into existence and in its relationship to the future," so that the "archivization produces as much as it records the event." [6] Derrida sees that the archive, despite its seeming retrospective orientation in its reference to "the signs of consigned memory" and tradition, really is "more than a thing of the past" because it calls into question "the coming future."[7] Archives are ultimately future oriented because "if we want to know what [the archive] will have meant, we will only know in times to come."[8] In other words, the effects of the present act of recording and storing signs of the material past will only be decipherable in some future time, so that the archive, and its affiliate form of textual narration, only become legible, and in fact useful, because of its anticipated projection or continuance of its present relevance as an external record of memory.

Walter Benjamin tells us that "for every image of the past that is not recognized by the present as one of its own concerns threatens to disappear irretrievably," so that in order for a past to be remembered, it must be remembered through narration to be useful to us in our present time, in its present capacity.[9] And, as I argue, because narration situates the pres-

ent in relation to its anticipation as a future-past, the past necessarily becomes useful and retrieved only in its continual becoming, in its continual, anticipatory projection forward for use.

Narration, then, is more than just telling stories for didactic or diversionary purposes: it is a cognitive function that organizes events around spatio-temporal time frames. Rancière tells us that "the real must be ficitionalized in order to be thought," meaning that we think in narrative terms, so that fiction defines "models for connecting the presentation of facts and forms of intelligibility that blur[s] the border between the logic of facts and the logic of fiction."[10] Therefore, according to Rancière, "Writing history and writing stories come under the same regime of truth": the regime of the truth of narration.[10] Because history and fiction fall under the same regime of discursive truth, an ontologically real and accessible past is complicated because the past can only exist as narrated tropes and figures, and as narrated characters and events. Furthermore, textual narrative—the written story—does not allow for the preservation of the historicity of a body or event because the act of narration displaces it from its past tense into a present locutionary graphic form that can be read and interpreted as much as it can be re-written and re-constituted. In other words, the past must necessarily be recorded in text in order to be thought and transmitted, so that it becomes an approximation of itself in rhetorical gestures and signs allowing for its commodification, appropriation, and circulation as a text to be read, re-inscribed and used. In this way, narration serves to continually "presentify" the past, even as it tries to preserve the past, through its recall and (re)present(ed) form. Thus, narration negates the clear separation of past and present, history and fiction, and ultimately shows that the past only exists in its narrated present form—and in our modern graphic age, more often than not, as words on a page.

Narration's proleptic time function further displaces the centrality or gravity of the historical because the narrative present is projected as a future memory, into a future where its own narration can be appropriated, reformed, and retold. In this manner, the narrative itself anticipates its own cancellation or extension in its future narrative use. Narrative's proleptic function positions the narrative present in relation to its continuation in its transmission because in order for it to be relevant it must continually be present: it must always be becoming, continually

being written in anticipation for its projected use as a shaping memory in the future.

Martin Heidegger writes in *Time and Being*, that "Whatever 'has a history' is in the context of a becoming ... Whatever 'has a history' in this way can at the same time 'make' history. 'Epoch making', it 'presently' determines a 'future'. Here history means a 'connection' of events and 'effects' that moves through the 'past', the 'present' and the 'future'. Here the past has no particular priority."[11] History, then, is made through and of narration, not for the purpose of retrieving an arrested past, nor for the ontological edification of the present through a retrospective understanding of the past's teleological end, but for determining a future, for a projected future use. This is the principle of prolepsis, which refashions our propensity for considering the present retrospectively, replacing it with an idea that the present does more to determine a future, than it serves as a point for retrospective contemplation of its past. Epoch making, or narrating the past, does not reveal the past as much as it shapes a future.

A modern reevaluation of the retrospection of narrative and history, and the relationship between past, present and future, informed by narrative's proleptic time function allows us to begin to understand futurity as a principle concern of narrative and history, even as we recognize their dependence on continually presentifying a past in anticipation of its projected future use. Narrative's proleptic time function demonstrates the weakness of the gravity of history.

NOTES:

1 Rancière, Jacques, *The Politics of Aesthetics*, trans. Gabriel Rockhill (New York: Continuum, 2004), 26.

2 Rancière, 36.

3 Currie, Mark, *About Time: Narrative, Fiction and the Philosophy of Time* (Edinburgh: Edinburgh Univ. Press, 2007), 144.

4 Currie, 21.

5 Currie, 22.

6 Derrida, Jacques, *Archive Fever: A Freudian Impression* (Chicago: U of Chicago Press, 1995), 17.

7 Derrida, 33-4.

8 Derrida, 36.

9 Benjamin, Walter, *Illuminations*, ed. Hanah Arendt, trans. Harry Zohn (New York: Schocken, 1968), 255.

10 Rancière, 38.

11 Heidegger, Martin, *Being and Time: A Translation of* Sein and Zeit, trans. Joan Stambaugh (New York: State University of New York Press, 1996), 347.

The film *Rosemary's Baby* is used as source material to generate visuals derived through spatial and temporal manipulation, resulting in a digital print and video. The video displays the film moving across the screen while preserving a visual trace of the film's pictoral space. As the film progresses within its own time, its movement across the screen erases previous traces with new renderings. The digital print is a drawing of the entire movie from start to finish. From this new point of viewer engagement, time-based scenes become textures in two-dimensional space that can be read either from left to right or from a more global perspective.

Drawing Through Rosemary's Baby (detail);
video and digital print, 27' x 7'; 2009.

Robert David

Infinity; oil on canvas; 68" x 68"; 2003.

Elizabeth Grachev
Elizabeth Grachev

Light Ray; oil on canvas; 60" x 92"; 1983.

Moment; oil on canvas; 66" x 60"; 2002.

TIME, UNIVERSE, AND METABOLISM

Michael Shulman

Nihil est sine ratione. (Nothing is without a reason)
Leibnitz

INTRODUCTION

What is Time? Why does the Universe expand during Time? These two fundamental scientific questions have never been truly answered in full. This essay attempts to shed new light on these unanswered questions through two concepts of the 20th century's Russian scientists.

On the one hand, the famous astrophysicist Prof. Nikolai Aleksandrovich Kozyrev (1908-1983) introduced the notion of Time rate and suggested that the Universe energy increases during Time. Prof. Kozyrev predicted and then discovered the volcanism on the Sun and received a gold medal from the International Academy of Astronautics in 1969.

On the other hand, a dynamic system age is usually measured by an *amount* of specific *events* that correspond with this age. For example, in embryology it is represented by the number of cell divisions; in ecology, genetics, and ethnography it is represented by the number of generations; in gas physics it is represented by the number of particle collisions.

Professor A.P. Levich (who is the Chairman of Russian Interdisciplinary Temporology Seminar and the WEB-Institute of Time Nature Explorations, Lomonosov Moscow State University) proposed introducing a *parametric time* for any system that is strictly proportional to its basic quantitative parameter. Also he explained the fact of the variability of the system by its consuming of some resource, i.e. by a generalized metabolism process. A living organism increases due to eating; a country can join (consume) other territories; a celestial body may attach external matter, etc.

BLACK HOLES IN OUR UNIVERSE:
VIEW FROM OUTSIDE

Some classical physicists remark that if a star's mass-to-radius ratio is too big, then light cannot leave the star surface and reach an external observer's eyes. Present-day General Relativity also states that a black hole is a region of space that is not causally connected with its environment, so a signal (light or particle) cannot carry some information about itself beyond this regional boundary.

Black Holes (BH) differ from all usual bodies: one can describe a BH using few parameters (degrees of freedom) only, these parameters are namely mass, electrical charge, and angular momentum. The real BH's existence became evident for physicists at the end of 60s.

Black holes in our Universe can be grouped as: primordial black holes, stellar-mass black holes, and supermassive black holes. The first is highly speculative; the second and third are widely accepted. Primordial black holes of all masses are postulated to have formed from quantum flutuations in the early Universe, no significant observational evidence has yet been found of the existence of these objects.

Stellar-mass black holes, ranging from a few to a few tens of solar masses, are normal but rare endpoints in the evolution of massive stars due to the gravitational collapse (at a mass more than 1,5–3 solar mass). Finally, supermassive black holes ranging from a million to billions of solar mass are disposed at the core of galaxies. The black hole at the center of our own Milky Way galaxy has a measured mass of 3×10^6 solar mass, based on the orbits of stars near the radio source Sagittarius A* associated with the Galactic core.

As it was turned out, an external observer can strictly consider a BH as 2D physical membrane consisting in a viscous fluid having certain mechanical, electrodynamic, and thermodynamic features. These membrane features are determined by its surface gravitational and electric charges. In fact, a mechanical membrane form (BH's event horizon) comes to a dynamic equilibrium due to interaction between surface pressure, gravitation and centrifugal forces. Electrodynamic features of BH are specified by the complete similarity between the membrane and conductive sphere, and the electric field flux form of a charged particle near the event horizon of a non-rotating BH is the same one of this particle near above conductive surface. From the thermodynamic point of view the membrane surface area is similar to any usual body entropy: it increases or does not decrease (Hawking theorem). The membrane itself is defined by an effective temperature that is proportional to its surface gravitational charge. Note that BHs (like stars and other self-gravitational objects) have a *negative* heat capacity.

WHAT IS INSIDE OF A BLACK HOLE?

The first attempts to describe theoretically what happens inside of a BH were made at the end of 1970s. The present-day General Relativity community believes that a BH's representation as a membrane is not correct for an internal observer. One derives such the opinion from the Einstein's equations general solution that is prolonged into the BH's internal region. These solutions (that are found by Schwarzschild, Reissner, Nordström, Kerr, Newman) are characterized by very exotic features: a mysterious internal BH's structure, central singularity, connections with infinitely distant in time our Universe's (or even other universes) states.

All these solutions are based in principle on the solution *dependence on a point distance from the center of BH*. However, this generates some fundamental problems (see Novikov and Frolov, 2001). Firstly, some initial singularity appears inside of the BH (like singularity for point electrical or gravitational potential in classic physics), whose correct description should take into account some essentially quantum effects. Secondly, some paradoxes appear that are connected with the time arrow and causality. Particularly, a BH's behavior is like as it lived at the opposite time (from the future to the past).

In my opinion, these problems are corollaries of the incorrect premise that the interior solution for BH is a prolongation of an exterior one. Thus, the authors of the work (Mazur and Mottola, 2002) refused such a concept of the BH's internal structure and proposed the new solution for a body endpoint of gravitational collapse:

By extending the concept of Bose-Einstein condensation to gravitational systems, a cold, compact object with an interior de Sitter condensate phase and an exterior Schwarzschild geometry of arbitrary total mass is constructed. These are separated by a phase boundary with a small but finite thickness (near Planck's length) of fluid, replacing both the Schwarzschild and de Sitter classical horizons. The new solution has no singularities, no event horizons, and a global time. Its entropy is maximized under small fluctuations and is given by the standard hydrodynamic entropy of the thin shell. Unlike black holes, a collapsed star of this kind is thermodynamically stable.

On the other hand, my own study (Shulman, 2007a) basing on the General Relativity known results revealed a very interesting picture of that happens near to the *finite size body* gravitational collapse. It turned out that during the object contraction (but before the collapse event) a new situation appears: the pressure distribution inside of the object is fully changing. Instead of a positive finite pulse that decreased from the center to the external object bound, an infinite bipolar pressure break point appears which is forced out to the bound while the collapse is approaching.

This impelled me to propose the more radical concept of description of BHs in our Universe, which also can be used as a foundation to explain the Universe's features. The concept suggests that the membrane-shell *really* appears at the BH's event horizon, however, the space-time topology change happens there as a gravitational collapse result, and physical space itself disappears as such inside of BH, the boundary between the interior and exterior regions of 3D space has the dimension number 2.

Then the representation of 2D membrane becomes exact, not approximate. The entire mass of the BH turns out to be concentrated uniformly in this 2D region, and there is no any difference depending on the distance from the BH's center. Now one may understand why the environment average entropy is proportional to the medium element volume, and the membrane entropy is proportional to the surface area element.

OUR UNIVERSE AS A BLACK HOLE IN AN EXTERNAL SUPER-UNIVERSE

In my opinion, the BH's structure transforms at the collapse. There will be *nothing* inside of the object boundary, all the matter will concentrate in the boundary shell, and the BH's dimension number reduces (new dimension number is old dimension number minus 1). Furthermore, the event horizon surface area increases while it consumes a matter and energy. From the hypothetical 2D observer point of view, who is disposed on the surface, its 2D universe increases, and the real measure of the universe variability is its total mass value. For such an observer the energy conservation law will not accomplish in its universe, and a pressure will be negative in this boundary degenerated part of space.

When we compare our Universe's behavior with this situation, we first before find out that is expands too. In 1993, I reflected on the Kozyrev's ideas and came to the Universe concept as a 3D shell of a 4D Euclidean sphere (Shulman, 2007b). The increasing sphere radius I identified with the Universe age, so it received a simple and clear meaning of Parametric Time. In such a model the velocity of light has a status of an empirical coefficient to transit from length measuring along 3D sphere surface to the length measure along the normal to this sphere.

On the other hand, the velocity of light status as a maximally possible one simply corresponds with the maximal angle (90°) of a possible inclination of a 4D world line relative to the spatial 3D sphere surface. Such a model can be deduced from the suggestion that our Universe is 3D Black Hole, i.e., 3D membrane in a 4D surrounding environment. This hypothesis that our Universe can be a black hole was also claimed in the paper by Lee Smolin (Smolin, 1994).

Furthermore, we use the introduced Parametric Time and have for this closed on itself Universe the usual Einstein—Friedmann equations. However, we take into account two very important statements:

- *The static pressure of matter is not a priori set to be zero.*
- *The energy conservation law is not applied as an axiom.*

Then we can find out the pressure and the energy as the solutions of these equations (Shulman, 2007b). Such a solution (as it should be) determines a (negative) pressure as a function exactly corresponding to the gravitational energy and the Universe total mass that is changing linearly during Time. This solution allows us to explain a number of the observed Universe's cosmological characteristics.

The physical meaning of the Big Bang becomes clear: it represents the gravitational collapse that is observed by an interior observer, i.e. by an observer inside of 3D membrane. The membrane age is exactly proportional to its current 3D radius. Energy (momentum) of any quantum object in it is universally measured as the ratio: Universe age (radius) to the object's constant wave period (wavelength). A mass of each such object as well as the total Universe mass increases linearly on Time, and by this way

Pressure: (R/r1) = 1.0605 (Density/Critical_density) = .70296
Initial value = -1655.109

Pressure: (R/r1) = 1.05 (Density/Critical_density) = .74621
Initial value = -24.45531

Pressure: (R/r1) = 1.01 (Density/Critical_density) = .94204
Initial value = -4.454901

Figure 1. The transition from a finite unidirectional pressure pulse to the discontinuous behavior. The shifting of the pressure break point to the sphere bound while one approaches to the collapse.

Kozyrev's thesis "Time transforms to Energy" is surprisingly true. Also, the linear Universe size dependence on the age eliminates the so-called "horizon problem" and "cosmological constant problem" (Shulman, 2007b, 2007c).

Furthermore, remember that Special Relativity postulates the equality of all the inertial reference frames, and absence of any preferred frame. Meanwhile, this fact does not extend on a rotating frame that is confirmed by a number of well known experiments with gyroscopes, etc. On the other hand, if our Universe is closed, then any difference between unidirectional linear motion and circular one disappear at all during a total fly-around of Universe. It is not speculative consideration only: it is shown in (Shulman and Raffel, 2008) that such a relict photon fly-around of Universe should generate a peak at the beginning of the temperature power spectra of CMBR that is actually observed but has not any common explanation in the present-day cosmology.

One more detail is associated with CMBR: its dipole anisotropy that can be explained namely using Solar system motion relative to preferred frame reference (Shulman, 2007d).

The present-day cosmology considers de-facto Universe as a closed system, particularly, while on integrates the Einstein—Friedmann equation. However, this leads a number of difficulties while one tries to explain the objectively observed picture, particularly, the total inconsistence with equilibrium state. Because of that *de-jure* the cosmology refers to General Relativity where the world as a single whole should be considered as a system in a variable gravitational field (not as closed system), where the second law could to be not accomplish.

Finally, the model proposes a new point of view on our Universe's thermodynamics. In this model the Universe entropy *decreases* (not increases) since (like a heat machine work medium) it receives an energy from outside at relatively high temperature and gives it up to own (interior) supermassive black holes at practically zero temperature (their core give a dominant contribution into our Universe's entropy, see (Egan and Lineweaver, 2009). Because of this, the cosmological Arrow of Time originates from thermodynamics and is primordial relative to biological (evolution) and psychological Arrows. This is the reason of the continuous differentiation of a Universe structure and increasing deviation of the Universe state away from equilibrium during 13.7 billions years of Parametric Time (Shulman, 2009b).

References

Mazur, Pawel O. and Emil Mottola. "Gravitational Condensate Stars: An Alternative to Black Holes." (2002) doi: http://arxiv.org/abs/grqc/0109035

Shulman M.H. "Cosmology: a New Approach." (2007) http://www.timeorigin21.narod.ru/eng_time/Cosmology.pdf

Smolin, Lee. "The Fate of Black Hole Singularities and the Parameters of the Standard Models of Particle Physics and Cosmology." (1994) ArXiv:gr-qc/9404011v1

Shulman, M.H. and G. Raffel. "On the Oldest Photons Phenomenon." (2008) http://www.timeorigin21.narod.ru/eng_time/Oldest_photons_eng.pdf

CANDY STRIPERS SERVE CACTI
AND CANDYTUFT SALAD

to a ward of fainting goats. I
am on eo fthem. I'm typing
faster than this machine can type
because the machine itself
is dangerous. No pause
possible, especially since a bar
of space exists—infinite—
between lips. Hi Jen Hyde
you have so many sides
to your personality I need
quadrilateral glasses
equipped with night vision
to see you equidistantly emerge
between curtains, velvet, polishing
a miniature, silver pistol,
rubbing out stars
with the idea of stars
& breathing. Who says a song.
Over. Who utters
the phrase transparent gutter
& stands back as a tube of rain
slides horizontally
across the sky
with nowhere to go but
clouds, one by one
out of nowhere, throats.
Has the soil. & a hackberry
prepares tiny, beak-sized orange meals
for the birds. Between
a peduncle &
the cirri's pompous, feathered hats
a barnacle; I live
on the side of a thimble-sized
ship. No need of a dry dock.
No need of a dock. Soon
they will sell saliva. Soon
the Mouth Breathers Association
will celebrate this victory! Soon
our foreheads will pivot into this world
installed with a one inch dormer window
& we'll leave ours open
to the snow—let a flake drift in
& land, exactly, on the thought of melting,
the word melting—islands
floating into &, axons & end rhymes,
written ti

Debra Swack

ZEBRA

TIGER

GIRAFFE

LEOPARD

Schematic Images for Animal Patterning Project Animation;
variable size projections; 2000–2010.

THE PHILOCTETES CENTER:

TIME

Panelists:

Olga Ast

George Musser

Mark Norell

Michael Shara

Peter Whiteley

Excerpt from the edited transcript of roundtable discussion at The Philoctetes Center for the Multidisciplinary Study of the Imagination (Francis Levy and Edward Nersessian, Co-Directors) at the New York Psychoanalytic Institute, December 5, 2009.

Levy: Mark Norell will moderate this afternoon's panel and introduce our other prestigious guests.

Norell: How do we talk about increments of time? I think that if you were to look at it purely from the academics that I'm used to, you would say, well we have social scientists and ethnologists who look at time in a generational kind of way... Then we have archeologists who look at time on a millennial time scale ... paleontologists look at it on a millions and millions of years kind of thing ... astrophysicists ... in billions of years ... But first I'd like to hear about what are the measures of time itself.

Shara: That's irresistible. One of the things that astrophysicists tend to do with most of our other professional colleagues who are interested in various kinds of stretches of time is the kind of arrogant, little boy approach that is: my dad can beat up your dad with both hands tied behind his back. We do deal in billions of years, and, in fact, we actually talk about trillions and quadrillions of years in a realistic sort of way.

Now, the universe is only 13.7 billion years old, and it's actually 13.7 plus or minus 0.1, which is itself a remarkable thing to be able to say, and astrophysicists have determined that only in the last ten years or so. Now, what in the world could I possibly talk about in [the sense of] a trillion years? What could be there? Well there are stars that I can point at, including one that you can see with a small pair of binoculars in the Southern Hemisphere, the companion to Alpha Centari, a little M-dwarf star, a thing that's about a tenth of the mass of the Sun that will still be in existence [in] about a trillion years from now ... And what about a quadrillion years from now? ... even those stars will have burned out, but the ashes of the death stars, including *our sun* ... will still not have reached zero degrees, will still be very slowly radiating a little bit of light a quadrillion years from now.

... what about longer timescales than that? What we seem to be seeing is the universe accelerating. ... a few trillion years from now in the future, ... there will be no galaxies out there because the universe will have expanded so much and accelerated so much that all of the galaxies will have disappeared beyond our event horizon, so there will be no light coming from any of them ...

... Into the much far future... we really haven't a clue as to ... what's going to happen because once things start to expand that much...once it's devoid of any kind of matter, it's very hard to even conceive of ... how you would objectively measure time. You need vibrating atoms, pendulums, quartz crystals. You need something to do something in order to be able to measure time... Does the concept of time have any reality?

Norell: Luckily that relates to the Hopi perspective.

Whiteley: ... It's interesting to ponder what time is in the first place, ... Can you even translate ... the word *time* effectively into other languages? There is clearly a difference between French usages of the word *temps* and English usages of the word *time*. Of course, Benjamin Lee Whorf's characterization of the Hopi language was that there was no concept that was directly similar to the way that time was used discursively in English. That's come under some criticism from some subsequent linguistic work, especially by a linguist named Malotki, who does indicate that Hopis are perfectly capable—and that's part of my experience too—of speaking about what we might, in English, call the past and the future and the present, even though they may have a different philosophical take on those things, and even though their sense ... of experience may be filled with a sense of predestination, [and] that the continuous flow of time isn't separate from any kind of universal intentionality or meaningfulness, but that it's saturated with the idea.., that the events ... have already been predestined, and we're simply getting to what's been prescribed since the beginning of time.

But, in any event, that leads me to think about the relationship between how we characterize time cross-culturally in a broader sense. It's obviously an abstract notion, in and of itself, and to contemplate measuring it requires conceptualizing it a priori in a certain sort of way... Nonetheless, we can arrange it as it were in space and count its lengths. Obviously the interrelationship between time and space is very much a part of the way that we conceptualize time on an ordinary basis...

But, I think it's pretty standardly the case cross-culturally that you do have this conjoined sense of linear time and cyclical time, of time that's sort of modeled by a geometrical line in the way that we tend to think about it mathematically or else in a circle. And where that particular design comes from, I think, is subject to debate. Obviously we experience aspects of both [concepts] in our own lifetimes. We are born; we grow up; we grow old; we die. But we also see the cycle of the seasons every year, if year is the appropriate measure that we're thinking of in a particular cultural context...

In any event we will try to deny the reality of our expectation of death by suggesting that we can control time by articulating measures of it. And I think that is something that comes out of ritual before it comes out of science, although the two are clearly linked. And if you take any number of examples, but I'm thinking particularly of the Mayan long calendar, we're basically—I'm sure you can do it into the quintillions—but where there is a thirteen/twenty year cycle that repeats itself every 260 years, and events that occur at a particular mo-

ment of the cycle will reoccur, or they will be revisited next time that cycle comes around. That to me serves as a kind of useful metaphor as how measuring time, how producing calendars of time, or [how] cutting up time into hours and minutes and seconds and so forth is basically a desire by human beings to control the flow of experiences that are basically uncontrollable.

If you say that you are going to predestine all events, which is in a sense what Hopi phenomenology does or what the Mayan calendar does in a somewhat different way, it comes down to the same principle, I think, that via a ritual organization, a symbolic organization of the flow of experience, you're trying to control events as they occur, so when we have our annual rituals of one kind or another, whether it's a mid-winter ceremony or, for the Hopis, a Katsina ceremony or a Snake ceremony, basically you're restoring the world to a time that exceeds the ordinary flow of linear time and rebalances everything, restores everything to a place of timelessness when the world was new, when it was created...

Musser: I think the Large Hadron Collider sees effects that occur in something like 10^{-25} seconds, and the longest time span ever probed was something like 10^{33} years, in understanding the possible decay of a proton. So that just leaves astrophysicists in the dust; a trillion years is nothing compared to 10^{50} or whatever that turns out to be.

One of the great issues in physics is why the physical notion of time is so mismatched with our other notions of time, those certainly in Western culture, let alone in those we see in other cultures that we're lucky enough to inhabit the planet with. Ironically, the kind of answer most physicists would give to that disconnect is to *worsen* the disconnect—to go even further from our notions that time is progressive or linear versus cyclic. Those just don't even enter into the emerging idea that time, in itself, is an emergent concept, that the universe is, at root, timeless, spaceless also, and that time kind of bootstraps itself into existence. And you'll notice that all the terms I use for this are themselves situated in time. Time is bootstrapping, but that's something that happens in time; "-ing" connotes something in time. So our language is already becoming stretched here, and it's hard even to conceive a process producing time, and therefore cannot operate within it. So how can it then be a process?

We seek to relate those kinds of notions of time and those different subsystems to one another. That's actually one of the leading ideas for understanding what time is, that it actually comes from the interrelationships among the subsystems in the universe. Time doesn't exist in the abstract as an absolute concept. It's something that we introduce into science and language and art and so forth as a way to describe interrelationships among things. Time, itself, is some kind of common currency among these different domains of human experience.

Levy: ... Aren't you talking about anthropomorphizing the concept of time, that basically it's just a creation that has very little to do with the actual existence of some other entity? ...

Musser: Well, first of all, I can't avoid anthropomorphizing because I'm a human being; that's a deep question that goes into the whole practice of how science is done. The mathematical understanding tells us that the universe is timeless, so time has to emerge somehow, just not at the fundamental level; it has to emerge at one of the other levels that reality presents to us. Maybe it doesn't really emerge at the human level, maybe it emerges at the particle level, maybe the string level or whatever the universe is made out of. In other words, I think there's an objective sense of time, at least within physics.

Levy: You don't need a perceiver in other words.

Musser: Right, so the system doesn't have to be a living system. The subsystem doesn't have to be living; it doesn't have to be capable of self-consciousness as we hopefully are.

Shara: It's a very difficult concept that physicists have been grappling with now for fifteen or twenty years. To try and get your hands around it, let me take one step back and talk about something that's a little more objective, that's extremely measurable, that I think all physicists agree with today, and that is the rate at which clocks

tick is not a constant in the universe. If you and I could somehow put on extraordinarily accurate atomic watches on our wrists, synchronize those watches somehow by sending light signals back and forth, and then one of us would simply sit in this room and the other would go for a walk around 81st or 82nd street and then come back here and compare clocks, our clocks would no longer be perfectly synchronized.

Einstein summed it up very beautifully by saying that you can move through space, you can move through time—we all do—and it turned out that you end up moving through the thing that he called space-time, the four-dimensional construct, essentially at a constant speed, but the faster you move through space, the slower you move through time, so that you end up moving at a constant speed. ... A logical consequence of this is ... twins paradox ...

So clocks don't tick at the same rate if they're not at same place in space-time, not moving together with each other. And that is not a theory. That's been extremely well measured. Atomic clocks have been put on a Boeing 747 and been flown around the world, come back to the same starting point in Colorado, and the clock on the 747 ticked a few billionths of a second less than the clock that remained behind. ... the closer you get to the speed of light, the slower your clock ticks relative to a clock that's stationary with respect to the rest of the universe.... But the objective reality is that clocks do not tick at the same rate if you're moving at different speeds. We see that also with elementary particles all the time. Particles coming down through the atmosphere, mesons, decay far too slowly relative to mesons at rest...

And I'll just finish by noting that there is one amongst us, a Russian cosmonaut, who in fact has experienced this more than anyone else. He's been in Earth orbit, I think a year and a half, longer than any other human being, and as a result he has aged, several millionths of second less than he would have had he remained here on Earth.

Whiteley:	May I say something about objective reality since you've raised that "dirty" word? It strikes me that in discourse about an asteroid hitting the earth sixty-five million years ago, or in calculating something in 3-33 or whatever and even in Einstein's twin example, we have to speak with the perspective of a subject, to answer your question of, "do you need a subject to perceive time?" I was just thinking about all of the discourse that we have presented, and I can't imagine it could have possibly occurred, this discourse about time, say in about 1890. Virtually none of the statements that were made could have occurred at a different moment in what we consider to be an absolute progression of time. So I wonder what that does to the ontological reality of the statements that we're making about some of those temporal processes.
Shara:	I don't think it changes reality of the fact that time is stretching. We just weren't aware of it in 1890. The fact is, we've now come to understand these concepts, but I don't think that in any way changes the reality of them. Stretching time existed thirteen billion years ago. There just were no humans around to do the experiments to check on it...
Whiteley:	And if we talk about it three hundred years from now in a totally different way, will even these statements have the same kind of relationship to what we are assuming is an objective reality?...
Norell:	This whole idea of timescales and measuring time and distances is something that I find really interesting. I'd like to hear from Peter and Olga's perspective from a visual and sociological point of view because what's really been called out to me from working in a lot of different communities around the world is that in some of the places that I work in, like Tibet and Laos, where average life expectancy is only about 35 years for people, they talk about things far differently than we do in our culture where life expectancy is twice that.
Whiteley:	I think generational and the perception of generational time is a significant component, certainly, of the sociological apprehension of time cross-culturally. In terms of life expectancy, I think that's going to vary a lot cross-culturally too... for example, Hopis constantly say nowadays, "in the past we used to live a lot longer." And they blame it on the modern diet that's been introduced from the outside world.

There are some objective indications that that's the case, that there were a lot of people, say, around 1930 or 1940 who were in their late nineties and older than that as well. So I think they, certainly, tend to see generational patterns as more similar to our own lengths of generations, but they're concerned with how the past is brought forward, how it's transmitted from one generation to the next. I think, again, that's something that varies a great deal cross-culturally, and if your culture tends to emphasize more the cyclical repeating aspect of time, that we're all on some sort of cosmic wheel or another, then that may be more or less calibrated back into the measurable past.

I'm thinking, for example, of the number of generations that people will count back in different cultures. Hopis don't count back very far. Once you get back past a grandparental or ... a great grandparental level, things become much more melded in terms of those sorts of discriminations, and frequently, that doesn't mean there isn't a very precise kind of memory about certain kinds of events. And it was really interesting to me to discover that people could start talking about a particular event from the past and it was as if they were speaking about it from their own experience. But I knew, from other patterns of information, that they were talking about something that happened three hundred years ago, and I could date it via the documentary record, for example, in archives.

That, sort of, sense of the past is nonetheless very powerful in that context. But in terms of measuring the time backwards from the present, they're not terribly interested in that kind of thing. Whereas the Kwakwaka'wakw of Vancouver Island (the people who used to be called Kwakiutl), or the indigenous Hawaiians tend to trace generations back really very precisely, back maybe 2000-2400 years in a way that, unless you were a Monarch, you wouldn't do in our society.

So, again, I think it's interesting to raise that question of generationality as it were. You mentioned your family would speak about things in, say, the 1800's. How much further back than that does it go? How many names of ancestors does one know, for example? I know that past my own grandparents I'm pretty well lost. I can recapture it from census records, but they're meaningless names. They don't have any resonance; they're just indexical of who the actual person was at the time, but they don't have any social salience to me.

Nersessian: What is the definition of time?

Shara: I like to think of time in terms of vibrations of the nuclei of atoms, which is, I guess, the geekiest way of doing it, but it's also the most precise way we have today. That's how atomic clocks were. It's really a certain number of vibrations of a certain kind of atom.

Nersessian: Is that the measurement of time or, actually, the definition?

Shara: ... That's certainly the measurement of time, but I don't think you can separate the measurement of something, in some sense, from its reality. At least our perception of time is one of time flowing in a linear sense forward, and we can measure that extraordinarily precisely using these kinds of technologies...

For example, the concept of simultaneity. We can all think of two events that happened at exactly the same time. And in particular, if I take two lead balls and drop them from the same height towards the table, you would expect that they would hit the table simultaneously. Or you if stand on the side of a set of railway tracks and you see two lightening bolts hit the train track simultaneously, you would think everyone would see the same thing simultaneously. That's nonsense. That's just wrong. It's not true.

Someone on board a train racing down those tracks, at, say, half the speed of light, sees the lightening bolt on the right side hit well before the lightening bolt on the left side. And then you'd have to ask the question, "who's right?" Is it the moving observer or is it the stationary observer, and the answer is both. And that's because this paradox is resolved by the fact that there is no such thing as simultaneity. The concept is meaningless. It's wrong. It was first demonstrated by Einstein, and all physicists agree on it today.

Now if we can't agree on simultaneity, or if we can't agree that concept of simultaneity is a meaningless one, then in some sense, all of the rest of our concepts of time dissolve. The whole basis on which we think we understand time as human beings is really a basis in sand, and our castle all comes crashing down. So the real answer to your question is, I can't answer that question.

Musser: Which is always the best answer, I think. It depends what level you're speaking on. Obviously, for an everyday experience or the experience of somebody who is lucky enough to be on train that is moving at half the speed of light, unlike the trains in this city, at that level—it's really a deeper level, and we're talking about a deep, deep level at which time might just fall through your fingers. You don't have anything of it.

But the way I like to think of time, and it's actually related, in a quite interesting way, to this whole question of lighting bolts and simultaneity, is time as an ordering device. It's like the psychological tests where you're given twenty frames of a story, and you're supposed to order them, and suddenly that makes sense. So, someone lights a match and then there's a fire rather than there's a fire and then they light the match. It allows you to order what would be otherwise a completely jumbled series of events. So, if you were to take all the physical events in the entire universe and then just dump them on the table like a jigsaw puzzle and try to order them, you would find that in that process, this idea of time would help you; time would act as a device to help you order things, and that actually comes up in this whole question of lightening bolts because, although, the simultaneity is relevant among the different observers, what is not relative among different observers is a cause and effect order.

Whiteley: I think there's a way in what you hinted at, and I think maybe we need some philosophy if we're going to be able to have definitions that we can agree on or, maybe, disagree on, but at least have definitions. But it struck me that the ordering principle in this psychological test, it resonates with Ricoeur's notion about the need of narrative to articulate our sense of temporality. He argues that temporality is the fundamental diagnostic definition of what it means to be human, and we make that sense of temporality via narrative, whether it's a biographical narrative, or a historical narrative in a group, or whatever.

And the other philosopher whose name I'll take in vain is Wittgenstein, and ... you can't say, "I can't answer that." It's not acceptable. The meaning of a word, in his sense, is its use ... If we agree that we're talking about something we can point at, in some sense, ostensively, then we've got to be able to say what the broad outlines of that thing are. So, I think we have to do an inventory of the ways that we use that word *time* and [do so] in ordinary language, and then we have to say, "well that's pretty much what the definition amounts to even if we use it idiosyncratically, whether we're physicists or anthropologists or via a whole range of other senses that distinguish our perspective on things."

Ast: I would like to say ... something on the definition of time... there are different visual metaphors of time that show how we define time visually in everyday life. For example, time as a river, time as a circle, time as an arrow... Sometimes time is defined as an ocean. Also, time can be shown as destruction and aging. If we start to think about time, we see that time is actually a very complex phenomenon that depends on other phenomena, and it couldn't be defined simply because everybody sees it differently.

I'd like to draw your attention to a painting by René Margritte. It shows a man looking in a mirror and seeing his back, not his face. Although the most famous interpretation of time is the omnipresent Salvador Dali's "The Persistence of Memory," where he connected time as a clock, a very obvious visual metaphor, to a flow ... Magritte also had his own interpretations of time, but he never associated this particular painting with it. It's named *Reproduction Interdite*, or *Reproduction Impossible*.

From my point of view, it's an absolute visual metaphor of human perception of time. We look anxiously ahead to our future, but what do we see? We see only own memories. We see only our back. To me this painting looks almost like a formula, like an equation: the Future equals the Past plus our Desire. The desire to be there... it

might be not so much our desire to be there, but our fear to disappear from there, fear of our death. And our concept of time is connected to our fear of death very closely. We are in constant search for immortality...

... Also one more comment on George Musser's "time as an ordering device" interpretation ... When I wrote about the causality I referred to *Crime and Punishment* famous novel by Dostoyevsky. But my editor, Julia Druk, corrected it as *Crime then Punishment*. Naturally I objected, "No, Julia. The novel's title is *Crime and Punishment*." She said, "No, within your context, the context of causality it has to be *Crime then Punishment*." And I realized that from just a novel's title, essentially a morality tale, a simple juxtaposition of Good and Evil, it evolves into a formula: Crime *then* Punishment. *Crime* and *Punishment* are static elements by themselves. Where's time? Time is in the connection between them. And also, "past" and "future" from the first equation are the static components. Where's time? It's in the desire or in fear. Time is in the connection between them.

This doesn't pass for the scientific definition, but it's a visual definition, and I think that we use visual language probably more often than verbal language. We talk to ourselves in visual language. For example, when you see a chair, you recognize it: it's a chair, but you don't say, "a chair is an object I can sit on that has four legs, etc." No, you recognize it. So, from my point of view, because of this, visual metaphors are very important.

From the beginning of the past century the visual metaphor of time as an arrow has become very popular and got implanted in our minds from the school years. However, in my opinion, it is rather limited. It is simplified and we like simple things: squares, straight lines, and perfect circles. But it does not say much to us about the complexity of the phenomenon of time.

Whiteley: On this question of language, I think that's very significant from a variety of perspectives, whether it's verbal or visual. Note that the way in which we've tended to be using time in this discussion is as a noun. It can be verb; of course you can time something. But most of the usages we have for it are as a thing that you can look at and somehow define. Part of the difficulty, I think, with translating that concept into other languages depends upon whether the same kind of emphasis upon nominal things versus verbal processes is present in one of those languages, and here I'm thinking, especially, of Hopi which tends to be a language which is more composed of verbs in various states and various processes than it is composed of nouns. The same is true in Navajo, where there are, for example, theoretically three hundred and fifty-six thousand endings on the verb, *to go*. But the verb, *to go*, is the principal verb in the Navajo language, rather than the verb, *to be*, which is associated with nominal states and things.

In practice, I think I've learned most about this in the context of Hopis describing certain events. Frequently events that are felt to be aesthetically pleasing or desirable are captured in personal names. Hopi names are like little haikus. They're representations or images of a particular process at a particular time. So, somebody was explaining a particular name to me, *Qötswisiwma*, which literally means, "whiteness turning around in a line," and it refers to a particular dance, a kachina dance, a dance of masked dancers, who reach a certain point in the performance, and each of them successively turns around in a line, and ... the top half of their bodies are painted white—so you see that happening in that process...

English can describe that with nouns, or even maybe with some verbs. But it's not ordinarily the kind of thing phenomenologically that English would pick out to describe about those kinds of aspects of phenomenal experience. ... One other example, a name that I had puzzled over for years was the name of ... the village chief of Old Oraibi until about 1960, and his name was Tawa-kwap-tiwa. Tiwa is a male name ending that may be associated with the verbal indication of process. Tawa is the word for sun and, incidentally, the word for clock. Now that they have clocks, tawa is a clock. Kwap is a plural term meaning, "several things get put above." So you have tawa, sun, several things get put above, and then the verbal male name ending.

I said recently to a friend, "You know, I haven't been able to figure this out. You've only got one tawa. You haven't got many tawas that are getting put on above. Why is there a plural in the verbal aspect of that?" And

he said, "That's obvious. Why haven't you figured that out? It's because it refers to the sun at various junctures in its passage across the sky. That it has been put up."

So, again, the visual imagery of that was very revealing about the way that Hopis think phenomenologically about that kind of process, and I think, again, it's associated with their language. I think we would tend to think about the sun in a particular spot, not certainly imagining the process or talking about the process. In our ordinary usages of it, we tend to think about it as fixed here and then moving to there and so forth, rather than the processual aspect itself. And I think maybe the same thing is a problem in understanding what time could be as we try to translate it into other languages, which are non-European.

Shara: ... The workings of the human mind are fabulous; I have no beginnings of understandings of how they function. And the perception, the completely different perceptions by different peoples of what can be conceived of as exactly the same process are to me fascinating ... that's something that I try to understand and put my arms around every day. I try to understand the universe; I try to understand the processes going on in the universe, and I try to make predictions about what is going to happen in the universe using the laws that I think govern the universe. But I'm very much aware that there are different perceptions.

Einstein may have summed it up best when he was asked often about time and relativity, and one of the best things he ever said, in my opinion, was, "You sit on a hot stove for a second and it seems like an hour. A pretty girl sits in your lap for an hour; it seems like just a second." That's relativity and time.

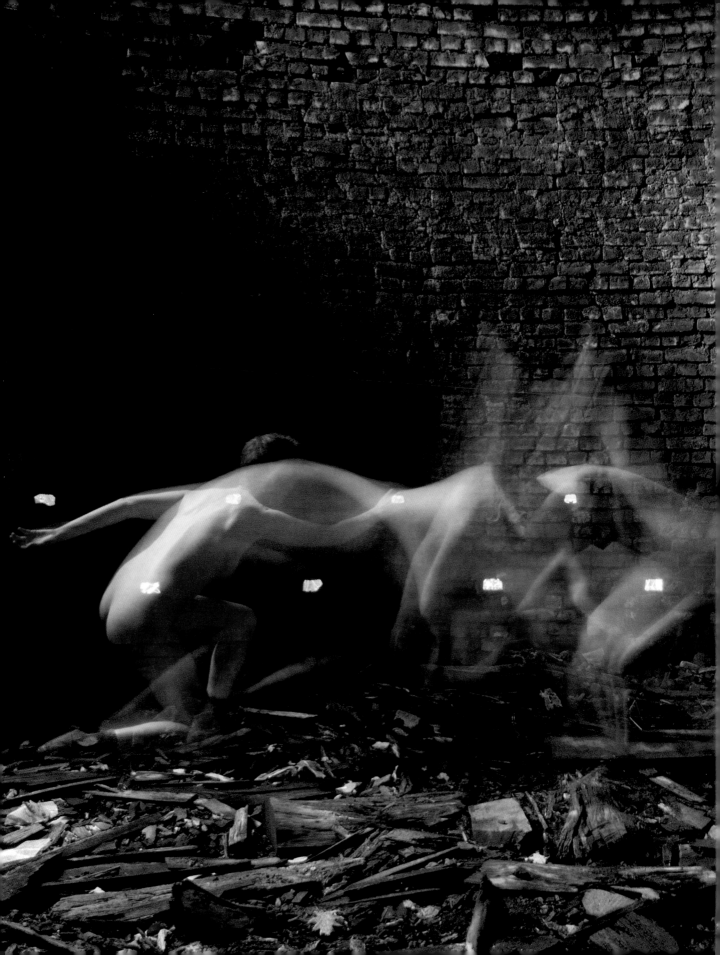

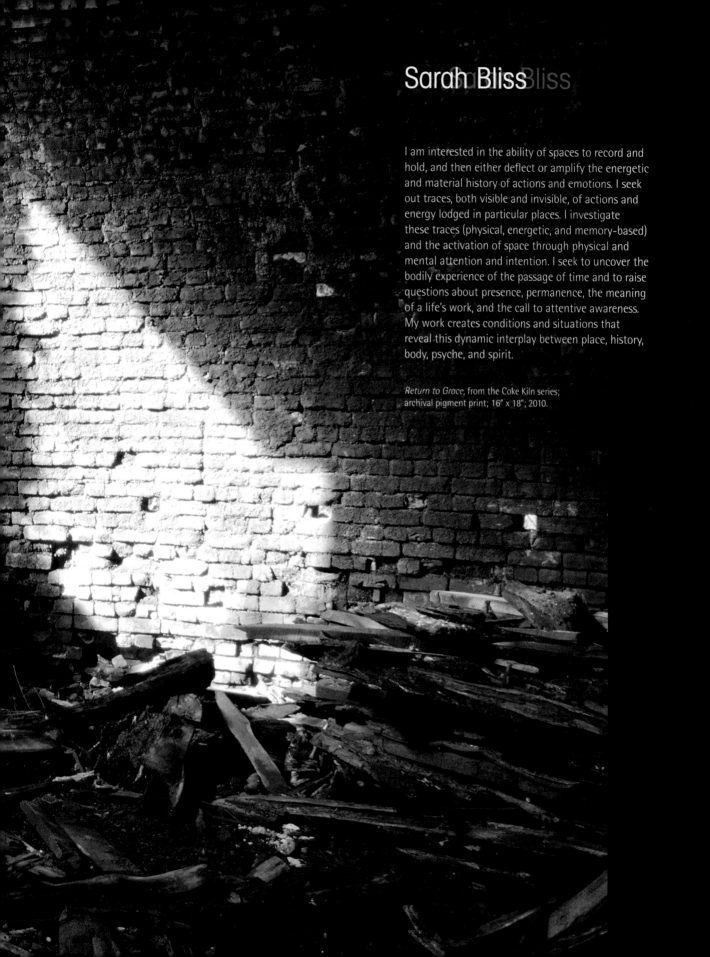

Sarah Bliss

I am interested in the ability of spaces to record and
hold, and then either deflect or amplify the energetic
and material history of actions and emotions. I seek
out traces, both visible and invisible, of actions and
energy lodged in particular places. I investigate
these traces (physical, energetic, and memory-based)
and the activation of space through physical and
mental attention and intention. I seek to uncover the
bodily experience of the passage of time and to raise
questions about presence, permanence, the meaning
of a life's work, and the call to attentive awareness.
My work creates conditions and situations that
reveal this dynamic interplay between place, history,
body, psyche, and spirit.

Return to Grace, from the Coke Kiln series;
archival pigment print; 16" x 18"; 2010.

White Hole (making time...view two);
12.94" x 10"; 2010.

Catherine Rutgers

32
Alloway,"The World is a Painting", op. cit., p.101

33
William H. Gass, Willie Masters' Lonesome Wife
(Evanston, Ill.: Northwestern University Press, 1968).

34
Brian O'Doherty, "Rauschenberg and the Vernacular Glance",
Art in America, September 1973, Vol. 61, p.84

35
Donald McDonagh, "Unexpected Assemblage", Dance Magazine,
June 1965, vol. 39, p.43

36
Cleve Gray, editor, "Feature: Marcel Duchamp, 1887-1968",
Art in America, July 1969, Vol. 57, p.38

37
Tomkins, op. cit., p.61

38
Francis Roberts, "I Propose to Strain the Laws of Physics"
Art News, December, 1968, Vol. 67, p. 62

39
Suzi Gablik, "Light Conversation", Art News, November 1968
Vol. 67, p. 60

40
"Exhibitions: Pop Goes the Biennale", Time, July 3, 1964,
Vol. 84, No. 1, p.54

41
Gray, op. cit., p. 40

42
O'Doherty, "Rauschenberg and the Vernacular Glance",
op. cit., p. 84

43
Melinda Terbell, "Los Angeles", Arts Magazine, September
1970, Vol. 45, p. 53

44
David Antin, "Art and the Corporations", Art News,
September 1971, vol. 70, p. 26

45
Tomkins, op. cit., p. 48

46
Alloway, "The World is a Painting", op. cit., p. 153

47
Tomkins, op. cit., p.39

Endnotes 76 (making time...view four); 12.94" x 10"; 2010.

BUT WHAT ABOUT THAT OTHER TIME?

Buzz Poole

What more can be said about time? In truth, quite a bit, and that's what makes this book timeless, which is either ironic or perfect, or maybe even the perfect irony. We have the time of poetic verse; the time of aging; the time of space and light; ritualistic time; the idea that time past, present, and future is all the same; time as subjective; time as objective; time as measured in frames, pixels, brushstrokes, graphs, glyphs, and rhythms; time as a function and the functions of time; time as the ultimate reckoner; time as the unknown and unknowable.

But for all of these temporal poses, we do not have my time, or your time. Our time is now, but even that is gone, replaced again and again. Time can be simultaneous but it is never static. Even when we stand still, time does not. In the center of time's ever-moving wheel, the lack of motion does not prevent time from passing, indifferent to what we think of it.

And how about the time I stepped through time? The threshold holding down a Long Island motel room vibrating after a Grateful Dead concert where I first learned of time's flexibility. My limbs had wound through the universe earlier, reeling out from my spine until my vertebrae were exposed the same as my brain; my hands embraced the stars. But I was in time then, not later, however, when I stepped through it. Or did it step through me? Around me? The night was on its way to lasting all morning and I knew sleep was necessary. Companions were a bit more cavalier about challenging time, outlasting it. But my crispiness had turned into a stale crumble. I left the room, but had not intended to walk through time. Yet, that is what happened, a step through time and space, delivering me to a room where a bed awaited, though sleep did not. After defying it and temporarily conquering time and space, I could not help but feel time's weight, the futile effort to reconcile the unexpected past with the imagined future, making for an unbearable present.

Even all of these detailed and learned examinations and appraisals of time that fill these pages do not account for the emotional, personal vagaries of time we carry with us, in our bodies and memories. Because all moments of personal significance become this or that time, like the time your brother accidently hit you in the head with a flashlight, resulting in the dimpled scar you wear above your eyebrow.

The time you lost your virginity; the first time you remember the idea of "death" becoming a presence in your life; the last time you ate peanut butter before it was clear you were allergic to the legume.

These are not the times of seconds and minutes, or even years, yet the lack of precision makes for times far more personal and important, for our times comprise this earthly realm. Memory, of course, is highly imprecise, but that is its greatest value, and perhaps time's greatest power. That imprecision is what creates our intimacy with time, something akin to a lie passed between parent and child, or two lovers, said by one who thinks it is for the best at that moment because the truth is not always so simple, or attainable.

Even the scientific, empirical evidence of time's behaviors does not change the fact that it too, like our memories of those times and our dreams of the times to come, is part of the ultimate human illusion. When our time ends, the rest of time will continue, indifferent to the scales of value we have created and charted in the name of an explanation.

But explanations do not guarantee resolutions, though they do help pass the time. This book definitely fills its reader's time with time, which is exactly what Olga Ast set out to do, since she was a child questioning her grandparents' clock. One aspect of time I think we can all agree upon is how as we grow older and put more time behind us, the more questions we have as time feels accelerated; thoughts consume us and remind of us how little time we have. It is up to us as individuals to decide how best to make use of our time. The contributors have challenged time, confronted it, called it out by name. The results are somber, funny, enigmatic, difficult, whimsical, self-indulgent, with many more applicable adjectives available. But no matter how many words we use, how many visuals we create, time will outlast them all and leave us asking, *But what about that other time?*

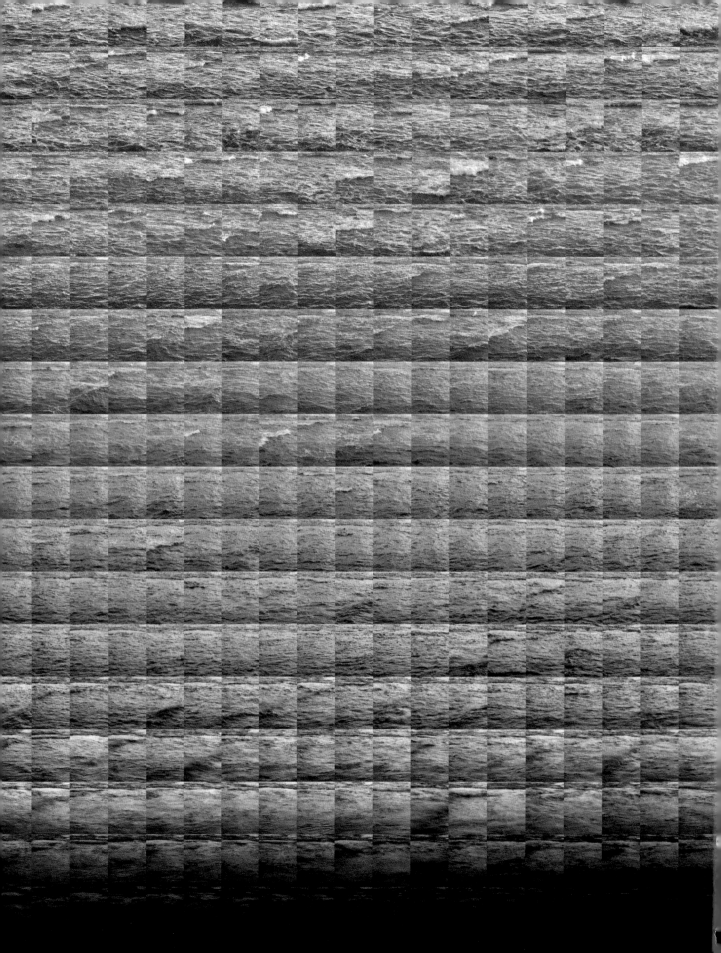

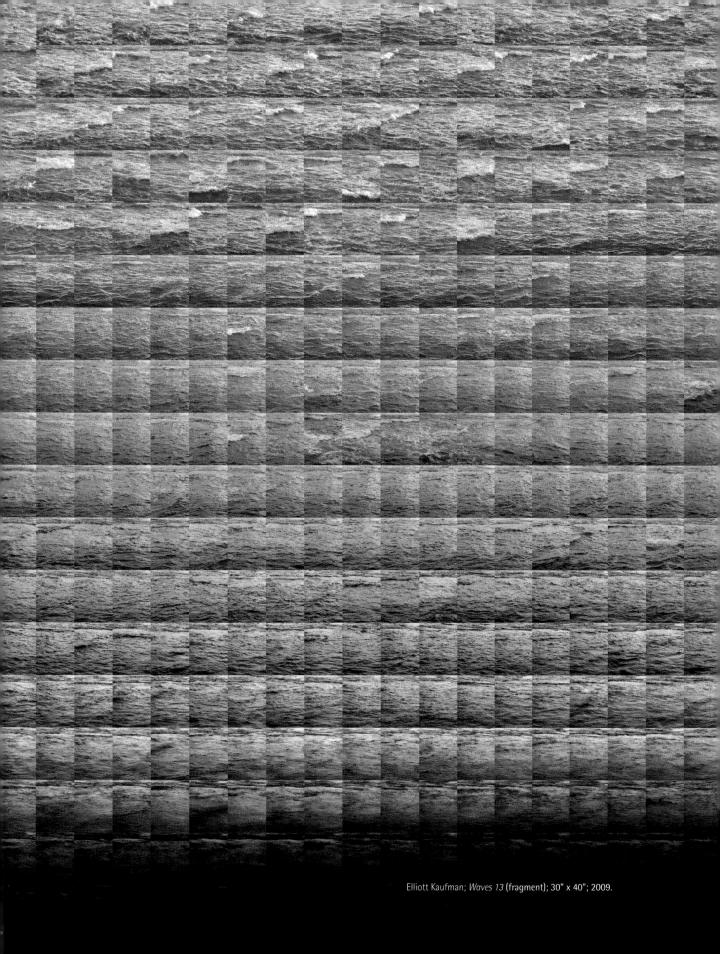

Elliott Kaufman; *Waves 13* (fragment); 30" x 40"; 2009.

David Z. Albert is the Frederick E. Woodbridge Professor of Philosophy and Director of M.A. Program in The Philosophical Foundations of Physics at Columbia University. Albert has published many articles on quantum mechanics, mostly in the *Physical Review*, and is the author of *Quantum Mechanics and Experience and Time and Chance*.

Vladimir Aristov is a poet and the chief of the laboratory of development of relative methods of study of time at the Virtual Institute on Temporology and a member of the interdisciplinary seminar on temporology at the Moscow State University. He is a winner of the Andrei Bely Award (in the area of poetry).

Colleen Asper is an artist and a writer. Her work has been shown internationally and she has contributed to publications that include *Art in America, The Brooklyn Rail, Beautiful/Decay Magazine, artcritical*, Possible Press, and *The Highlights*.

Olga Ast is an interdisciplinary conceptual artist whose work investigates the connection between time, space, and information. She has exhibited and lectured internationally. In 2009, she organized the ArcheTime Conference and Exhibition in New York, dedicated to exploring artistic, academic, and scientific concepts of time. In 2009, she published *Fleeing from Absence*, a book of four essays that explores the nature and interpretations of time.

Chris Basmajian's work has been exhibited internationally at places like FILE 2009 Electronic Language International Festival, Ruth Cardoso Cultural Center, Sao Paulo, Brazil, International Forum Art Tech Media Córdoba in Córdoba, Spain, Jyväskylä Art Museum in Jyväskylä, Finland, and Orange County Center for Contemporary Art in Santa Ana, California. He received a MFA from Maryland Institute College of Art, and a BA from George Washington University in Washington, D.C.

Ilya Bernstein is a poet and philosopher. He is the author of one collection of poems, *Attention and Man* (Ugly Duckling Presse, 2003).

Sarah Bliss is a Massachusetts-based multidisciplinary artist, focusing on the bodily experience of the passage of time and questions about presence, permanence, the meaning of a life's work, and the call to attentive awareness. She is the recipient of full fellowship awards from the School of the Museum of Fine Arts, Boston and the Vermont Studio Center. She received her MTh from Harvard Divinity School. www.sarahblissart.com.

John Boone works with the words and colloquial expressions of American English by collecting, editing, and arranging them before painting them in an italicized digital font of his design. His work is in the collections of MoMA, the Rubin Museum, Italy's Bellagio Study and Conference Center, the New Jersey State Museum, and in many private collections.

David Bowen is a studio artist and educator. His work has been featured in numerous group and solo exhibitions including Brainwave at Exit Art, New York, NY; The Japan Media Arts Festival at The National Art Center, Tokyo; if/then at Vox Populi, Philadelphia, PA; Artbots at Eyebeam, New York, NY; and Data + Art at The NASA Jet Propulsion Laboratory, Pasadena, CA. His work has been featured in *Art in America, Leonardo*, and *Sculpture Magazine*. He is currently an Associate Professor of Sculpture and Physical Computing at the University of Minnesota, Duluth.

Costica Bradatan (PhD, University of Durham) is Assistant-Professor of Honors at Texas Tech University. He has also taught at Cornell University and Miami University, as well as at several universities in Europe and Asia. He is the author of *The Other Bishop Berkeley. An Exercise in Reenchantment* (Fordham University Press, 2006), as well as two other books in Romanian: *An Introduction to the History of Romanian Philosophy in the 20th Century* (Bucharest, 2000) and *Isaac Bernstein's Diary* (Bucharest, 2001). He has also guest-edited a special journal issue on "Philosophy as Literature" for The European Legacy (2009) and another on "Philosophy in Eastern Europe" for Angelaki (2010).

Keith Brown, founder and President of Fast-UK (Fine Art Sculpture & Technology in the UK), has done much to encourage and support digital sculpture at a national and international level, with assistance from the Arts Council of England, Manchester City Council, and MIRIAD. He is currently one of the foremost digital sculptors working in Europe and regularly participates in international electronic and digital art symposia and exhibitions. He has exhibited internationally and, as a result, has gained international acclaim as a pioneer and leader in his field.

Patrick Calinescu lives in Constanta, Romania, where he writes short stories in both Romanian and English. Calinescu started his literary career in 2001; more than 50 of his texts have been published in various literary magazines. His first book, a collection of short-stories written in Romanian, appeared in 2003. www.jurnaleidotomic.egophobia.ro/

Sean Carroll is a Senior Research Associate in Physics at the California Institute of Technology. He received his PhD in 1993 from Harvard University, and has previously worked at MIT, the Institute for Theoretical Physics at the University of California, Santa Barbara, and the University of Chicago. Carroll is the author of *From Eternity to Here*, about cosmology and the arrow of time.

Stephanie Clare is a PhD student and instructor in Women's and Gender Studies at Rutgers University. Her current research is about how taking into account humans' dependence upon the earth transforms the way we think about power and the self. Clare has also written about concepts of agency and temporality in feminist thought, as well as on queerness in feminist film criticism.

Hallie Cohen is a watercolor artist and associate professor and chair of the art department at Marymount Manhattan College in New York City. She is also on the Board of Directors of the Philoctetes Center for the Multidisciplinary Study of Imagination and is the curator of exhibitions. Cohen received her MFA from the Hoffberger School of Painting of the Maryland Institute College of Art and received her BFA from the Tyler School of Art. Cohen is a founding member of the artists' group Retrogarde.

Irina Danilova received her MFA from the School of Visual Arts in 1996. Her work, including performances, videos, and installations, has been exhibited in the US and internationally. Danilova won an international art competition in Halle, Germany, and has been sponsored by Arts Link project in Russia.

Rob David has been working in digital media content development for educational deployment for over a decade. He has generated websites, videos, and 3D models for architecture projects and colleges. In 2006, he completed a Fine Arts degree specializing in fine bronze casting. Since then he has been incorporating his digital skills into a hybrid practice involving video, prints, text, and objects.

Katherine Davis is a student at the University of California, Los Angeles, studying studio arts, physics, and mathematics. Through her art she explores the applications of complex mathematics and physics as related to social, psychological, and philosophical issues.

Luba Drozd views motion art and drawing not as a self-contained medium in itself but as a matrix that can be used to extract specific perceptual states in order to trigger and involve particular perceptual mechanics of viewers themselves. Born in Lemberg, Ukraine, Luba can be intercepted in NYC or San Francisco at sine wave, white noise manipulation events.

Julia Druk graduated from Yale University with a degree in Intellectual History. She continues to explore the social and psychological impact of new media, and most recently edited a book of four essays on time, *Fleeing from Absence* by Olga Ast.

Jennifer Dudley is an artist who works in a variety of media, engaging modalities of narrative from fan-fiction and folklore to adaptation and translation. Her work has been exhibited in New York, Los Angeles, and San Francisco. Dudley received her BFA from the University of Georgia in 1998, an MFA from Yale University in 2005, and attended Skowhegan School of Painting and Sculpture in 2006.

Ula Einstein is a Swiss born multidisciplinary artist based in New York City. Her work includes drawing, sculpture, painting, ongoing installations, and photography, often with hybrid processes. Einstein's work has been exhibited in numerous museums, galleries, and non-profit spaces in the US and abroad. She is a recipient of several New York City art fellowships.

Dan Falk is an award-winning science writer, broadcaster, and author, based in Toronto, Canada. He has written about science newspapers and magazines, including *New Scientist, Astronomy*, and *Sky and Telescope*, and has made nine feature-length documentaries for CBC Radio. His first book was *Universe on a T-Shirt: The Quest for the Theory of Everything*, and his most recent book, *In Search of Time: Journeys Along a Curious Dimension*, was published in 2008.

Nathan Felde, Chair of Design at the Art Institute of Boston at Lesley University, is a founding board member of the Institute for Study of Anticipatory Systems. His work, spanning the behavioral arts and technology, includes projects for Mercedes Benz, Orange Labs, Harvard Business School, Circus Family Sardine, and Samsung. He was a founding partner of Images design studio and Communication Arts and Technology Group; and an Executive Director of NYNEX Science and Technology. Felde received his MS in Visual Studies from MIT's School of Architecture.

Michael Filimowicz is an interdisciplinary artist working in the areas of sound, experimental video, creative writing, net art, public art, and digital photography. As a writer he has published poetry, fiction, and philosophy, and as a sound designer he has mixed soundtracks for film and television. He is on the faculty in the School of Interactive Arts and Technology at Simon Fraser University.

Christian Friedrich is an architect born in Germany. He has an architectural engineering degree from Hanzehogeschool Groningen, and finished his graduate education (MSc) in architecture at Delft University of Technology, Netherlands. He is co-founder of the media artist collective Ezthetics. Since 2002, he he has been involved in several projects of the architectural office of Kas Oosterhuis and Ilona Lénárd, ONL.

Matthew Fritze is an artist whose work spans poetry, assemblage, and printmaking. Fritze's visual art has moved from the deeply meditative geometric abstraction of his early prints to the more spontaneous, poetic and alchemical amalgams realized through his assemblages of found objects. Samples of Fritze's work can be viewed at: www.artistsspace.org.

Evgeny Golovakha, PhD, ScD, is the Deputy Director of the National Institute of Sociology of the Ukraine. He is the co-author (with A.A. Kronik) of the goal-and-causal theory of psychological time, published in the book, *Psychological Time of Personality* (Kiev, 1984; Moscow, 2008), which won the 2009 Golden Psyche award (St. Petersburg, Russia) as the best project in psychological science (in Russian language).

Elizabeth Grachev is an artist originally from Russia residing in New York since 1978. Grachev worked as a programmer at Lehman College for eighteen years. Her artwork is in the permanent collections of the State Russian Museum in St. Petersburg, the State Tretyakov Gallery in Moscow, Moscow's Museum of Modern Art, and other leading Russian museums.

Christian Hawkey has written two full-length collections and three chapbooks of poetry, including *Ventrakl* (Ugly Duckling Presse, 2010), a mixed-genre exploration of the life and work of Georg Trakl. In 2006 he received a Creative Capital Innovative Literature Award. In 2008 he was a DAAD Artist-in-Berlin Fellow. His work has been translated into thirteen languages.

Kai-Min Hsiung's work includes video, installation, and video installation controlled by computer programs. Hsiung lives and works in Taipei, Taiwan. In 2008, he received his MFA in Computer Art from the School of Visual Arts, New York.

Duoling Huang, born in China, 1950, was sent to the remote countryside from Beijing during the Cultural Revolution. She started painting there and went to Tianjin Fine Art College later. She taught painting in a design institute before coming to New York in 1987. Huang has been exhibiting paintings since 1990 in North America.

Ken Jacobs is an American experimental filmmaker. He is the director of *Tom, Tom, The Piper's Son* (1969, USA), which was admitted to the National Film Registry in 2007, and *Star Spangled to Death* (2004, USA), a nearly seven hour film consisting largely of found footage. He coined the term paracinema in the early 1970s, referring to cinema experiences provided by means outside of standard cinema technology.

Edward Johnston is a new media artist working in a variety of contexts involving 3D animation, interactive media, and digital fabrication. He has exhibited and screened his creative work in venues throughout the United States and abroad. Johnston has been awarded multiple funding opportunities including a Trailblazer Grant, Jean Paul Slusser Fellowships, and the Shapiro/Malik Award. In addition, he received the 2009 Young Artist's Program Grant Award from the D.C. Commission on the Arts & Humanities, partly funded by the National Endowment for the Arts.

Elliott Kaufman began shooting in the mid-1970s and developed ideas for site-specific photomurals and wall art. Commissioned by the Public Art Fund to create a 35' x 45' mural outside of the Holland Tunnel, a New York State Council on the Arts grant led to the exhibit "Murals for Astor Place" at the Houghton Gallery of the Cooper Union.

Aleksandr Kronik, PhD, ScD, is an Adjunct Professor of Psychology at Howard University, and a licensed psychologist with clinical practice in Maryland. He is the co-author (with E.I. Golovakha) of the goal-and-causal theory of psychological time, published in the book, *Psychological Time of Personality* (Kiev, 1984; Moscow, 2008), which won the 2009 Golden Psyche award (St. Petersburg, Russia) as the best project in psychological science (in Russian language).

Kat Kronick is a practicing psychologist and artist. In 1984, she received her Doctorate in Psychology from the Psychological Institute (Moscow, Russia). Three years later, she published a book about human attraction, *The Cast of Characters* (Moscow: Mysl, 1987). Kronik's art has been showcased at various international solo and group shows. Numerous private collections and galleries around the world include her paintings.

Eliza Lamb is a graduate of the Savannah College of Art and Design where she earned her BFA in Photography and is currently pursuing graduate studies at Columbia University. Her photographs have been exhibited on a local and national level. www.elizalamb.com.

Helene Lanois has had close to 100 exhibitions in Canada, the United States, and Europe. She has worked as an art teacher, conference speaker, radio broadcasting arts commentator, and was the artistic director of a contemporary art gallery Nouveau Re g'Art in Québec, Canada. She obtained a Master's Degree in Metaphysical Science and three Bachelor's Degrees (Psychology, Education and Fine Arts) and is now studying toward her Doctorate in Metaphysical Science.

MaryAnne Laurico is a PhD candidate in the Department of English at Queen's University in Kingston, Ontario, Canada. Specializing in contemporary Canadian literature, she earned her HBA and MA from the University of Toronto.

Julia Morgan-Leamon is a painter and video installation artist from Western Massachusetts. Her interdisciplinary work examines ordinary gesture, the impulse to move, and how trajectories of motion connect memory and occurrence. Her paintings, videos, and installations explore the interchange between time, memory, and experience.

Dr. Richard Leslie has been visiting assistant professor of art history and criticism at the State University of New York-Stony Brook since 1990 and is a member of the Graduate Faculty at the School of Visual Arts, New York City. He has published dozens of reviews and articles with books on Pop Art, Picasso, and Surrealism, served as Managing Editor of the journal *Art Criticism*, as foreign correspondent and now contributing editor for *Art Nexus* magazine, and is recipient of several fellowships. He has curated several exhibitions on art and technology and served on the Board of Directors for Art and Science Collaborations, Inc. (ASCI) since the early 1990s.

Jeremy Levine is the principal of the architecture firm, Jeremy Levine Design. Levine earned a Master's Degree in Architecture from the Southern California Institute of Architecture. He began his design career art directing horror films for the infamous producer Roger Corman. Since opening his architecture and design firm in 2001, Levine's work has been featured on the cover of *Dwell* magazine and on the TV show *Renovation Nation*.

Francis Levy's debut novel, *Erotomania: A Romance*, was released in August 2008 by Two Dollar Radio. His short stories, criticism, humor, and poetry have appeared in the *New York Times*, the *Washington Post*, the *New Republic*, the *Village Voice*, the *East Hampton Star*, the *Quarterly*, *Penthouse*, *Architectural Digest*, *TV Guide*, the *Journal of Irreproducible Results*, and other publications. He is the co-director of The Philoctetes Center for the Multidisciplinary Study of Imagination.

Andrea Liu is a visual art and dance critic. She has completed artist residencies at the Museum of Fine Arts at Houston CORE program, Atlantic Center for the Arts, Vermont Studio Center, Wildacres, Jacob's Pillow Research Fellowship and has written for *ArtUS*, *Women and Performance*, *Postmodern Culture*, and *Journal of Aesthetics and Protest*. She studied

literature at Yale (BA) and thereafter studied literary criticism at Centre Parisen D'Etudes Critiques.

Craig Res Morehead is a literary scholar with a focus on Transatlantic Modernism. His research examines the intersections of scientific principles, film history, and modernist literature, especially in relation to scientific theories of time, filmic manipulation of time, and narrative temporal structures.

Paul Doru Mugur studied medicine in Romania, France, and the United States. He is currently an associate professor of Medicine at Weill Medical College of Cornell University in New York. He is also a published writer and he has been acknowledged as one of the top 100 upcoming Romanian artists. He is the founding editor of *Respiro*, a multilingual quarterly cultural magazine.

George Musser covers astronomy and fundamental physics for *Scientific American Magazine*. He was the originator and an editor of the special September 2003 issue, "A Matter of Time," which won a National Magazine Award for editorial excellence. He is the author of *The Complete Idiot's Guide to String Theory*.

Edward Nersessian is professor of psychiatry at Weill Medical College, Cornell University, and a training and supervising analyst at the New York Psycho-analytic Institute. A practicing psychiatrist and psychoanalyst since 1973, he has served as president of the New York Psychoanalytic Foundation and was a founder of the New York Psychoanalytic Neuro-Psychoanalysis Program. He is founding editor of *Neuro-Psychoanalysis: An Interdisciplinary Journal for Psychoanalysis and the Neurosciences*, and has published numerous articles. He is co-founder and co-director of the Philoctetes Center for the Multi-disciplinary Study of Imagination.

Michaela Nettell graduated from Norwich School of Art and Design in 2003 and the Royal College of Art, London in 2007. Combining video and film projections with glass, water, and mirrors she creates short films and sculptural installations. Nettell's work has been exhibited in galleries throughout Europe and the US. www.michaela-nettell.com

Gary Nickard is a conceptual artist committed to exploring the consilience between art and science while simultaneously engaging such diverse topics

as literature, philosophy, music, and psychoanalysis. He works in photography, installation, and various time-based media as well as electronic music. He joined the UB Art Department in 1995.

Brandon Neubauer was born in California in 1978, and has lived and worked in New York City since 1996. He has received fellowships from Chashama North, the Rotunda Gallery Video program, the Saltonstall Foundation for the Arts and the Vermont Studio Center. He has participated in a variety of group exhibitions and his first solo exhibition, "Fractured Landscapes," took place in 2005 in Berlin, Germany. www.brandonneubauer.com

Dr. Mark Norell is Chairman and Curator-in-Charge of Fossil Amphibians, Reptiles, and Birds at the American Museum of Natural History, and Professor of Paleontology at the Museum's Richard Gilder Graduate School. Norell has an interest in Asian art and history, sits on the board of the Rubin Museum of Art, and is Curator of the AMNH exhibition, The Silk Road: Ancient Pathway to the Modern World.

Satomi Orita is a graphic designer. After graduating high school in Tokyo, Japan, Orita moved to the Unites States, where she attended Skagit Valley College, Washington, and majored in graphic design at The Art Institute of Boston.

Eugene Ostashevsky is a Russian-American poet and translator residing in New York City. His most recent book of poems, *The Life and Opinions of DJ Spinoza*, deals with inconsistencies in natural and artificial languages. He is also the editor of *OBERIU: An Anthology of Russian Absurdism* (Northwestern UP, 2006).

Emanuel Dimas de Melo Pimenta is an architect, music composer, and writer. He is an active member of the New York Academy of Sciences, the American Association for the Advancement of Science in Washington DC, and the American Society of Media Photographers. He is member and advisor of the AIVAC (Association Internationale pour la Video dans les Arts et la Culture), in Locarno, Switzerland. Pimenta has served as a professor and lecturer at several international institutions and universities. He lives in Locarno, Switzerland. www.emanuelpimenta.net

Vanessa Place is a writer and lawyer, and co-director of Les Figues Press. She is the author of *Dies: A Sen-*

tence (Les Figues Press), the post-conceptual novel *La Medusa* (Fiction Collective 2), and, in collaboration with appropriation poet Robert Fitterman, *Notes on Conceptualisms* (Ugly Duckling Presse, 2009). Place is also a regular contributor to X-TRA *Contemporary Art Quarterly*. She is also the author of *The Guilt Project: Rape and Morality* (Other Press, 2010)

Buzz Poole is Mark Batty Publisher's managing editor. He has written for numerous publications, including the *Village Voice*, *The Believer*, *Print*, and *The Millions*. He is the author of the short story collection *I Like to Keep My Trouble On the Windy Side of Things* and *Madonna of the Toast*, which the *New Statesman* named one of 2007's Best Underground Books.

Melissa Potter has exhibited her work internationally. She has an MFA from Mason Gross School of the Arts, Rutgers University and a BFA from Virginia Commonwealth University. She is the founder of the feminist critique group, Art364B and an assistant professor in the Interdisciplinary Arts Department at Columbia College Chicago. Potter is a two-time Fulbright recipient. Her critical essays on art have appeared in *BOMB*, *Art Papers*, *Flash Art*, *Proximity Magazine*, *Hand Papermaking*, and *AfterImage*.

Don Relyea is an artist, programmer, sound designer, and inventor. He is particularly focused in the area of computational art; writing his own custom art software in C++ and Open GL. Relyea's artwork has been exhibited internationally. Relyea lives and works in Dallas, Texas, with his wife and three kids.

Glen River has made art since childhood, including writing, poetry, lyrics, music, printmaking, painting, photography, and movie making. A progression of work and solo shows in the United States, England, France, Switzerland, and Greece was followed by interdisciplinary works created in his studio in Weston, Connecticut.

Kara Rooney is a New York-based artist, writer, and critic. Her visual work has been exhibited in numerous international galleries and museums including the Chelsea Art Museum. Her writing has appeared in various publications, including the *Brooklyn Rail*, Degree Critical, the *Daily Constitutional*, and *Performa Live 07*. She has an MFA in Art Criticism from the School of Visual Arts.

Daniel Rosenberg is associate professor of History in the Robert D. Clark Honors College at the University of Oregon. With Anthony Grafton, he is author of *Cartographies of Time*.

Anje Roosjen received her training as an artist at Rietveld Art Academy (Amsterdam) and served her apprenticeship with the Dutch artists Pat Andrea (Paris) and Peter van Poppel (Utrecht). She traveled to Japan, India, and China for international artist in residence projects. Since 2005, she has been organizing exhibitions and cultural events, profiting from her academic background as an urban planner (University of Amsterdam, 1997). www.anjeroosjen.com

Catherine Rutgers works with painting, collage, construction, and mixed media on canvas. Her first solo exhibition took place in 1979. Since 2001, her focus has been on creating digital images originating in photographs of conceptual sculpture and high-resolution scans of three-dimensional artwork and objects. Rutgers earned her BA in Culture and Society from Purchase College, State University of New York.

Dr. Michael Shara is curator in the Department of Astrophysics at the American Museum of Natural History. Prior to joining the museum, he spent seventeen years with the Space Telescope Science Institute at Johns Hopkins.

Dr. Alexei Sharov is a staff scientist at the Genetics Laboratory, National Institute on Aging in Baltimore. He received his BS, MS, and PhD degrees at Moscow State University in Russia. www.home.comcast.net/~sharov.

Michael Shulman was born in the Soviet Union in 1946, and lives in Moscow. He is a graduate of Moscow Power Institute (1969). Since 1997 he has been a member of the Russian Interdisciplinary Temporology Seminar and the WEB-Institute of Time Nature Explorations. www.timeorigin21.narod.ru

Jesse Stewart is a composer, percussionist, improviser, visual artist, instrument builder, writer, and researcher dedicated to re-imagining the space between artistic disciplines. His music has been featured at international festivals and he has performed with musical luminaries including George Lewis, Roswell Rudd, Evan Parker, Bill Dixon, William Parker, Pauline Oliveros, and Joe McPhee. As a visual

artist, he has exhibited work in over a dozen solo, group, and juried art exhibitions. He is a professor in the School for Studies in Art and Culture at Carleton University in Ottawa, Canada.

Linda Stillman works in various media: painting, photography, collage and installation. Her work has been exhibited at several institutions and in 2010, she had a one-person exhibition of her photographs, "Found New York" at the New York Public Library. She was awarded a fellowship by the Virginia Center for the Creative Arts in 2010. Stillman is a graduate of the University of Pennsylvania and the School of Visual Arts. She received her MFA from Vermont College of Fine Arts.

Debra Swack is a new media artist whose projects have been presented internationally at such venues as The University of California at Irvine, Princeton University, The New Museum, The New York Hall of Science, The Banff Center for the Arts, The Arts and Genomics Center in Amsterdam and Vancouver, Xerox's Palo Alto Lab, Real Art Ways (Sol LeWitt Collection) and the Beecher Center for Arts and Technology.

Lisa Tannenbaum is an architectural historian with a focus on spas, bathing, water, and places of wellness. She teaches at Parsons the New School in the Department of Art and Design History and Theory.

Catinca Tilea was born in the south of Romania and moved to Bucharest in 2003 to study product design at the National University of Arts. She then went on to a Master's Course in product design, specializing in recycling problems. In 2009, Tilea moved to the Netherlands to pursue a Master's Course in interior architecture and retail design at the Piet Zwart Institute.

Camilla Torna graduated in history of art at the University of Florence, Italy. She teaches illustration and graphic design at SACI Studio Art Centers International, Florence, and has designed for both print and digital media. www.icastic.com

Vladimir Tuchkov is a fiction writer, poet, and performance artist from Moscow, Russia. His work has appeared in various international publications. He is the recipient of several literary awards, including International Turgenev Festival and Russian Vers Libre Festival. Tuchkov's collection of short stories,

Death Comes Via the Internet, was named by the Academy of Russian Literature among one of the most important works of the 1990s.

Ellen Wiener's intimate page-size paintings and illuminated alphabet made for a contemporary *Book of Hours* have been exhibited widely at galleries, universities and libraries.

Steve Witham is a software engineer in the Boston area with interests in mathematical and computer art. Occasionally, he blogs about ways of thinking about the future.

Peter Whiteley has been curator of North American Ethnology at the American Museum of Natural History since 2001. Principal publications include *Deliberate Acts: Changing Hopi Culture through the Oraibi Split*, *Rethinking Hopi Ethnography*, and *The Orayvi Split: A Hopi Transformation*.

Courtney Wrenn (aka scrapworm and Sean Wrenn) graduated from NYU with a Bachelor of Science (Studio Art) in 2002, and proceeded to organize "Art as Experiential Moment" collaborative/trans-genre festivals under the umbrella of NeoIntegrity and has produced numerous solo Chashama installation projects 2003-2010. Wrenn received the Mount Royal School of Art MFA Fellowship at MICA (2006-2008).

Matvei Yankelevich's books and chapbooks include *Boris by the Sea* (Octopus Books), *The Present Work* (Palm Press), and *Writing in the Margin* (Loudmouth Collective). His translations from Russian have cropped up in *Calque*, *Circumference*, *Harpers*, *New American Writing*, *Poetry*, and the *New Yorker* and in some anthologies, including *OBERIU: An Anthology of Russian Absurdism* (Northwestern) and *Night Wraps the Sky: Writings by and about Mayakovsky* (FSG). His translations of Daniil Kharms were collected in *Today I Wrote Nothing: The Selected Writings of Daniil Kharms* (Ardis/Overlook). He teaches at Hunter College, Columbia University School of the Arts (writing), and the Milton Avery Graduate School of the Arts at Bard College. At Ugly Duckling Presse, he designs and/or edits various books, is the editor of the Eastern European Poets Series, and a co-editor of *6×6*. He lives in Brooklyn.

Jayoung Yoon was born in Seoul, Korea. She received her MFA from Cranbrook Academy of Art

in 2009, a post-baccalaureate certificate from Maryland Institute College of Art, and a BFA and an MFA from Hongik University in Seoul. She was awarded the Franklin Furnace Grant and the Gerhardt Knodel Fund/Cranbrook Merit Scholarship. She has attended many artist-in-residence programs such as Skowhegan School of Painting and Sculpture in Maine, and Anderson Ranch Arts Center in Colorado. Her work has been exhibited in numerous solo and group shows in the United States and Korea. www.jaiyoung.com

Norman J. Zabusky gave the keynote talk, "Scientific Computing Visualization" published in *Science and Art Symposium*, 2000. In 2005 he organized and directed ScArt4: 4th Science and Art Conference (New Brunswick, NJ). From 1988–2005 he was State of New Jersey Professor of Computational Fluid Dynamics, Rutgers University, Dept of Mechanical & Aerospace Engineering. In 2003 he was awarded the Otto Laporte Award of the American Physical Society, Division of Fluid Dynamics.